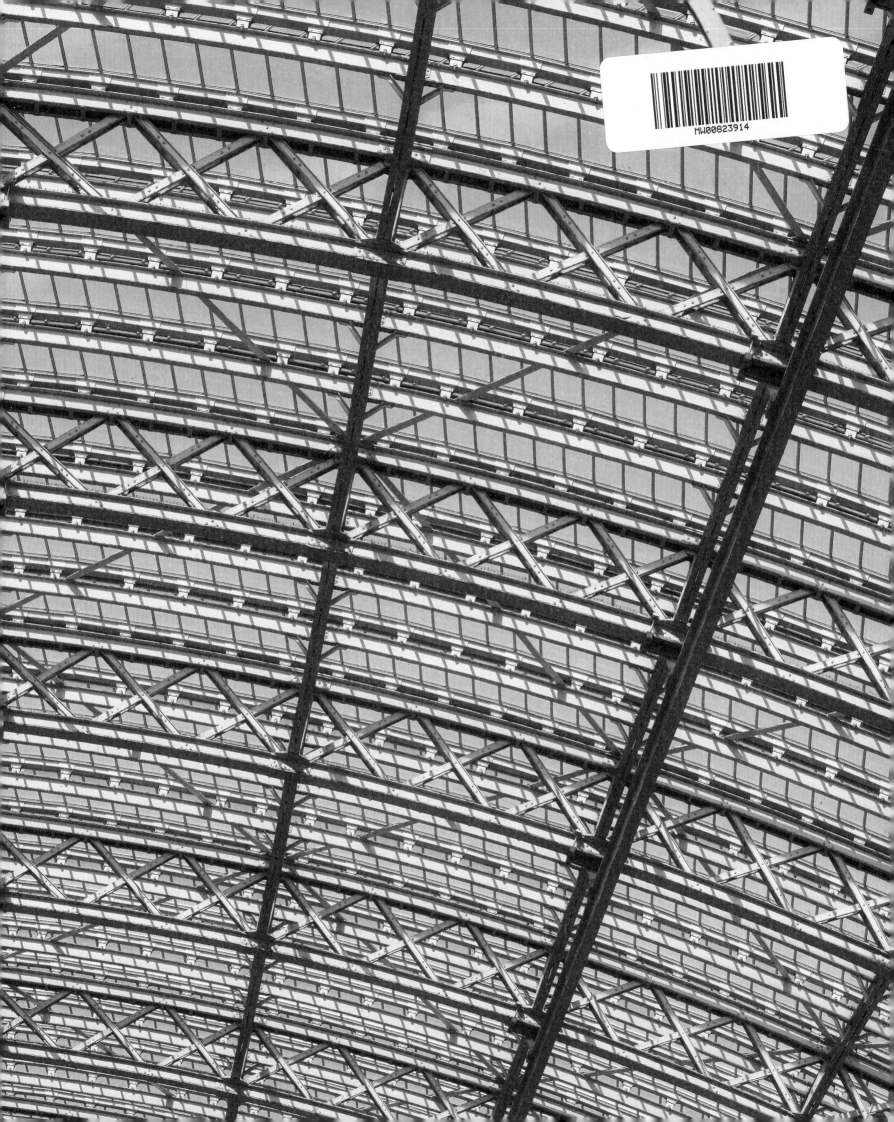

London's Great Railway Stations

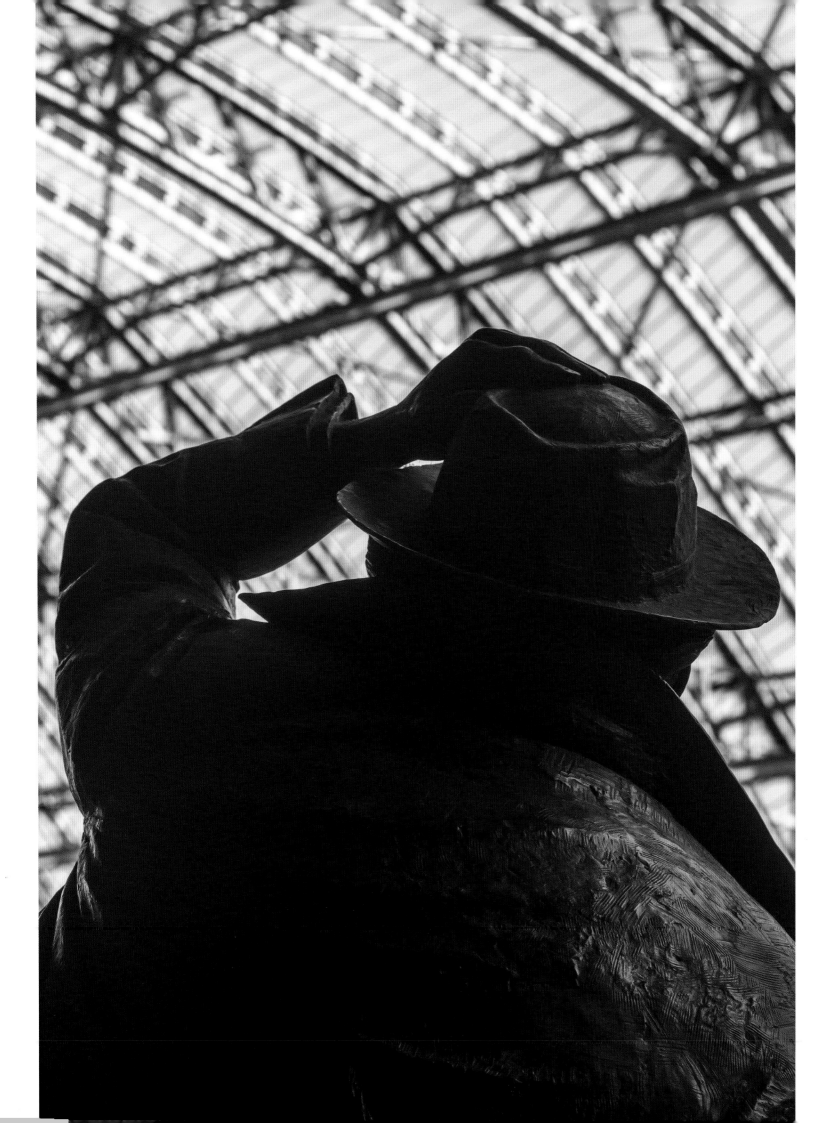

London's Great Railway Stations

Oliver Green

Photography by
Benjamin Graham

FRANCES
LINCOLN

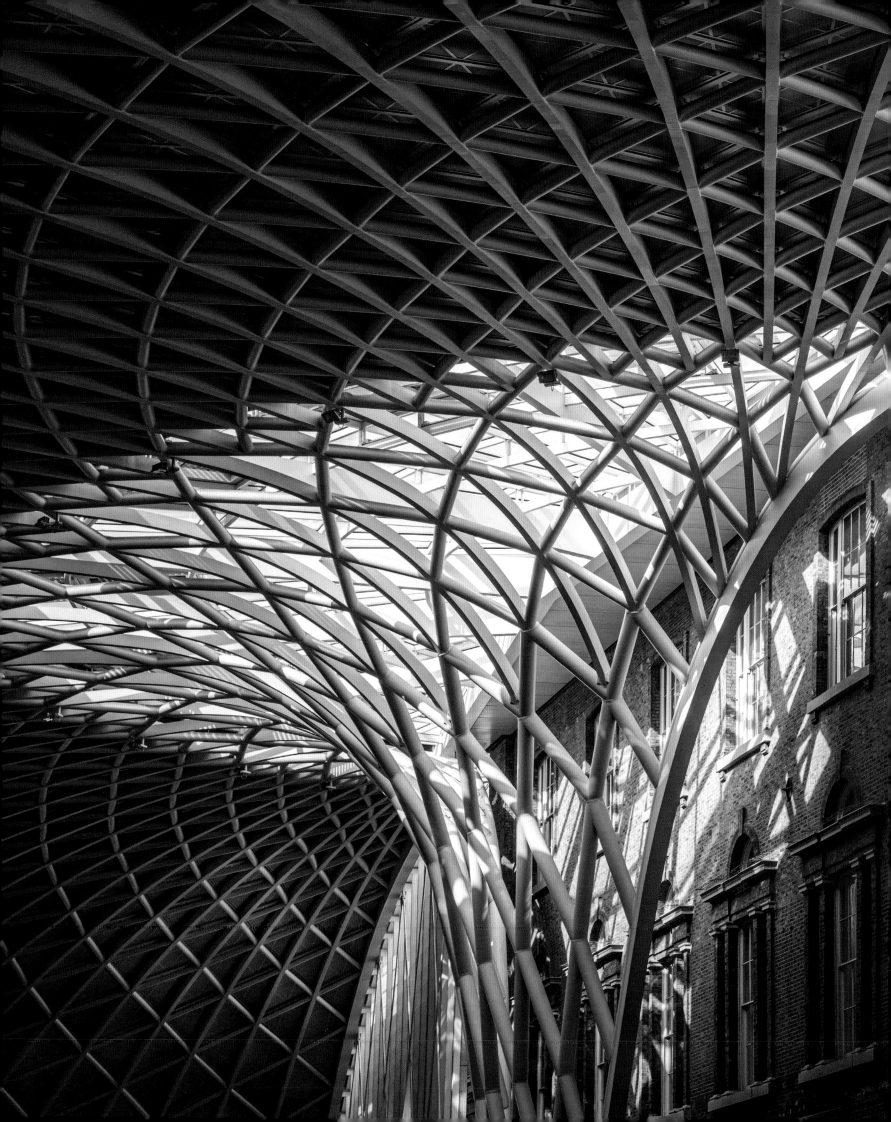

Previous page Sir John Betjeman (1906–84), the Poet Laureate who loved railways, now has his own statue at St Pancras, gazing up at the great roof he helped to save. Betjeman's enthusiasm for London's great stations, large and small, was an inspiration to everyone who worked for their restoration and protection. Without him we would have lost a lot more of them.

Left The new departures concourse building on the west side of King's Cross station, with its spectacular roof support structure, opened in 2012.

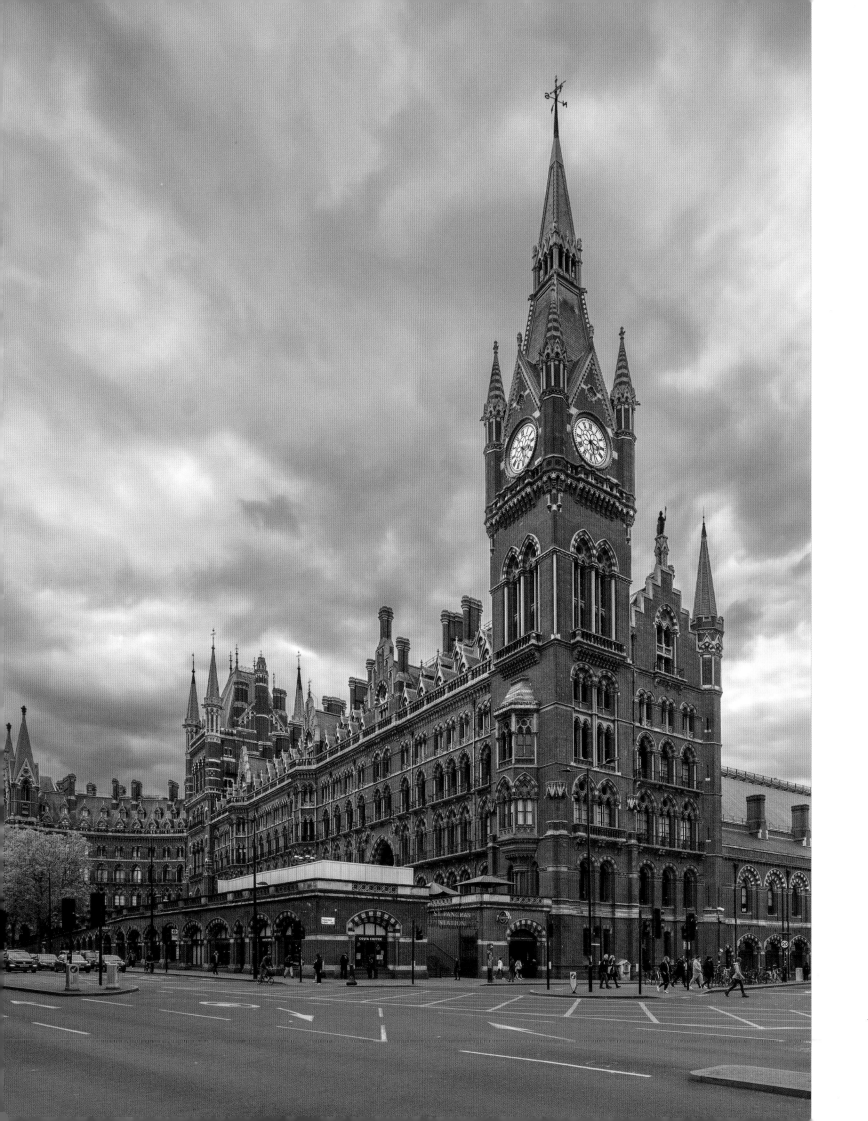

Foreword

Left London's greatest Victorian gothic building, the former Midland Grand Hotel commissioned by the Midland Railway to front their enormous trainshed at St Pancras, seen to the right.

Right The main staircase of the Midland Grand, now restored to become the St Pancras Renaissance Hotel. The re-opening took place on 5 May 2011, 138 years to the day after the original opening in 1873.

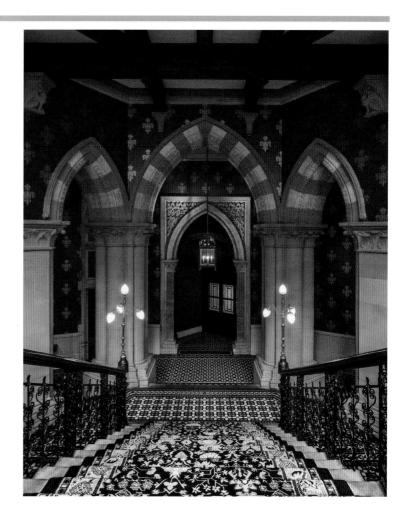

One of the great joys of my working life has been, and is, the privilege of being the temporary custodian of great buildings, both in my time as Commissioner of Transport for London and now as Chair of Network Rail. The railway, and later the underground railway, were both originally brought to life in Britain, and have not only changed our society and economy, but bequeathed us some glorious buildings as well. Describing railway hardware as 'assets' is questionable – many of the earthworks and structures are actually expensive liabilities – but it would be heartless to describe most stations in the same way. The architecture of the great railway era has for the most part aged extraordinarily well, and the country, and particularly London, is all the richer for our great stations, which is why this book, written by transport historian Oliver Green, and featuring Benjamin Graham's wonderful photographs, is so welcome.

As buildings, they are monuments to the steam (and less often, the electric) age; with travellers and visitors in them they take on lives of their own, with individual characters. Paddington, I'm sure you'd agree, is a grand place, the start of many significant journeys; in my case, when I was small, travelling on the Cornish Riviera Express to the seaside. The bustle of Charing Cross and Cannon Street is obviously suburban; an express would look out of place (both did have them, though not many).

And the stations have shaped the neighbourhoods around them, too. The regal hotels at Paddington, St Pancras and Charing Cross are dominant and set more than the tone of just the stations; they command the surrounding areas, leaving no one in any doubt about the importance of those buildings to the appearance, life and economy of the neighbourhood.

Benjamin's newly commissioned photographs will remind you of just how fabulous many of these stations are, and how much we should treasure them. Unlike some times in the past, Network Rail and Transport for London both now do their best to do just that, and we also try hard to build new and replacement stations as functional and elegant as those of our inheritance. I'd like to think that the new London Bridge, the Jubilee line and certainly the new Elizabeth line stations all qualify.

As you turn the pages and follow the fascinating story, please savour the beautiful photographs of our railway inheritance. The buildings are ours to maintain, but these images, and the stations themselves, are for all of you to admire, travel through (virtually and actually) and enjoy.

Sir Peter Hendy CBE
Chair, Network Rail

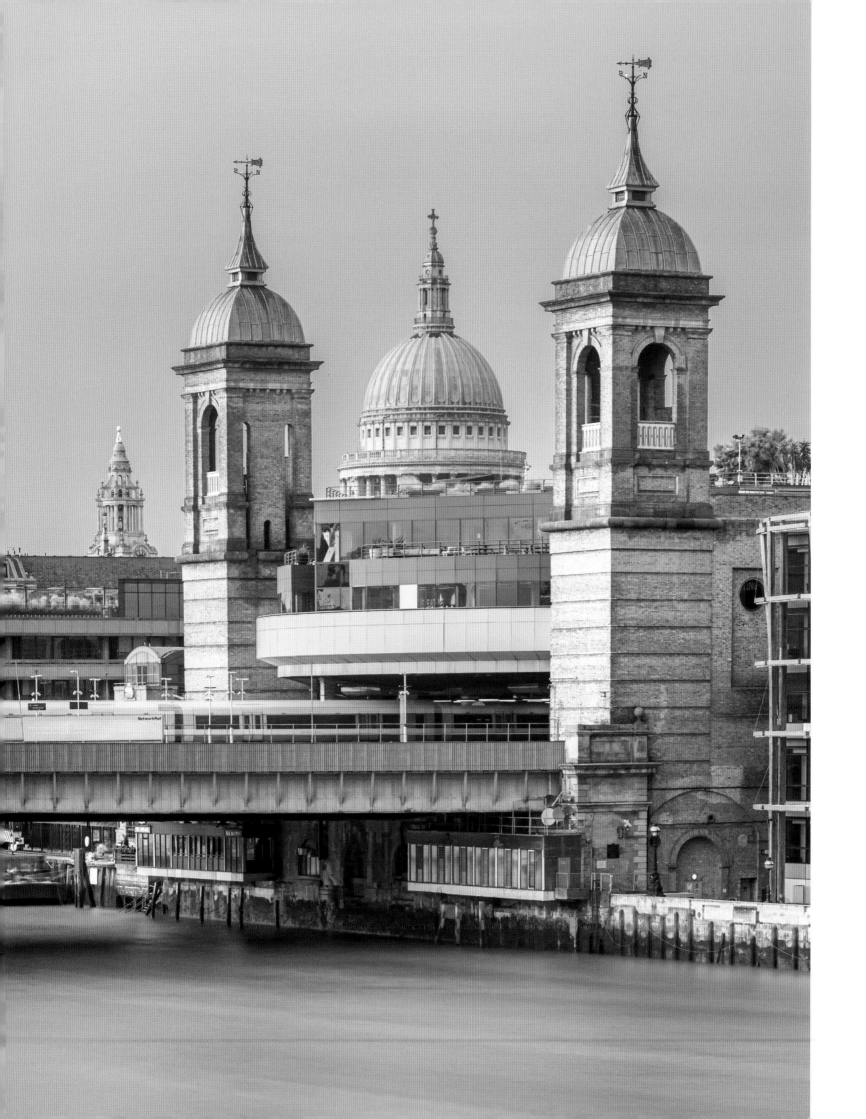

Introduction: Capital Tracks

London has more main-line railway stations than any other city in the world, all of them first built in the Victorian period. Its earliest terminals were opened in the late 1830s, when the first lines between the capital and the regions were planned. The original station at London Bridge, the capital's first passenger terminus, opened in December 1836, six months before Queen Victoria came to the throne. The last main line to London in the nineteenth century, terminating at Marylebone, opened in March 1899, two years before the elderly queen died.

More than one hundred years later, two additional main lines (HS1 and HS2) have been under development to bring high speed trains to and from the capital. Although both are completely new railways on physically separate alignments from the Victorian main lines, both will operate from existing termini that have been rebuilt and extended. High Speed One (HS1) was opened to the renamed St Pancras International in 2007 and HS2 is now under construction to a new station alongside Euston, where it will open in the late 2020s.

Over the six decades that Victoria reigned, London's size and population grew from a city of about 2 million people to a huge metropolis of around 6.5 million in 1901. London was already the largest city in Europe before a single passenger railway had been built, but the development of a national rail network in the nineteenth century transformed the whole of Great Britain. Passenger journeys that had taken days by road were reduced to hours by rail. Heavy and bulky goods that in 1820 could only be transported by ship and canal barge could be distributed almost anywhere by train forty or fifty years later.

Most of the early steam railways were built in the industrial North, where at first they carried coal and minerals rather than people. The Stockton and Darlington Railway (S&DR) was the first to carry passengers in 1825, but its main purpose and business was shifting coal. Five years later, the Liverpool and Manchester Railway (L&MR) was the first to be built as an inter-city passenger route. Its success soon led to plans to construct main lines from the regions to the capital.

This was not a straightforward process. The railway companies established from the 1830s onwards were business enterprises floated with private capital. Their success and survival depended upon the financial return they were able to give their shareholders. In the free-enterprise culture of the nineteenth century, the Government was not involved in managing or financing railway development, but Parliament had a crucial role in giving authorization for every project. Each proposed new line and terminus required a private Act of Parliament to give the railway company power to buy land by compulsory purchase, and to secure this every plan had to face detailed scrutiny from Parliamentary committees, and occasionally Royal Commissions.

Despite this apparently rigorous process, regulation was light touch, with a good deal of duplication as a result of fierce competition between rival companies. There was certainly no

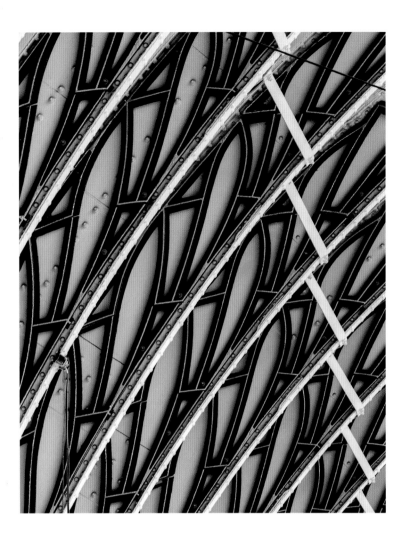

plan for a logical and integrated network across the country. Railway development in London was particularly contentious and complicated by issues of property ownership and the physical geography of the city area. During the nineteenth century, plans for London termini came to involve more than a dozen separate railway companies, often battling for access to adjacent station sites but with little collaboration between them. They were also up against powerful obstruction and objections from wealthy landowners and authorities such as the City of London Corporation. The losers were usually the poor, particularly if their homes lay in the path of an approved rail installation.

Having a main-line terminus built as close as possible to the twin centres of the City and Westminster was always a prime objective, which partly explains why new projects kept emerging over six decades. But the pattern of development is not obvious from the physical positioning of London's various termini. They are distributed in a rough rectangle bound by the New Road (now the Euston and Marylebone Roads) in the north, lined up from Paddington in the west to King's Cross in the east; from the edge of the City at Liverpool Street and Fenchurch Street; just across the river to the south at London Bridge and Waterloo, with forays over the Thames to Cannon Street, Blackfriars and Charing Cross; and a final south-west outpost at Victoria. The last four southern termini, together with St Pancras on the northern perimeter, were all completed in the frantic construction boom of 1860–75, when seven new terminal stations were opened in London.

These new termini were linked up by the Metropolitan and District Railways, the earliest cut-and-cover sections that became the Circle line of the London Underground opening between 1863 and 1884. At this time the central area of Westminster and the City within this misshapen 'circle' was still left untouched by railways apart from the north–south link through Blackfriars, until the development of the deep-level electric Tube system in the 1900s. Only Marylebone, positioned at the north-western edge, was still to be built in the 1890s.

By 1901, London's railway infrastructure, built up throughout Victoria's long reign, was enormous. Stations, depots, goods yards, tracks, bridges and other railway facilities, such as hotels and stables, covered huge areas of the capital. The world's largest city had come to depend on its railway links to function. London's food and coal supplies were brought in by train. Its manufactured and imported goods were distributed by rail. National newspapers and the Royal Mail went by train. Thousands of Londoners were directly employed by the railway companies and many more, such as cab and delivery drivers and hotel staff, depended on them for much of their work. The social and economic impact of the railways on the great metropolis was huge and unprecedented.

The main-line stations had become the gateways to London. Anyone travelling to or from the metropolis on business or pleasure took the train and passed through one of the great railway terminals. By the late nineteenth century, this included a growing army of season ticket holders travelling daily to work in the City

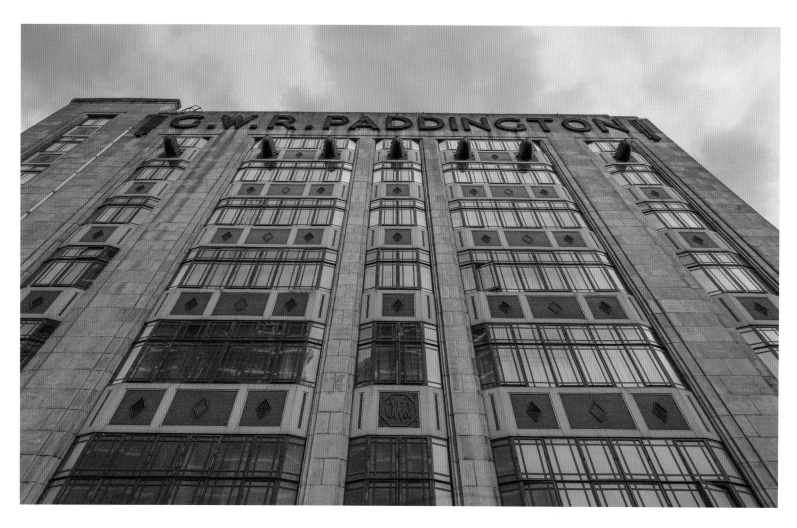

or Westminster, and back to their homes in London's spreading suburbs or beyond. These commuters became the main users of the busier London stations in the twentieth century, particularly the southern termini at Waterloo, Victoria and London Bridge.

In the Edwardian decade of the 1900s, Liverpool Street was the busiest London terminal of all. A Royal Commission on London Traffic calculated that 65.3 million journeys were made through Liverpool Street in 1903, more than twice the number using Waterloo (31 million), which was then only the second busiest station. By the 1920s, however, as electrification improved the growing suburban services of the Southern Railway termini, Liverpool Street was grappling with growth, still using the most intensive steam-worked suburban passenger service in the world.

H.G. Wells, in his essay *Anticipations,* published in 1902, looked back on the Victorian age and commented that if a symbol was needed to characterize the nineteenth century it would be 'almost inevitably … a steam engine running upon a railway'. Looking forwards he predicted huge changes in transport based on the new technology offered by oil and electricity for land, sea and air travel.

The Edwardian decade did bring a revolution on London's streets with electric trams and motor buses replacing horse drawn passenger transport almost completely by 1911. On the railways the demise of steam was a premature prediction above ground but there was a rapid transition below the surface to non-polluting electric trains, which could run in deep tunnels through

underground stations served by electric lifts. The new Tube lines provided connections between the great main-line termini and for the first time offered rapid railway links across the centre of London, criss-crossing the City and West End, which had been almost closed to surface railways since the 1840s.

This meant that the fifteen main-line stations, an absurdly high number of termini even for the world's greatest city, could appear to bask in what seemed like a golden age before 1914. Their main-line traffic was booming, their onward connections for commuters in central London were served by the new Tubes and the expensive capital cost of electrification could be carried out gradually, if not postponed indefinitely.

Into the twentieth century

In the first half of the twentieth century this mutual dependency of the city and the railway, which was always more pronounced in London than any other metropolis, began to change. More than half the people who work in central and inner London today use the national rail system for their home-to-work journey, although the pattern of use may well change significantly in the wake of the COVID-19 pandemic. Regular five days a week commuting by train stopped suddenly with the national health emergency in 2020 and it may never return to the old pattern for many former London office staff, who have now adapted to at least partial home working.

Statistics compiled for the Royal Commission in 1903 showed nearly 300 million annual passenger journeys being made

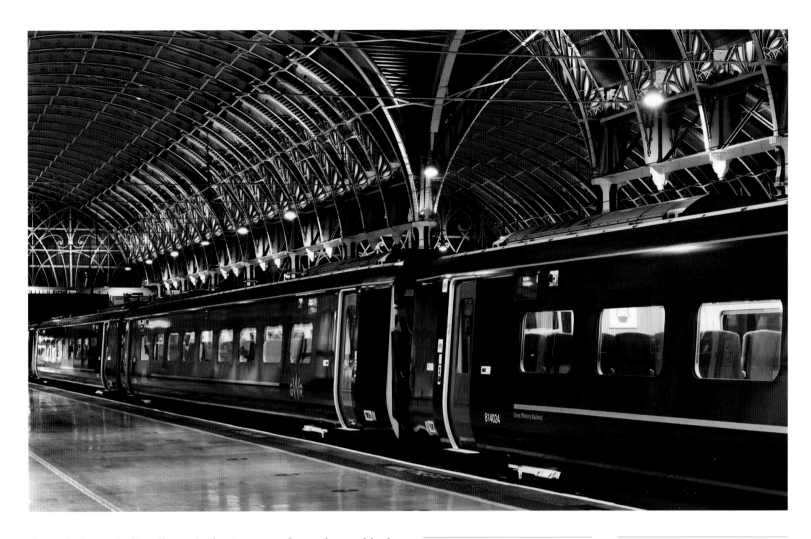

through the capital's rail terminals. A century later, the total had increased to over 400 million and rising, though London's once-massive rail freight and parcels traffic had almost disappeared. The huge former railway goods yards and depots are still being redeveloped in the twenty-first century for housing, retail, offices, leisure and other uses – notably north of King's Cross, and at Stratford in east London, where the 2012 Olympic Park and the Westfield shopping complex both occupy former railway lands. The next big change of land use will be around Old Oak Common in west London where a major interchange station for HS2 will be created that will become the temporary London terminus for the new high-speed line, with onward connections to central London and Heathrow via the Elizabeth line and London Overground. A new final terminus for HS2 is now under construction alongside Euston.

The main Victorian railway termini nearly all still exist, although some have been resited and others partly or completely rebuilt. Only two of the City terminals, Broad Street and Holborn Viaduct, have actually been closed, demolished and wiped off the map. There was no original grand plan to co-ordinate their siting or construction, which was undertaken by more than a dozen separate railway companies in the nineteenth century. These independently run organizations rarely worked together unless made to do so, such as the forced grouping into just four big private companies imposed by the Government in 1923. Even this was not an entirely logical distribution of the London

Left The Art Deco era at Paddington: new GWR offices designed by Percy Culverhouse in the 1930s retain their original lettering and lighting.

Above Brunel's 1854 trainshed at Paddington, cleaned, painted and relit.

Overleaf A view from the platforms at Waterloo station, with the arched roof of the former Eurostar terminal, built in the 1990s, curving away beyond.

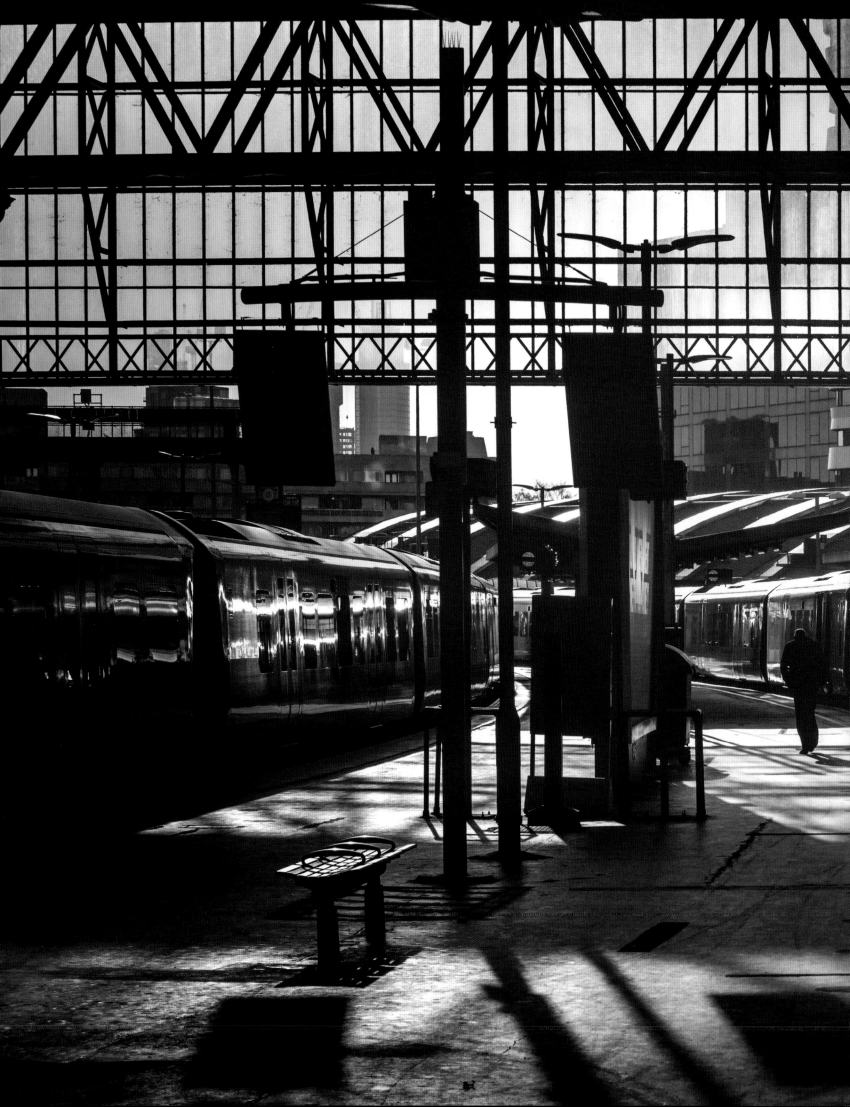

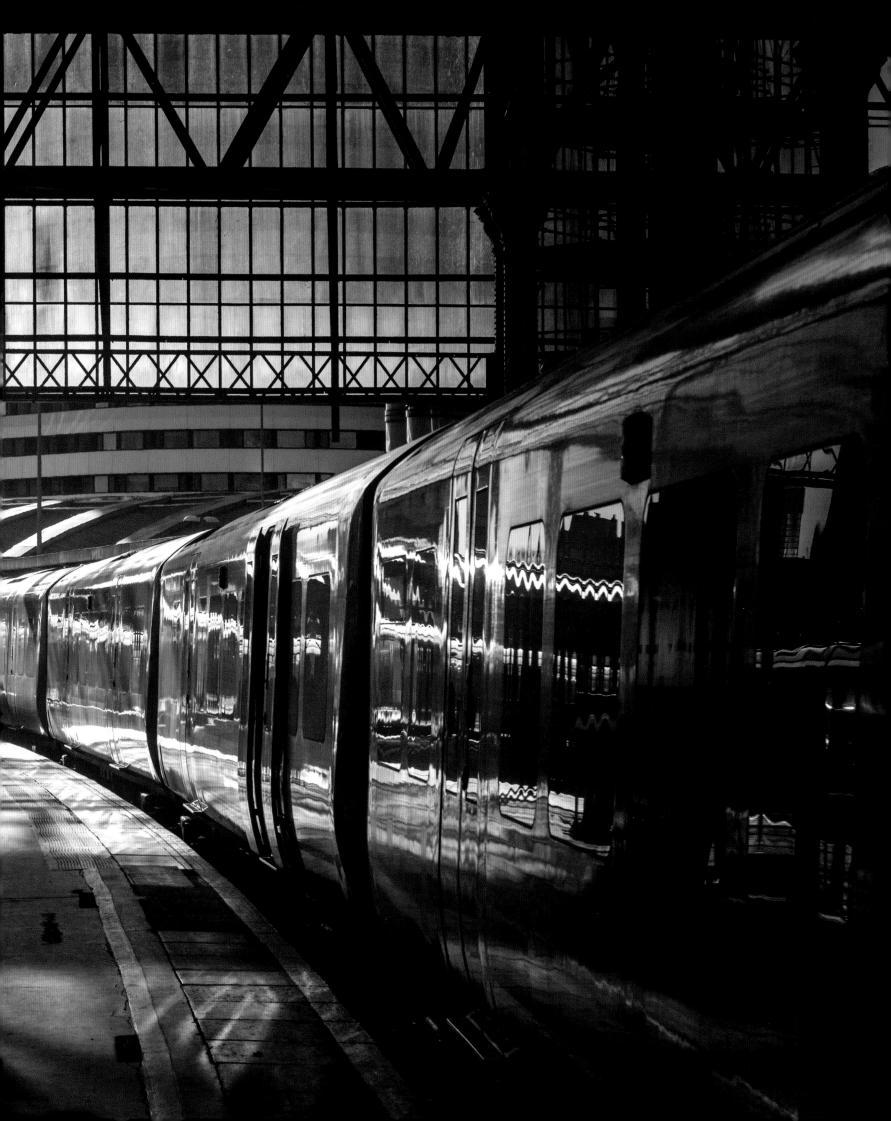

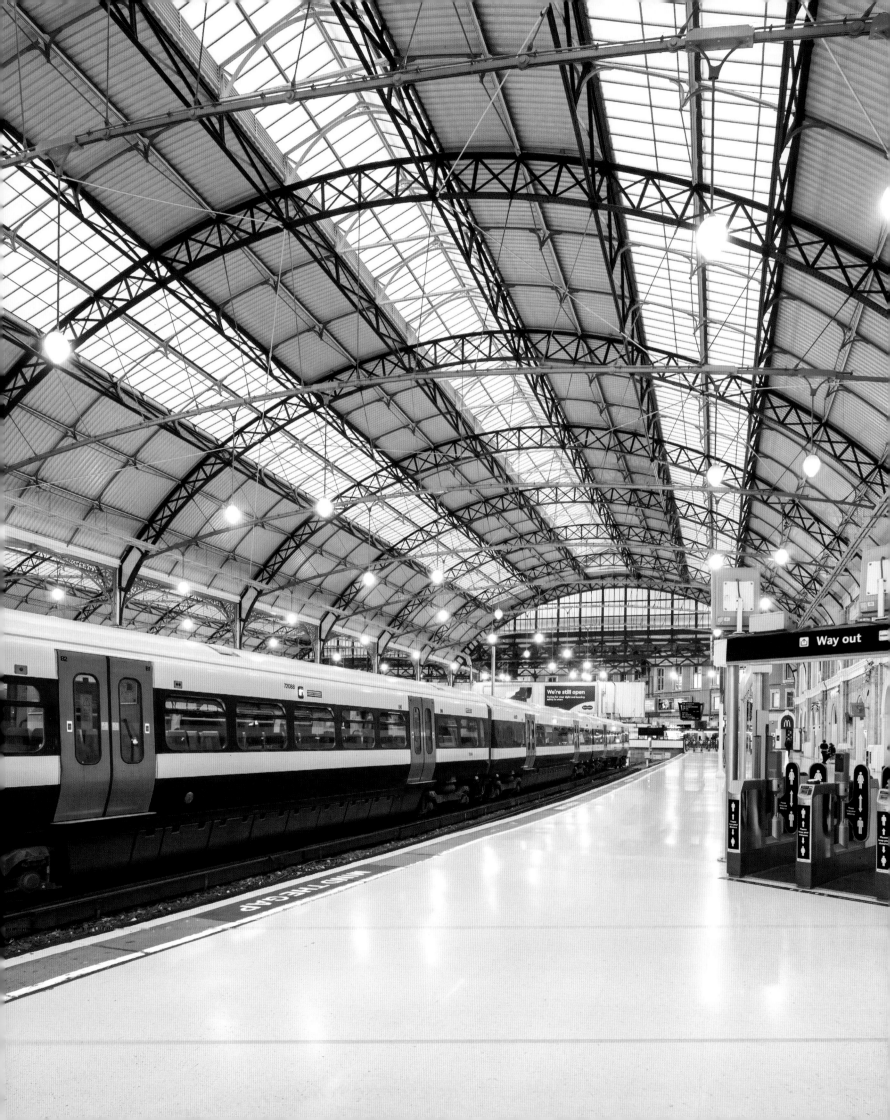

Left The Chatham side of Victoria
station, where the listed 1860s roof
has been cleaned and restored.

Right Roof columns at Victoria by
Sir John Fowler, 1860–2.

stations. The Great Western continued to run Paddington, the southern termini were all grouped under the Southern Railway (SR), the London, Midland and Scottish Railway (LMS) became responsible for Euston, St Pancras and Broad Street, and the London and North Eastern Railway (LNER) was given the mixed bag of two major termini, King's Cross and Liverpool Street, plus two relative tiddlers, Marylebone and Fenchurch Street. The grouping together of the last four explains the choice of stations for the original British Monopoly board when the game was launched in the 1930s, but the last two were still treated as exceptions when British Rail was privatized in the 1990s.

The London terminals were designed in the nineteenth century as statements of each railway's ambition and individuality. They were never rationalized in the twentieth century despite nationalization in 1948 and various attempts since the 1950s to modernize them. The wholesale redevelopment of Euston in the early 1960s became the first conservation battle over London's Victorian heritage. This particular fight to save the Euston Arch and the Great Hall was lost but the more determined modernizers were unable to destroy other early railway infrastructure so easily. Many of the stations were given at least partial statutory protection through the listing process in the 1970s. This certainly saved St Pancras, although it was many years before a solution was found which guaranteed, in separate programmes, a secure future for both the station and the hotel.

The early office blocks that were tacked on to both Cannon Street and Waterloo in the 1960s, and the frontage of the rebuilt Euston in the 1970s were badly designed and poor quality additions, which did not make a positive contribution to the urban environment and have mostly now been redeveloped again. When planning consent was given for a massive five-storey office development over the Brighton side of Victoria, which took place from 1982, it did enable the partial modernization of the station below. The flashy design aesthetic soon looked dated, however, and the glazed offices perched above the Edwardian station façade on Buckingham Palace Road still look deeply incongruous and curiously old fashioned.

The last thirty years

Fortunately a new approach to London's railway heritage was adopted from the 1980s onwards. Office space in the City was still at a premium and the closer to a railway terminus the better. With a booming economy, there was still pressure to use air space above the terminals and build on former railway lands around them. This has been particularly marked around Paddington, King's Cross/St Pancras and Broad Street/Liverpool Street. At Charing Cross and Cannon Street air space development has brought sizeable new offices perching right on top of the stations but incorporated at least part of the heritage structure to maintain the character of the original architecture even where it is little more than a façade, as at Fenchurch Street. At London Bridge everything above ground level, including the listed trainshed, was

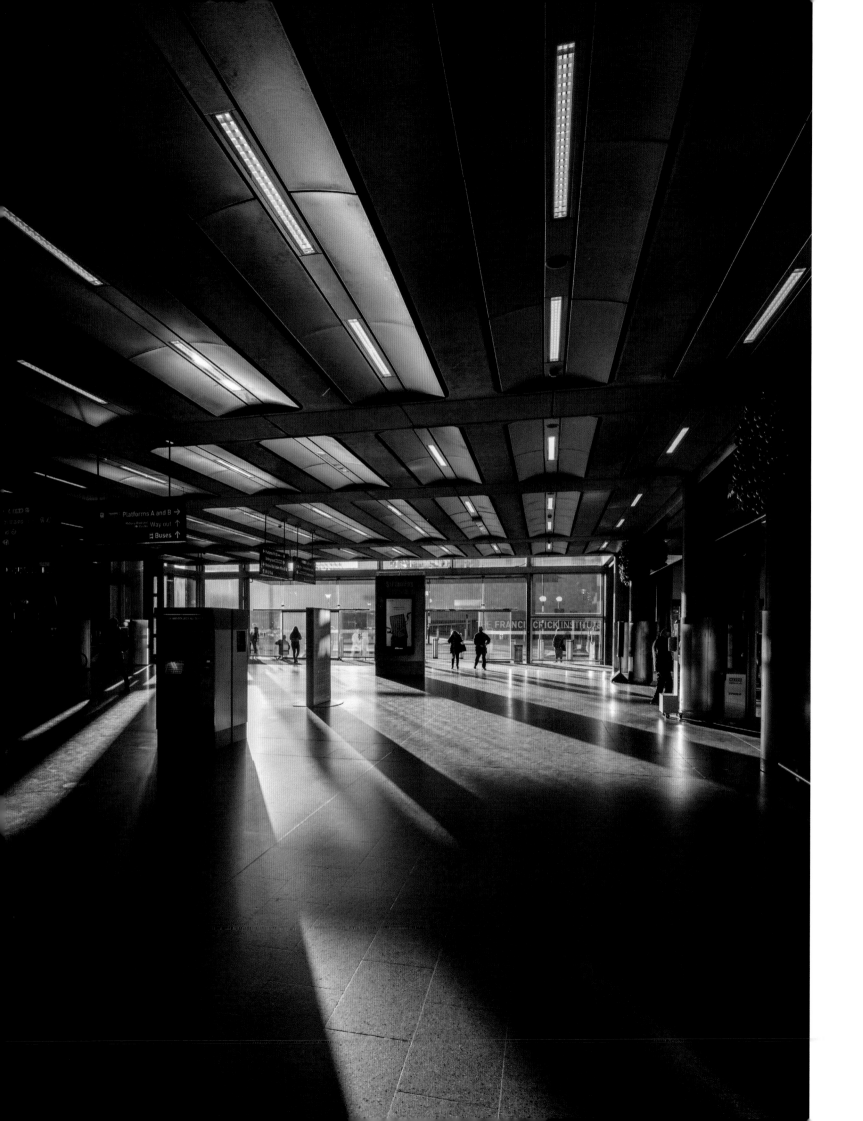

Left The modern western entrance to St Pancras International below the station extension by Foster Associates, which opened in 2007.

Right The blend of architecture and engineering at St Pancras: Scott's Gothic Revival entrance arch and Barlow's great iron trainshed.

Above The towers of the City of London beyond the rebuilt and extended Blackfriars station, which now bridges the Thames.

Right Twenty-first-century redevelopment at St Pancras. On the left, the extended wing of the Midland Hotel; on the right, the British Library (centre) and the Francis Crick Institute, both on the former Somers Town goods yard.

eventually sacrificed in the twenty-first century reconstruction, but the Victorian undercroft has been opened up and enlarged to create a better planned and more coherent station than ever existed in the chaotic layout that had grown up a century earlier.

Inevitably there have been further conflicts between conservationists and developers over new projects, but the public enquiry over the redevelopment of Liverpool Street in 1976–7 marked the beginning of a radically different approach where heritage and modernity might be combined rather than in constant conflict. The subsequent redevelopment of Liverpool Street and Broad Street in 1985–91 was almost a model project, which showed creative ingenuity by conservation planners, architects, engineers and developers. In the twenty-first century, three major schemes at London terminals – the creation of St Pancras International, the expansion and conversion of King's Cross and the rebuilding of London Bridge – have all been outstandingly successful in demonstrating how modernization can be achieved without wholesale destruction of our Victorian railway heritage.

While the role of the terminals has been retained and developed, the great stations have been augmented by the construction of new through links across London on the north–south Thameslink route and the new east–west Crossrail axis. These have effectively created new transport hubs at enlarged and reconstructed through-stations such as Farringdon, Blackfriars and Canary Wharf. Completion of orbital rail connections, now collectively branded as London Overground, has also made getting

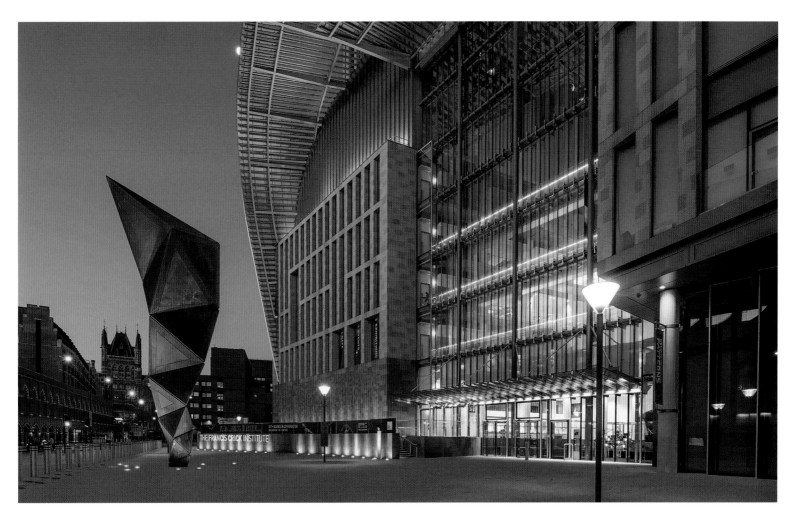

around and across London easier while relieving the overcrowded Tube network. These infrastructure projects have all taken longer to achieve than originally planned, but they now give London a properly integrated rail network for the 2020s and beyond.

There has been impressive new architectural and engineering work in the last thirty years that has transformed London's great termini above and below ground, and reshaped the urban environment around them. A tour of the terminals is a fascinating trip through nearly 200 years of change. This book is designed as a visual impression of London's terminals through the lens of photographer Benjamin Graham and text by historian Oliver Green combined with historic images – paintings, posters and photographs – which give the stations and their environment context over time. It is laid out as a journey around the terminals looking at the individual history of each one. The journey begins at Paddington in the west, travelling clockwise as if on London Underground's Circle line, which was of course built to connect the main line stations. Marylebone, Euston and Fenchurch Street are a short walk from the nearest Circle line station and both London Bridge and Waterloo require a short Tube trip south of the river.

The writing and photography for this book have both taken place during the COVID-19 pandemic of 2020–21, which may well bring about major changes to the way people live, work and travel in London and the rest of the UK. The railways will almost certainly have to adapt to what may be considerable changes in people's lifestyles, environmental conditions and transport requirements. These are difficult to predict, but we can be sure that all the great stations we have featured here will continue to play a key role in London's social and economic future.

Why not one big station?

The concept of the *Hauptbahnhof*, or grand central station, where nearly all train services for a big urban centre meet under one roof, was adopted in many European cities such as Amsterdam, Milan and most recently Berlin. A similar arrangement of joint access to a single central station took place in the Union stations of many of the big North American cities, including Chicago, Los Angeles and Washington DC. It was first suggested as an arrangement for London to the 1846 Royal Commission but rejected as a proposal then and every time the capital's railway development has been considered since.

As Michael Robbins, London Transport's historian has put it: 'the expense would have been enormous, the companies maintained their ingrained political outlook and disliked shared accommodation and joint arrangements, and the difficulties would probably have proved insuperable, not only on the railway operating side but in relation to the street traffic problem that a single location would have thrown up.' Another railway historian, Bill Fawcett, has suggested that 'in the 1880s world leadership in large station design passed to Germany, where state funding helped secure the building of central stations on a lavish scale'. By this time the expansion of London's railways on the surface

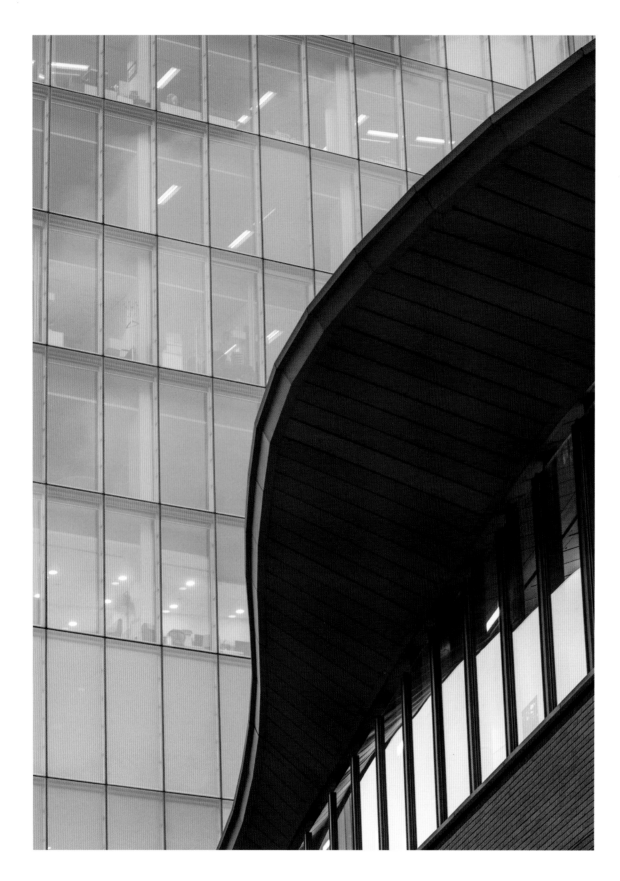

Left The rebuilt London Bridge station, completed in 2018.

Right Paddington station's trainsheds, all now renovated. Brunel's three cast-iron originals are furthest from the viewer. The wider fourth span on the left, completed in 1916, is made of steel.

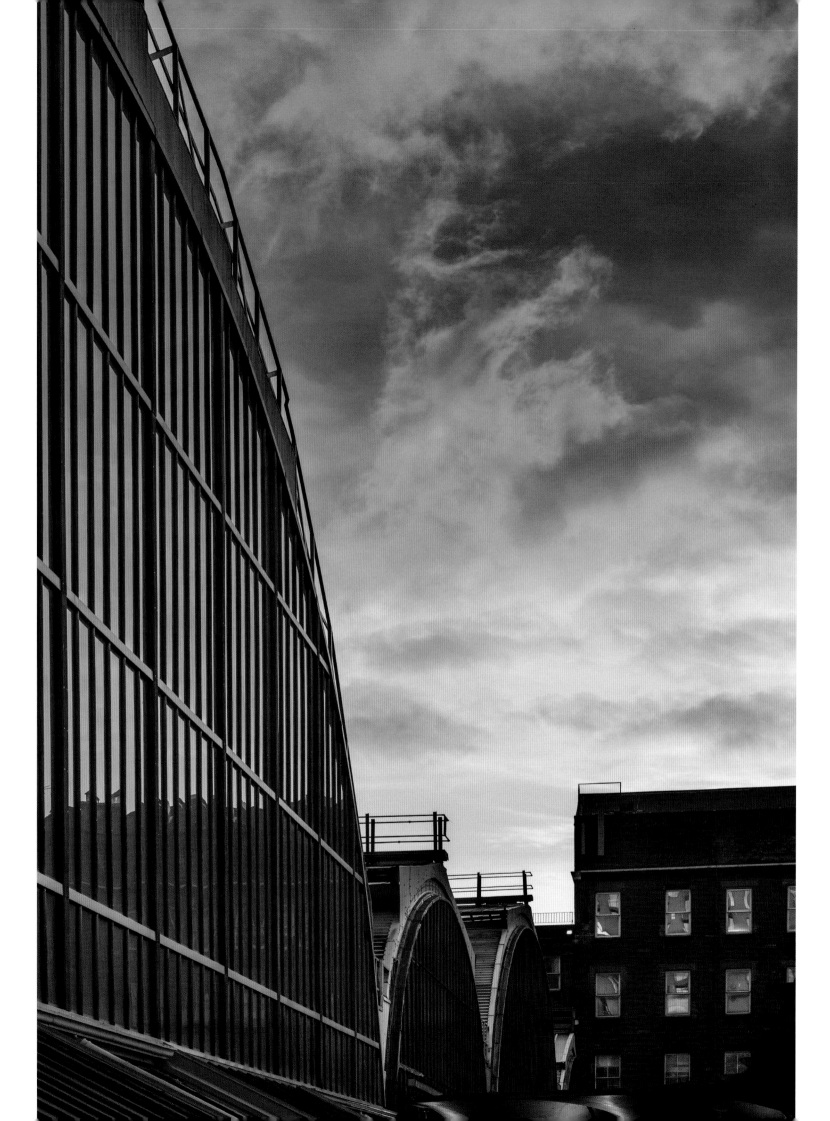

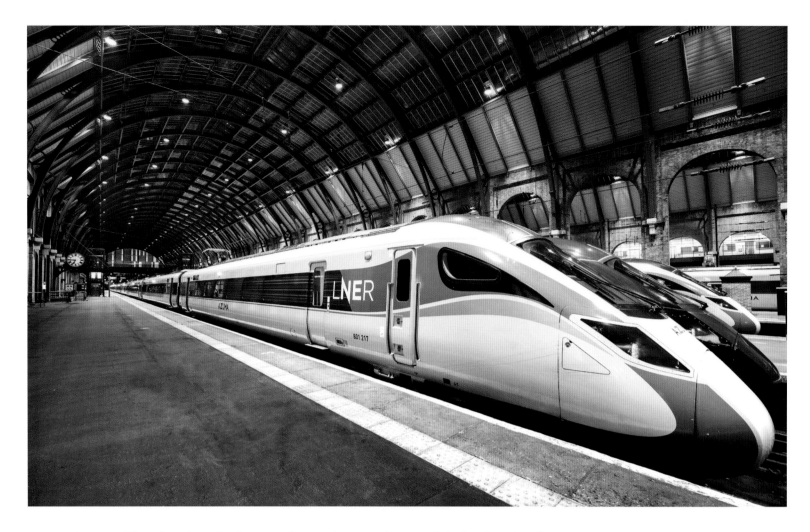

was nearly over, although serious development deep underground had yet to begin. There would be no more large terminal stations in London and apart from the lengthy reconstruction of Waterloo at the turn of the century, and the long overdue facade at Victoria, no major further developments would take place in London until the late twentieth century. The era of the great Victorian railway stations was over.

Concentration in a single station would not have worked in a vast, sprawling and essentially unplanned metropolis like London. On the Continent, Paris is now the leading rail city, with services to and from six principal terminals. German railways remain impressive, particularly the new central station in Berlin opened in 2006, but the latest grand project for a new *Hauptbahnhof* combined with an urban redevelopment in one city centre, Stuttgart 21, has run into serious political, planning and construction problems. Work began in 2010 with completion scheduled for 2019, but the potential opening date has since been moved back to 2025 and is still uncertain.

In numbers, London's distributed Victorian terminal arrangements still win hands down, with thirteen busy termini and, in the 2020s, new passenger services running under the city from north to south and east to west. London Overground now provides services all round the inner suburban area with new and reinstated connections that link up the old North London, East London, South London and West London lines. These were not very effective or integrated schemes in the nineteenth century,

and declined or closed in the twentieth century, but have now experienced a remarkably successful revival. Getting around or across London by rail has never been easier, although it has taken nearly thirty years to create the current network.

Future prospects
It seems likely that demand for rail travel in London will grow again after recovery from the sudden collapse in 2020–21 following the COVID-19 pandemic. However, patterns of travel will almost certainly change, perhaps with a spread beyond the traditional rush hour peaks. Many commuters will not return to regular five days a week travel and if they are able to continue working from home at least part of the time they may choose to do this. Season ticket pricing and availability will have to become more flexible and responsive in the process. There are various development schemes scheduled or under way to improve capacity, which may no longer be required, but moves to reduce existing rail services are unlikely. London's largely Victorian passenger railway infrastructure will be further adapted but not reduced to meet the needs of the twenty-first century. We may be at a turning point but whatever new patterns emerge, London will still be shaped and influenced by its railway infrastructure more than any other world city. The debate about how this should be planned, managed and sustained is set to continue.

Station opening dates

Existing passenger terminals are shown in CAPITALS, closed stations in *italics*, with the railway company responsible for the first station on each site and the original opening date. They are listed in date order.

LONDON BRIDGE: London & Greenwich Railway, 14 December 1836.

EUSTON: London & Birmingham Railway, 20 July 1837.

Nine Elms (*Vauxhall*): London & Southampton Railway, 21 May 1838.

Paddington 1: Great Western Railway, 4 June 1838.

Shoreditch: Eastern Counties Railway, 1 July 1840.

Minories: London & Blackwall Railway, 6 July 1840.

FENCHURCH STREET: London & Blackwall Railway, 2 August 1841.

Bricklayers Arms: South Eastern Railway, 1 May 1844.

WATERLOO: London & South Western Railway, 11 July 1848.

Maiden Lane: Great Northern Railway, 7 August 1850.

KING'S CROSS: Great Northern Railway, 14 October 1852.

PADDINGTON: Great Western Railway, 16 January 1854.

Pimlico: West End of London & Crystal Palace Railway, 29 March 1858.

VICTORIA: London, Brighton & South Coast Railway, 1 October 1860.

CHARING CROSS: South Eastern Railway, 11 January 1864.

Blackfriars (*Bridge*): London, Chatham & Dover Railway, 1 June 1864.

Ludgate Hill: London, Chatham & Dover Railway, 1 June 1865.

Broad Street: North London Railway, 1 November 1865.

CANNON STREET: South Eastern Railway, 1 September 1866.

ST PANCRAS: Midland Railway, 1 October 1868.

LIVERPOOL STREET: Great Eastern Railway, 2 February 1874.

Holborn Viaduct: London, Chatham & Dover Railway, 2 March 1874.

BLACKFRIARS: (originally St Paul's): London, Chatham & Dover Railway, 10 May 1886.

MARYLEBONE: Great Central Railway, 15 March 1899.

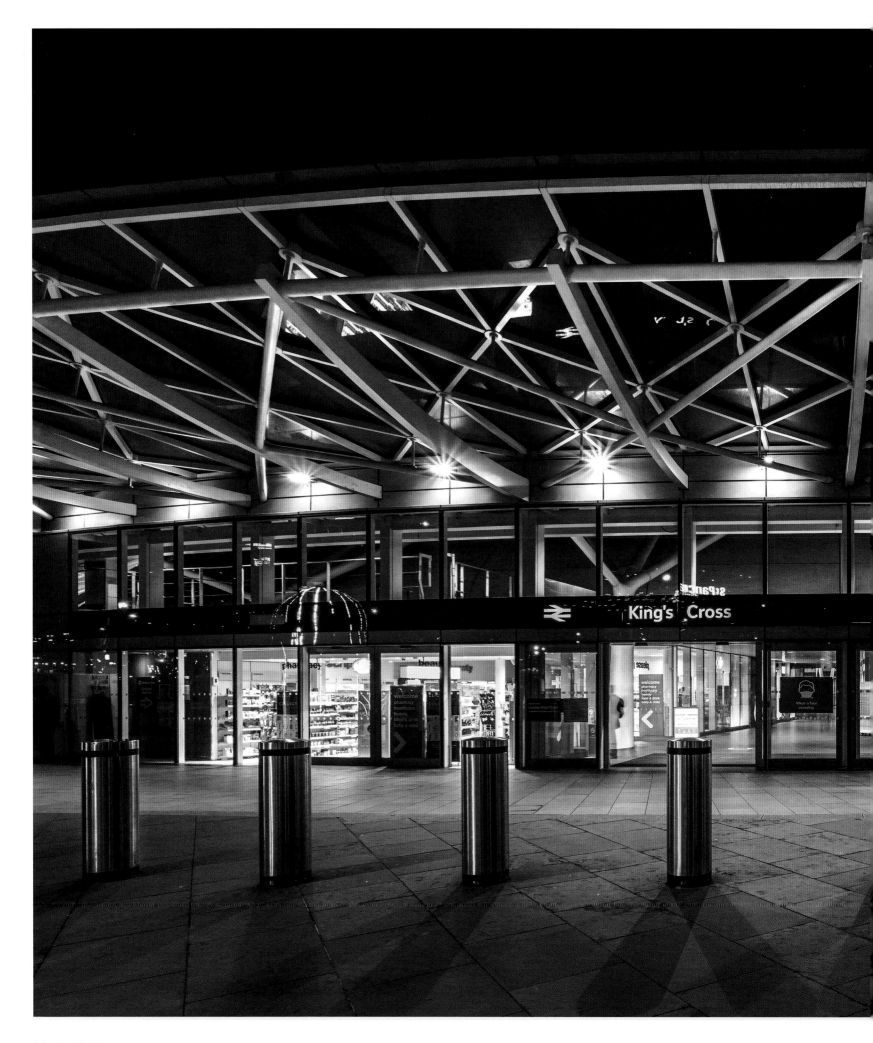

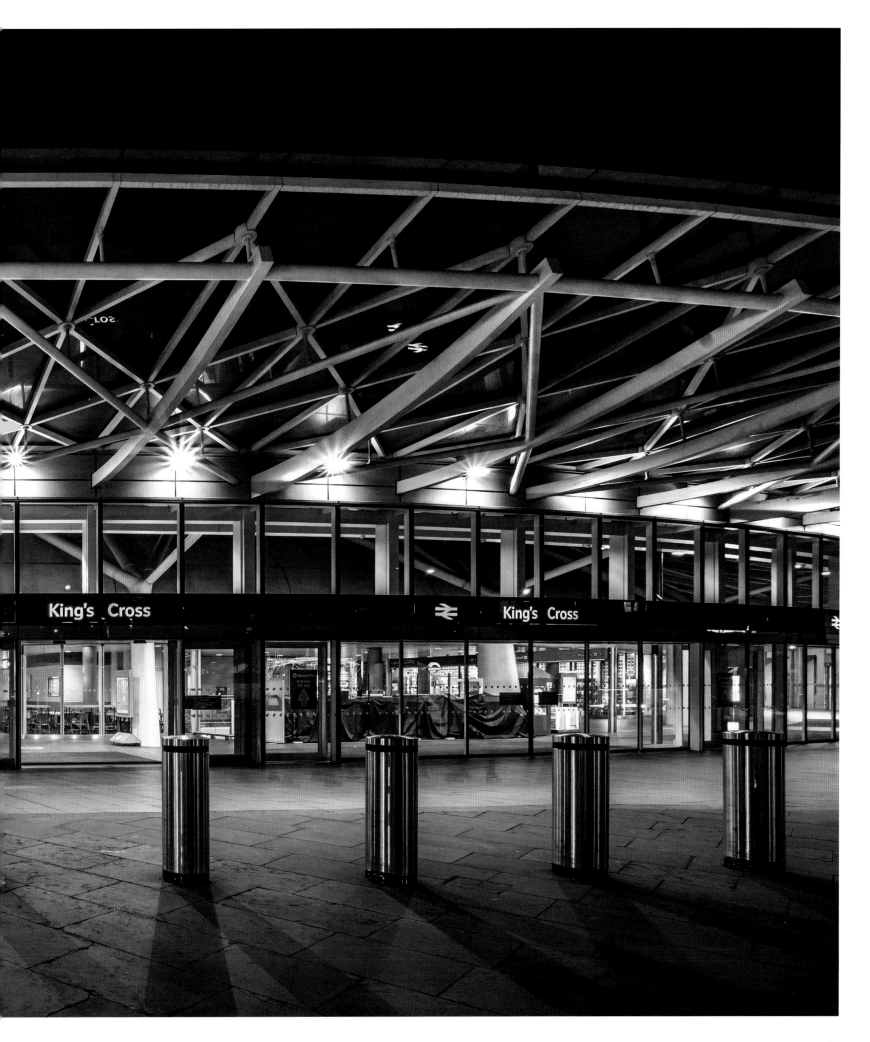

Right Map of Central London (1898), showing all the main-line stations built in the nineteenth century. Marylebone is featured but was still under construction, opening in March 1899. The contents of this book are arranged as a clockwise circular journey from Paddington in the west (upper left) to Victoria in the south-west (lower left).

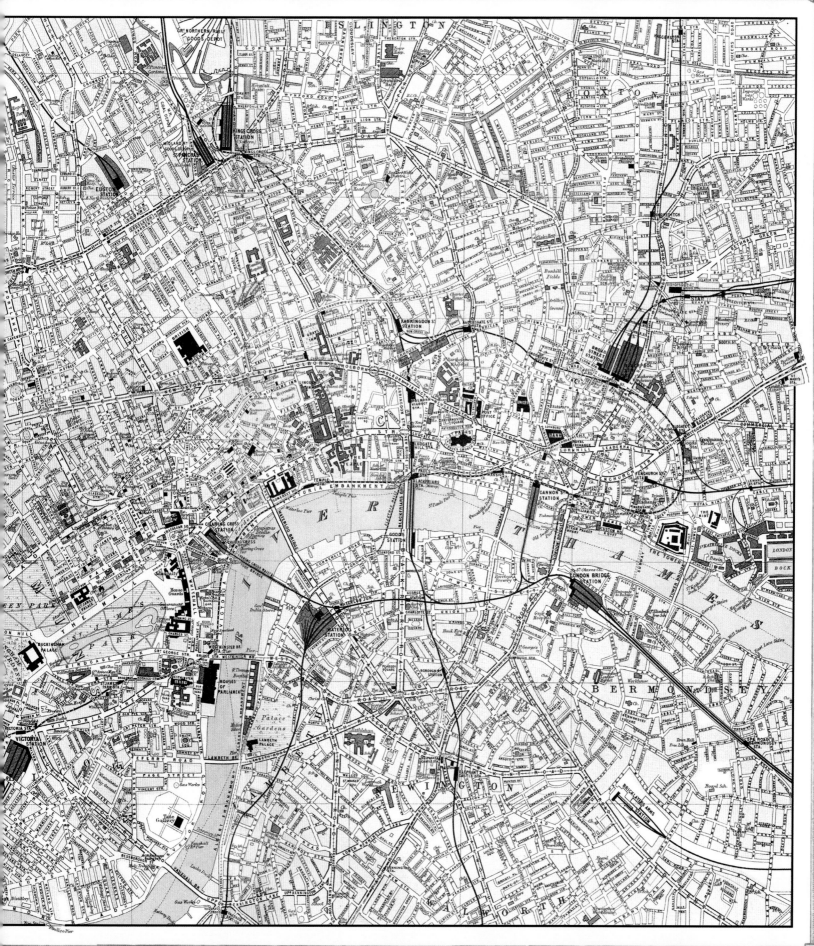

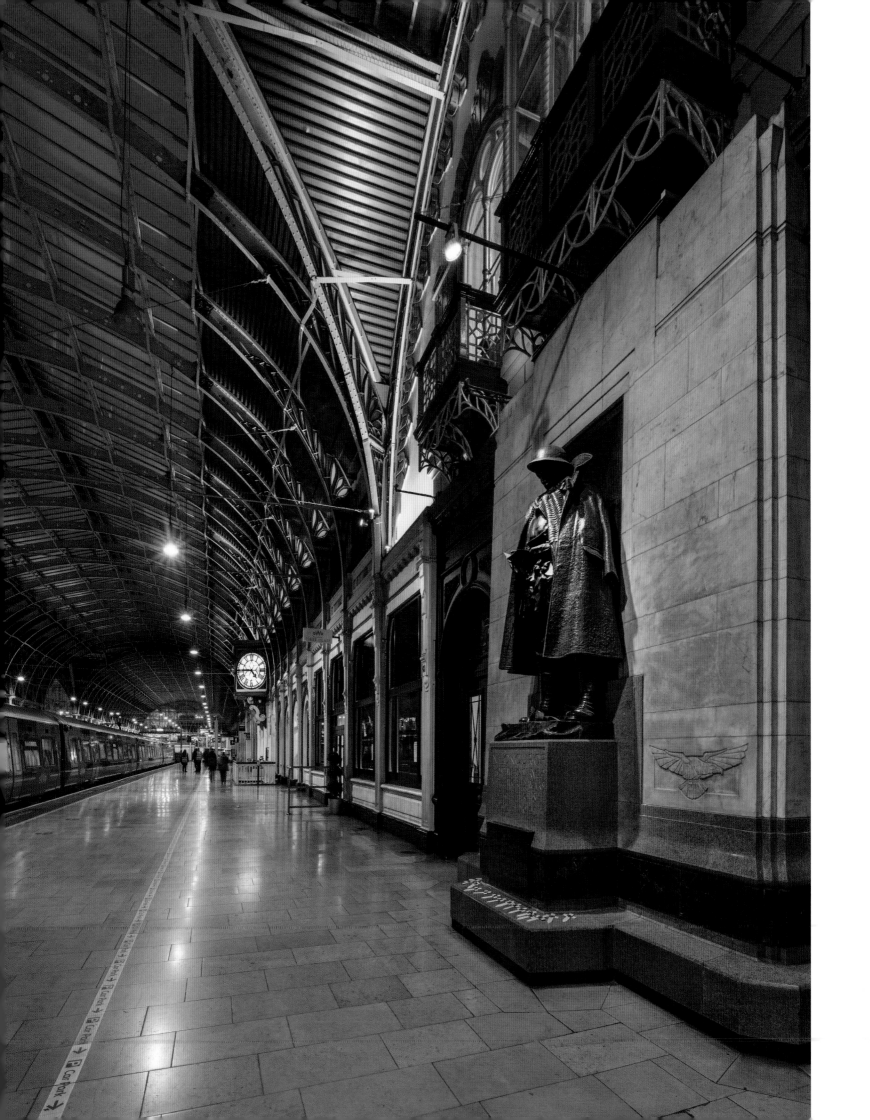

Paddington

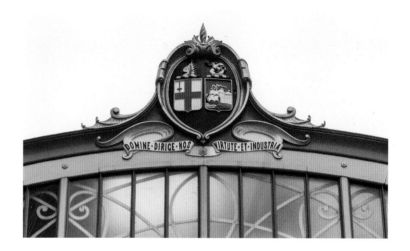

Paddington is the best-preserved of London's Victorian terminals. To step off a train under Isambard Kingdom Brunel's great triple-span iron-and-glass roof is one of the most dramatic ways to arrive in the capital. The station looks better today – cleaned, renovated and spectacularly lit – than at any time since it was built in the 1850s, and one's arrival is a moment to savour.

What we see now is not the original London terminus of the Great Western Railway (GWR). The line was built in the 1830s to link London with Bristol, and later the West Country, West Midlands and South Wales. In 1835, when construction work began on the section of line just west of London near Ealing, the final site of the passenger terminus had not been chosen. Brunel, the GWR's chief engineer, had discussions with Robert Stephenson, whose London and Birmingham Railway (L&BR) was approaching from the north-west, about creating a joint terminus for the two railways at Euston Square. The main lines would have linked up near Kensal Green in west London, where they are still only a short distance apart, for the final run in to Euston. However, despite some six months of negotiation between the companies in 1835–6, no agreement could be reached on terms for the site occupation. The GWR pulled out and the L&BR occupied the Euston Square site alone, opening the capital's first inter-city main-line terminus there in 1837.

Brunel already favoured Paddington, probably because the site was adjacent to the basin of the Grand Junction Canal, which had opened there in 1801, followed by the Regent's Canal

in 1820. The potential for trans-shipment of goods on to the canals was an important consideration for the early railways. The canal basin had already encouraged the rapid growth of Paddington from a tiny village into the developed western edge of London. Coachbuilder George Shillibeer introduced London's first horse-drawn omnibus service between Paddington and the Bank of England in 1829, and this new mode of urban passenger transit was already booming in the metropolis before any railway had opened.

The first Paddington

Because of the high cost of the land purchased for the Paddington route and site, the GWR could only afford to build a rather small, modest passenger terminus for the opening of the line in 1838. It stood just north of the current station, on the site now occupied by Paddington Central, the modern office and residential complex built between the railway and the canal basin in the early years of the twenty-first century. This is all on former railway land.

The first Paddington station has been described as a makeshift affair, and Brunel certainly regarded it as a temporary London terminus. Architecturally, it was no match for Euston, and passenger facilities were very basic. The road entrance, booking hall, parcels office and waiting rooms were all squeezed into the arches of the first Bishop's Road Bridge. This was built right across the site on twenty-six brick arches, which effectively formed the station façade, and given rather more architectural grandeur

than the plain structure deserved in J.C. Bourne's flattering lithograph in his *History and Description of the Great Western Railway*, published in 1846.

The Bishop's Road station hardly matches Brunel's original Temple Meads terminus in Bristol. The platform area at Paddington, which Bourne's illustration does not show, was little more than a long open-sided wooden canopy supported by iron columns, with a covered roadway under it between the single departure and arrival tracks. This allowed enough room for the private carriages of wealthy passengers to be loaded on to wagons at the back of the train so that they could use them when they disembarked. Brunel clearly expected this to be a popular option on the Great Western, but in practice the arrangement was soon abandoned.

First- and second-class services from Paddington to Maidenhead started in June 1838, extending to Reading in 1840 and through to Bristol in 1841. The GWR began carrying freight in 1839 and third-class passengers in 1840, who originally travelled in uncovered open wagons. On 13 June 1842, Queen Victoria herself made her first journey by train between Slough (then the nearest station to Windsor Castle) and Paddington. The Queen announced that she was 'quite charmed' by the experience but alarmed at the speed and requested that any train she travelled on in future proceed more cautiously.

As the GWR's traffic grew in the 1840s, the inadequacies of its cramped temporary terminus at the London end of the line became more obvious but there was no commitment from the company to replace it. Eventually, in 1850, the Great Western was persuaded to commission a much larger new station on the present Paddington site. The low-level cutting alongside Eastbourne Terrace, where the station now stands, had originally been used for a railway goods shed. Now the passenger and freight areas were effectively to be swapped over, allowing the expansion of both within a more logical plan. At Euston, the ill-considered station arrangement centred around the Doric Arch and Great Hall had given the L&BR little flexibility to develop, but the Great Western at Paddington was able to adapt its initial terminus environment more thoughtfully. A significant consequence of the 'site swap' and plan for a complete rebuild was that it gave Brunel the opportunity to adopt the latest 'glasshouse' technology he had seen that was introduced to house the 1851 Great Exhibition in Hyde Park. As Brunel biographer Steven Brindle suggests in his history of the station, 'the Crystal Palace is the key to understanding his rebuilding of Paddington'.

Brunel's permanent Paddington

On 13 January 1851 Brunel wrote excitedly to the architect Matthew Digby Wyatt, secretary of the main Great Exhibition committee, outlining his plan:

> I am going to design, in a great hurry, and I believe to build, a Station after my own fancy; that is,

Left J.C. Bourne's flattering lithograph of the GWR's first Paddington terminus, c.1846. The platforms are beyond the arches of the Bishop's Road Bridge, which ran across the station site, now the Paddington Central office complex.

Right A hotel luggage label from c.1935, when the hotel interior and the station 'lawn' area behind it were given a fashionable Art Deco makeover, and the GWR was given a new logo for its centenary.

Below The Great Western Royal Hotel opened with the permanent station in 1854. Brunel's trainsheds, seen in the left distance, were still not connected to the hotel when this photograph was taken c.1910.

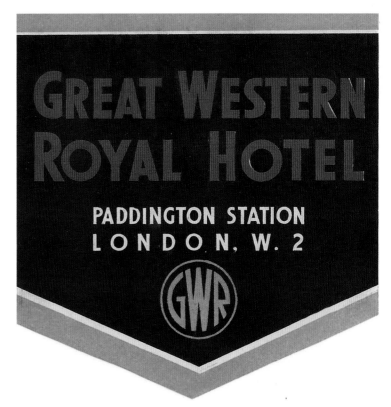

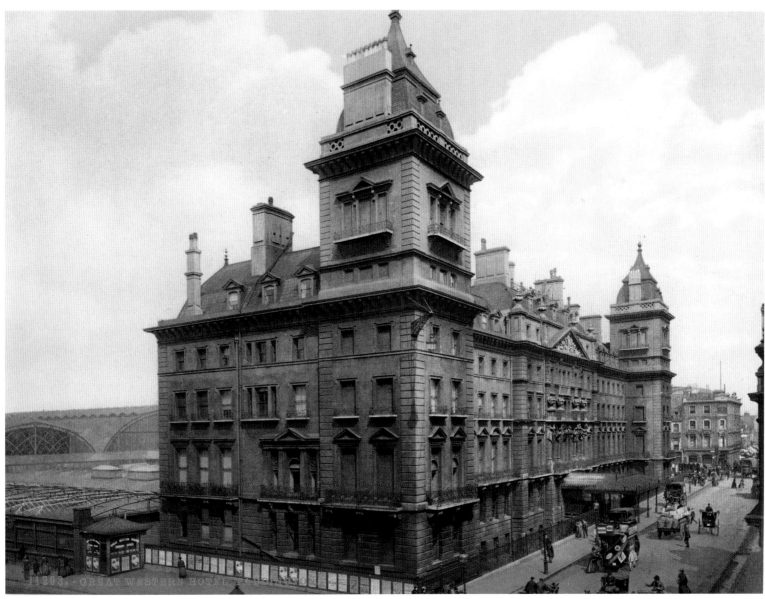

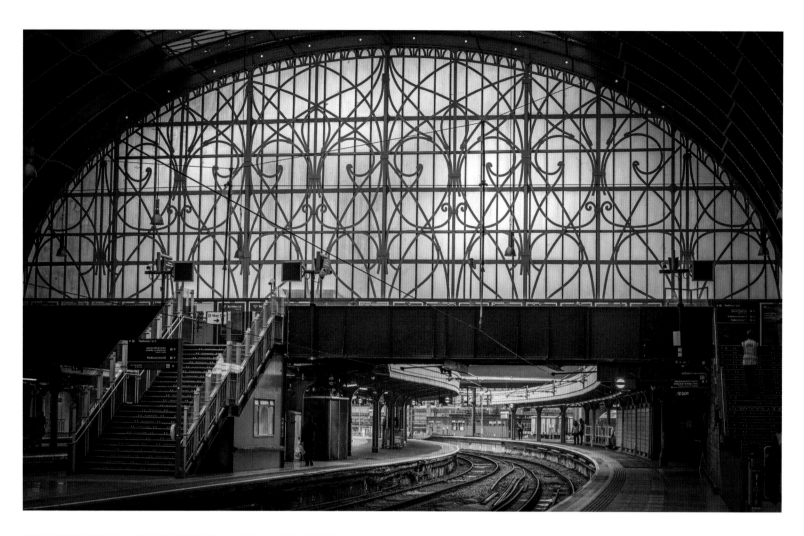

Brunel's broad gauge

Brunel had persuaded the GWR directors to build a broad gauge railway, with the rails 2.14m (7ft ¼in) apart. This, he believed, would allow faster and safer running than the 'standard' gauge of 1.43m (4ft 8½in) adopted by Stephenson for the L&BR. The broad gauge might have made a joint London terminus for the two main lines at Euston more complicated, and taken up more land, but clearly neither company saw much benefit in a compromise or joint solution. Brunel got his way with his more expensive broad gauge to Paddington, although the system was not to survive even on the Great Western. The Gauge Act of 1846 recognized 1.43m (4ft 8½in) as the national standard for railways in the UK and in 1861, just two years after Brunel's death, the GWR introduced dual-gauge tracks to London. On 20 May 1892, the last through broad-gauge express to Penzance – the 10.15am Cornishman – left Paddington and at 5pm that day the final broad-gauge passenger train for Bristol left London. Over the following weekend the remaining 275km (171 miles) of broad gauge track on the GWR network was converted to standard gauge, and the entire remaining broad-gauge locomotive fleet was sent to Swindon to be broken up.

with engineering roofs etc. It is at Paddington, in a cutting, and admitting of no exterior, all interior and all roofed in …

Brunel, along with Stephenson, was a member of the building committee, which had been struggling in the summer of 1850 to come up with a suitable design for a temporary structure that could be put up in Hyde Park within the exhibition budget and tight timescale. There was no enthusiasm for the committee's own proposal, to which Brunel had contributed a dome, but the last-minute offer by Joseph Paxton to design a suitable enclosure of iron and glass saved the day. Paxton was not an architect, but the Duke of Devonshire's Head Gardener on the Chatsworth estate in Derbyshire, where he had developed an ingenious iron-and-glass roofing system for the Duke's greenhouses. For the Great Exhibition, Paxton envisaged an enormous version of these, which could be quickly pre-fabricated and assembled almost as a kit of parts.

Building technology had moved on in one giant leap and Brunel gave Paxton's proposal his full support. Despite, or perhaps because of, his involvement with the failed 'official' scheme prepared by committee, he was keen to develop a version of Paxton's glasshouse concept himself at Paddington, and was clearly inspired by its revolutionary design. Brunel also seemed to be acknowledging that his own skills lay in engineering rather than architecture. Who better to ask for help in designing the new Paddington than the young secretary of the Great Exhibition

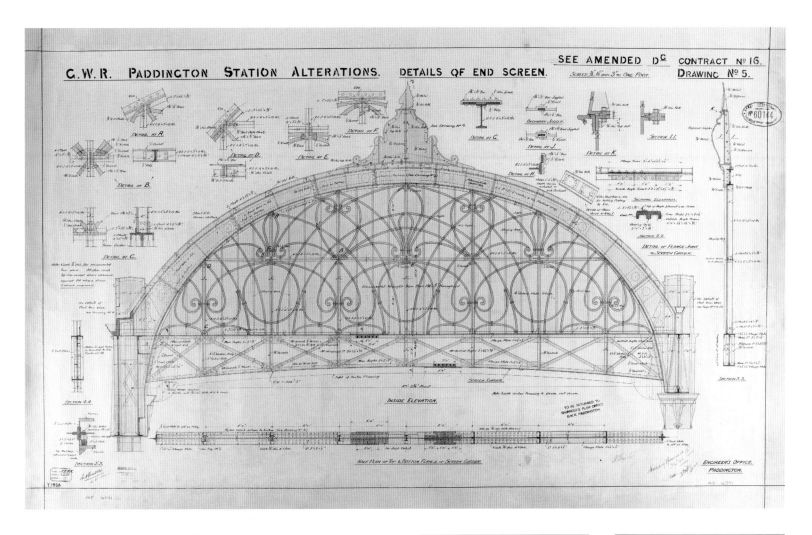

committee? It was an astute collaborative move. Brunel asked Wyatt to act as his assistant on the decorative details and aesthetics of his new trainshed, although it seems he did not get the GWR board's permission to do this. Wyatt and Brunel then approached the engineering contractors Fox Henderson, who had been responsible for fabricating and assembling the Crystal Palace, to build the central structure enclosing their station with a giant trainshed.

The Moorish design style at Paddington also shows the influence of Owen Jones, who had been Superintendent of Works for the Great Exhibition. Brunel and Wyatt consulted him over introducing decorative elements to the arched iron roof trusses just as Jones was preparing his monumental full-colour pattern book of decorative motifs, the *Grammar of Ornament,* published in 1856. This soon became the essential handbook and guide for mid-Victorian architects and builders anxious to replicate the detail of medieval Gothic and other historic decorative features in new suburban housing. Wyatt's main contribution, as architectural collaborator at Paddington, was the attractive metal tracery on the end screens of the shed and the two sets of oriel windows on the first floor of the office building overlooking platform one. These were not essential structural features of Brunel's building but effectively softened the stark appearance of the impressive trainshed interior.

In December 1851, the GWR board engaged another architect, Philip Charles Hardwick, who had just completed the

Left Wyatt's Moorish decorative tracery on the end screens of Brunel's trainshed.

Above GWR engineers' drawing of the end screen for span four at Paddington, c.1913.

Overleaf The interior of Paddington, with GWR's newly introduced bi-mode Intercity Express Trains, built by Hitachi.

Great Hall at Euston, to design a large hotel at the front of the station on Praed Street. Brunel seems to have had no involvement in this, and perhaps this explains why there was originally no physical or covered connection between the rear of the hotel and the end of the trainshed in the area still known as 'the Lawn'. While Brunel concentrated on the interior of his trainshed, Hardwick's hotel effectively formed the street façade of the whole station complex with a far more elaborate and imposing exterior than his Great Hall at Euston. In fact, the Great Western Royal was the first really grand, monumental hotel in Britain, setting a new standard in size, amenities and comfort. It was also influential in introducing a new kind of commercial opulence into Victorian architecture. Its French-inspired 'Second Empire' manner became

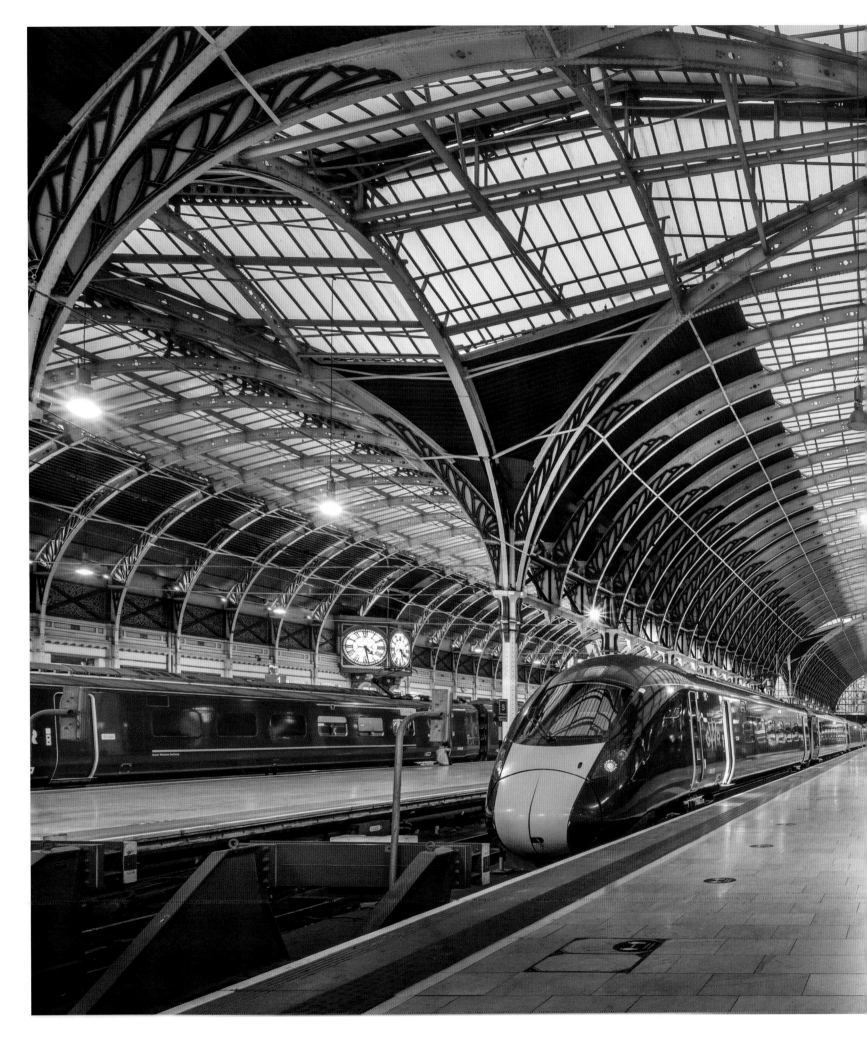

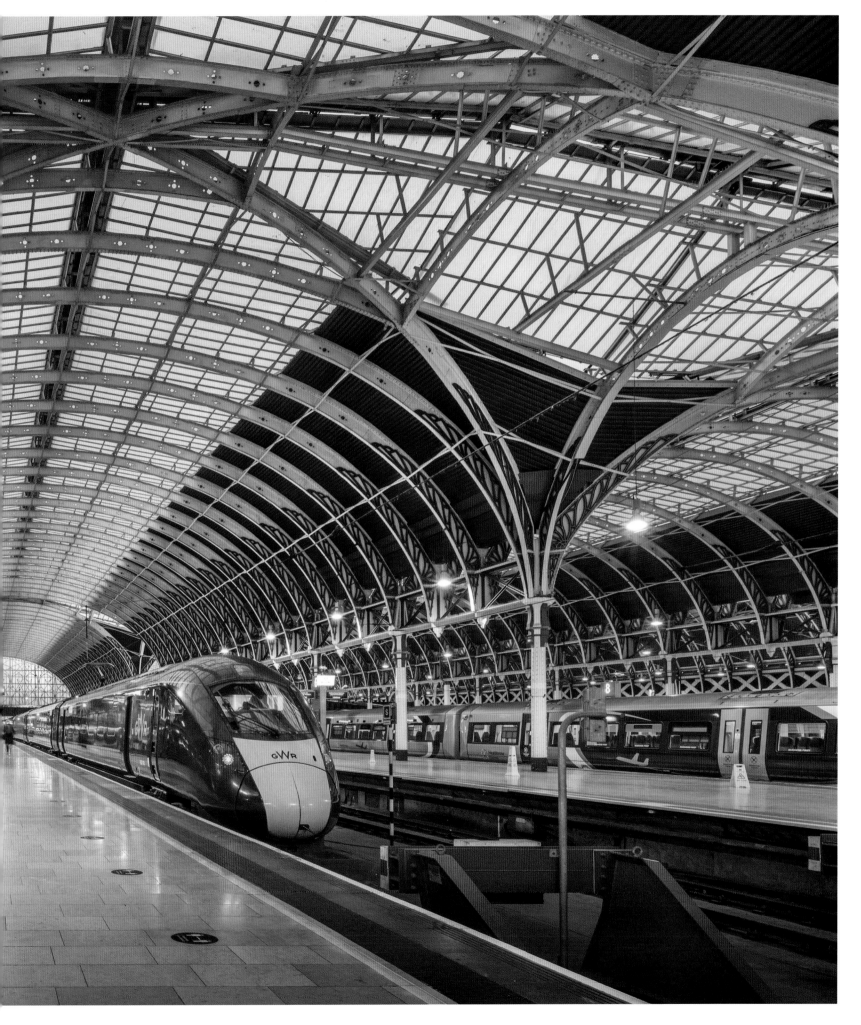

Frith's panorama

Paddington is the subject of one of the best-known Victorian paintings, William Powell Frith's *The Railway Station*, first exhibited in 1862. It was the third of the artist's immensely popular 'social panoramas' of modern life, depicting a carefully contrived range of individuals in a crowded but recognizable setting. Frith had previously represented *Life at the Seaside (Ramsgate Sands)* in 1854 and *Derby Day* in 1858, but was doubtful about the appeal of a railway scene: 'I don't think the station at Paddington can be called picturesque, nor can the clothes of the ordinary traveller be said to offer much attraction to the painter.' Frith's art dealer Louis Flatow convinced him with an enormous commission fee, said to be the largest offered to any artist at the time, an exclusive gallery exhibition of the large original oil painting and reproduction rights to a smaller print version, which was still being advertised for sale forty years later.

All classes of Victorian society are represented here, with more than sixty figures on the station platform. Two detectives are arresting a man on the right as he steps on to the train. Frith's models for these characters were two well-known detectives of the day, Haydon and Brett. On the far left, a working-class group are heading for the third-class compartments. In front of them is a harassed middle-class family apparently off on holiday to Devon or Cornwall, with a porter pushing their luggage on a barrow. Nearby another middle-class couple are seeing their two boys off to school. Frith portrayed his own wife and sons here, with a self portrait as their father. Next, in the centre, is a bearded man and his wife apparently arguing over the fare with the cab driver who has brought them to the station. Frith's model here was an Italian political refugee who was giving his daughters Italian lessons in London. Further along to the right is a wedding party.

In the same way as Brunel employed Wyatt as his advisor and assistant, Frith got another young architect, William Scott Morgan, to help him with inanimate details like the station architecture and the train loaded with luggage on the carriage roofs. The result is a lively picture in which even the locomotive, one of Gooch's broad-gauge Iron Duke-class engines, is shown in accurate detail, painted from a photograph of *The Sultan*. The portly gentleman admiring the locomotive is, appropriately enough, a portrait of Frith's art dealer Flatow.

Below William Powell Frith's popular 1862 oil painting *The Railway Station*, engraved print versions of which decorated many Victorian homes and were still being advertised forty years later.

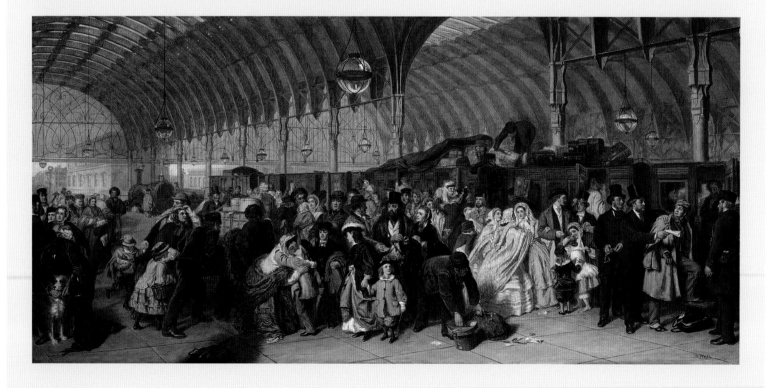

Above The last broad-gauge through-train to Penzance, the *Cornishman* express, about to leave Paddington at 10.15am on 20 May 1892.

Overleaf The main concourse at Paddington, very effectively remodelled in the 1990s by Nicholas Grimshaw & Partners.

the most popular style for large hotels in Britain, featuring a high Mansard roof, which created a distinctive skyline and also conveniently housed the accommodation of the hotel staff. In London the Grosvenor Hotel at Victoria (see page 248), opened in 1860, was the first to follow its stylistic example.

Nothing now remains of the elaborate hotel interior, which was completely remodelled in 1931, but the exterior still retains most of its decorative features, including the impressive twin towers and the elaborately decorated pediment between them. Here Hardwick engaged the sculptor John Thomas, who had made relief sculptures for his Great Hall at Euston, to create *Commerce Attended by Plenty and the Four Continents*, which is a substantial allegorical piece including fifteen figures placed within the pediment at fourth-floor level on the Praed Street façade. This tableau of mid-Victorian self-confidence, featuring the combination of Art, Science and Industry, continues to reflect the values of the Great Exhibition held in Hyde Park three years earlier. Appropriately, the hotel was opened in 1854 by the Prince Consort, one of the principal advocates of the exhibition and already a regular and enthusiastic traveller on the GWR between Paddington and Slough. Albert was also able to grant the hotel its royal title.

Work on the outlying new facilities around the old station site at Paddington, which included a huge covered goods depot and engine, carriage and wagon sheds, continued until 1857. Altogether, these improvements at Paddington cost the GWR nearly £700,000. Collectively the various buildings and features of the site were artfully combined to create an elegant yet supremely functional railway station complex. The main trainshed is, as John Betjeman fondly described it, 'an aisled cathedral in a cutting'. The church-like layout is formed by three parallel spans, each 213m (700ft) long, punctuated by two crossways transepts at right angles, making the whole structure the largest trainshed in the world when it opened. Unlike a cathedral, the interior layout has proved infinitely adaptable as railway operation has changed. It has been through substantial modernization without ever losing its functionality or succumbing to wholesale reconstruction.

The *Illustrated London News* recognized Paddington's qualities as soon as it opened and suggested the essential key to Brunel and Wyatt's collaboration:

> The principle adopted by them was to avoid any recurrence to existing style and to make the experiment of designing everything in accordance with the structural purpose or nature of the materials employed – iron and cement.

Unlike Euston, where the Doric Arch made a grand statement but had no practical function and the Great Hall served little useful purpose, Paddington has worked well for more than 175 years. The great trainshed is spacious and elegant with decorative detailing in the wrought ironwork that enhances the long vista without overwhelming the design.

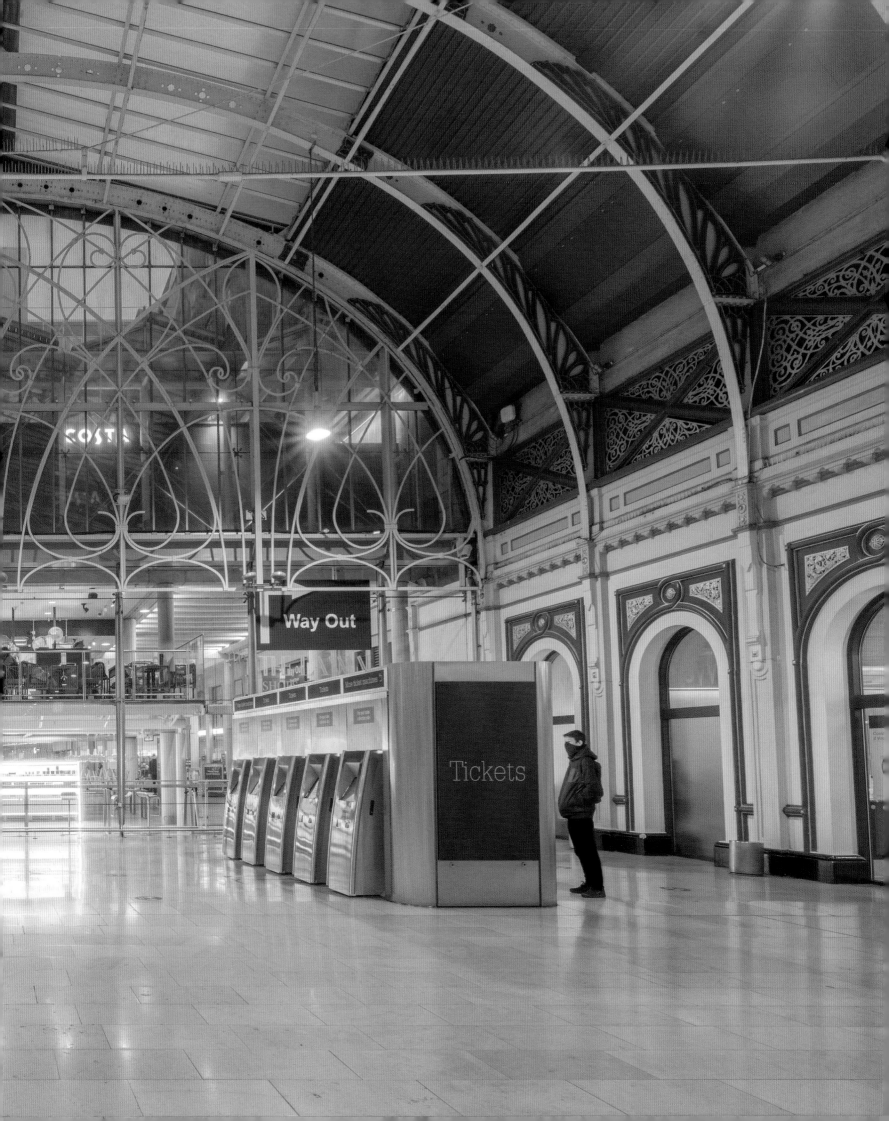

Remembrance at Paddington

More than 2,500 GWR employees were killed in the First World War (1914–18) and a memorial to them was commissioned for Paddington by the railway company. It is prominently sited halfway along Platform 1 and was dedicated on Armistice Day 1922. The impressive larger-than-lifesize bronze figure by Charles Sergeant Jagger shows a British Tommy dressed for battle but unarmed, apparently reading a letter from home while serving on the Western Front. It is highly unusual in featuring this reflection on home rather than the trappings of conflict and is one of the most moving war memorials in London. Poppy wreaths are still placed here on Remembrance Day every November.

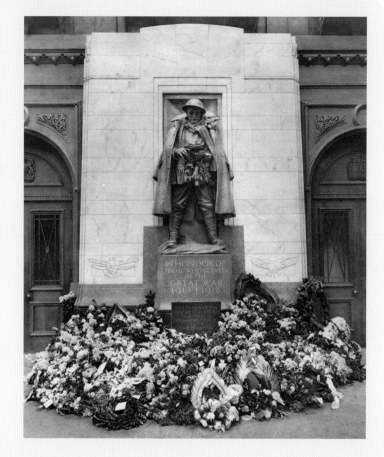

Right The GWR war memorial at Paddington, shown after its unveiling on Remembrance Day 1922.

Brunel died in 1859, aged only fifty-three, worn out by the stress of his final engineering project, the construction of the ill-fated *Great Eastern*, then the largest steam ship ever built. Daniel Gooch, the GWR's locomotive engineer, wrote of his friend and colleague: 'the commercial world thought him extravagant, but although he was so, great things are not done by those who sit down and count the cost of every thought and act'.

Gooch's comment should be borne in mind when viewing the 1982 statue of Brunel by John Doubleday, now positioned at the centre of the station. The great engineer sits surveying the interior of his trainshed, an unlikely relaxed pose for such a workaholic, but he is clutching his famous stovepipe hat in his left hand as if ready to rush off to another site inspection.

Paddington underground

In January 1863, the world's first urban underground railway opened between Paddington and Farringdon Street. The Metropolitan was a separate but associated company with the Great Western, which provided the GWR with an important direct onward link between its west London terminus and the financial heart of the City. There was a junction with the GWR main line just outside Paddington and a separate station for the Metropolitan, originally called Bishop's Road. This soon became a through-station when services began over a joint GWR/Metropolitan extension line running westwards to a terminus at Hammersmith, which opened in 1864. Originally there was no

connection for passengers between the Hammersmith & City line station and the main Paddington terminus, but a footbridge was added in 1870. Rebuilding to create additional suburban platforms for the main station alongside the Metropolitan took place in the 1930s when the name 'Bishop's Road' for this outpost was dropped. Major reconstruction in the twenty-first century has created a spacious new booking hall with lift access for the Hammersmith & City and Circle line platforms here and a new station exit for Paddington Central, which opens directly on to the canal. Leaving the station at this point may not be quite as exhilarating as arriving in Venice by train and getting a first view of the Grand Canal from the station steps, but waterside Paddington has certainly been transformed.

A second underground station at the other end of Paddington main line, originally called Praed Street, was opened over the road from the Great Western Royal Hotel in 1868, when a branch of the Metropolitan was extended running southwards towards Kensington. This is now London Underground's District and Circle line station, which was partly rebuilt in 1914 with a replacement booking hall at street level and over the tracks, designed by Charles W. Clark, the Metropolitan's first resident architect. The street façade is in Clark's characteristic white-tiled faience, with shop units either side of the entrance and originally a tea room on the first floor. Inside, the booking hall has been rebuilt but the station still has the original 1860s platform retaining walls and part of the overall roof. Underground services through both

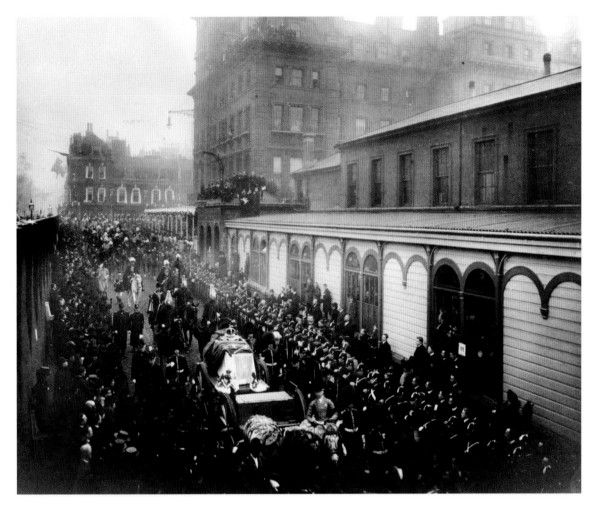

Left Queen Victoria's funeral procession arrives at Paddington on 2 February 1901. The new King Edward VII and Victoria's grandson, Kaiser Wilhelm II, are riding together behind the funeral carriage.

Below Brunel's goods depot, built on the site of his first passenger station at Paddington in the 1850s, being demolished in 1925. An even larger new goods depot replaced it and was finally closed in the late 1960s. The area has now been redeveloped as Paddington Central.

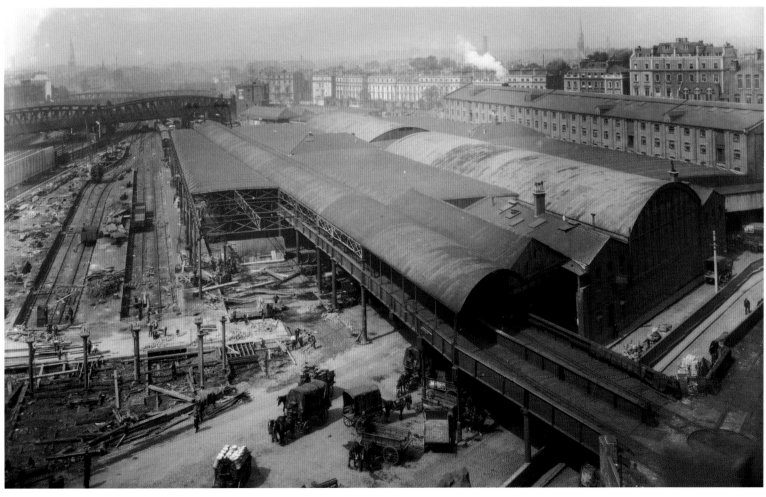

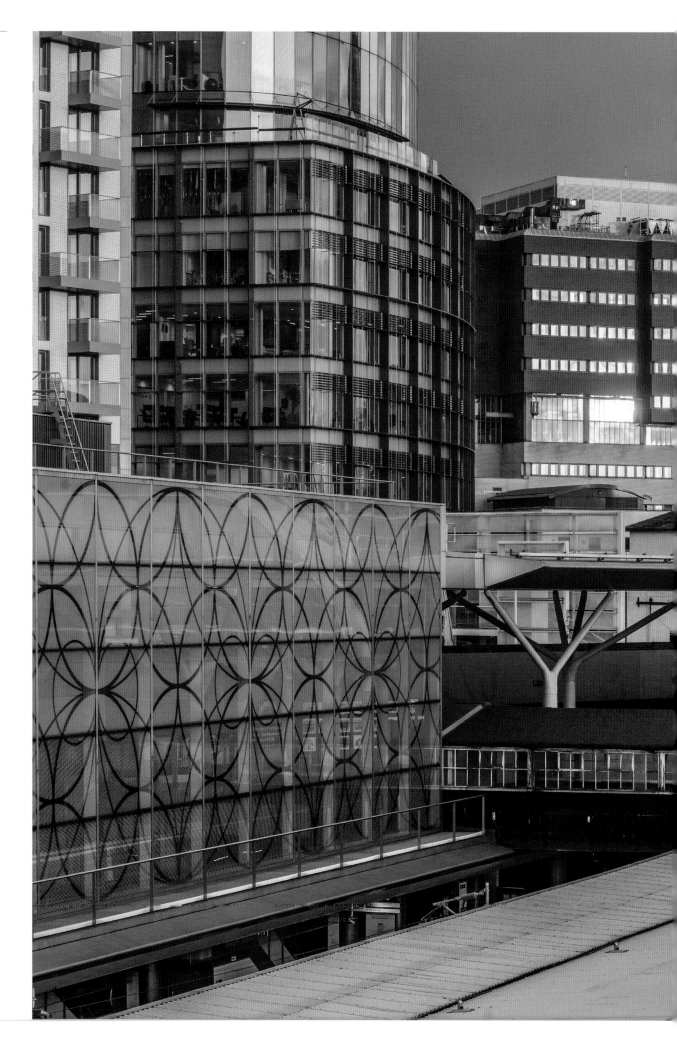

Right Paddington from Bishop's Bridge Road in 2021. On the left, the glazed booking hall of the rebuilt Hammersmith & City line station, with span four of the main-line station on the right. Beyond is St Mary's Hospital and new high-rise offices round the canal basin.

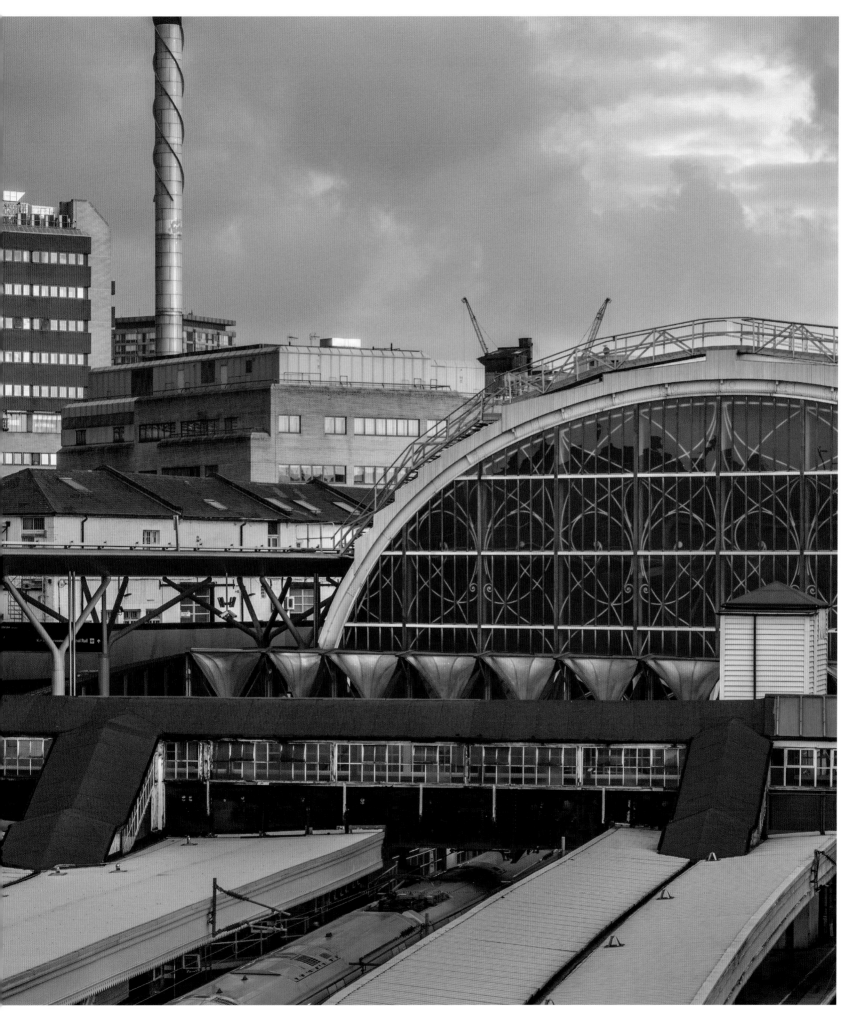

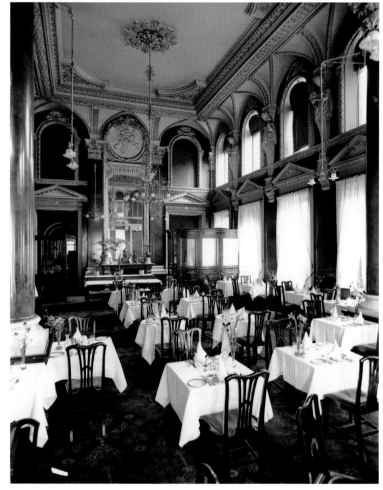

Bishop's Road and Praed Street were electrified in 1905, sixty years before steam trains disappeared from the main-line station.

Changes afoot

At the start of the twentieth century, when Paddington was used as a staging post for Queen Victoria's funeral cortege to Windsor in 1901, the GWR's passenger traffic was beginning to outgrow Brunel's trainshed. In the 1850s, only twenty trains a day left Paddington. By 1907 it was three hundred every 24 hours. Since 1903 the great three-faced clock over Platform 1, which was designed and made by Kays of Worcester, has watched over every departure. It was mechanically driven until 1929, when it was converted to electric operation, controlled from the station master's office.

A new fourth roof span, on steel rather than cast-iron supports, was added to Brunel's triple-arched trainshed in 1913–15 to provide additional covered platform space. This was mainly to accommodate the growth of suburban services, although in contrast to Liverpool Street, which served working-class east London and Metropolitan Essex, Paddington was still dominated by long-distance trains. The GWR never considered itself a suburban railway and prioritized its famous express services to the West Country. In December 1913, Paddington gained a direct Tube connection with London's West End, when an extension to the Bakerloo line was opened. This had the novelty of escalators, then described as 'moving staircases', to the new deep-level platforms directly below the main-line station.

Despite the further expansion and rebuilding in the early twentieth century of the Paddington goods depot on the site of the original terminus, the main station continued to handle extensive non-passenger traffic. Most of the GWR's perishable market traffic came through Paddington. In the 1920s, this included 50–200 tons of flowers, fish, fruit, meat and vegetables a day, and about 5,500 milk churns from the West Country, together with more than 200 tons of daily newspapers going out of London to the west every night. Even more important was the huge business served by the parcels and mail departments at Paddington. At Christmas 1936, when both sections would have been working at their peak, the GWR proudly reported having shifted nearly 80,000 parcels and post bags in twenty-eight special train loads.

By this time the innovative Post Office Railway (later rebranded as MailRail in the 1980s) was also in full operation. This was a separate, narrow-gauge fully automated driverless electric underground railway, opened in 1927, which ran under central London between Paddington and Liverpool Street, calling at the GPO's main London sorting office at Mount Pleasant in Clerkenwell. Mail for the West Country was transferred directly on to a fast Night Mail express postal service from Paddington to Penzance, which was sorted by Post Office staff on the train. The Travelling Post Office (TPO) operation from Paddington continued until 1995 when Royal Mail operations at five London main-line stations were transferred to a new road/rail hub at Stonebridge Park in north-west London. MailRail was closed down

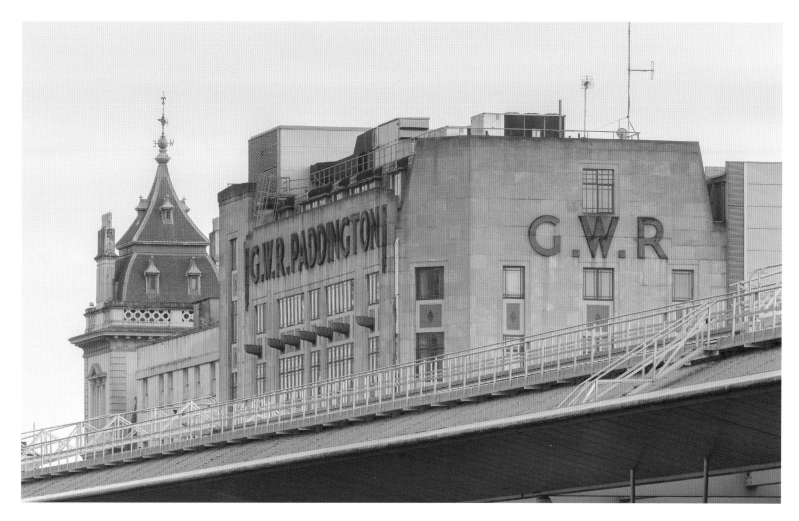

Far left above Free catering on the Lawn at Paddington for military personnel returning from the First World War, 1919.

Far left below Refreshments on the station platform, c.1935.

Left The original double-height coffee room of the Great Western Royal Hotel photographed in 1922. This was remodelled and subdivided in the 1930s in Art Deco style.

Above The new GWR offices and hotel extension in the 1930s modernization, beside the Praed Street entrance, seen above span four of the station.

Right 150th anniversary celebrations for Paddington in 1979 included a steam special hauled by *King George V*, the first of the GWR's powerful King-class engines built in 1927. It is pulling out past one of BR's then-new Inter-City 125 diesels, which were only replaced in 2019.

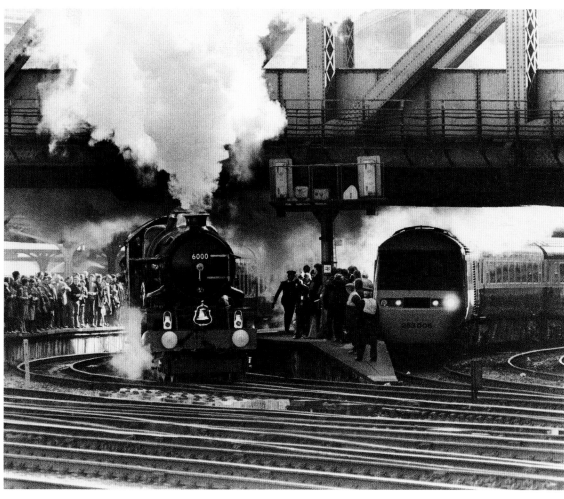

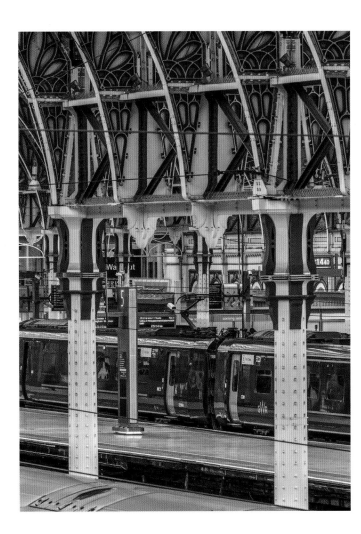

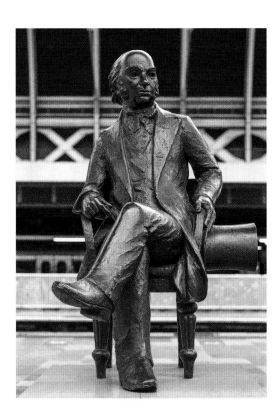

in 2003 and all mail both across and out of London is now carried by road, but it is still possible to visit and take a ride on a restored original section of MailRail at the new Postal Museum in Phoenix Place, close to Mount Pleasant, which opened to visitors in 2017.

In the early 1930s there was an attempt to improve Paddington's rather primitive and antiquated passenger facilities, prompted by the approaching centenary celebrations of the GWR in 1935. The area between the rear of the hotel and the station platforms, which had been used as a loading area for parcel delivery vans, was turned into a proper passenger concourse. This space has always been referred to as 'the Lawn', although there has not been a blade of grass there since construction of the present station began in the 1840s.

The Victorian hotel was extended at the back with a rear entrance giving direct access to the station and a modish 1930s refurbishment inside and out. The elaborate original interior was gutted, including the spectacular double-height coffee and dining room. This was now divided up and replaced with a new streamlined lounge and cocktail bar. A large modern office block in matching Art Deco style was built alongside the station entrance ramp from Praed Street, with substantial extension to the hotel alongside the Eastbourne Terrace ramp on the other side. All of this was designed by the Great Western's architect, P.A. Culverhouse. Look up as you enter or leave the station from Praed Street to see 'GWR PADDINGTON' still proclaimed in giant raised capital letters at the top of the building. It is

particularly impressive at night when this façade is delicately illuminated by stylish shell-shaped 1930s uplighters. As Steven Brindle has observed, 'Culverhouse's work was a typical instance of the 1930s reaction against Victorian taste, but with hindsight it was very regrettable, diluting the hotel's design and weakening its architectural impact'. But despite the unfortunate loss of the grand Victorian interior in the 1930s, its replacement has benefited from a sensitive refurbishment of the Art Deco style carried out in 2001–2, when the Great Western Royal reopened as the Hilton Paddington.

The GWR became the Western Region of British Railways on nationalization in 1948 but there was little money available to repair war damage and modernize the station. However, the Western Region maintained the GWR tradition of doing things differently from other railways and reintroduced its pre-war colours with 'chocolate and cream' carriages to distinguish its express trains. They also revived some of their famous pre-war named trains such as the *Cornish Riviera Express,* the *Bristolian* and the *Cambrian Coast Express,* as well as introducing the *Royal Duchy* to Penzance, the *Mayflower* to Plymouth and the *Capitals United* to Cardiff.

The WR also went its own way experimenting with diesel hydraulic drive units in most of its new locomotives built at Swindon from 1958, instead of using conventional diesel electrics like the rest of BR. Rather like Brunel's broad gauge, this turned out to be a costly mistake, and few of the underpowered and unreliable Warships, Westerns and Hymek diesel hydraulics

Paddington Bear

Paddington was badly damaged by bombing during the Second World War, with direct hits on the station trainshed and the Eastbourne Terrace buildings, which had to be partly demolished and rebuilt. Praed Street Underground station was also bombed, with several casualties in one of the early Blitz raids in September 1940. One year earlier Paddington had been a departure point for hundreds of children evacuated from London to the safety of the countryside on the outbreak of war. Each child carried a small suitcase and had an identification label tied to his or her coat. This was part of the inspiration for the popular children's character Paddington Bear, created by the author Michael Bond in the 1950s. Named after the station where he was found in the original story, Paddington was a stowaway who had travelled from his home in 'darkest Peru', surviving the journey to London on marmalade sandwiches. He now has a decorated photo bench on Platform 1, and is featured nearby as a bronze sculpture, complete with battered suitcase, based on the original book illustrations by Peggy Fortnum. A specially designed stall on the concourse sells all the Paddington Bear books and branded merchandise. The character's fame and popularity have grown considerably since the release of two very successful feature films, which both include sequences shot in the station. In 2021, a major exhibition on the famous little bear, complete with a marmalade trail, opened at the British Library.

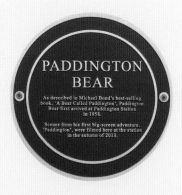

Above Paddington's plaque at the station.

Below Bronze statue of Paddington Bear currently on Platform 1, close to his photo seat.

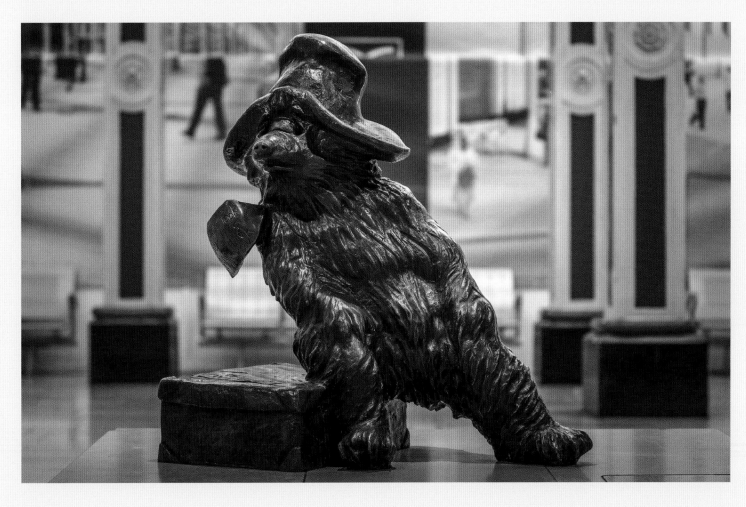

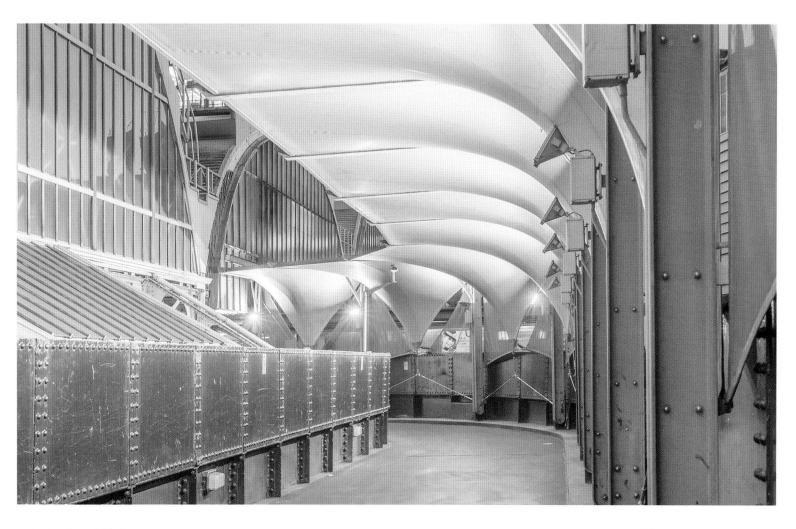

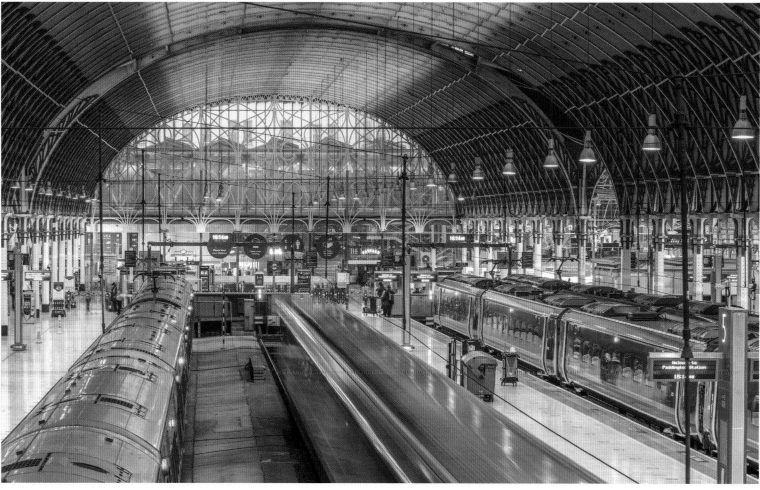

Goods and horses

The Paddington goods depot site, north of the station, was completely redeveloped in the first decade of the twenty-first century with high-rise offices between the railway and the canal, and around the canal basin. A new canalside entrance to the main station and the rebuilt Hammersmith & City line platforms have dramatically improved this end of Paddington. The spacious new Underground booking hall has a large glazed wall overlooking the main-line platforms, with Wyatt's decorative patterns from the end of Brunel's trainsheds etched right across the glass.

There were plans to demolish the fourth roof span and build a raft over the tracks to create even more commercial office in 'air space' above the suburban platforms. This scheme has now been abandoned and the fourth span has been suitably renovated and restored. Office encroachment has, however, continued at the Praed Street end of the station, where a new development is rising above the Bakerloo line street entrance and the adjacent site of the large former GPO sorting office on London Street, which has recently been demolished.

Just round the corner here on Winsland Street is the last surviving building that formed part of the extensive GWR goods handling complex located between the station and the canal basin. Now called the Mint Wing of St Mary's Hospital, this block was built as a multi-storey stable range, progressively enlarged from the 1870s. It eventually housed about 600 horses on four floors. They were used to haul carts and wagons delivering goods from the railway depot all over London before lorries began to take over in the 1920s and 1930s. The stables were converted and extensively rebuilt for hospital use in the 1960s but are now listed for their remaining heritage features, which include the sloping ramps in the yard once used to lead horses to the upper levels.

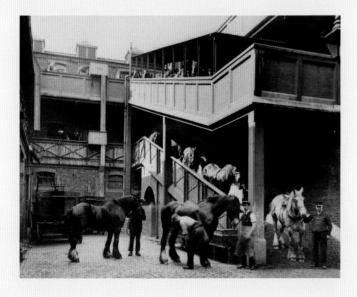

survived on the WR main line by the mid-1970s. Lightweight diesel multiple units replaced steam on the Paddington suburban services in the early 1960s, and the last regular main-line steam run from London was in 1965.

None of the first generation diesels on the WR could match the performance of the GWR's Kings and Castles, designed at Swindon in the 1920s, which had handled most of the main-line express services out of Paddington for nearly forty years. A dramatic and lasting improvement over steam only came with the introduction of British Rail's Inter City 125 High Speed Trains (HSTs) in 1976, which were not unique to the Western Region. HSTs operated most long-distance services out of Paddington until the partial electrification of the Great Western main line to Bristol and South Wales was achieved in 2019. The diesel HSTs were then finally ousted by sleek new Hitachi bi-mode trains, which have electric motors powered from overhead electric wires but also have diesel generators to enable the trains to operate on unelectrified track beyond the wires.

One of the first of these Intercity Express Trains (IEPs), as they are called by the current operator, Great Western Railway, was named *Queen Elizabeth II* by the monarch herself at Paddington on 14 June 2017. The Queen had arrived at Paddington on the unit, travelling from Slough, on the 175th anniversary of the first-ever train journey by a reigning monarch, made on the same route by Queen Victoria.

Refurbishment and the future

In the 1990s, a major refurbishment of Paddington station was carried out. This included the creation of an open retail and café area on the Lawn, with a glazed screen to Brunel's trainshed. This was a very effective reworking by Nicholas Grimshaw and Partners that has improved the passenger facilities but also enhanced the station's historic features. Cleaning, repairing and reglazing the roof has followed with a completely new lighting scheme that picks up the decorative details obscured for decades by the dirt and grime of steam trains. The station looks better now than at any time since its construction.

The first electric trains arrived at Paddington in 1998 with the inauguration of the Heathrow Express, which provided

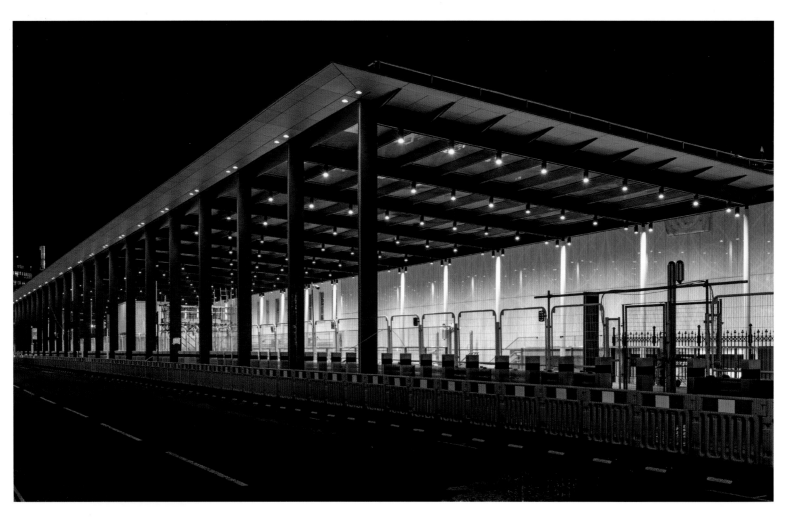

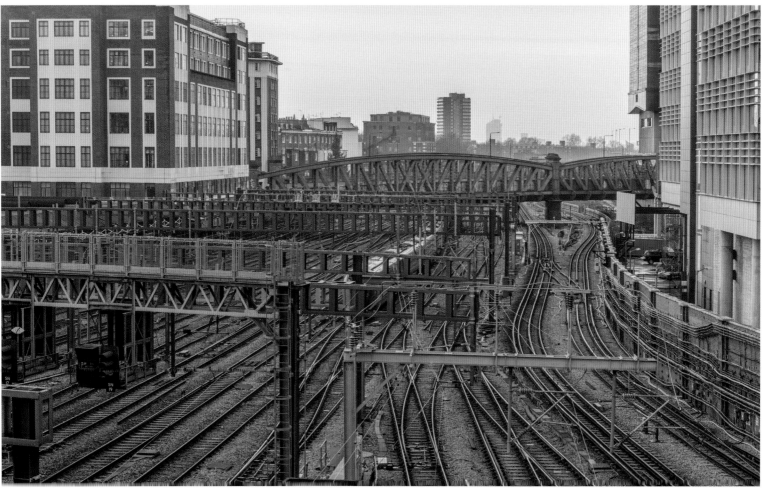

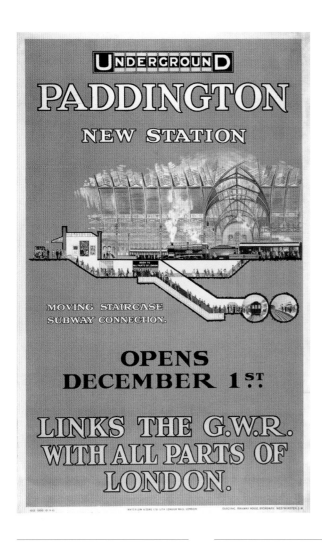

Left above The main entrance to the new Elizabeth line on the Eastbourne Terrace axis of the station, which will open in 2022.

Left below The view westward out of Paddington. The brick wall on the right is all that remains of the much taller side wall of the railway goods depot that stretched from here to the canal until the late 1960s, all now redeveloped as the offices and apartments now called Paddington Central.

Above left London Underground poster by Charles Sharland, announcing the opening of the Bakerloo line platforms at Paddington (1913). This was one of the first deep-Tube stations to have 'moving staircases' (escalators).

Above right The canal view outside the new Bishop's Bridge Road station exit for Paddington Central.

Overleaf One of Wyatt's 1854 Moorish window designs for the original GWR offices, overlooking Platform 1 at Paddington.

a direct train to the airport every 15 minutes. With a 15-minute journey time it is easily the quickest way to get to the airport from central London, faster than cab or Tube, although one might argue that Paddington is still on the edge and not at the heart of the city at all. Heathrow Express was augmented by the Heathrow Connect stopping service from Paddington from 2005, and a through service from Heathrow running on to the new Elizabeth line under Paddington main line will be introduced from 2022.

The next development at Paddington is Crossrail, now renamed the Elizabeth line, which will open in 2022. This is a new railway under central London linking Heathrow and Reading/Maidenhead in the west with the east and south-east of the city at Shenfield and Abbey Wood. There is direct interchange with the Underground at key points in the West End, City and at Canary Wharf. Crossrail services will leave the existing Great Western main line just outside Paddington and run eastwards in tunnel from Royal Oak, calling at a new station underneath the main-line terminus and surfacing again on the other side of London on two branches. It will also provide a fast cross-London link between Paddington and Liverpool Street, where the new Elizabeth line station entrance is just outside the former site of Broad Street station, now the Broadgate Centre.

The Crossrail/Elizabeth line platforms at Paddington are on the Eastbourne Terrace axis of the station alongside Brunel's trainshed. Natural light is brought down to the underground platforms in a great slit trench with a glazed roof decorated with etched clouds, which sits above the former cab rank (now transferred to the other side of the station). As a combined architectural and engineering concept on a grand scale, this project is firmly in the Brunel tradition. Unfortunately, like so many big infrastructure projects, Crossrail ran into unpredicted technical problems that seriously delayed its completion, which was originally scheduled for 2018. In Spring 2021, Crossrail Ltd were still announcing plans to bring the Elizabeth line into passenger service. Responsibility for managing the Elizabeth line has now been transferred to Transport for London (TfL), who plan to open the railway as soon as possible in 2022.

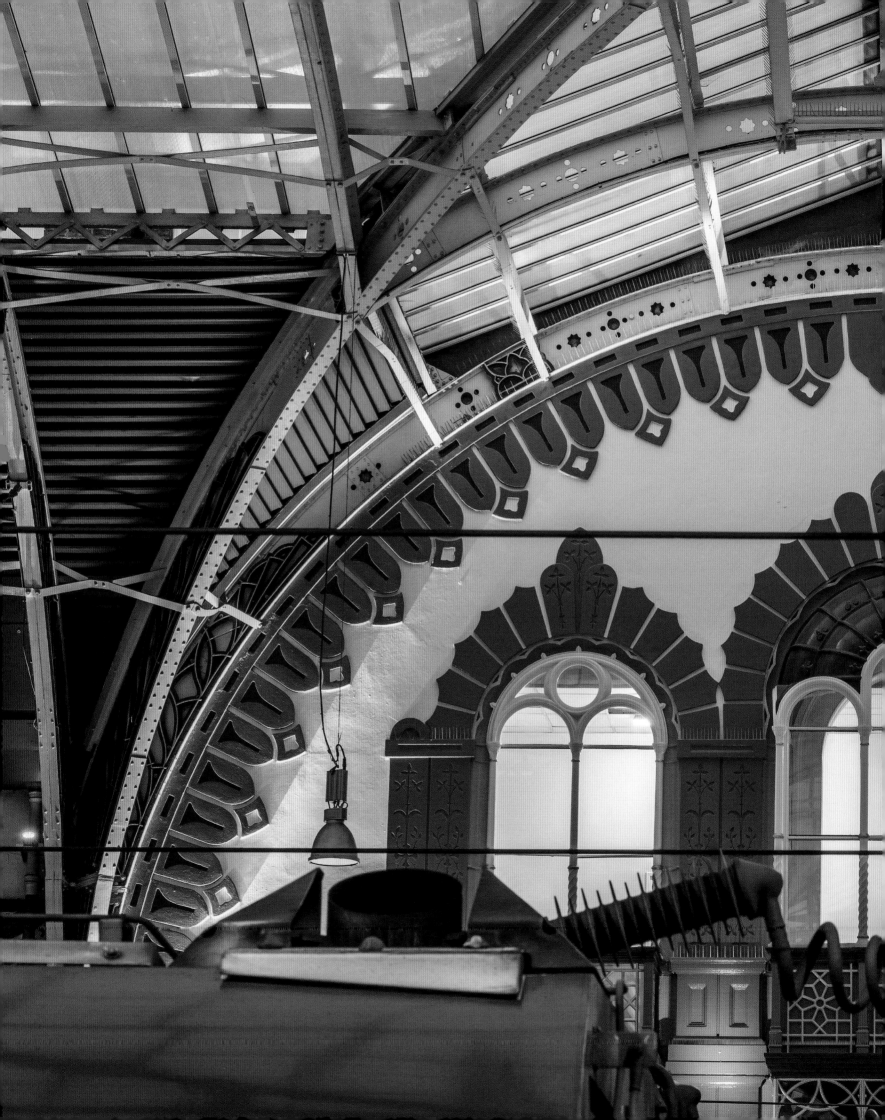

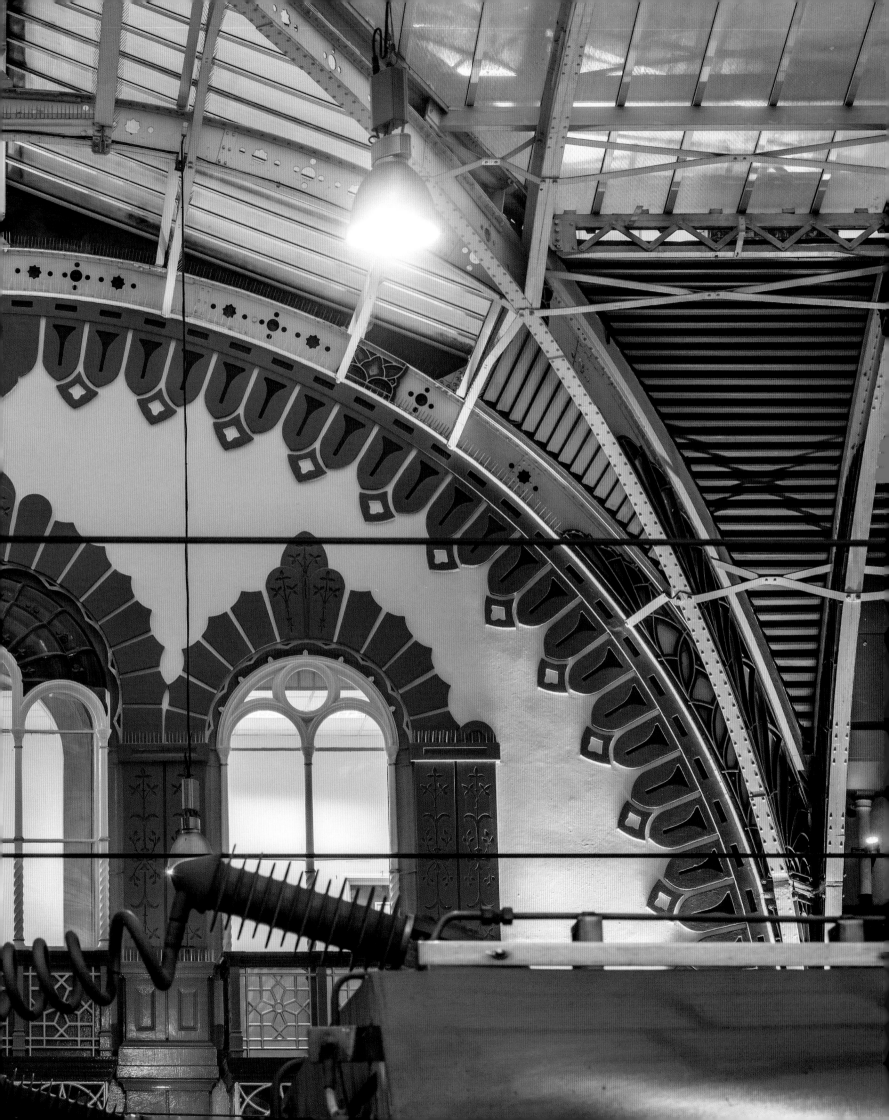

Marylebone

Left Modest red-brick Marylebone, the Great Central's London terminus.

Right Guests assembled on the platform for the official opening ceremony, 9 March 1899.

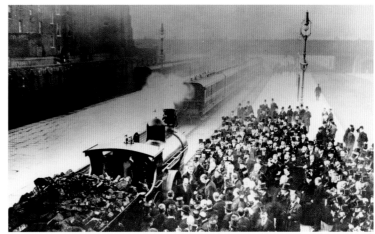

Marylebone was built as the terminus of the last Victorian main line to London, which brought the Great Central Railway (GCR) into the capital. At the ceremonial inauguration of the station on 9 March 1899, C.T. Ritchie, President of the Board of Trade, who cut the tape, remarked that it was an event London was not likely to see again. There was a general feeling at the time that London already had quite enough railway termini and Marylebone's future commercial prospects looked uncertain from the start. The GCR faced an uphill battle for customers, competing with established main-line services by other companies linking London with Manchester, Sheffield and Nottingham.

Marylebone was never a great success and had a roller coaster history for most of the twentieth century. Eventually, in the early 1980s, a plan to convert the rail line into a coach route with Marylebone as a bus station and existing rail services diverted to Paddington was given serious consideration. Closure notices were posted prematurely by British Rail at the station in 1984, but immediately met with unexpectedly strong opposition from both local authorities and regular rail users. A fierce legal battle ensued, which lasted two years. Fortunately, the conversion project proved impractical due to the headroom limitations on the line and the proposed closure was quietly dropped. As we shall see, this proved to be a turning point in Marylebone's fortunes, which led to a radical rethink by BR of the line's future.

The driving force behind the original Marylebone project was Sir Edward Watkin, one of the most powerful and far-sighted of the Victorian railway barons. Watkin was chairman of the Manchester, Sheffield and Lincolnshire Railway (MS&LR) and had grandiose plans to extend its main line through the Midlands to London. The MS&LR's change of name in 1897 to the GCR confirmed the scale of his ambition. Watkin was already chairman of both the Metropolitan (MR) and the South Eastern Railways (SER), and also of a company planning to build a Channel rail tunnel. His ultimate aim was to link all these projects together and create a grand passenger rail route from Manchester to Paris.

The GCR's approach to London was to be over the Metropolitan Railway's main line from Buckinghamshire and then on new parallel tracks from Harrow through the north-west suburbs to Finchley Road. From here, where the Met dives underground to Baker Street, a new parallel line was needed to take the GCR another 3.5km (2 miles) through St John's Wood, mainly in tunnel, to Marylebone. A large site was cleared for a goods and coal depot at Lisson Grove, and the passenger terminus was planned just beyond this point, to be fronted by a grand hotel on the Marylebone Road.

Clearing the way

Preparations for the final approach to Marylebone were both costly and controversial. The GCR built six large tenement blocks just off St John's Wood Road, in a new estate named Wharncliffe Gardens, to rehouse about 3,000 of the nearly 4,500 people whose

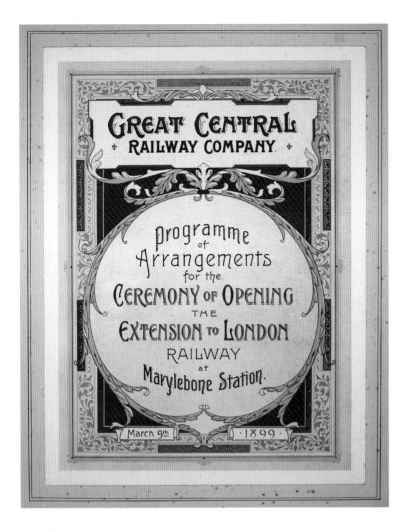

Left Programme of Arrangements for the opening of Marylebone and the GCR's London extension.

Below 'Lords in Danger', the famous *Punch* cartoon of 1890.

Right The straightforward and simple trainshed at Marylebone, which covered less than half the planned platform area.

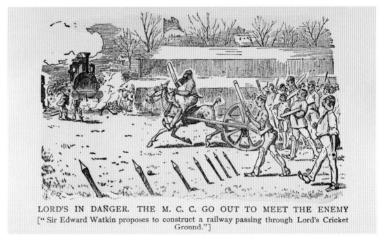

LORD'S IN DANGER. THE M. C. C. GO OUT TO MEET THE ENEMY
[" Sir Edward Watkin proposes to construct a railway passing through Lord's Cricket Gronnd."]

homes had to be demolished. The extensive railway goods depot in Lisson Grove included transfer facilities on to the Regents Canal and a massive five-storey warehouse, which took three years to build. This was later destroyed in a bombing raid in 1941. Both the GCR housing and the entire goods yard site were redeveloped in the 1970s by the Greater London Council to create the Lisson Green Estate. Almost no trace of the former railway facilities survives today.

There was a much bigger fuss about the need to build the railway through middle-class St John's Wood and in particular under Lord's, home of the Marylebone Cricket Club (MCC). When word got out in 1890 of the threat to the sacred turf, *Punch* magazine published a cartoon showing the eminent batsman W.G. Grace leading his cricket team out to meet the new enemy: Watkin and his railway. To placate the MCC and public opinion, Watkin offered a guarantee that all necessary work would be carried out between the end of one cricketing season and the start of the next. Work on this critical section eventually began at Lord's on 1 September 1896. The turf was carefully removed, the tunnels excavated and covered over at record speed, and the reinstated pitch was handed back to the MCC just eight months later, on 8 May 1897. Not one day's play had been lost and the club had gained nearly 0.8 hectares (2 acres) of land as part of the deal. As the Great Central's historian George Dow has put it, Watkin had 'effected a satisfactory, if somewhat expensive, settlement with the MCC, who thereafter offered every assistance'.

Mounting costs

Because of the escalating cost of getting its line into Marylebone, the GCR had to economize on its passenger terminus. The station buildings were designed not by a commissioned architect but by one of the railway's engineering staff, H.W. Braddock. Only four platforms were provided, with the promise of future expansion on the site, which then never materialized. The station is a modest construction in red brick, hidden from the Marylebone Road by the enormous bulk of the Great Central Hotel. As the railway historian Alan Jackson has aptly commented, 'the result would have been creditable as council offices for a minor provincial town, but was hardly worthy as the London terminus of a railway that aspired to be in the first rank'. Similarly, John Betjeman always considered that 'modest Marylebone' resembled a branch public library from the Midlands.

An elaborate but elegant iron-and-glass canopy over the entrance yard provided a covered link between the station and the Great Central Hotel. As the railway had run out of money, the hotel was financed as a separate enterprise by Sir John Blundell Maple and lavishly fitted out with a marble staircase and a series of period rooms by his family's furnishing company, who ran a large department store on Tottenham Court Road. The architect was Colonel Robert William Edis, who spared no expense on the Renaissance exterior and the grand reception and dining rooms. The nine-storey hotel was built around a great glazed central courtyard and there was even a cycle track on the roof for energetic guests,

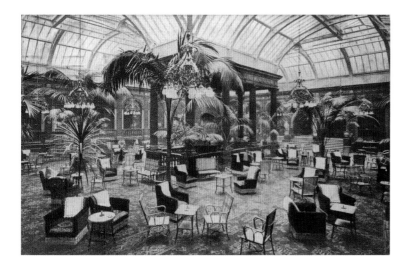

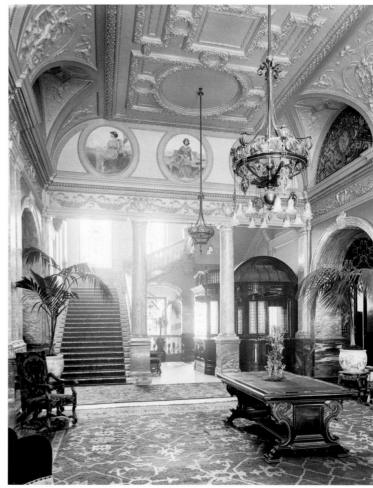

Left The Marylebone Road entrance to the Great Central Hotel.

Above Postcard view of the central lounge area of the Great Central Hotel, c.1905.

Right The lavish marble staircase and foyer on the station side of the hotel as opened in 1899, now fully restored as the Landmark London.

Neither the station nor the hotel prospered. Sir Edward Watkin had stepped down as chairman of the GCR following a debilitating stroke before his new terminus was completed. When Marylebone opened in March 1899, the ailing Watkin attended the ceremony in a Bath chair. Most of his 700 guests arrived on three special trains from Manchester, Sheffield and Nottingham, all key centres for the GCR. They sat down to a sumptuous luncheon in the Marylebone trainshed. Watkin at least had the satisfaction of seeing his great London extension project finished, although he died just two years later.

The Great Central Hotel, one of Maple's Frederick Hotels group, opened four months after the station, on 1 July. It is unlikely that the 700 bedrooms were ever fully booked, and passenger traffic through the station could not have filled them. Maple died in 1903 and did not live to see his grand hotel make a profit. At the time there were just eleven trains a day scheduled each way in and out of Marylebone, seven of them expresses to and from Manchester. The trains were luxurious but slower than their established rivals on the shorter London and North Western Railway (LNWR) route to the north-west from Euston and the GCR's station porters at Marylebone were often said to outnumber the passengers.

Things were looking up

Things began to change with the arrival of the energetic Sam Fay as general manager of the GCR in 1902. Fay recognized that the

Great Central would never become a serious challenger to the other main-line companies with long-distance passenger trains on the London extension. The GCR's financial rewards lay in freight, not passengers, and particularly in coal from Nottinghamshire and South Yorkshire, and both fish and coal traffic through the ports of Grimsby and Immingham, which the railway owned.

Fay's particular skill lay in creating successful and continuous good publicity for the GCR, backed up with a high standard of passenger service. It was what we would now call niche marketing, and it worked really well in the Edwardian years with the development of outer suburban services, which soon became the mainstay of Marylebone. These were run in agreement with the Metropolitan Railway over the jointly owned line to Aylesbury and with the GWR over its newly opened route via High Wycombe. Both these lines became popular with more affluent season ticket holders, who commuted in to London from newly flourishing country towns such as Beaconsfield, Gerrards Cross and Princes Risborough.

Marylebone became a convenient terminus for the West End when a Tube station on the extended Bakerloo line was opened on the western side of the main-line station in 1907. The original station name, Great Central, was dropped ten years later but has reappeared at the end of the Tube platforms alongside Marylebone after being revealed during restoration of the wall tiles. The GCR's initials also survive, repeated in the decorative railings all along the main Marylebone station frontage opposite the hotel.

The Great Central Railway disappeared as a name in 1923 when it was merged with a number of other companies to create the London and North Eastern Railway (LNER). In the following year, traffic through Marylebone was boosted considerably by the decision to hold the British Empire Exhibition at Wembley, for which a 10-minute service of non-stop trains was introduced. Sporting events at Wembley Stadium, first used for the FA Cup Final in 1923, also brought large crowds through Marylebone, though these busy occasions only punctuated long periods of quiet.

When the railways were nationalized, Marylebone was run initially by the Eastern Region of British Railways (BR) and the Great Central Hotel, which had closed before the war, became the headquarters of the new British Transport Commission (BTC) and later of BR. The grand public rooms were stripped of their decorative features and the increasingly dowdy interior came to look like any other faceless government offices, with bleak fluorescent lighting throughout. Railway staff knew it, appropriately enough, as 'the Kremlin', or '222', from its postal address on the Marylebone Road. BR eventually moved out in 1991 and the building was sold for re-use as a hotel once again. By now it was a listed building, and sensitive renovation has recreated a luxury hotel with much of the character it must have had when it first opened. It reopened as the Landmark London Hotel in 1995.

BR did attempt to revive main-line services from Marylebone by introducing two named express trains in 1948, the *Master* *Cutler* to Sheffield and the *South Yorkshireman* to Bradford, but these were withdrawn in 1960. Diesel multiple units replaced steam on the Marylebone suburban services from 1961, and five years later the old Great Central main line north of Aylesbury closed completely. By the end there were just three trains a day each way to Leicester and Nottingham, and a single night service to and from Manchester. These 'semi-fasts' were the last steam passenger trains in north London, finally disappearing in 1966.

Saving Marylebone

As the quietest of the London termini, Marylebone was ideal for holding modest ceremonies and facilitating commercial filming. The first of BR's new standard express passenger steam locomotives, No. 70000 *Britannia*, was named here in January 1951 by the Minister of Transport Albert Barnes, but immediately put into passenger service from Liverpool Street, not Marylebone. Scenes from two classic British movies of the 1960s were shot here: the start of the Beatles' first film, *A Hard Day's Night*, in 1964, where Marylebone doubled for both Euston and Liverpool Lime Street; and the opening sequence of the spy thriller *The Ipcress File*, starring Michael Caine, in 1965. Marylebone continued to slumber through the 1970s, with declining services, until the threat of complete closure came in the early 1980s. But when the ill-considered bus station idea collapsed, Marylebone was reprieved in 1986 and as part of British Rail's newly created Network South East, the London regional sector of BR, an

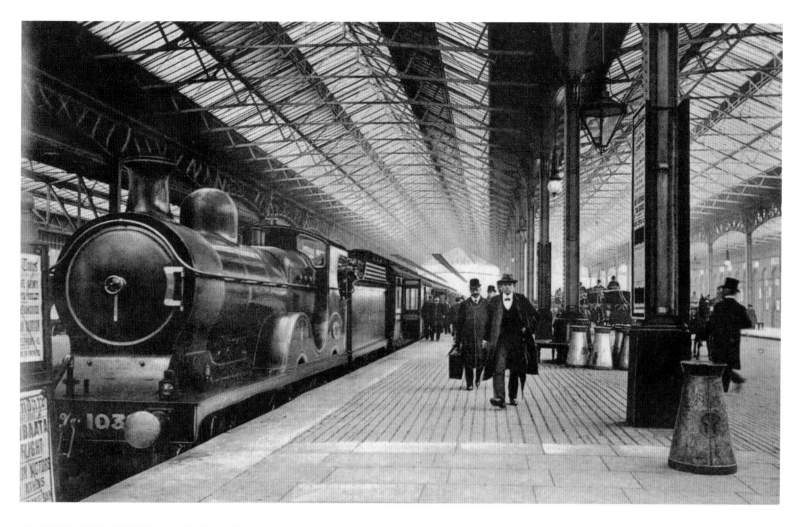

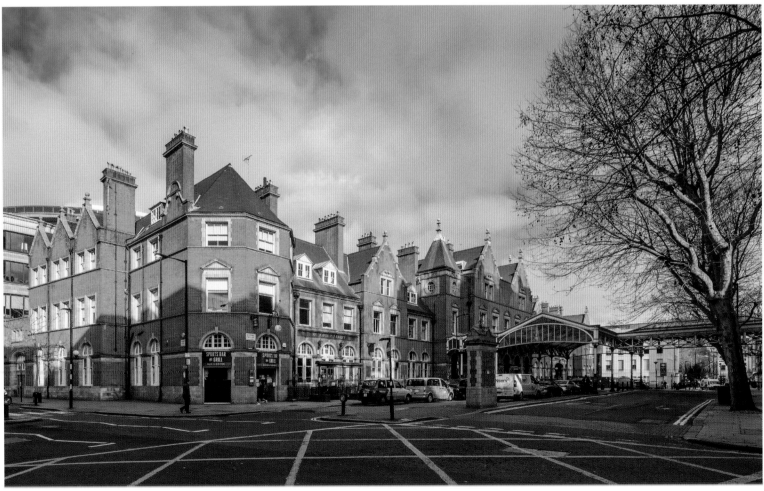

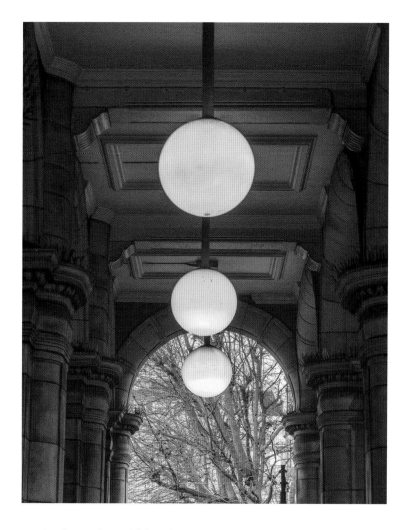

£85 million 'total route modernization project' was announced for
the station and the line. Marylebone's prospects were looking up.

By the 1990s the station was being completely upgraded and
refurbished with a new terrazzo-style passenger concourse, which
meant a reduced footprint for the platforms. The western span
of the trainshed was removed, and the land released was sold for
commercial office development. By taking out the wide but unused
cab road down the centre of the station, three platform faces could
comfortably fit under the remaining double roof span.

New 'Turbo' diesel multiple units were introduced on what
had become known as the 'Chiltern Line' and all services were
improved and upgraded with new signalling, which allowed
faster turnaround at what was still one of the smallest and least-
used London termini. When British Rail was privatized in 1996,
Chiltern Railways, the train operator that won the franchise, was in
a strong position to develop the business as sole operator of both the
station and all train services. More station improvements and new
trains followed as Marylebone celebrated its centenary in 1999. The
tasteful conversion of the old GCR booking hall into an early M&S
'Simply Food' store, with a florist's next door on the concourse, was
somehow emblematic of the station's upmarket transformation. It
became a very pleasant and well kept terminus to use.

Passenger numbers grew rapidly, both for leisure and
commuter travel, and Chiltern Railways have been consistently
entrepreneurial, with a high standard of customer care. A longer-
distance inter-urban service to Birmingham Snow Hill and a

service beyond to Kidderminster was also opened. Two new short
platforms at Marylebone and a depot at Wembley Stadium were
built to enable a more intensive passenger service to operate,
and from 2015–16 a new link via Bicester allowed Chiltern to
introduce direct services to Oxford. By 2018 a passenger survey
found that London commuters from Oxford preferred the new
Chiltern service to Marylebone over the established Great Western
route to Paddington via Reading, which is marginally faster but
less reliable.

Chiltern Railways' only disadvantage is its environmental
position. Marylebone now stands out as the only London terminus
that has not been fully electrified. All suburban services on the
line still use traditionally powered and heavily polluting diesel
multiple units, with big diesel electric locomotives hauling many
of the long-distance trains. Full electrification looks unlikely in
the short term because of the high cost, but with growing pressure
to decarbonize the railways, the introduction of hybrid, bi-mode
or battery electric trains may be a solution. This must be the next
area for creative modernization and investment as the remarkable
renaissance of Marylebone looks set to continue. Both Watkin and
Fay would surely have approved.

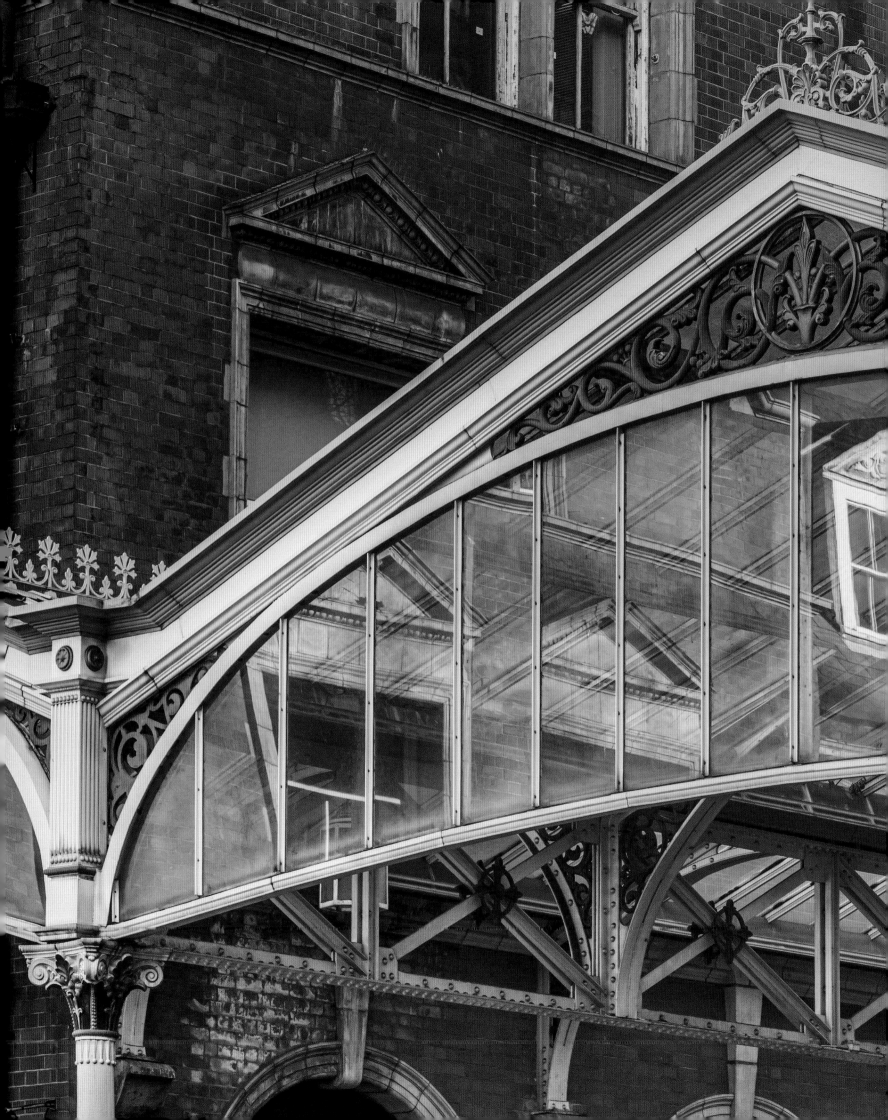

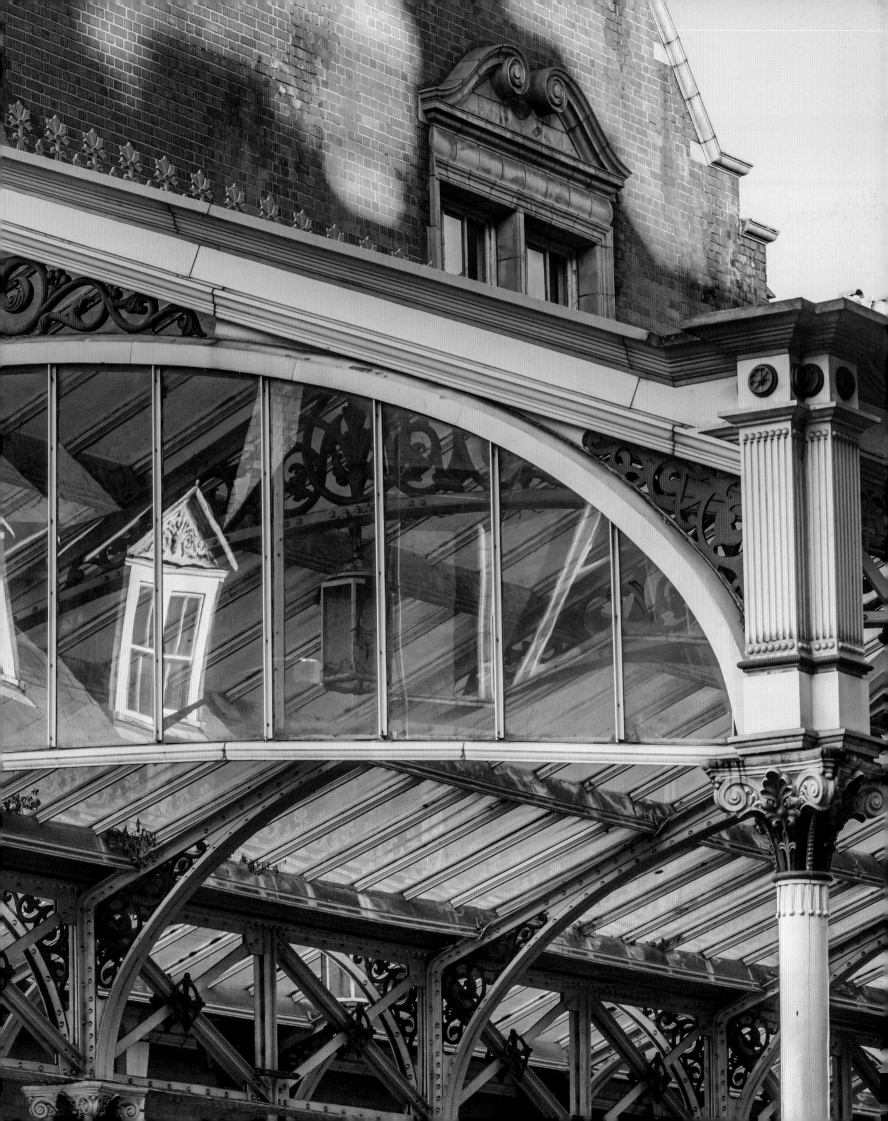

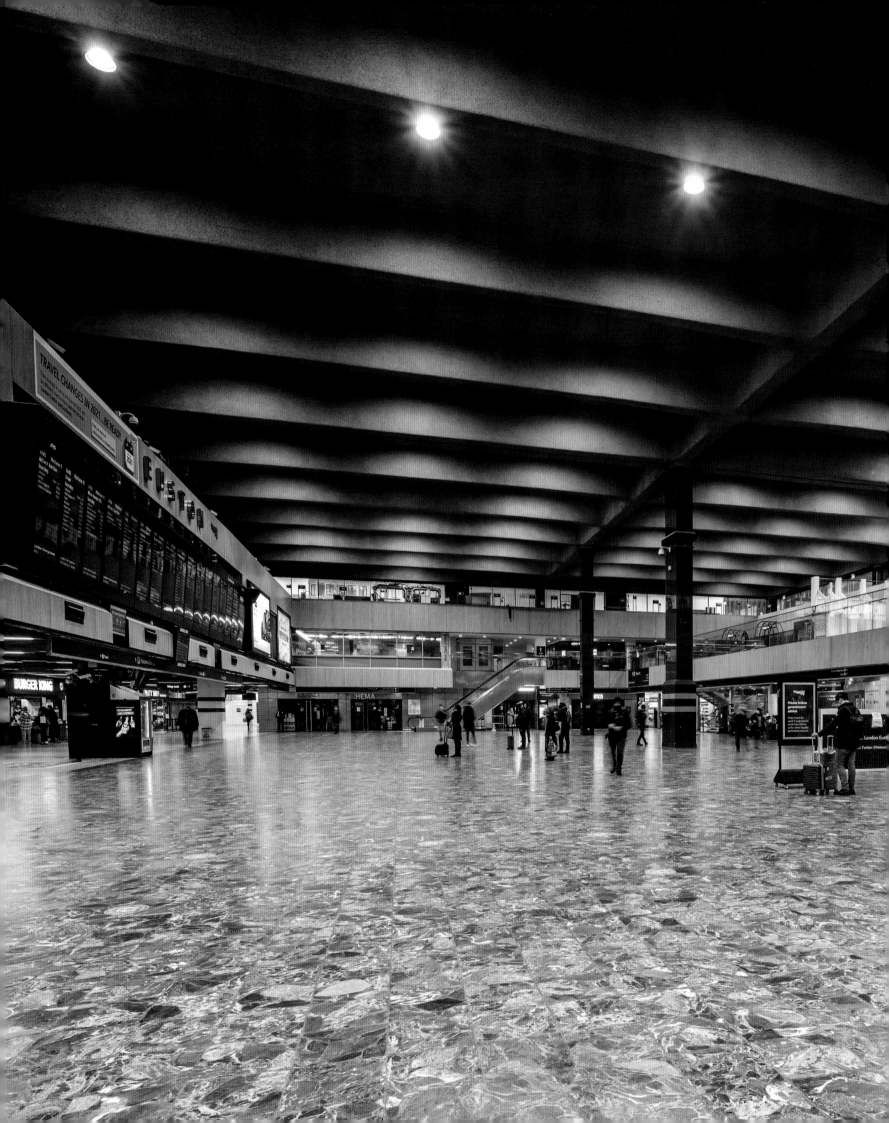

Euston

The original station that opened at Euston in July 1837 was London's first inter-city main-line terminus, connecting the capital with Birmingham. London Bridge station had opened in the previous year, but trains from there ran initially only as far as Greenwich, a few miles down the Thames. The London and Birmingham Railway (L&BR), engineered by Robert Stephenson, was a much more ambitious and larger-scale project, bringing the Midlands, and later the whole of the north-west, within easy reach of London for the first time. Euston is still London's main rail gateway to the north west, but no trace of the original station survived the brutally comprehensive redevelopment of the site in the 1960s.

The railway authorized by Parliament in 1833 was to terminate at Camden Town, just north of the Regent's Canal. A year later the L&BR got permission for an extension, taking the line across the canal and just over 1.6km (1 mile) closer to central London. The station site, just north of the New Road at Euston Grove, happened to be the very spot where, in 1807, the prolific Cornish inventor Richard Trevithick had first demonstrated a working steam locomotive, *Catch-Me-Who-Can*, on a circular track. Trevithick's pioneering experiment was treated as a fairground attraction and led to nothing more at the time. It was nearly thirty years later that Stephenson's great project brought a full-scale passenger railway to this point.

The originally proposed station site at Camden became a large goods depot, with transfer facilities on to the canal, extensive horse stabling and an engine shed. The goods yard stables have survived to become part of the popular Camden Lock Market, while the goods locomotive roundhouse, built in 1847, has now found a new use as the Roundhouse theatre and performing arts centre. A second, larger depot for passenger locomotives working out of Euston was opened on the other side of the main line at Camden in 1847, later rebuilt in the 1920s and finally closed in the 1960s. No trace of this survives today. There are no longer any operational rail freight facilities at Camden, but at least some of the impressive infrastructure of the Victorian railway can still be appreciated at Camden Lock, while just down the main line at Euston nothing remains of Stephenson's pioneer passenger railway terminus.

Stephenson's terminus

Euston station was opened to the public on 20 July 1837, just one month after Queen Victoria's accession to the throne. The operational part of the terminus was quite basic at this stage, consisting of just two wooden platforms known respectively as the 'arrival stage' and the 'departure stage'. There were four tracks and a simple 61m (200ft) cast-iron-and-glass trainshed, the first of its kind, designed by structural engineer Charles Fox, with the station offices alongside the departure platform. On the other side of the offices an avenue was laid out from the New Road (later to be the Euston Road) to the station, and a great Doric portico and screen, designed by the architect Philip Hardwick, was completed here in 1838.

Left J.C. Bourne's view of the London & Birmingham Railway under construction at Primrose Hill, just north of Euston, c.1835.

Below Hardwick's Doric portico and screen frontage to Euston as originally constructed for the London & Birmingham terminus in 1837–8.

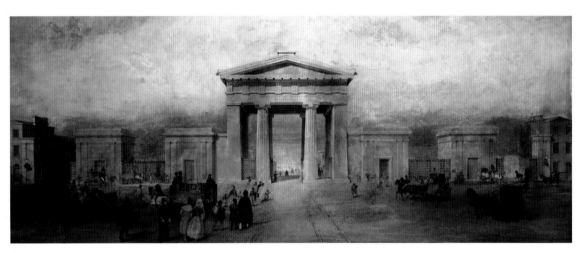

This was to be the central showpiece of the whole project. Hardwick's 22m (72ft) high Doric portico, soon generally but wrongly known as the 'Euston Arch', was designed to symbolize the arrival of a major new transport system in London. As the directors of the L&BR explained to their shareholders in February 1837:

The entrance to the London passenger station, opening immediately upon what will necessarily become the Grand Avenue for travelling between the Midland and Northern parts of the kingdom, the directors thought that it should receive some architectural embellishment. They accepted accordingly a design of Mr Hardwick's for a grand but simple portico, which they considered well adapted for the national character of the undertaking.

Hardwick's portico served no practical purpose but it was an immensely impressive gateway to the north and, of course, a powerful symbol of the railway's new dominance, representing the successful marriage of steam and technology in the Victorian era, but clothed in classical garb. Correspondingly, its destruction in 1962 seemed to herald both the end of the great age of steam and the eclipse of the railway as the nation's principal form of transport.

Hardwick's 'arch' and screen frontage would have formed a better centrepiece entrance to Euston if a matching terminus for the Great Western Railway had been built alongside to the west, as briefly proposed in 1835. After the GWR decided to go

to Paddington instead, the L&BR's Euston site was developed in an asymmetrical layout that soon compromised Hardwick's own architecturally balanced original station plan. In 1839, two matching four-storey buildings, one the superior Euston Hotel for first-class passengers and the other a 'dormitory and coffee room' named the Victoria after the new Queen, were built in front of the portico and screen on either side of the station entrance. These pioneer railway hotels were very successful operations, but when a large link block was added in the 1880s to create a single establishment, the new central section completely obscured the dramatic vista on the approach to Hardwick's frontage. The architectural crowding of Euston effectively began quite early on through the station's piecemeal development.

In 1846 the L&BR became part of a larger company, the London and North Western Railway (LNWR). Hardwick's son, also called Philip, was immediately commissioned to extend and improve the facilities at the LNWR's London terminus. Once again, architectural grandeur seemed to trump practicality, as Hardwick designed a monumental Great Hall, placed in the centre of the Euston site beyond his father's great gateway. The impressive interior featured a main hall in classical style 38m (125ft) long, 18.6m (61ft) wide and 19m (62ft) high. It had an iron gallery topped by a coffered ceiling with eight allegorical bas-reliefs in the corners representing the cities served by the line. Beyond the main hall on the first floor was a board room and shareholders' meeting room to the north, accessed by a sweeping

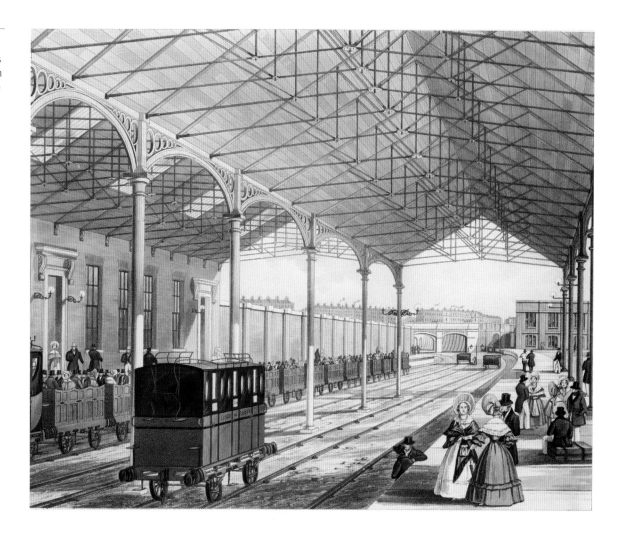

Right The iron-and-glass trainshed at Euston, designed by Charles Fox, was the first of of its kind when the station opened in 1837. The first stage of the line up the steep gradient to Camden was cable-hauled until 1844, and third-class passengers travelled in open trucks.

Camden by cable

The first section of line from the Euston terminus up to Camden had to be built on quite a severe gradient in order to bridge the canal. As early steam locomotives were not very powerful, Stephenson decided to use cable haulage on the incline. Power for the continuous cable was supplied by two stationery steam engines housed below ground under two tall chimneys on either side of the line. Alan Jackson gives us a vivid description of the carefully controlled cable haulage procedure involving 'bankriders' and railway policemen (signalmen):

> At Camden, the engines of incoming trains were detached and the passengers' tickets collected. Trains then descended the bank unaided, attached to the cable and controlled by 'bankriders' … On the outward run (from Euston), the bankriders pushed the loaded coaches to the 'Messenger', the rope which attached the train to the winding cable, and fastened it. When all was ready, and the policemen with their red, green and white flags had signalled the line clear, the men in the engine house at Camden were alerted by the 'wailing whistle', an organ pipe operated by compressed air let into the

connecting main at Euston. This air main was also used to sound a similar pipe at the terminus, giving warning of the approach of an up (London bound) train. When the whistle was heard, a bell was rung to carry the message on to the porters and cabmen, and it is said that the noise would cause the cab horses to raise their heads from their nosebags and preen themselves for action.

Cable working ended in 1844 after only seven years' operation, but even when more powerful steam locomotives were used they still needed assistance to bring trains up the steep grade out of Euston either by 'double heading' with two engines at the front or by using a 'banker' at the rear. The redundant stationary steam engines at Camden were apparently sold off and exported to a Russian flax mill.

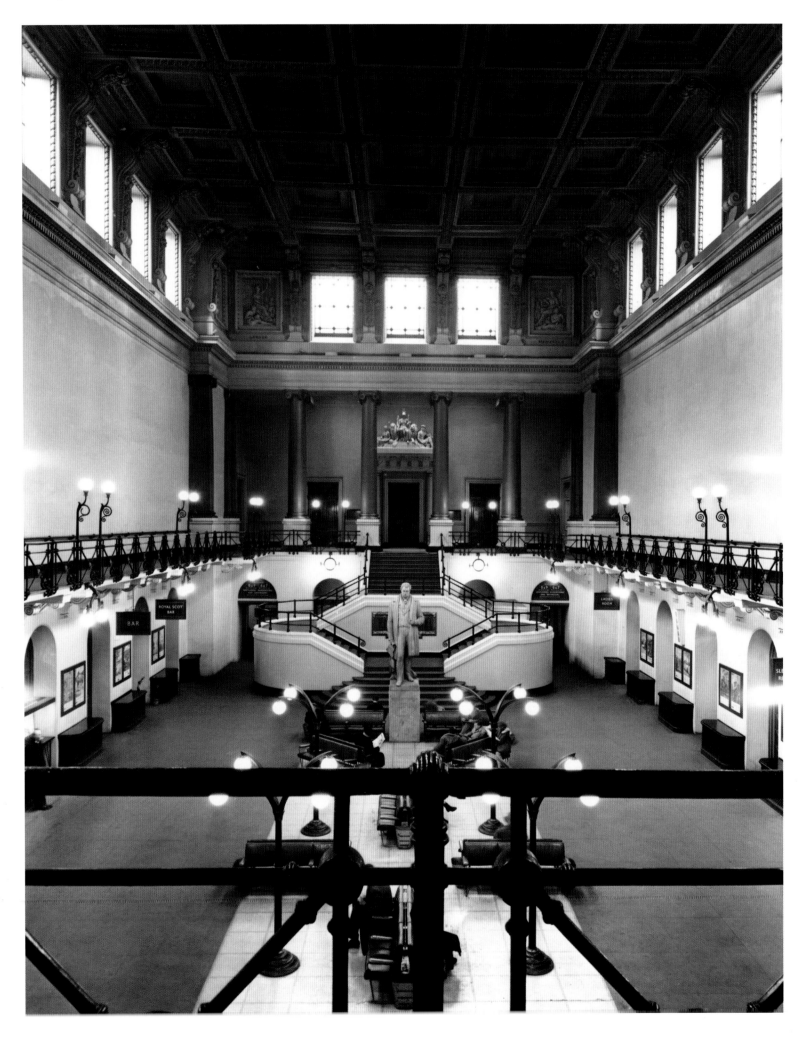

double flight of stairs. It was certainly impressive, but there were doubts about its practicality almost as soon as it opened.

In his book *Rides on Railways,* published in 1851, Victorian journalist Samuel Sidney commented:

> We cannot bestow unqualified praise upon the station arrangements at Euston. Comfort has been sacrificed to magnificence. The platform arrangements for departing and arriving trains are good, simple and comprehensive; but the waiting rooms, refreshment stand, and *other conveniences* are as ill-contrived as possible; whilst a vast hall with magnificent roof and scagliola pillars, appears to have swallowed up all the money and all the light of the establishment.

Hardwick's grandiose building complex for the LNWR effectively split the station site and made it difficult to extend the terminal's platform space around it.

The continued growth of long-distance railway traffic at Euston forced a major expansion on the station's west side from the late 1880s to create additional platforms. The work involved realigning Cardington Street across part of the overflow burial ground of St James's Church, Piccadilly, which had been established here in the eighteenth century because there was already no further space near the church in central London. A large, but apparently unrecorded, number of coffins were removed and reinterred at St Pancras Cemetery, Finchley, at the LNWR's expense. This allowed six further platforms to be created at Euston in 1891–2, bringing the total to fifteen. The remaining part of the burial ground became St James's Gardens, with a number of monuments retained but no record of the grave numbers or locations. More than a century later, when the next expansion of Euston to create a terminus for HS2 was under way in 2018, St James's Gardens would disappear completely as the entire site was to be covered by the new station. This time, construction was preceded by one of the largest archaeological excavations ever undertaken in London, carried out across the entire site.

A scheme for the complete reconstruction of Euston was first considered in the early 1900s, but the only improvements that materialized were piecemeal, including a new booking hall and the refurbishment of the Great Hall. Two separate new Tube connections for onward travel on the Underground were opened below the station in 1907, and electric trains were introduced on the suburban services to Watford in 1922. A year later at the railway Grouping in 1923, the LNWR became part of the London Midland and Scottish Railway (LMS), the biggest of the 'Big Four' railway companies. In fact, the LMS was soon proudly claiming to be 'the largest private enterprise in the British Empire' and almost inevitably got in competition with the London and North Eastern Railway (LNER) for faster express services between London and Scotland.

When the LNER introduced its streamlined *Coronation* train on the 632-km (393-mile) East Coast route in 1937, taking just

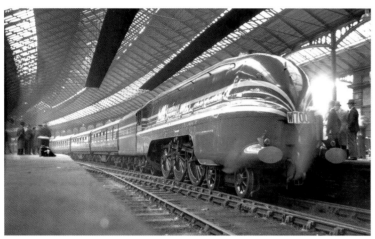

Above Architect's perspective for an Art Deco rebuild of Euston, issued by the LMS at the time of the station's centenary in 1937. The project was never even started, because of the outbreak of war in 1939.

Left The streamlined *Coronation Scot* on arrival at Euston after its first run from Glasgow, 1937. This was the LMS response to the LNER's introduction of its streamlined Coronation service on the East Coast route from King's Cross to Edinburgh.

six hours from King's Cross to Edinburgh, the LMS responded with the new *Coronation Scot* service. This also used fashionably streamlined locomotives pulling specially designed matching sets of coaches, and covered the 642km (399 miles) up the heavier inclines of the West Coast route from Euston to Glasgow in 6½ hours. The same route was used by the fast overnight Scottish postal service, memorably publicized in the classic documentary *Night Mail,* made by the GPO film unit in 1936, which features W.H. Auden's famous rhythmic poem of the same name and an innovative musical score by Benjamin Britten.

By the time it was celebrating Euston's centenary in 1938, the go-ahead LMS had announced new plans to rebuild its main London station, using a government loan guarantee. An architect's perspective was released showing a giant American-influenced building in monumental Art Deco style, which would combine station facilities, railway offices and even a heliport on the roof. Unlike London Transport, who had moved fast with new Tube extensions and stations funded in the same way in the 1930s, the LMS only managed to build a chunky new nine-storey Art Deco-ish head office building to house 1,300 of its own admin staff at Euston in 1934, but nothing to improve the travelling experience of passengers. The office block, named Euston House, still stands just east of the station on Eversholt Street, but is no longer a railway property. War broke out before any work on the grand new terminus scheme had even started. A smaller-scale version of what a 1930s-style Euston might have been like can still be experienced

at Leeds station, where the LMS in-house architect William Henry Hamlyn designed the Queens Hotel with a stylish new station entrance concourse alongside, all opened in 1938.

Patching up Euston

When British Railways (BR) took over the LMS on nationalization in 1948 there was money available to patch up quite considerable war damage to Euston and to redecorate the Great Hall, but nothing more. Although the station had character and an almost antiquarian charm, it was becoming increasingly squalid and run down. Euston House became, briefly, a new head office for BR. Eventually, in 1959, comprehensive rebuilding of Euston was on the agenda again as part of BR's full scale modernization and electrification scheme for the main lines to Birmingham, Manchester and Liverpool. The plans involved the destruction of both Euston's grand monuments, the Great Hall and the Doric Arch. The loss of the Great Hall was perhaps inevitable as it stood in the way of a rational platform layout and could not have been moved.

Construction work on the new station, designed by a team led by BR London Midland Region architect Ray Moorcroft, began in 1962. This was a unique opportunity, which has never been repeated, to create a brand new terminal station in London from scratch on a completely cleared site. The only restriction was the development of the new Victoria line by London Transport, which went on deep below the main-line station at the same time, and involved the partial reconstruction of the existing Northern line

Lost Euston

The reconstruction plan for Euston became one of the first major architectural conservation battles in the UK, and its first casualty. The Earl of Euston, the Earl of Rosse, John Betjeman and the Victorian Society all protested about the redevelopment and there was a formal demonstration against the demolition inside the Great Hall by architects and students. The protest was taken all the way to the Prime Minister, Harold Macmillan, who received a deputation led by the president of the Royal Academy, Sir Charles Wheeler. But Macmillan would not intervene, and the complete demolition of everything at old Euston was carried out with almost indecent haste in 1961–2. Architectural historian Gavin Stamp has described this as 'one of the greatest acts of post-war architectural vandalism in Britain'.

Just three decorative features of old Euston were saved. The large statue of George Stephenson, 'father of the railways', which stood in the Great Hall, the *Britannia* sculpture by John Thomas above the doorway of the shareholders' meeting room and the ornate bronze gates to the Doric portico, were carefully salvaged and are now housed in the National Railway Museum in York. The *Britannia* sculpture was found a temporary new home inside the new station buffet. The few physical remnants of the old station still on site are outside its original footprint: two Portland stone lodges dating from 1870 on either side of the original Euston Road entrance, today used only by buses entering and leaving the cramped 1970s bus station. Both lodges are now listed buildings and have been cleverly adapted to become tiny but very popular craft brewery pubs, one mainly for beer and the other for cider, both part of the Euston Tap.

The exterior walls of the lodges are still incised with the names of destinations served by the London and North Western Railway (LNWR) from Victorian Euston. Between them was a statue of Robert Stephenson by Baron Carlo Marochetti, presented to the railway by the Institution of Civil Engineers in 1870. This was moved to preside over the new station plaza a century later but is currently boarded up while another rebuild takes place. Behind the site where Stephenson originally stood is a memorial to the LNWR staff killed in the First World War. Designed by Reginald Wynn Owen, this takes the form of a stone obelisk on a granite base guarded by four bronze military figures. It was unveiled in 1921 but today is marooned on a traffic island encircled every few minutes by buses.

Below left Statue of Robert Stephenson, temporarily removed from Euston during rebuilding works.

Below right The Euston war memorial, now isolated on a traffic island outside the bus station.

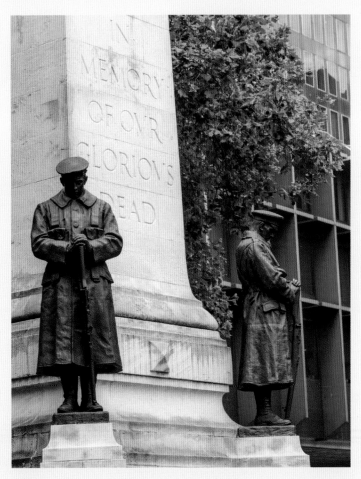

Left The Information Centre and booking hall opened in 1968, now with new ticket machines but retaining the curious eggbox ceiling feature.

Right above The eggbox ceiling must originally have provided forced air conditioning directly over the ticket and information desks, but is now a non-functional period artwork which should be preserved even if the building is demolished.

Right below The 1968 Great Hall of Euston 2, which will be rebuilt or remodelled to create Euston 3.

platforms. Remarkably, both projects were carried out on schedule for formal royal openings by the Queen in 1968 (Euston main-line station) and 1969 (the complete Victoria line).

The underlying idea was to follow the logic of airport planning in the 1960s by arranging the entire layout of the station around a series of separate 'flows' for passengers, taxis, Royal Mail vans, catering supplies and so on. This was intended to achieve maximum efficiency and allow trains to be quickly serviced, turned round and dispatched. It would also, in theory, mean that passengers would not have to negotiate platforms cluttered with trolleys and goods being loaded on to trains. Instead they would pass through a succession of circulation spaces from the main concourse to their train, descending ramps to the platforms, which were at a lower level. Above the platforms there would be a large self-contained Royal Mail parcels depot with separate vehicle access, while public facilities would be housed below ground.

Keeping the passengers in mind

British Rail worked hard to promote the benefits of its new London terminus. The new Euston was certainly far more functional than the motley collection of buildings BR had enthusiastically swept away to make it possible. In the words of the *Passengers' Guide* published for the opening in 1968:

> Simplicity is the keynote in the design of the new Euston. The aim has been to confine all vehicles, mail

and parcels to certain areas in order to give passengers unrestricted movement in the station precincts … all vehicular movement takes place below ground while passengers have sole use of the ground level area.

This sounded promising in theory, but the experience of using the new Euston was to be sadly disappointing in almost every way. However radical the concept, Euston's architecture and design turned out to be dull and uninspiring. Euston 2's main feature is the passenger hall, quickly named the Great Hall after its predecessor, but not resembling the lost structure in any way. Bizarrely, Euston 2 was designed to be approached underground, by Tube, taxi or the car park, which gave no sense of impending excitement to a journey and required the use of unreliable lifts and escalators. The taxi rank below ground was an unpleasant area full of exhaust fumes. No connection was provided with Euston Square Underground station on the Metropolitan and Circle lines, which is still a short walk away.

Approaching Euston on foot at ground level the prospective passenger found no clear entrance route to the station. Walking across from the Euston Road meant having to negotiate a busy bus station and a bleak little plaza that was home to a few cafés. This was overshadowed until recently by a bland office development thrown up in front of the station in the 1970s by architect/developer Richard Seifert when British Rail was refused permission to build over the station itself.

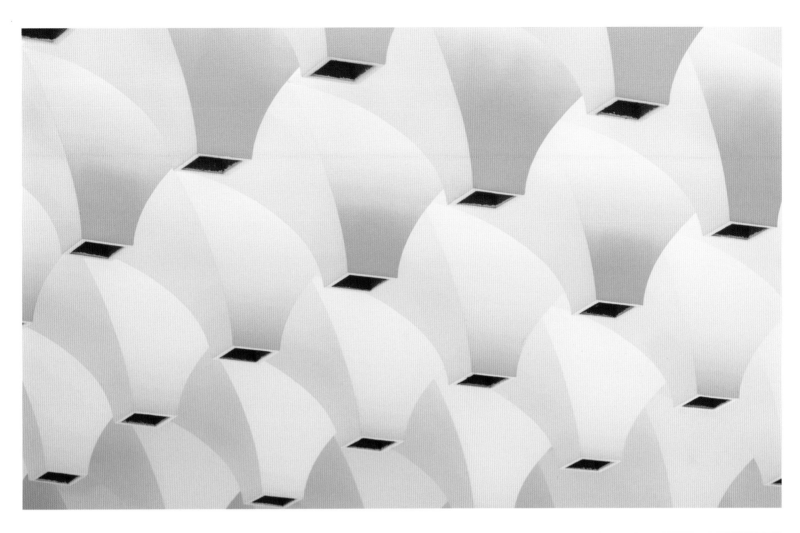

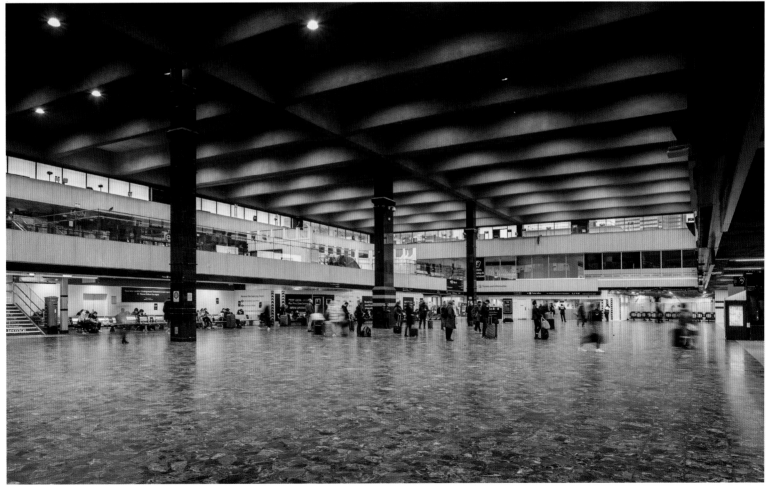

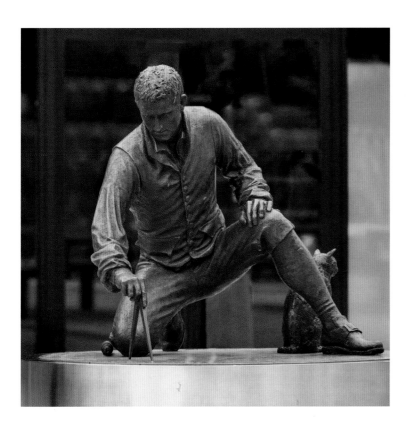

Opposite Euston House, the LMS head office designed in the 1930s, towering over the featureless modern station built by BR in the 1960s.

Overleaf One of the 1970s office towers outside Euston just before demolition in 2020 for the construction of the new HS2 terminus.

Left A statue of Captain Matthew Flinders, the first circumnavigator of Australia. Flinders was buried in St James's churchyard to the west of Euston in 1814, where his grave was rediscovered in 2018 during archaeological investigations prior to the construction of the HS2 station.

Euston 2's Great Hall, almost invisible from the Euston Road after the 1970s accretions and bus station were added, is a long, low structure with no street presence. The building is basically a box 61m (200ft) by 46m (150ft), in a dull and featureless International Modern style. Travel writer and television presenter Michael Palin once memorably likened it to 'a great bath, full of smooth, slippery surfaces where people can be sloshed about efficiently'.

Euston certainly does resemble an airport, but without the seating that passengers might expect. There were regular complaints about this in the 1960s, but the seating has never appeared. Instead, the enormous shiny green marble floor of the hall has been kept clear to give standing travellers a good view of the departure boards, but no room to relax. The ambience is unwelcoming, the acres of space wasted. Shops, cafés and other passenger facilities are housed round the edge of the hall, or inconveniently placed on the first-floor balcony. They are all quite cramped, with narrow-stepped access, and are difficult to negotiate with luggage.

Only the travel centre to one side still works well as a usable space, dominated by the sole decorative flourish in the entire building. This has a prominent ceiling feature, a '1960s modern' design resembling a clutch of egg boxes. Its function is unclear. Could it provide sound insulation for your travel enquiry, is it special air conditioning or just an abstract 1960s art installation? Below the egg boxes, where in 1968 there were glazed and staffed booking counters, there is now a curved row of ticket machines for customers who have not booked online or need to collect their pre-booked tickets. With the move towards completely digital, paperless ticketing booked by smartphone, perhaps even the latest ticket machines have a limited life expectancy.

The remodelling of Euston in the 1960s was long overdue, but it was done at the worst possible time. There was little interest then in retaining and refurbishing Victorian public buildings, and the construction and design quality of the new environment that replaced them was often poor. Brutally comprehensive redevelopment was favoured over any attempt to combine and integrate old and new. It was even too early for proper disabled access to be considered. If only the Euston project had been planned thirty years later, the outcome would no doubt have been very different.

Preparing for Euston 3

There is hope for Euston yet. Euston 2 is itself now well over fifty years old and after lengthy argument and debate another major reconstruction has recently got under way. Euston 3 will become the London terminus for HS2, the controversial new high-speed railway from London to the Midlands and the North, phase one of which was finally approved by the Government in 2017.

The HS2 terminus at Euston will mainly occupy land alongside and to the west of the current station, taking over the whole of St James's Gardens to the Hampstead Road border. This will allow the initial development to take place without really affecting Euston 2. Rebuilding or at least remodelling the Great Hall and forecourt areas

Right One of the entrances to Euston 2, more like arriving at a 1960s office than embarking on a great rail journey north.

Opposite Two Pendolino high-speed electric tilting trains at the grim concrete platforms built for Euston 2 in the 1960s.

will follow on from this and when HS2 opens, its temporary London terminus will be at Old Oak Common in west London where there will be interchange with Crossrail (the Elizabeth line). Demolition of two of the 1970s Seifert office blocks on the western frontage of the station and other properties on Melton Street, including a pub and a hotel, took place in 2020–21. Further north off Cardington Street, the brutalist bulk of the four-storey Euston Signals and Telecommunications Centre (STC), built to house the control systems and signalmen of the newly electrified main line in the mid-1960s, will also be demolished. This is on the site of a turntable at the north-western end of the station that was used by passenger locomotives in the steam age. With a cab at either end, the electric locos that replaced them did not need to be turned before making a return journey. The STC is now redundant after the installation of new and more compact signalling and control equipment on the main line. The decommissioned 'Euston box' now stands in the path of the HS2 station approach and will soon disappear.

An unlikely survivor on Melton Street at the time of writing is the distinctive ox-blood tiled former Hampstead Tube station, which opened in 1907 and has been closed to passengers since Euston's last reconstruction. The former lift shaft inside now houses ventilation equipment for the rebuilt Tube while the abandoned deep corridors below still have a frozen display of West End film posters dating from the station's final period of use in 1960: *Psycho*, *West Side Story* and *Spartacus* are all still advertized. There is even a poster for the Midland Pullman, BR's

first luxury diesel train, which offered a fast first-class express service to Manchester from St Pancras while the line from Euston was being disrupted by electrification.

Until recently it was possible to visit these eerie underground spaces on special tours organized by London Transport Museum, but as HS2 preparations continue and demolition of the surface buildings approaches, access has been restricted. It is still possible to book a virtual tour of Underground Euston online via the museum's Hidden London website.

Before any further construction work could begin at Euston, one of the largest archaeological investigations in the country was carried out by HS2 at St James's Gardens in 2018. The former burial ground was thought to contain the remains of up to 60,000 Londoners buried here during its use as a cemetery in 1790–1853. An unknown number of burials were reinterred before the first station expansion in the late nineteenth century, but there was no accurate information about the remaining part of the gardens required for HS2's station site.

The railway has now disturbed the dead yet again but the disruption has been preceded this time by far more carefully considered and recorded investigative research. This has revealed a large number of 'lost' burials moved during the Victorian excavation of the burial ground, including Captain Matthew Flinders, the first European circumnavigator of Australia. He was buried here in 1814, but his grave and remains were rediscovered by archaeologists in 2018, when he was identified by the inscribed

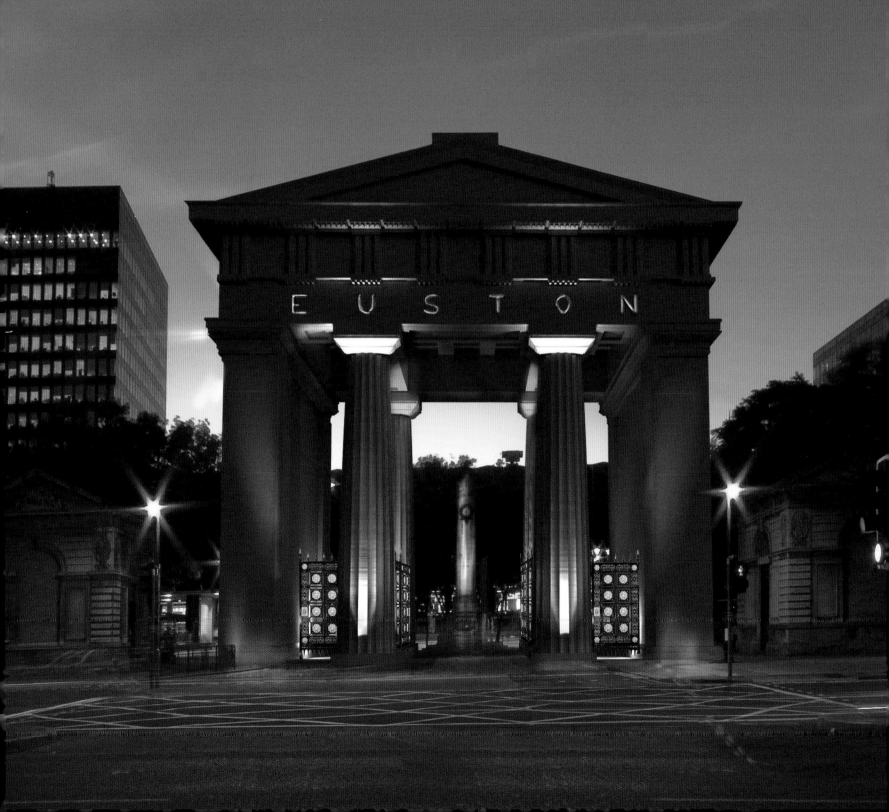

silver breastplate that was found on his coffin. He will be reinterred in the churchyard of Donnington, the Lincolnshire village where he was born in 1774. A statue of Flinders by sculptor Mark Richards was put up on the plaza outside the station entrance at Euston in 2014 before his remains had been discovered nearby.

There will no doubt be further variations and refinements in the new redevelopment at Euston, just as there have been in the plans for HS2's approach to central London from Old Oak Common. As designs for a new station façade and improvement of the Euston Road frontage are developed the idea of resurrecting the Euston Arch may even be reconsidered. Some 60 per cent of the original stonework was rediscovered in the 1990s in a channel of the River Lea in east London, where it had been used to plug a hole in the riverbed after the arch was taken down in 1962. British Waterways salvaged the blocks from the river in 2009 and the Euston Arch Trust was established to campaign for its re-erection.

In the words of Michael Palin, patron of the new trust, 'the restoration of Euston Arch would restore to London's oldest main-line terminus some of the character and dignity of its great neighbours'. It would also give Euston 3 a distinctive sense of place; qualities completely lacking in the station and surrounding buildings thrown up in the 1960s and 1970s. A recreation of Hardwick's arch in front of an imaginatively redesigned Great Hall with subsurface links to St Pancras International and Euston Square Underground station could be just what Euston needs to complete a more thoughtful long-term development, but it has a way to go.

Left A computer-aided impression of the Doric Arch rebuilt between the lodges on the Euston Road, with the war memorial beyond.

Above Architect's impression of the entrance of the new HS2 station now under construction on the west side of Euston 2.

Overleaf Concept image of the new Euston, which will be remodelled with eleven new high-speed platforms, scheduled to open in the late 2020s.

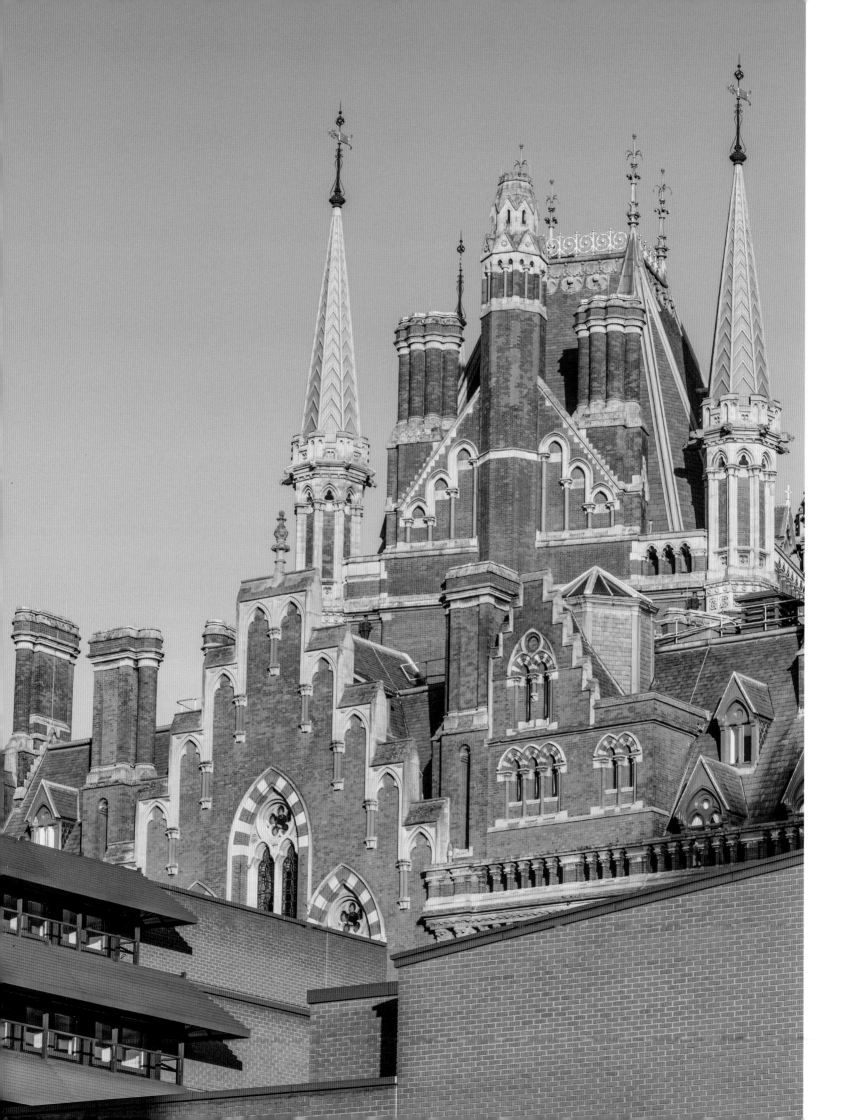

St Pancras

'Railway termini and hotels are to the nineteenth century what monasteries and cathedrals were to the thirteenth century. They are truly the only representative buildings we possess.' When this suggestion appeared in the journal *Building News* in 1875, the writer would have been thinking of St Pancras in particular, where the railway terminus had recently opened and the grand station hotel in front of it was almost complete. St Pancras was already seen as a symbol of the age when it was brand new. It was then, and remains to this day, the most spectacular of the great London railway stations.

Both the trainshed and the hotel at St Pancras, which were designed separately by an engineer and an architect, were built on the largest possible scale. They were unquestionably grandiose statements of a railway company's ambition, but also a very practical and harmonious combination of elements. This could never be said of Euston. Nevertheless, over time the hotel in particular became widely viewed as a high Victorian folly that no longer served a useful purpose, yet it could not be severed from the station. After decades of blight and uncertainty, both halves of this magnificent edifice have at last been renovated and successfully adapted to new use in the twenty-first century. St Pancras will not suffer the same ignominious fate as Euston.

The heights of St Pancras

St Pancras station was a late arrival in London, created because the Midland Railway (MR) wanted its own passenger terminus in

the capital. In 1858, the company started running goods and coal trains from the industrial east Midlands to London over the Great Northern main line. As traffic grew, the company soon decided to build its own separate goods depot just north of King's Cross, and by 1863 had plans to reach this with its own new London Extension line. The ambition grew from being primarily about freight access into a full-scale passenger main line, which of course required a suitably grand London terminus as well as a goods depot.

The Midland Railway's London Extension line, built in the 1860s, was designed by the MR's consulting engineer, William Henry Barlow, who also planned the layout and infrastructure of the large station and goods depot complex just north of the Euston Road. This was as close to central London as Parliament would permit the Midland to build. It still required massive property demolition on the route through Camden and in the working-class areas known as Agar Town and Somers Town, which had grown up since the arrival of the first trunk line to nearby Euston thirty years earlier.

Having bridged the canal, Barlow's Midland main line approached the Euston Road at high level, rather than descending to just below street level on a steep gradient like Camden bank on the approach to Euston. The Midland also chose a different approach to the Great Northern, which runs into King's Cross through tunnels *under* the Regent's Canal. Barlow deliberately went for a simpler elevated route and designed St Pancras with

Clearing the living and the dead

Seven streets of housing and a brand new church were obliterated to make way for the new station alone and a similar sized area of land was required for the main goods depot alongside. The railway company had to rebuild the church in Kentish Town, but there was no offer of compensation or rehousing for the thousands evicted from their homes.

There was a greater public outcry at the careless way railway navvies began to cut through part of the old St Pancras churchyard, which lay in the path of the railway. In preparatory works to the site, human skeletons were scattered and mixed up as rotting coffins were clumsily excavated and fell apart. The Vicar of St Pancras found skulls and thigh bones thrown about and complained to the Bishop of London, who asked the Home Secretary to get the work stopped. Anxious to avoid a scandal, the railway company engaged the architect Arthur Blomfield to oversee the exhumations and ensure that respectful reburial was carried out. Blomfield would drop in unexpectedly at the site to ensure that the clerk of works was not cutting corners, and gave one of his pupils the task of checking the coffins on a daily basis as they were removed. When work finished in 1867, the remains of an estimated 8,000 deceased Londoners had been relocated, either elsewhere in the churchyard or to the growing suburban cemeteries such as Highgate and Kensal Green.

Blomfield's young pupil, who was given the gruesome job of monitoring the removals, was the twenty-six-year-old Thomas Hardy. Many years later after he had abandoned an architectural career and become a writer, Hardy recalled his experience at St Pancras in a poem of 1882 called *The Levelled Churchyard*:

We late-lamented, resting here,
Are mixed to human jam,
And each to each exclaims in fear,
'I know not which I am!'
When we are huddled none can trace,
And if our names remain,
They pave some path or porch or place
Where we have never lain!

The gravestones that were removed from the path of the railway were repositioned round a tree in the graveyard, now known as the Hardy Tree. These exhumations at St Pancras in the 1860s would not be the last. Further incursions to the churchyard were necessary more than one hundred years later when the new high-speed line of London and Continental Railways was shoehorned in to bring Eurostar services into St Pancras International in 2007. These works were preceded by a careful archaeological investigation to record and study the burials and skeletons, and the gravestones now form another group closer to the tall, rebuilt churchyard wall. They are just a few metres from the railway over the wall, but this location remains a tranquil and peaceful oasis in a rapidly changing urban environment.

Left The engine bay outside St Pancras c1910. The gasholder frames to the left and the ornate Midland Railway water tower behind the engine were both moved and reconstructed close to the canal in the early 2000s (see page 92).

Right The Hardy Tree, with gravestones displaced when the railway navvies first cut through the churchyard in the 1860s. More graves were moved when HS1 arrived. The Victorian gasholder frames seen beyond the wall were moved at the same time.

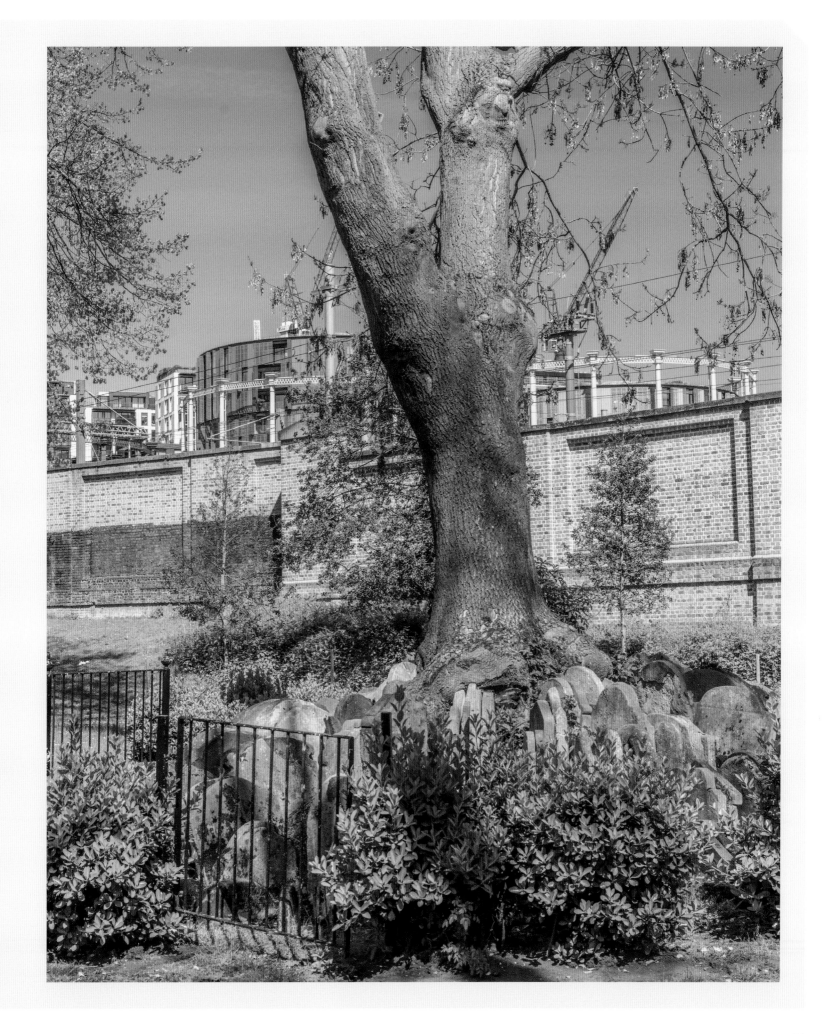

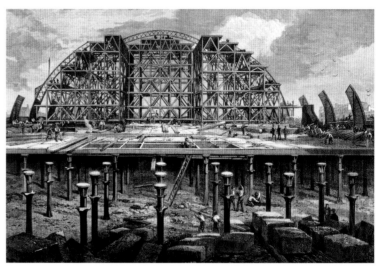

the passenger terminus platforms at first floor level above a large ground floor basement. He also planned a separate goods yard just across Midland Road to the west, on a site almost as large as the area taken up by the station and hotel together. This was reached by trains leaving the main line at a junction just outside St Pancras and crossing Midland Road on a bridge, another benefit of the high-level approach. The Somers Town goods yard was closed in the 1960s and the site was eventually used for the new British Library, opened by the Queen in 1998. There was still room on the goods yard site for another major new building, the Francis Crick Institute for biomedical research, which opened in 2016 opposite the new west side entrance to St Pancras International.

For his passenger station at St Pancras, Barlow designed an enormous cast-iron trainshed, 213m (700ft) long and reaching 30.5m (100ft) above the first floor level of the tracks. This great roof structure was tied into the brick piers of the side walls but also had cross-ties running under the station floor in the form of horizontal cast-iron girders. It was the tallest and widest single span structure in the world, giving a huge uninterrupted flexible space for the track and platform layout inside the station. The station opened with five platforms, which was later increased to seven by infilling some of the carriage sidings. The trainshed was erected using a giant wooden centring frame that ran on rails across the platform deck. Barlow acknowledged the close co-operation of another leading Victorian engineer, Rowland Mason

Ordish, who was responsible for the Albert Bridge in London, in the detailed design of the great roof.

In the ground-floor vaults below the platforms, cast-iron pillars and girders supported the station floor deck above and were divided into a grid based on the dimensions of the brewery warehouses in Burton-upon-Trent. As Barlow later put it himself, 'the length of a beer barrel became the unit of measure upon which all the arrangements of this floor were based'.

The MR intended to run three special beer trains a day direct from the Midlands to London. These trains were not destined for the goods depot at St Pancras, but were split into individual wagon loads, which could be lowered by hydraulic lift to the vaults below the passenger station, and moved around with ropes using capstans and turnplates. The beer barrels could then be loaded directly on to horse-drawn drays for delivery to pubs all over London. All of this could be carried out without passengers and goods ever crossing each other's paths or competing for room on the station platforms. This was a particular problem at Paddington, where milk trains from the West Country were unloaded and milk churns cluttered the passenger platforms both on delivery and the return of empties. This continued until a separate platform was provided outside the station in the 1920s and rail milk tankers delivering to a separate rail connected depot were introduced in the 1930s.

By contrast, Barlow's station plan at St Pancras was a brilliant use of space and rationally planned logistics. The structure is also a superb piece of engineering. The station was opened for both

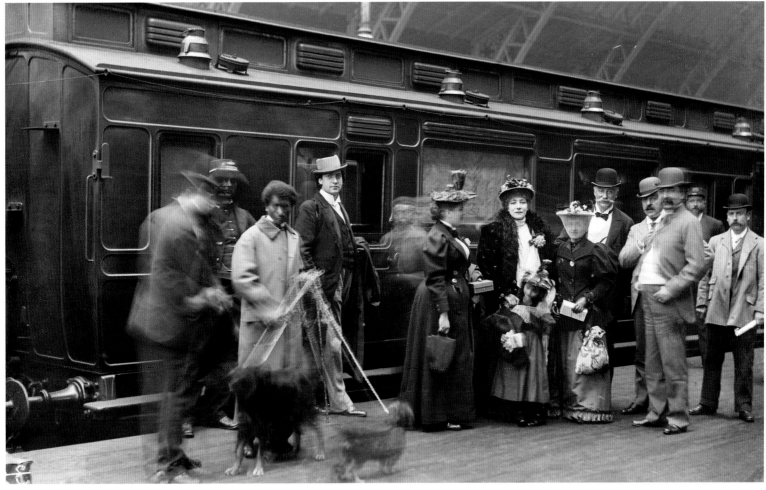

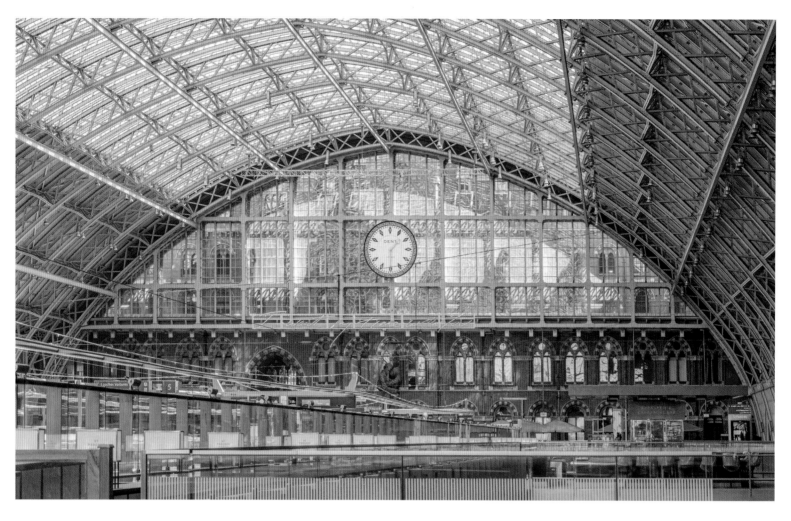

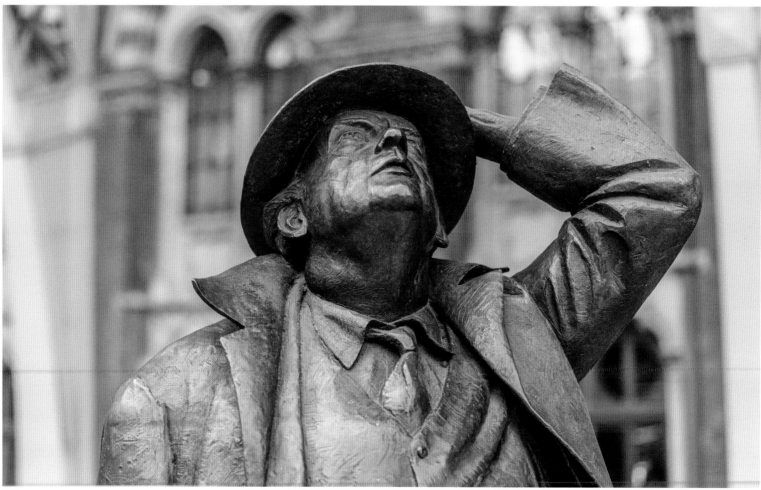

passenger and beer traffic in 1868, when the hotel, which was to form the frontage and main entrance on Euston Road, had only just been started. Underneath St Pancras station a curved tunnel took two tracks down to join the Metropolitan Railway below the Euston Road. These 'Widened Lines', as they were known, ran in a tunnel alongside the Met tracks to Moorgate and a junction with the cross-river line of the London, Chatham and Dover Railway, which bridged the Thames at Blackfriars. This gave the Midland a useful suburban extension right into the City as well as access to a cross-London route for goods trains, which was eventually upgraded more than a century later for Thameslink passenger services.

Barlow's generous station layout meant there was never any need to expand St Pancras beyond his trainshed. In 1902, there were 150 trains in and out daily, which could easily be accommodated. The *Railway Magazine* commented:

> At no time of day can St Pancras be called a busy station in the sense in which the word is understood at Waterloo or Liverpool Street. The long distance expresses leave at stated – and stately – intervals, the only approach to bustle being at midnight, when three important trains leave within five minutes of each other.

In 1923, the Midland was merged with the LNWR to become part of the London, Midland and Scottish Railway (LMS), which concentrated on Euston as its principal terminus for main-line

services to the north. The LMS did little to bring either station into the twentieth century but it did close the Midland Grand in 1935 and turn the hotel into rather unsuitable railway office accommodation. This was the start of a long, slow decline for St Pancras, with periodic attempts to close the station completely. Writing as long ago as 1949, just after nationalization, John Betjeman saw little hope for it: 'I have no doubt that British Railways will do away with St Pancras altogether. It is too beautiful and romantic to survive. It is not of this age.'

Even after the furore surrounding its destruction of Euston, BR continued to consider proposals to demolish the Midland Grand and convert the trainshed to some other use. In 1967, St Pancras was added to the national list of protected historic buildings at Grade 1, the highest category, but still no solution was found that might preserve it in a realistic and sustainable manner.

The solution

Eventually, an exciting and appropriate long-term use for St Pancras was found as the London terminus for High Speed One (HS1), a new railway between the capital and the Channel Tunnel. When the rail tunnel to the Continent first opened in 1994, the cross-Channel Eurostar services ran on existing main lines through Kent to new terminal platforms at Waterloo. The Eurostar trains could only run at top speed over the dedicated high-speed lines on the French side of the Channel Tunnel. Work on the first section of HS1 in England began in 1998 with the construction of

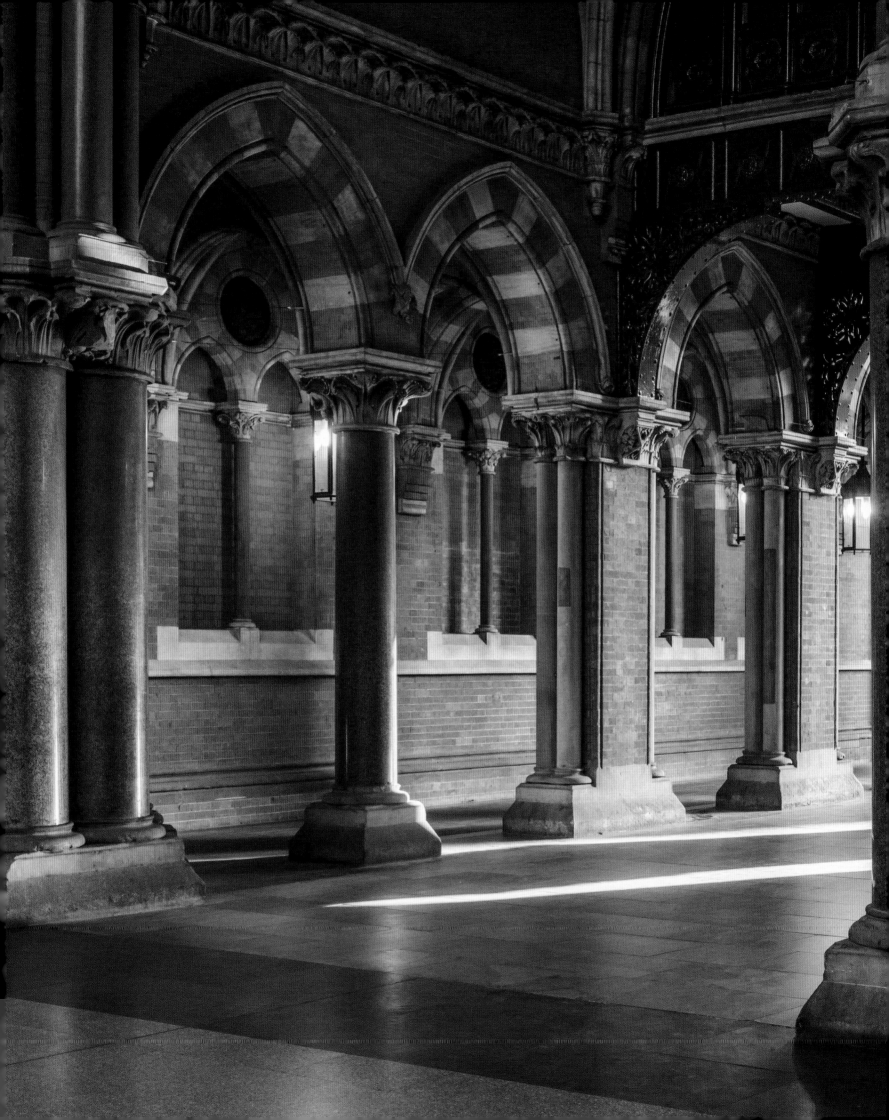

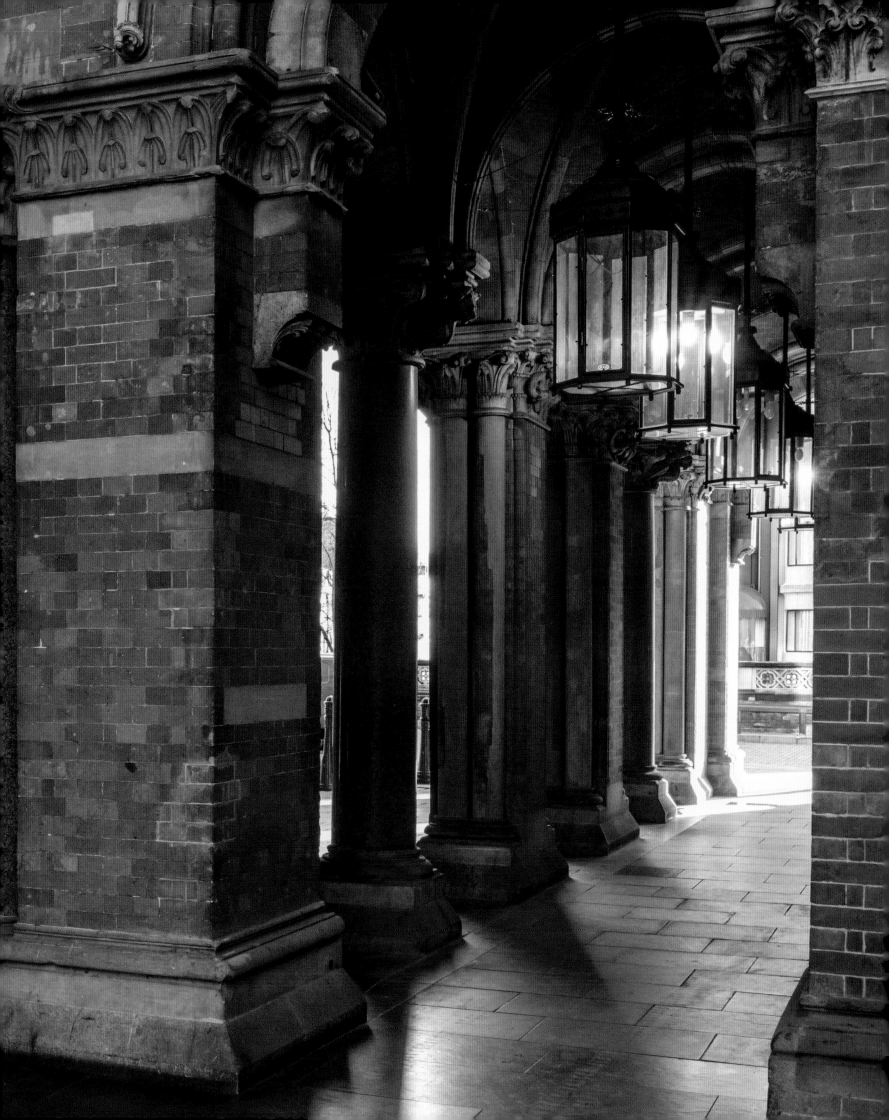

London's grandest hotel

The Midland chose the architect for their Grand Hotel in 1865 by holding a competition, inviting proposals from eleven leading architects. The winning entry was by George Gilbert Scott, already the most celebrated Gothic Revival architect of the day. His imposing design in polychromatic brick, with a soaring spire and tower, was quite different from the first generation of railway hotels that preceded it. Above all, its appeal to the Midland directors was no doubt that Scott's building would completely overshadow both the hotel and station of the Great Northern Railway next door at King's Cross. After years of being obliged to pay high access rates to the GNR for running its trains through to London, the MR could use its own main line and physically dominate its neighbour and rival at the terminus. They also wanted a station and hotel that could attract traffic from both King's Cross and their other rival, the LNWR at Euston. As architectural historian Simon Bradley puts it succinctly: 'lavishness was the essence of a design that aimed to put the Midland's rivals in the shade'.

It has sometimes been suggested that Scott's design for the Midland Grand was simply a rehash of his rejected Gothic design of 1856 for the Foreign Office, but they have only a loose stylistic similarity. Although Scott worked independently of Barlow, the engineer's site plan had already been accepted when Scott started work and he had to follow key elements of Barlow's layout, such as the entrance and exit routes and high platform level with ramp-access from the Euston Road. Scott's gothic style for the hotel is clearly influenced by the great medieval cloth halls of Flanders, such as Ypres, but it is a very modern medievalism that incorporates obvious cast-iron beams and girders rather than being a mock re-creation of the past.

The Midland Grand is undeniably extravagant inside and out, although economies were imposed almost as soon as the main building programme began during the national economic downturn of the late 1860s, when there were several bankruptcies in what had been a booming market. Scott took out a whole floor from his original design for the hotel and work was carried out in stages. Construction started in 1868, but after five years only part of the hotel was opened to guests. The west wing was not completed until 1876.

High-quality materials were used throughout and costs were high. The Midland Grand was nine times more expensive than the Great Western Hotel at Paddington and more than fourteen times the cost of the modest Great Northern Hotel at King's Cross next door, both completed in the 1850s. Scott had no regrets, even recording in 1870 that 'it is often spoken of to me as the finest building in London; my own belief is that it is almost too good for its purpose, but having been disappointed, through Lord Palmerston, of my ardent hope of carrying out my style in the Government offices … I was glad to be able to erect one building in that style in London'.

As economic historian Jack Simmons remarks perceptively in *The Victorian Railway*, 'It was Gothic through and through, and richly loaded with gothic ornament. Too richly perhaps, yet the decoration was good, and it was skilfully fused into the whole design. The materials were excellent throughout, the strong red brick calculated to make everything at King's Cross look anaemic.'

The Midland Grand certainly had all the state-of-the-art features of the time, including gasolier lighting, electric bells for room service and hydraulic lifts, although by the early twentieth century it was felt to lack such essential modern comforts as central heating and an adequate number of bathrooms. By the early 1900s it had been overtaken by the next generation of grand hotels in London such as the Savoy, the Cecil and the Ritz.

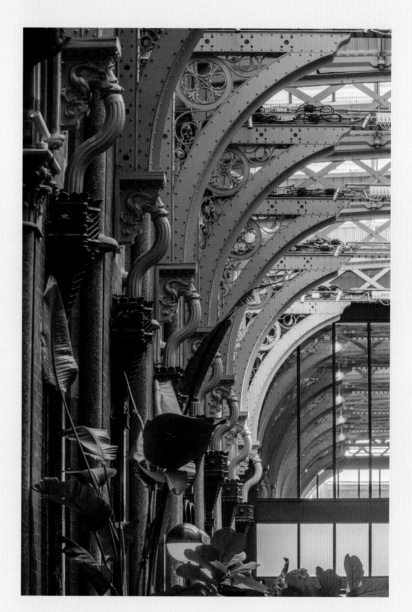

Above The original cab entrance, now fully enclosed as the Renaissance Hotel foyer and reception. Note the ornate drainpipes.

Right Scott's Gothic Revival grand staircase, fully restored in the Renaissance Hotel with replicated decoration. It is a very modern medievalism, with iron beams and electricity.

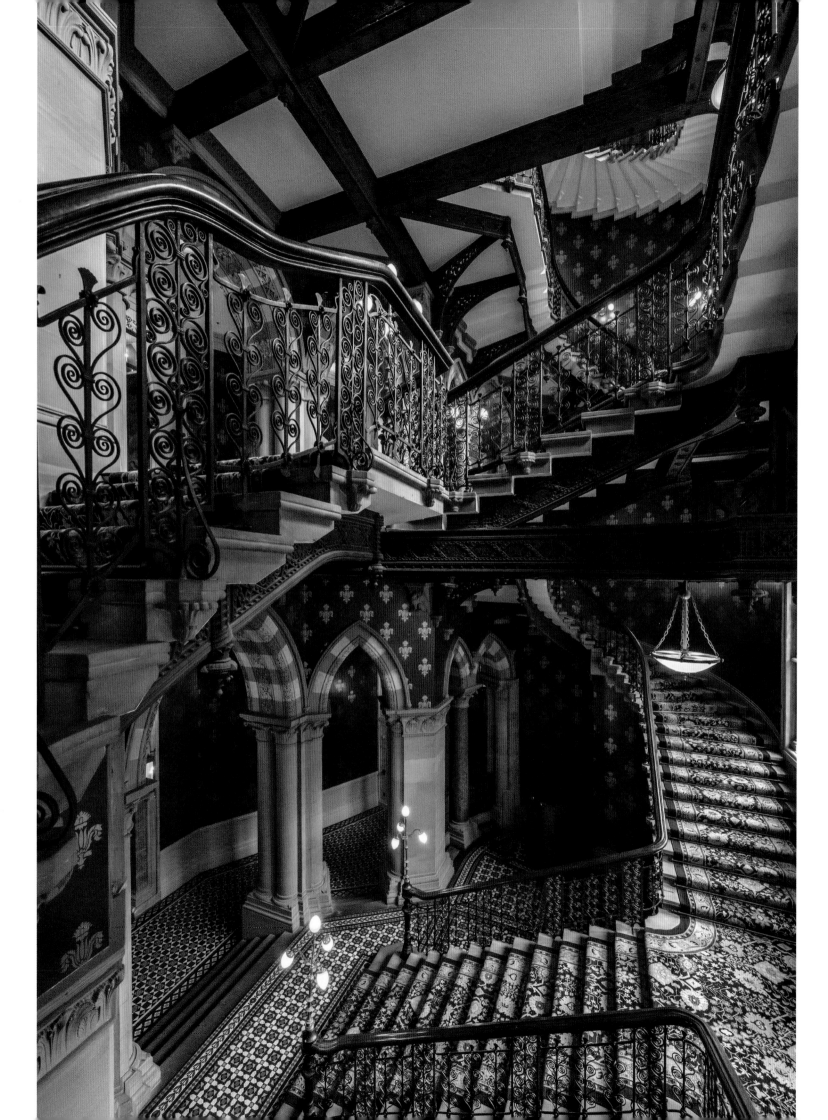

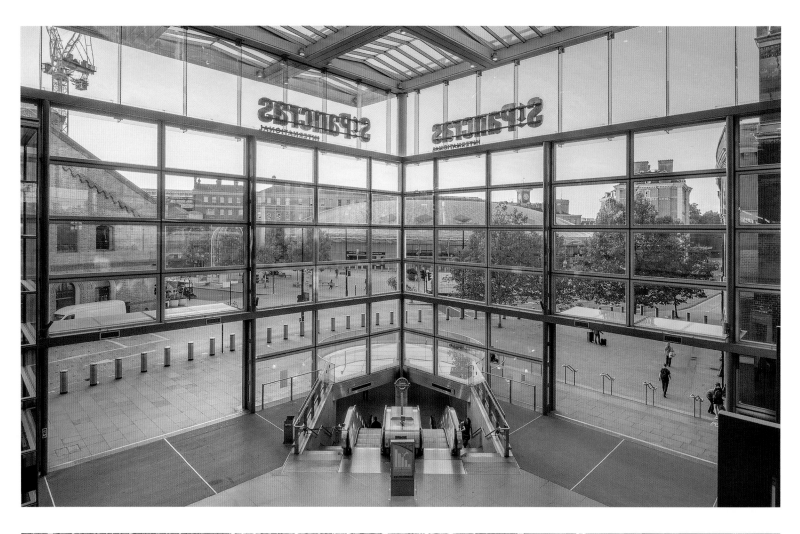

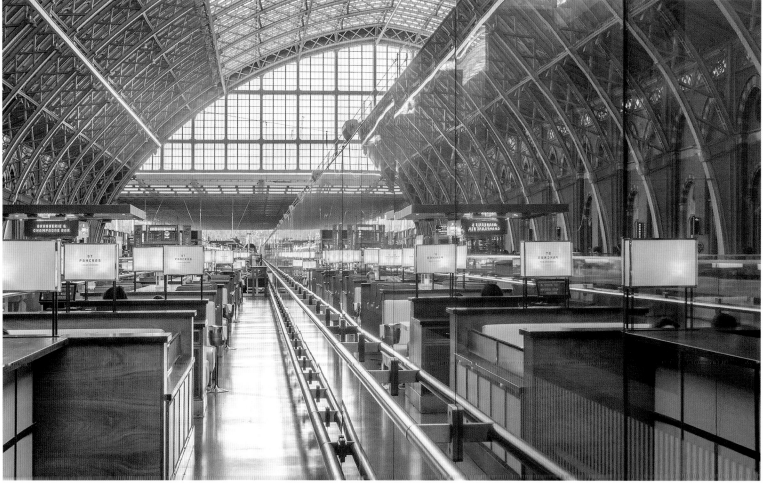

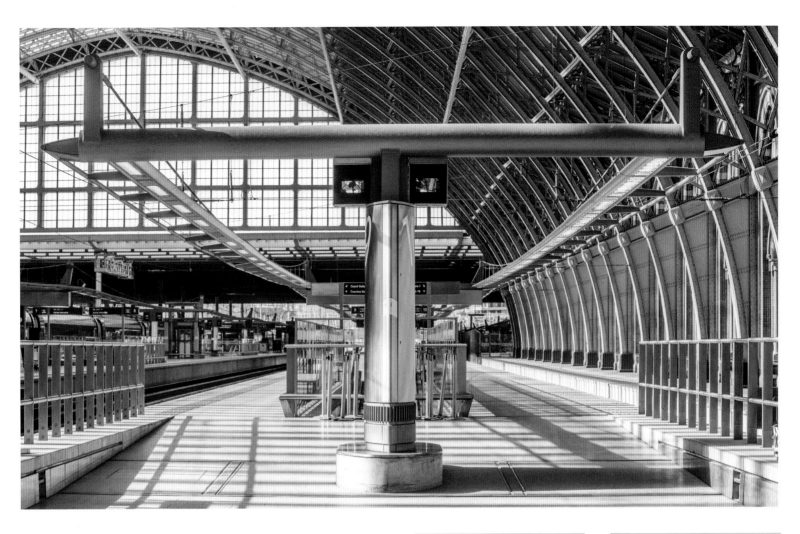

separate high-speed tracks from the tunnel entrance at Folkestone through Kent, mostly alongside the existing main line. Towards the London end, HS1 diverges to run through new tunnels under the Thames into Essex and below east and north London via Stratford, emerging just north of King's Cross to curve into St Pancras. After lengthy planning delays to its agreed route under London, physical work on this final section began in 2001 and was completed six years later. St Pancras was officially re-opened as St Pancras International and the HS1 service was launched on 6 November 2007 by the Queen and the Duke of Edinburgh. Who could have predicted this phoenix-like renewal?

The project was set up as an £800 million public/private partnership; the favoured methodology for big public infrastructure schemes in the 1990s. London and Continental Railways (LCR), established at the time of British Rail privatization in 1996, was selected by the Government to reconstruct St Pancras, complete the Channel Tunnel Rail Link and take over the British share of the Anglo-French Eurostar operation. The design and project management of the station modernization was undertaken on behalf of LCR by a consortium of engineering and systems building companies. Chief architect for LCR was Alastair Lansley, who had been project architect on the very successful redevelopment of Liverpool Street in the 1980s. The challenge at St Pancras was to integrate and conserve one of the masterpieces of Victorian engineering and architecture with the operational requirements of a new, high-speed twenty-first-century railway.

Left above King's Cross station from the eastern entrance to St Pancras International. The restored German Gymnasium is on the left and the Great Northern Hotel on the right.

Left below The longest champagne bar in London.

Above Modern fittings blend well with the Victorian structure.

Below A florist's stall where beer barrels were once stored.

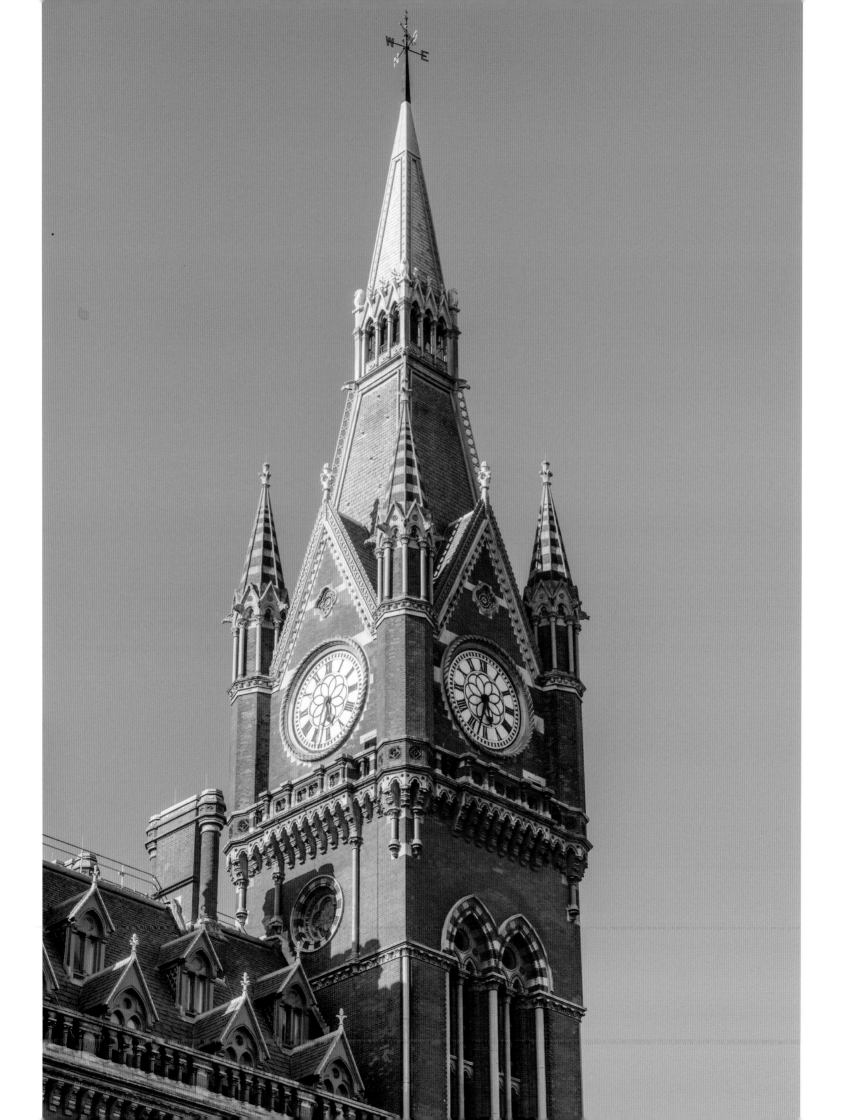

Opposite The restored spire at the eastern end of St Pancras.

Left The tower of the British Library on the western side of St Pancras, completed in 1997 on the site of the former Midland goods depot. It stands in complete stylistic contrast to the Midland Grand, but somehow the restrained Scandinavian modernism is the perfect architectural counterpoint to its showy neighbour on the Euston Road.

Overleaf John O'Connor's atmospheric evening view of St Pancras from Pentonville Road, painted in 1884, has become a defining image of Victorian London. It also exaggerates the size and dominance of Scott's hotel relative to its neighbours, with little King's Cross shrinking into the mist next door.

To accommodate Eurostar trains as well as domestic services, it was necessary to double the length of the platform area at St Pancras. Foster + Partners designed a low but almost transparent steel-and-glass box structure that extends from the end of Barlow's restored roof but does not detract from the dramatic interior view of the historic trainshed. The extension covers as large an area as the original station, but this is only obvious in aerial photographs.

The station undercroft, at street level below the platforms, was never seen by passengers and originally used exclusively for the Burton beer trade. This was converted into a spacious passenger concourse and lounge for Eurostar travellers, linked to the platforms above by lift and travelator. On the west side it has been opened up by slicing through the elevated train table to create a top-lit shopping and travel walkway that feels like a covered, pedestrianized street, almost the London equivalent to the arcaded Victorian galleries of Brussels or Milan. There are a number of upright pianos in the 'street' that are available for anyone to play. In 2016, Elton John gave an impromptu performance here on a piano he subsequently donated to the station as a gift.

Barlow's great trainshed high above has been meticulously renovated, cleaned, painted in light blue and reglazed to give the station interior a lightness it never possessed in the black and grimy days of steam. A life-size bronze figure of Sir John Betjeman, who died in 1984, stands on the platform level of the concourse. This is by the British sculptor Martin Jennings and commemorates Betjeman's successful campaign to save the station

from demolition in the 1960s. It was unveiled by his daughter, the author Candida Lycett Green, two days before the official opening of the station by the Queen in 2007. The bronze Betjeman is holding his hat, gazing up in apparent wonder at the restored roof, which he would have been surprised but delighted to see. If he turned to look the other way, he might have been less appreciative of Paul Day's huge commissioned sculpture *The Meeting Place*, featuring two giant lovers embracing under the station clock, a rather less subtle new artwork for the station.

Betjeman would certainly have enjoyed the final outcome of the quirky tale of the St Pancras clock. Removing the original for sale to an American collector was one of BR's less glorious acts of asset-stripping in the 1970s. The deal collapsed when removal contractors accidentally dropped and smashed it. A glass-reinforced plastic (GRP) copy to replace it was put up at St Pancras in 1975. The damaged original clock was bought by BR signalman Roland Hoggard, who meticulously reassembled the broken pieces for display in his garden in Leicestershire. Its lucky survival enabled Dent and Company, makers of the original Victorian clock, to create a very precise high-quality working replica for St Pancras International.

Much of Scott's Midland Grand has also been returned to its original function as a luxury hotel. Now appropriately renamed the St Pancras Renaissance, its grand re-opening took place on 5 May 2011, 138 years to the day after the original opening in 1873. The Renaissance occupies the main public rooms of the Midland

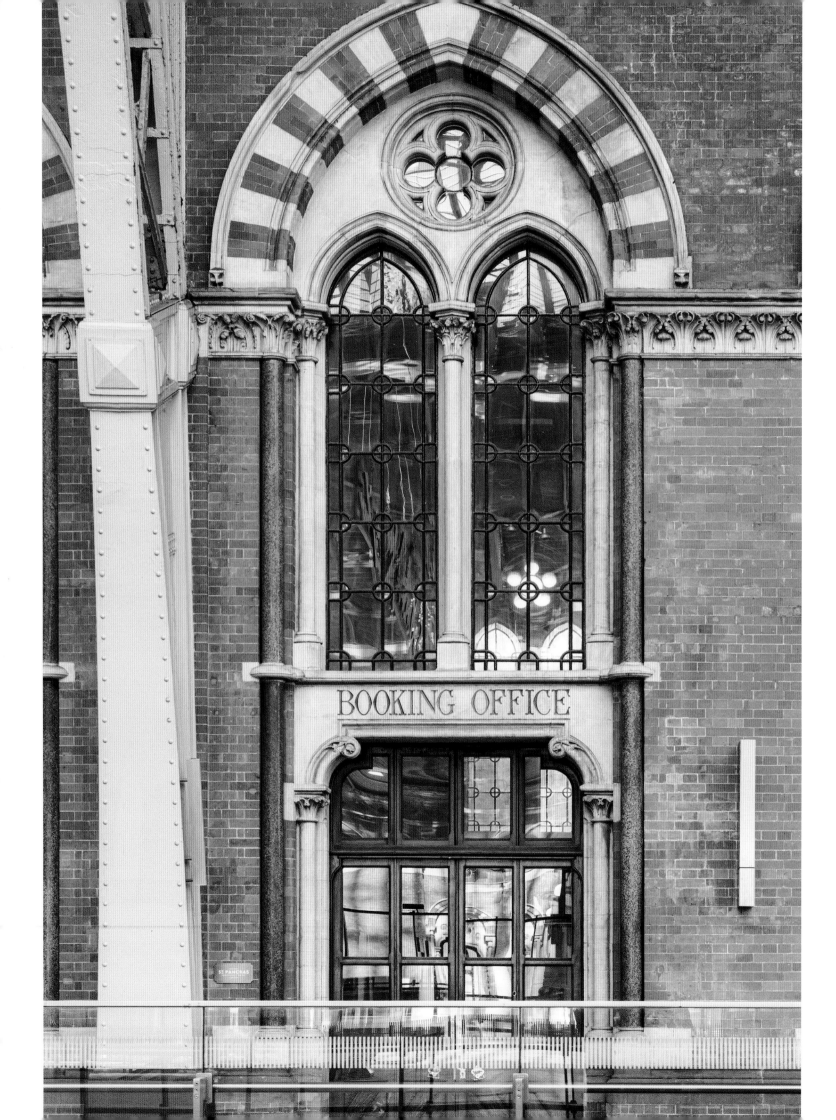

Left The former booking office, now the bar of the Renaissance Hotel.

Above Detail of the station interior walls.

Right View of the retail walkway from the upper platform level.

Overleaf Eurostar trains under Barlow's magnificent roof.

Grand, all beautifully restored, together with a newly built bedroom wing on the western side of the Barlow trainshed, which matches Scott's building externally but without the architectural trimmings. The upper levels of the original hotel on the Euston road frontage have been developed as luxury private apartments, most of them sublet via Airbnb due to their desirable location.

Scott's meticulously restored grand staircase is undoubtedly the most impressive heritage feature of any hotel in London. The former station booking hall with its wooden linenfold panelling and corbelled stone capitals depicting engine drivers, guards and signalmen, now serves breakfasts to hotel guests and becomes the bar in the evening. The hotel restaurant occupies the former Midland Grand's coffee room on the western side near the original Victorian entrance on the Euston Road. The new entrance and reception for the Renaissance Hotel, replete with wonderfully ornate drainpipes once on the exterior, is through the original carriage and cab arch outside the former station booking hall at platform level, all now fully enclosed and furnished.

This has been an entirely separate project to the station conversion, but the two dovetail together visually and practically, just as Barlow's and Scott's respective designs did in the 1860s. St Pancras now takes pride of place once held by Victoria as the international rail gateway from London to the Continent. Seventy years ago the post-war *Golden Arrow/Fleche d'Or* could offer a first-class rail-and-sea journey from London to Paris taking six hours and forty minutes. Since 2007, the fastest non-stop Eurostar trains running over HS1 and through the Channel Tunnel, can get from London St Pancras to Paris Gare du Nord in just 2 hours 15 minutes.

St Pancras International has become the London terminus for Eurostar's high-speed trains to Paris, Brussels, Amsterdam and Lille. Through services to the south of France operate in the summer months and to the French Alps during the winter ski season. Direct services to Bordeaux are planned, but long discussed through services to Germany have not yet materialized. Britain's departure from the EU in 2020 may delay further rail co-operation with Europe, while Eurostar's services will need to recover from the serious impact of the COVID-19 pandemic in 2020–21 when international travel collapsed for more than a year.

Meanwhile, domestic services from St Pancras have continued to grow. It is the terminus for East Midlands Railway (EMR) services from London to Derby, Leicester, Nottingham and Sheffield. Cross-London Thameslink trains call at platforms beneath the main station, running south to Gatwick Airport and Brighton and north to Luton Airport Parkway for Luton Airport and Bedford. From 2018 a new rail tunnel connection to the Thameslink platforms from the East Coast mainline outside King's Cross has enabled some trains from Cambridge formerly terminating at Kings Cross to be diverted through St Pancras, Farringdon and Blackfriars across London to Sussex. High speed 'Javelin' domestic services from St Pancras to Kent, run by South Eastern, depart on the same level as Eurostar and EMR trains. St Pancras has effectively developed into a domestic as well as an international rail hub.

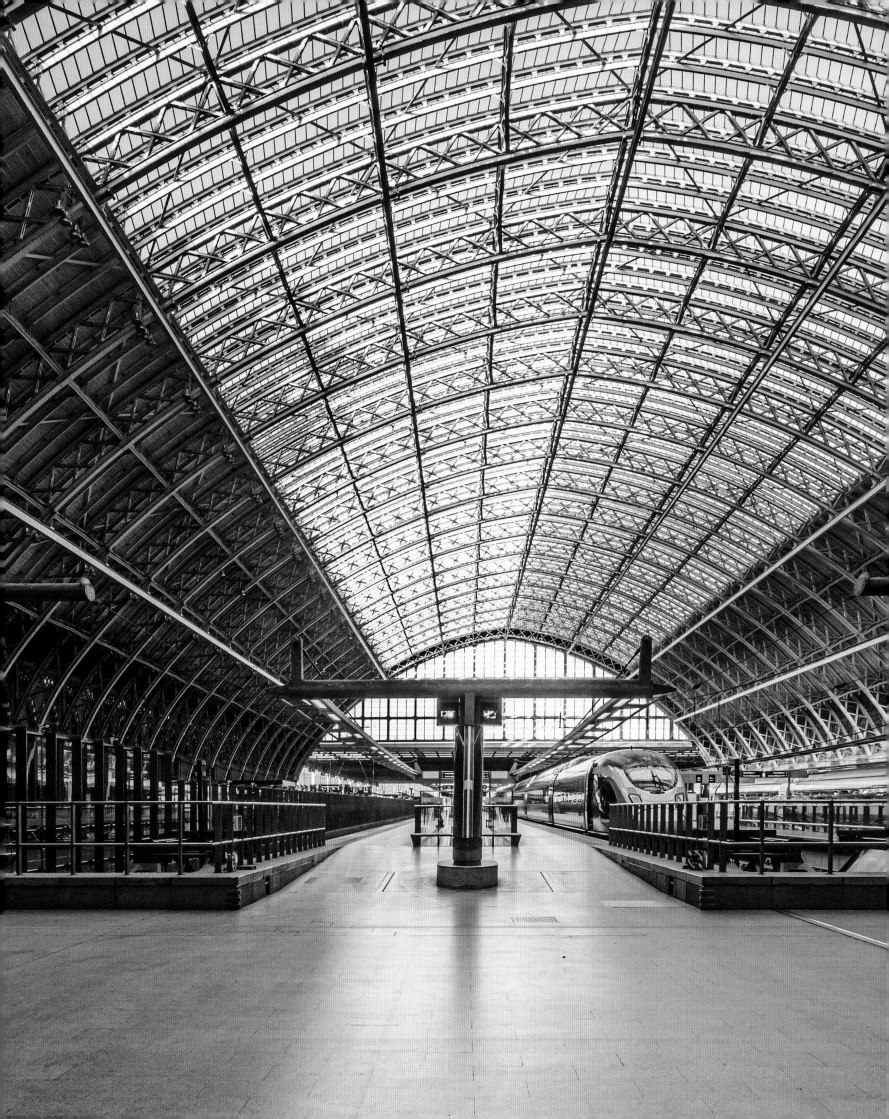

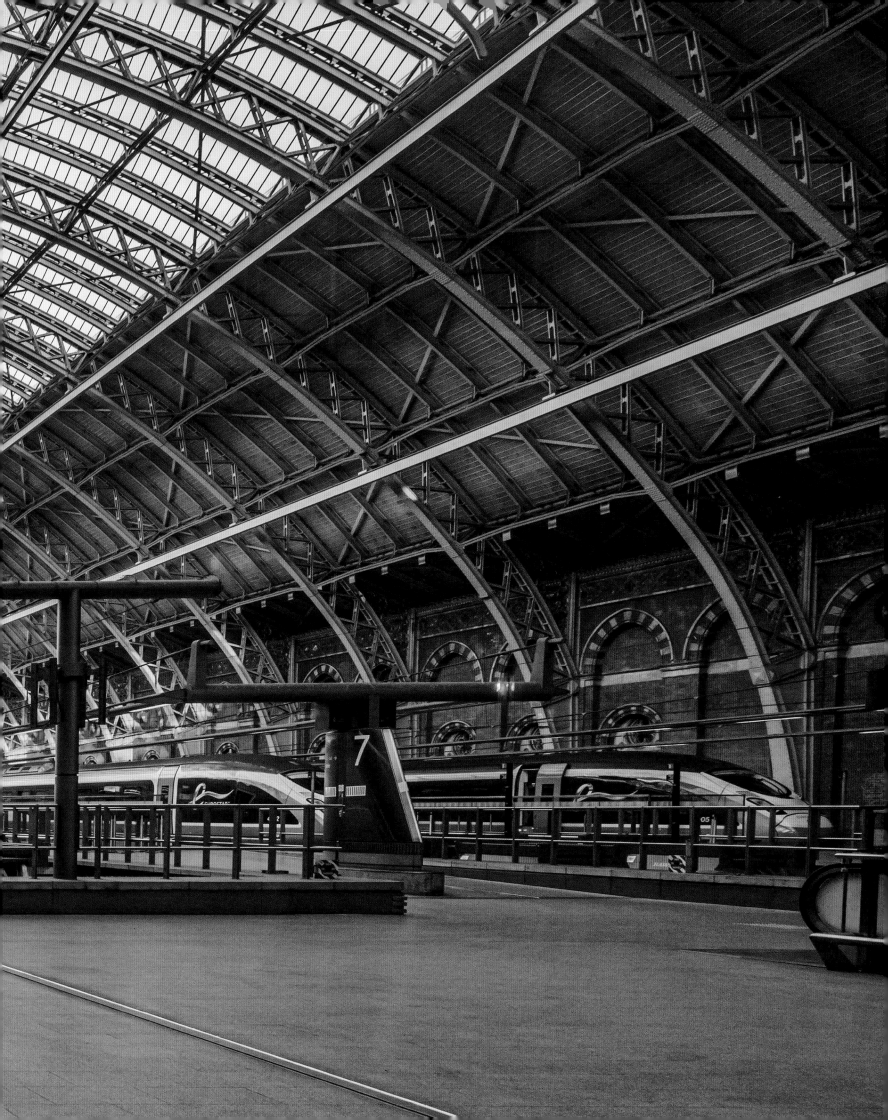

King's Cross

When King's Cross opened in 1852 it was the largest railway station in the country, and much admired. Sceptical shareholders of the Great Northern Railway (GNR), who muttered about extravagance in their new terminus, were told by the company chairman that it was 'the cheapest building for what it contains, and will contain, that can be pointed out in London'. He was probably right. The total construction cost of £123,500 was far less than the combined bill for the Euston Arch and Great Hall alone.

King's Cross station was designed by Lewis Cubitt, younger brother of master builder Thomas Cubitt, who had developed much of Belgravia and Bloomsbury in central London a few years earlier. Lewis was apparently not related to Joseph Cubitt, Chief Engineer of the GNR, who worked with his namesake on the station. King's Cross is straightforward, functional and economical, a complete contrast to the ostentatious showiness and impracticality of the Doric arch and Great Hall just down the road at Euston. Lewis Cubitt announced that what he wanted to achieve at King's Cross was 'fitness for purpose and the characteristic expression of that purpose'.

The GNR arrived in London in 1850, at first using a temporary station at Maiden Lane (now York Way), just north of the Regent's Canal on the site to be developed as a goods depot. While the tunnel taking the railway under the canal to the permanent passenger terminus was being built, the very basic facilities at Maiden Lane had to accommodate huge numbers of tourists visiting London from the North for the Great Exhibition

in 1851. Even Queen Victoria and Prince Albert had to make do with the temporary facilities at Maiden Lane station when they set off for Scotland by GNR in August 1851.

The permanent King's Cross station was built on a 10-acre site formerly occupied by smallpox and fever hospitals. The Cubitts created a pair of long brick trainsheds for the arrival and departure platforms, separated by a strong arched wall. Each platform hall originally had a full-length glazed wooden roof, later replaced with iron and glass. At the London end are two huge glazed arch windows, with a clock-tower above and between them as the only decorative feature. The turret clock inside the tower, designed by Edward Dent, was displayed at the Great Exhibition in Hyde Park, where it won a medal, before being installed at the station.

Just to the west and originally separate from the station is the Great Northern Hotel, a rather plain Italianate addition, also by Lewis Cubitt, that was completed in 1854. Unlike the Great Western Hotel at Paddington, which was put up at the same time as the station, the Great Northern looks like an afterthought and did not appear to be integrated with the main station site. The odd curved shape of the hotel follows the former line of Pancras Road, which for years emphasised its detachment. After being threatened with demolition in an early version of the King's Cross masterplan, it has recently been completely renovated and physically linked to the station for the first time by a giant semi-circular roof over a spacious new passenger concourse.

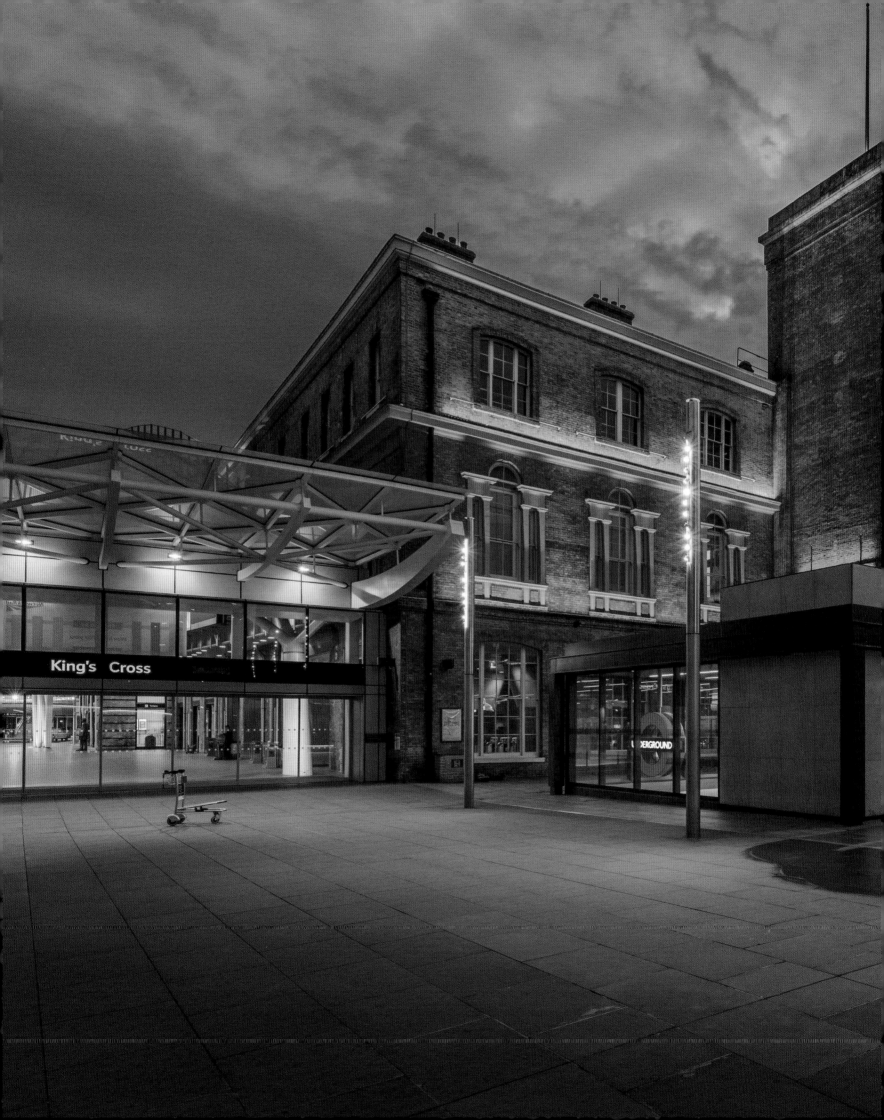

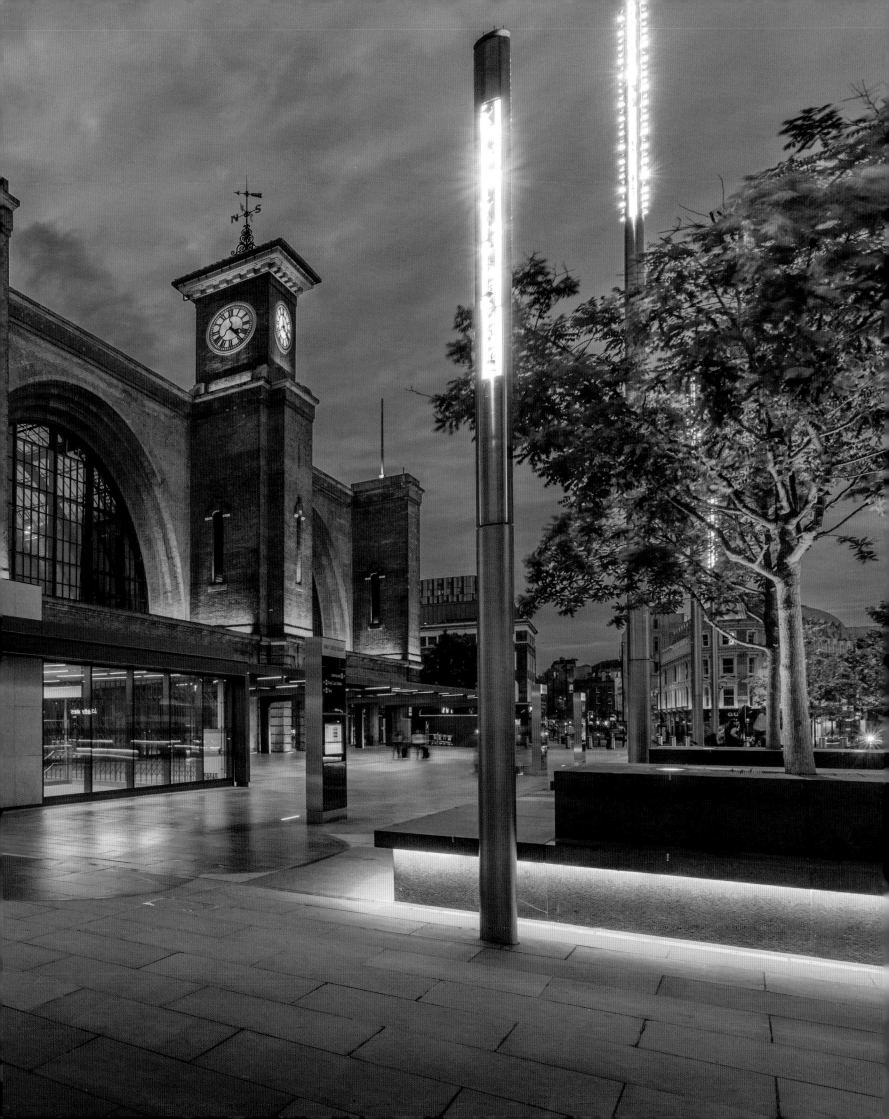

Left above LNER express trains awaiting departure behind Gresley Pacifics, c.1928.

Left below Two morning express trains for the north leaving King's Cross together at 10am, with the non-stop *Flying Scotsman* on the right, c.1928.

Right above King's Cross soon after opening in 1852, with the Great Northern Hotel nearing completion on the left.

Right below *Going North – King's Cross Station* (1893), a painting by George Earl, showing wealthy families heading for Scotland with their dogs and sporting gear at the start of the grouse shooting season in August.

The routes out of Kings Cross

The simplicity of the original station layout at King's Cross was soon compromised by the rapid growth of traffic and the lack of space to expand. As well as being the terminus for the East Coast main line to the North, King's Cross had fast-developing local passenger services to the north London suburbs and Hertfordshire by the 1860s. A sharply curved branch line down each side of the station took GNR suburban trains alongside the Metropolitan Railway on the Widened Lines to Moorgate, and a junction at Farringdon took goods trains through Blackfriars and over the Thames, a cross-London route eventually rebuilt for Thameslink passenger services in the 1980s.

In north London, branch lines built off the Great Northern main line soon brought suburban services in from Edgware, High Barnet, Alexandra Palace and Enfield. All trains had to be squeezed through the bottleneck of the King's Cross tunnels. Daily departures from King's Cross grew from nineteen in 1855 to eighty-nine in 1873, most of them suburban trains. It was a complete reversal of the pattern at Euston, Paddington or later St Pancras. Between 1867 and 1873 the number of GNR season-ticket holders more than doubled to over 6,000. By 1881, it was approaching 15,000, but the GNR began to see its expanding commuter traffic as a potential problem rather than a growth opportunity, with dark talk of the railway's 'suburban incubus' stifling its more prestigious main line to the North. Additional tunnels were added just outside King's Cross and extra platforms

were installed, but the pressure on the station was not greatly eased until the 1930s, when extensions to the Piccadilly and Northern line Tubes helped spread the suburban commuter traffic on to the Underground.

The GNR became part of the London and North Eastern Railway (LNER) in 1923. The LNER was not the largest of the 'Big Four' companies, but it soon demonstrated the best flair for publicity and promotion. Virtually nothing was done to improve services for the LNER's long-suffering suburban commuters, but the glamorous long-distance departures from King's Cross were always in the news.

In those days everybody knew that the *Flying Scotsman*, Britain's most famous train, left King's Cross at 10am every morning for its fast run to Edinburgh Waverley. In 1928, this became a non-stop express service, always hauled by one of the LNER's powerful Pacific locomotives designed by Sir Nigel Gresley. A large crowd on the platforms watched the first non-stop 'Scotsman' leave King's Cross on 1 May 1928 behind engine number 4472, also named *Flying Scotsman*, and today one of the icons of the National Railway Museum's collection. Gresley now has a modest statue on the new concourse at King's Cross, which blends almost too well with the station brickwork and hardly does justice to Sir Nigel's ability to design some of the finest and fastest British steam locomotives in the inter-war years.

Press photographs of the latest LNER expresses always showed departures from King's Cross, particularly in the 1930s, when Gresley unveiled his A4-class streamliners on the new

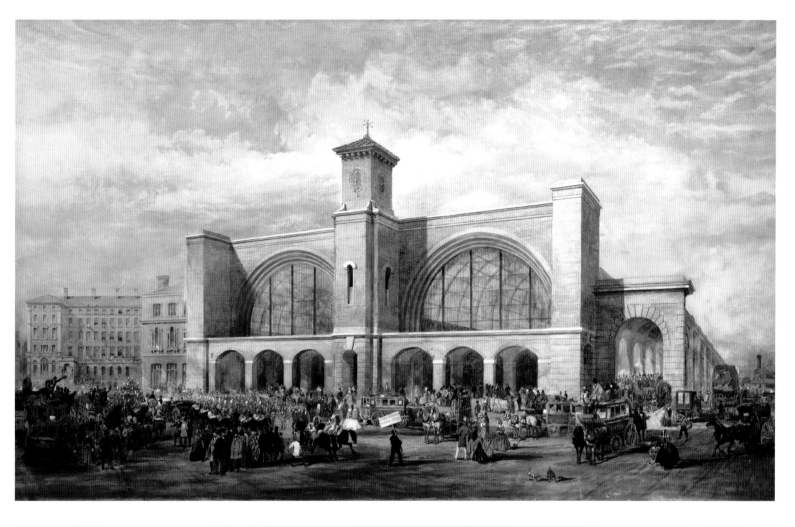

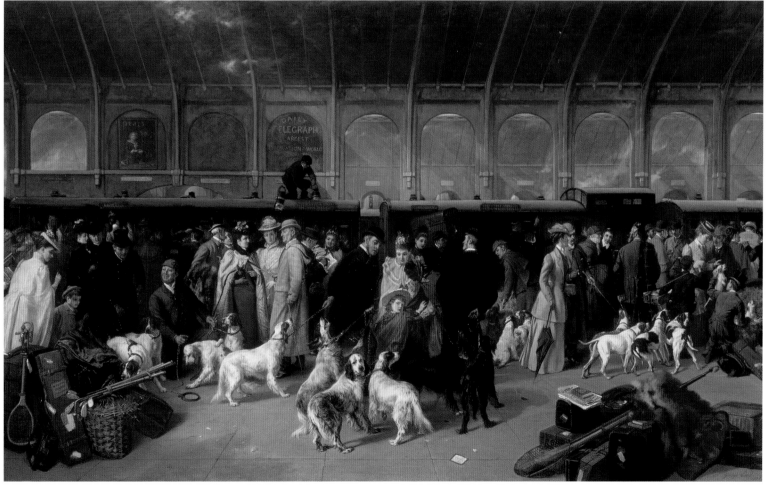

Right Platform 8 at King's Cross, with one of the magnificent station clocks.

The Ladykillers

In 1955, King's Cross and its environs achieved lasting cinematic status as the location for *The Ladykillers*, one of the best in the classic series of comedy films made at Ealing Studios in the 1940s and 1950s. It is the black comedy story of a bungled robbery at King's Cross by an incompetent gang of thieves, led by Professor Marcus (Alec Guinness) who pose as a group of musicians staying in the cottage of little old lady Mrs Wilberforce (Katie Johnson). She lives alone with her parrots in a lop-sided cottage that sits over the entrance to the Copenhagen Tunnel, just outside King's Cross on the main line. All goes according to plan with the heist until the gang members make a clumsy mistake, fall out between themselves and begin to meet their fate on the railway outside Mrs W's house …

Below David Shepherd's artwork for the BR poster 'Night Service', issued in 1955, showing a nocturnal view of King's Cross.

Right Poster by Reginald Mount for the film *The Ladykillers*, released in 1955. It illustrates all the gang members but not Mrs Wilberforce.

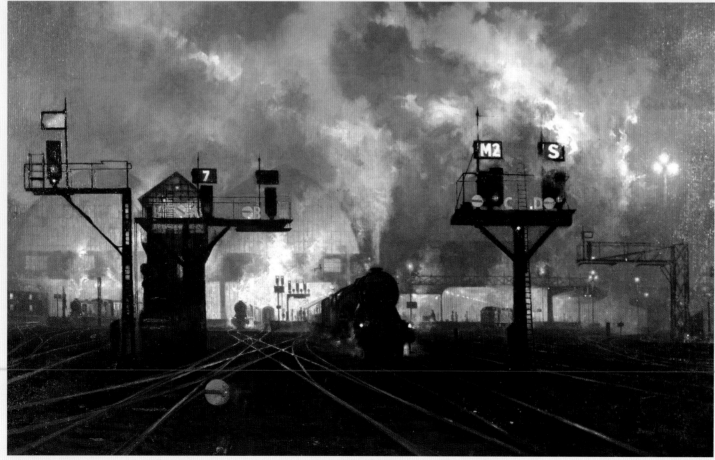

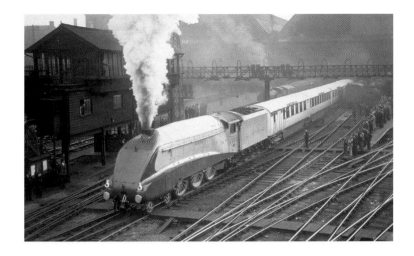

'Silver Jubilee' service to Newcastle. It was one of the A4s, number 4468 *Mallard,* that broke the world speed record for steam in 1938, reaching 203km/h (126mph) on the main line, a speed never bettered for steam. *Mallard* is also now preserved as part of the National Railway Museum's collection.

After the war, when British Railways (BR) introduced the non-stop 'Elizabethan' express on the King's Cross to Edinburgh run in Coronation year, 1953, this A4-hauled service was promoted in a special British Transport Films documentary. As the film demonstrates, the A4s were fitted with corridor tenders that enabled a crew change to take place halfway through the journey to Scotland without stopping the train.

Inadequacy prompts change

The glamorous image of King's Cross as the great departure point for the North, in which it consistently outshone its busier rival Euston, has always been at odds with the reality of a rather cramped terminus with poor passenger facilities. The area on the Euston Road in front of the station, which had been an open forecourt when King's Cross opened in 1852, housed an unplanned mixture of temporary structures by 1900. An entrance building for the new Piccadilly Tube appeared here in 1906, and was quickly surrounded by small shops and street clutter in front of the station, which became known locally as 'the African village'. A curious addition to it in the 1930s was

a full-size suburban showhome, put up by the builders Laing to promote their new housing estate on the Piccadilly line at Oakwood. This survived at King's Cross until the late 1950s.

Diesel trains replaced steam at King's Cross in the early 1960s, but little was done to the fabric of the station building. A modern, single-storey travel centre was added as an extension to the station facade in 1974, though passengers were still expected to queue for main-line departures in lines snaking round the tiny platform concourse.

This did not feel like the grand gateway to Scotland and the North. King's Cross was seedy, unwelcoming and increasingly run-down. A terrible fire on the Piccadilly line escalators to the Tube below caused by a dropped cigarette in November 1987, in which thirty-one people died, seemed to confirm the area's reputation for neglect. This fatal incident was, however, a catalyst for change.

The main-line station even acquired new fame after its appearance in 1997 in the first of the Harry Potter books, where the departure point for the 'Hogwarts Express' is the invisible Platform 9¾. Author J.K. Rowling possibly chose her site in celebration of a long-standing myth about King's Cross that this is precisely where Boudicca, warrior queen of the Iceni, was buried after her final defeat by the Romans in AD 60. Needless to say, there is absolutely no historical or archaeological evidence for this, but a popular Harry Potter photo opportunity spot has been created on the concourse.

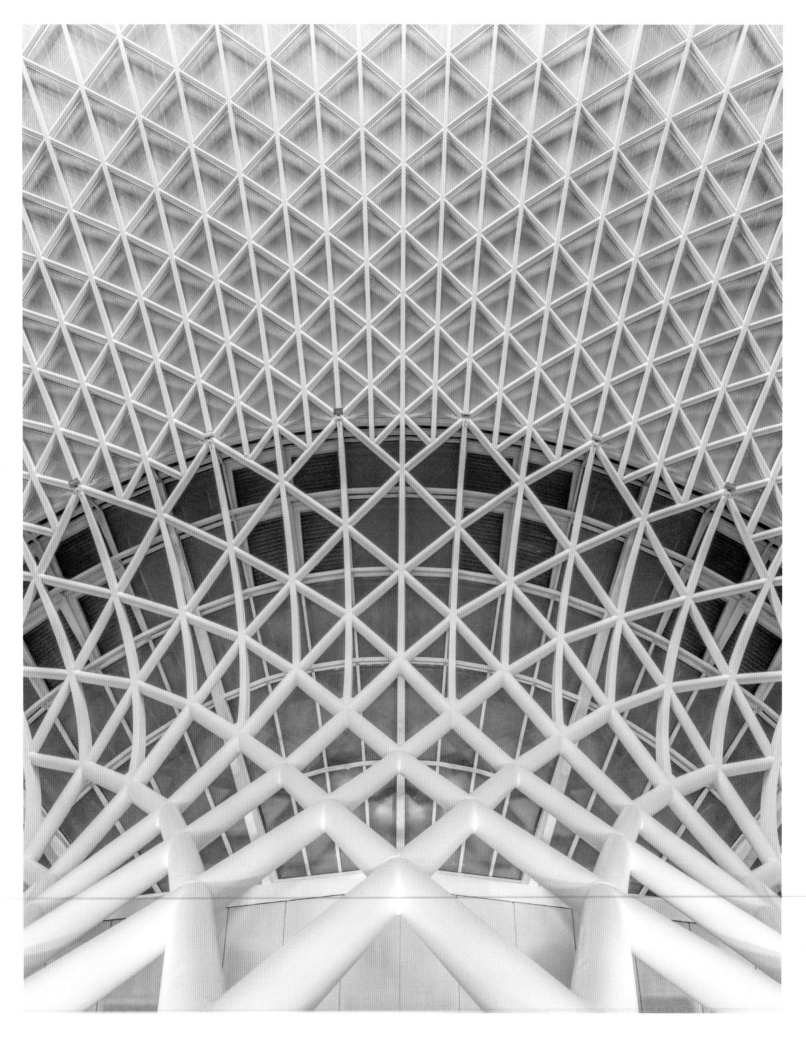

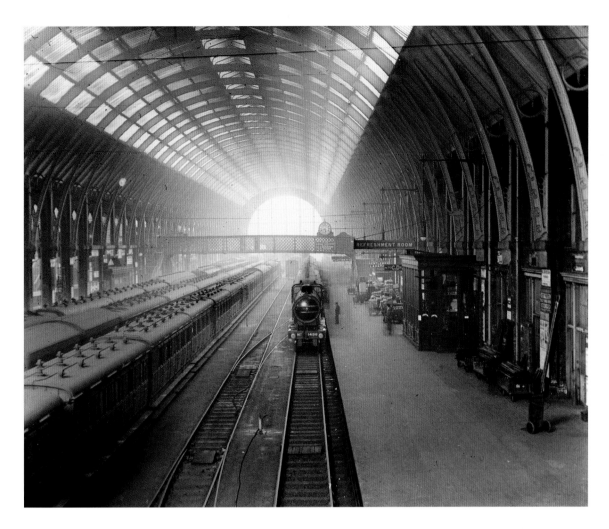

Opposite The spectacular roof structure of the new departures concourse opened in 2012, which finally links the station with the Great Northern Hotel.

Left The departures trainshed at King's Cross GNR, *c*.1901.

Overleaf New Azuma bi-mode trains built by Hitachi and operated by the new LNER in the fully restored trainshed, 2021.

A master plan was eventually prepared in the 1990s for the redevelopment of the whole area between and around King's Cross and St Pancras stations. This has involved detailed negotiation, consultation and partnerships between public authorities and private-sector developers, which took a long time to produce results. Two large and spacious new sub-surface booking halls for the Underground station were completed by 2009. Better facilities on the surface within and along the western side of the listed main-line station buildings followed, together with the renovation of the Great Northern Hotel, which had originally been scheduled for demolition. London's most complex transport hub, where three surface and six Underground lines meet in what had become an increasingly chaotic mess, is at last looking properly planned.

The £500-million restoration plan for the station itself was announced by Network Rail in 2005. This involved restoring and reglazing the original arched trainshed roof and removing the 1970s extension at the front of the station. The whole area between the station façade and Euston Road was cleared to create an open air plaza named King's Cross Square. Cubitt's elegant frontage, overshadowed for so long by St Pancras and the scruffy collection of buildings that obscured the station, is now revealed. The 'square' (actually more of a triangle) is now populated by two new glazed Underground entrances, a large Henry Moore sculpture and, during the day, by thriving street-food market stalls.

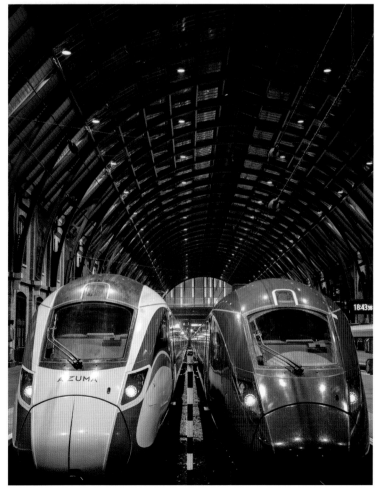

Kings Cross Central

Just to the north of King's Cross, beyond the canal, 27 hectares (67 acres) of former railway land, which once contained extensive goods yards, canal wharves and a locomotive depot, now constitutes the largest inner-city regeneration site in Europe, known as King's Cross Central. Argent St George were appointed developers of King's Cross Railway Lands in 2000, starting a lengthy process of planning and community consultation with Camden Council, which did not always run smoothly. Planning permission for a worked-up scheme was granted in 2006 and 2008, but amendment and development work will continue here well into the 2020s. It is an imaginative mix of new commercial office schemes, private and social housing, the refurbishment of historic warehouses and the re-use of other structures such as coal-drops, gasholder frames and a water tower, some of which have been relocated on the site.

An extensive retail and restaurant area on two levels has been created in the converted Great Northern coal drops yard, a stunning combination of Victorian brickwork and modern architecture topped by Thomas Heatherwick's swooping new broken roof design. A new campus for Central St Martins, part of London's University of the Arts, now occupies the GNR's massive Granary Warehouse. In front of this is Granary Square, where some of the original wagon turning plates and capstans have been incorporated with a new water feature that marks out in multiple rising and falling fountains the area where barges once entered the warehouse through narrowboat tunnels from the Regents Canal. The plaza steps down to the canal with an attractive public seating area. The latest commercial development here, now under construction between the walkway down to King's Cross and realigned station platforms, will be the European headquarters of Google.

The whole environment of King's Cross, which had been run down, desolate and inaccessible for so long in the late twentieth century, is still changing rapidly and dramatically for the better, but with key features of its historic railway infrastructure now put to new use instead of being swept away. What were once walled, enclosed and fenced off spaces have effectively become a popular part of what planners like to refer to as 'the public realm'.

Left Christmas decorations in Granary Square, 2020. The six-storey Granary on the right, designed by Lewis Cubitt in 1850, was the centrepiece of the GNR's King's Cross goods yard. It is now occupied by Central St Martin's, part of London's University of the Arts.

Below left Coal Drops Yard, with re-erected Victorian gasholder frames encircling new apartments.

Below right Granary Square and Coal Drops Yard viewed from across the Regent's Canal.

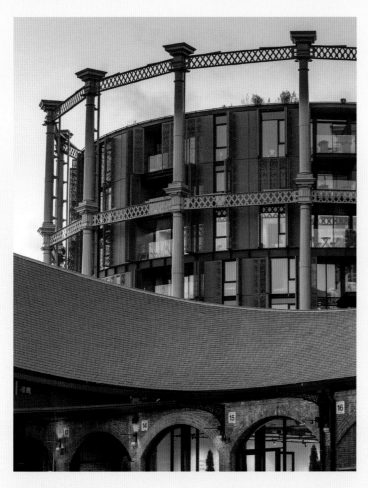

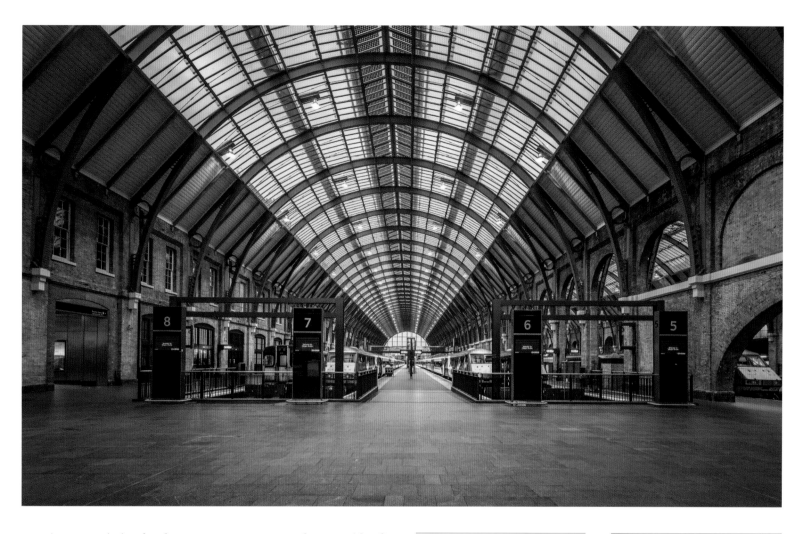

A new semi-circular departures concourse on the west side of the station designed by architect John McAslan and built by Vinci opened in 2012. This is covered by a spectacular single span roof that links the hotel and station for the first time without touching the listed Victorian station buildings behind it. The new roof, engineered by Arup, was described by Kieran Long in the London *Evening Standard* when it opened as being 'like some kind of reverse waterfall, a white steel grid that swoops up from the ground and cascades over your head'. Simon Jenkins calls it exhilarating, but also 'a textbook exercise in brazen modernism tempered by historical context'. As he explains this was the outcome of a heated running battle between the architect and English Heritage, which ended with the best sort of creative compromise – a solution that celebrates and preserves the station's heritage while providing for its future in a practical, dramatic and visually exciting way.

The new concourse cover has more than 2,000 triangular roof panels, half of which are glazed. The white steel grid changes colour to yellow and purple as the daylight fades and the roof is bathed in subtle internal lighting as the sky darkens. Waiting passengers can now sit on the balcony with a coffee, a clear view of the departure boards and no need to queue round the cramped former Travel Centre for their train. Train travel from King's Cross has become, as it should be, a much less stressful and more relaxed experience.

What should be the final piece of infrastructure improvement work on the station itself was carried out by Network Rail in

Left above Cafés and decorations in Granary Square.

Left below Converted transit sheds, new apartments and canal barges at King's Cross Central.

Above King's Cross, fully restored in 2020, awaiting delivery of the new fleet of Azuma trains for the East Coast main line.

Overleaf The roof support structure in the new departure concourse, engineered by Arup. It is designed to stand proud of the listed Victorian station building behind it. Sir Nigel Gresley merges with the station wall on the right.

2020–21, when the track layout and platforms at the station throat were realigned. The project has involved replacing track, signalling and overhead line equipment, while simplifying the approach to King's Cross. The new layout increases the number of tracks running into the station from four to six, bringing back into use one of the disused tunnels. This in turn will increase capacity on the East Coast Main Line, enabling the new Azuma bi-mode trains to provide up to 10,000 extra seats a day on long distance services.

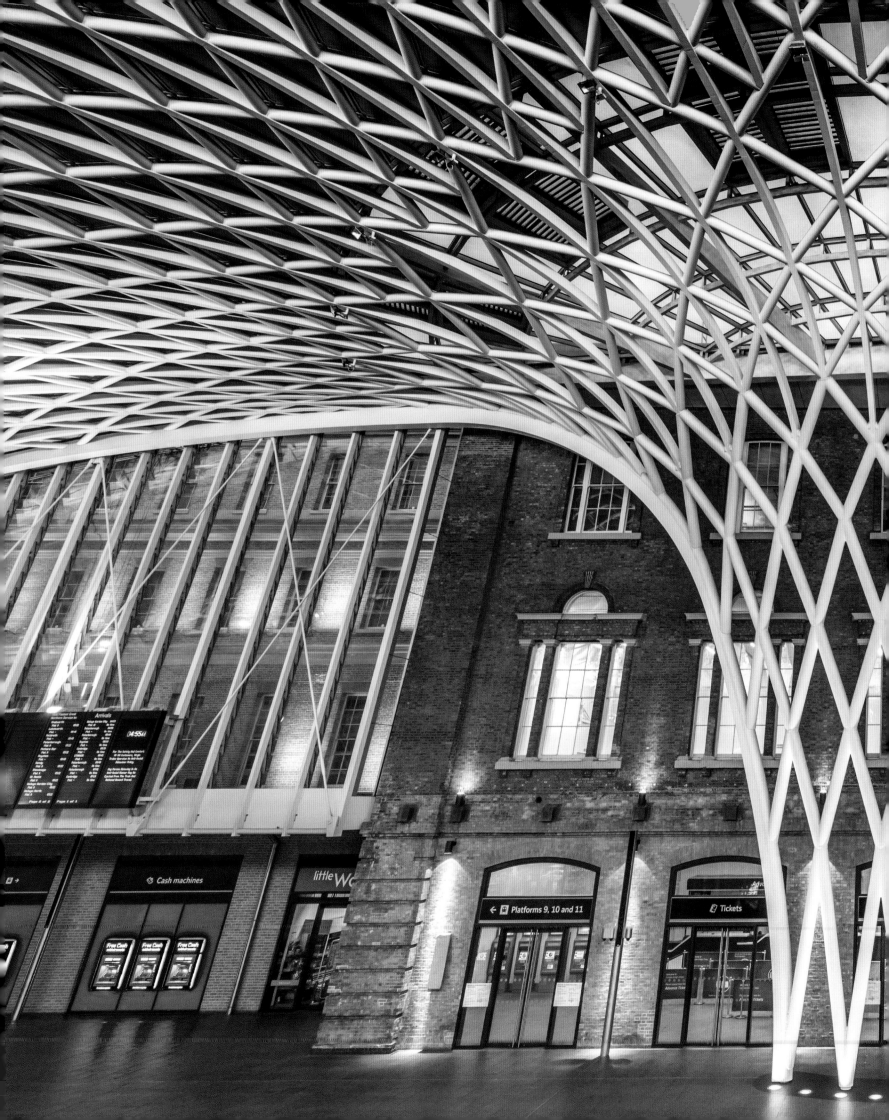

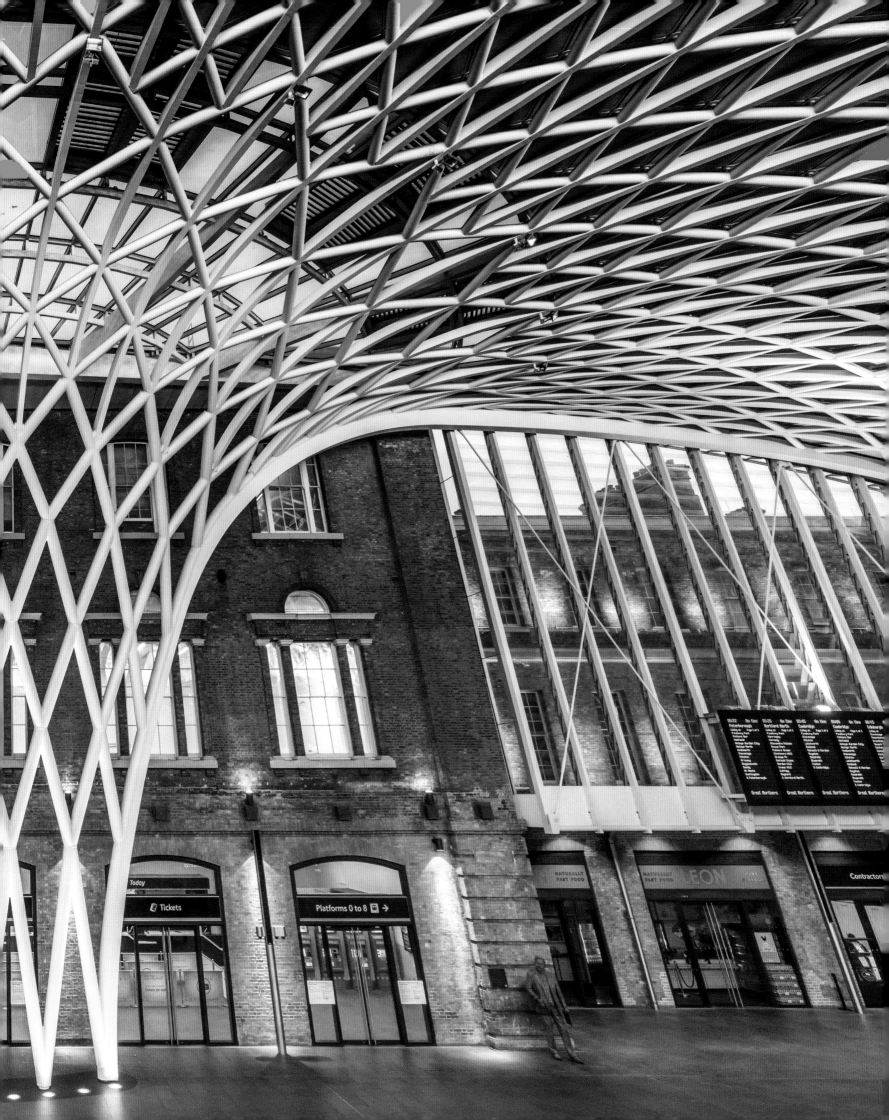

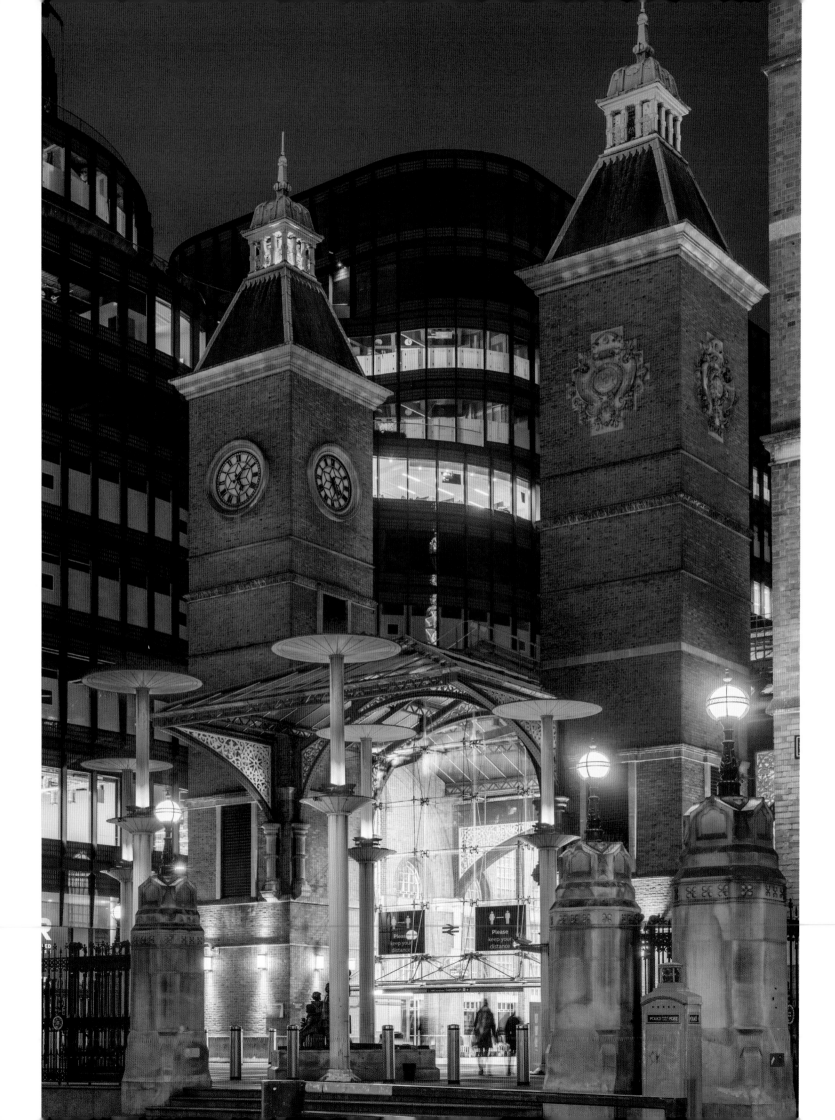

Liverpool Street

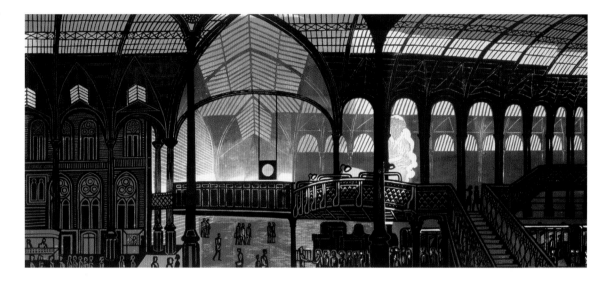

Left Liverpool Street's twin entrance towers, built in the 1980s but looking older. Beyond is the Broadgate Centre, which replaced Broad Street station next door at the same time.

Right Edward Bawden's evocative lithograph of the 'black cathedral', with its high-level walkways in the days of steam.

Few of the commuters who pass through Liverpool Street every working day pause to look at its remarkable architecture and environment. No City worker under the age of forty will remember the completely different atmosphere of this station before its radical reconstruction in the late 1980s. John Betjeman had a particular fondness for the elevated Edwardian tearoom, which was perched on the upper level of the concourse above the original entrance to the Tube: 'I know of no greater pleasure for elevenses in London than to sit in this tea-place and watch the trains arrive and depart. Later the crowds are too great …'

As he wrote these words Betjeman would have been unaware that his much loved 'black cathedral' was about to face a comprehensive redevelopment plan by British Rail that threatened the whole station with demolition and reconstruction. Fortunately, this was not to be. Simon Jenkins recalls what happened next:

> With the blood of Euston still on the British Rail carpet, the opposition was this time better able to marshall its forces. With Betjeman, Spike Milligan and others to the fore, a public inquiry was achieved, leading to one of the great conservation triumphs of the 1980s. It was commensurate with the saving of Covent Garden and Piccadilly Circus.

The outcome of that long public inquiry turned the destructive original plans for Liverpool Street into the most successful large-scale heritage redevelopment in the square mile of the City of London. The best aspects of a historic environment have been retained and integrated with a huge new office scheme on three sides and partly above it. Much of the station now dates from the late twentieth century, but it is partly in late-Victorian style to complement the restored and reinstated original features. Extensive demolition has taken place on part of the site, including the whole of Broad Street station, but this project was also a triumph of building conservation. Thirty years on it is almost impossible to distinguish genuinely old from new, yet the result does not feel like a pastiche.

Plans for the original construction of Liverpool Street were drawn up by the Great Eastern Railway (GER) soon after the company's creation in 1862. The GER was formed by merging five existing companies, which between them controlled virtually all the railways of East Anglia. The largest component was the Eastern Counties Railway (ECR), which had opened a London terminus at Shoreditch in 1840. This station, known as Bishopsgate from 1846, was just east of the City of London border and not very convenient for passengers travelling to the central financial district. It was also surrounded by one of London's most notorious slum areas.

The GER already ran some trains into Fenchurch Street, but this tiny terminus could not be expanded. Negotiation with the North London Railway (NLR) to share its new City terminus, then under construction at Broad Street, came to nothing. To develop its City traffic and build up suburban services, the GER

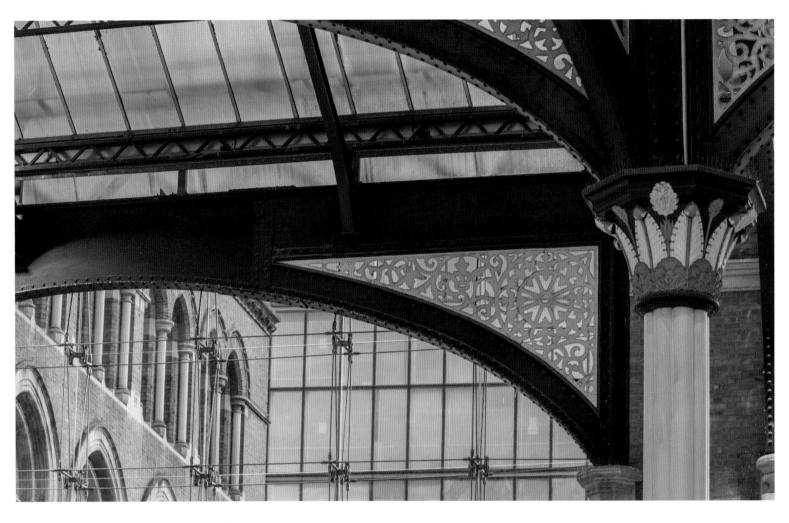

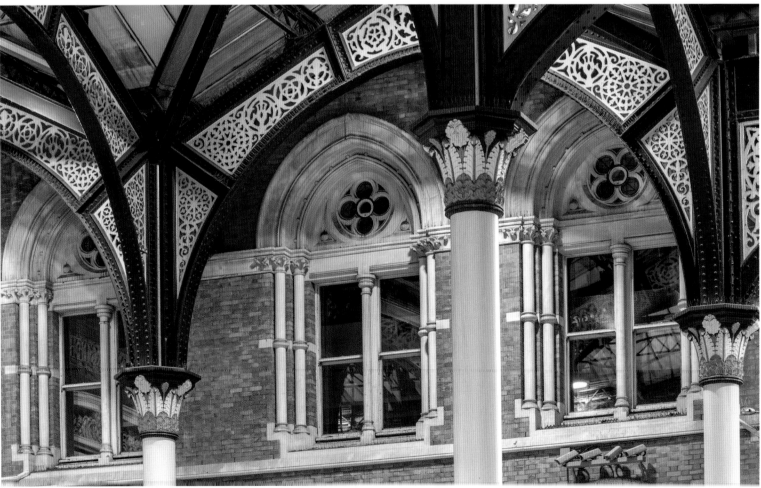

From the tearoom window

In 1910, when the Great Eastern Railway introduced a monthly staff magazine, every issue featured a page of GER gossip and observations called 'From the Tearoom Window' headed by a banner illustration of the view over the station concourse and platforms at Liverpool Street, which claimed to have 'the most interesting outlook in London'. The page was anonymously written by 'Autolycus', the thieving son of Mercury in classical mythology, but better known in Shakespeare's *The Winter's Tale* as 'a snapper up of unconsidered trifles'. Many years later, Betjeman highlighted the tearoom in his own affectionate book on London's railway stations published in 1972, which is illustrated with evocative black-and-white photographs by John Gay. Liverpool Street was, he claimed, 'the most picturesque and interesting of the London termini' but there were already plans for its comprehensive redevelopment. Sadly, Betjeman's cosy tearoom with a view would be one of the losses in the heavily amended renewal scheme that was carried out in the 1980s, but much of the old station was saved.

Left above and below The west side of the station, restored and reconstructed in the 1980s.

Above The Edwardian tearoom in the 1970s, swept away in the redevelopment of the 1980s.

Overleaf A Liverpool Street roofscape.

decided that an extension of its line to a large new terminus of its own just inside the City boundary at Liverpool Street, alongside the NLR's Broad Street, was the only way forward.

Bringing the line less than a mile into the City took ten years to achieve and was an expensive and flawed project. The NLR line to Broad Street entered the City at high level on a viaduct, but the GER chose to build their terminus with the platforms below street level. This was mainly to provide a through connection with the Metropolitan Railway, which in the end was hardly used and was removed in 1907.

To bring the line down to this level at Liverpool Street, the extension had to be built down a steep bank from Bethnal Green, which gave the Great Eastern long-term operating difficulties. Lord Claud Hamilton, the GER's last chairman, acknowledged in 1923 that building Liverpool Street at low level had been a serious mistake, which 'has been a great inconvenience to the travelling public … every one of our heavily laden trains has to commence its journey at the bottom of an incline'. In steam days this was quite a problem, and it remained so until electrification in the 1960s. Modern passengers barely notice the effortless climb past Bishopsgate.

The first trains to run into Liverpool Street, when it was only partially complete, were suburban services on the new lines from Enfield and Walthamstow in 1874. The rest of the station, consisting of ten platforms altogether, came into use a year later when the old Bishopsgate terminus was closed to passengers. This

was converted into a goods depot and used until 1964, when the main building was destroyed in a fire. The large original brick-arched support structure built in 1840 survived for another forty years before being demolished for the creation of the East London line extension link in 2004. This new railway opened in 2010 as part of the new London Overground network, reusing much of the former Broad Street approach route at high level through Hackney, which had closed in 1986.

The layout of Liverpool Street

When Liverpool Street station first opened in 1874–5, it was laid out in an L-shape, with short platforms for suburban trains on the western side and longer main-line platforms to the east. The long leg ran south almost to Liverpool Street itself and in the angle between the two legs there was ramp access to both sides of the station from the street, which is at a higher level. Tucked into the L, around the access ramps, were the station buildings, an unexceptional French Gothic-style office block in stock brick, which rose to three and four storeys and a clock tower with a spire. This was designed by the GER's engineer, Edward Wilson.

The platforms were covered by a very long and tall wrought-iron and glass roof consisting of two aisles and two naves separated by a double line of support columns down the middle. The great transept over the suburban concourse and main-line platforms gave the centre of the station a cathedral-like quality,

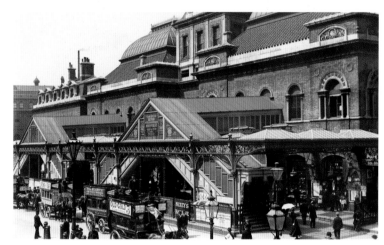

later enhanced by an elaborate four-faced Gothic clock, which hung over the tracks. The impressive roof structure was also designed by Wilson, working closely with the manufacturers, the Fairbairn Engineering Company of Manchester.

Despite the size of its new City terminus, the GER soon needed more space to meet the growing demand for suburban services to north-east London. As early as 1884, the company chairman boasted to shareholders that the GER could fill a thousand trains daily in and out of Liverpool Street but that their ten-year-old station could handle only two-thirds that number. Another 2.4 hectares (6 acres) of land, between the eastern edge of the station and Bishopsgate, was acquired, and work began in 1890. Four years later the East Side extension was opened, with eight additional platforms covered by a much plainer trainshed. It was designed by John Wilson, Edward's nephew, and W.N. Ashbee, the company's architect.

Meanwhile, the Great Eastern Hotel was completed alongside the Liverpool Street frontage in 1884, designed by Charles and C.E. Barry in a vaguely French Renaissance style. The hotel was extended and doubled in size along the Bishopsgate axis in 1899–1901 by Colonel Robert William Edis, who had just completed the Great Central Hotel at Marylebone (see page 58). The Great Eastern was the largest hotel in the City of London, and its opulent interior included the rococo Hamilton Hall, the Abercorn Rooms and two Masonic temples – one Grecian and the other Egyptian. Two of the tracks in the station ran right under

the hotel to a mysterious basement area known as 'the backs'. This had a loading bay, and coal and food supplies were delivered at night by a special goods train, which also removed hotel refuse and ash from the loco coaling area at the north of the station.

At the start of the twentieth century, Liverpool Street was for a time the largest and busiest London terminus, with eighteen platforms and nearly 1,100 train movements every 24 hours. Although it offered long-distance express services to Norwich, Cambridge and the Continent via Harwich, Liverpool Street has always been primarily a terminus for City workers. The GER deliberately built up an intensive suburban service from all over north-east London, and this became its main customer base.

Providing some cheap workmen's fares was a condition of the Parliamentary authority to extend the line to Liverpool Street. This was in addition to the requirement to rehouse residents displaced by the railway's demolition work around Bishopsgate. New tenements for 600 people were built nearby at the GER's expense, and low fares were supposed to enable other workers to move out and commute by train. It is unlikely that many of the GER's new suburban passengers had been displaced from the slums of Shoreditch, but the cheap trains were a big encouragement to the development of Tottenham, Edmonton and Walthamstow as residential areas.

By 1912, when Liverpool Street got a Tube connection to the Central London Railway, the main terminus above was handling about 200,000 passengers a day, travelling on 1,000

Left above The Liverpool Street station pilots gleaming in the gloom, c.1958.

Left below Postcard view of a Great Eastern express leaving Liverpool Street in c.1910. The locomotive is a 'Claud Hamilton' built at Stratford, just up the line.

Right above The short suburban platforms where the Jazz Service was introduced, c.1920.

Right below Sunlight and shadow on the main-line platforms, c.1950.

separate trains. After the First World War this rose by more than 10 per cent. There was no space to enlarge the station again, and electrification seemed the only option to increase capacity. New electric trains were enabling lines in south London to offer improved suburban services, but the Great Eastern could not afford the high cost of modernizing its lines, which was estimated at £3 million.

Instead, the company launched an intensive new steam suburban service in 1920, which doubled the number of rush-hour trains. At the height of the evening peak, twenty-four sixteen-coach trains, each with 848 seats, ran in quick succession over one of the tracks between Liverpool Street and Bethnal Green. This was an amazing achievement with manual signalling and little steam tank engines. It was soon christened the 'Jazz Service' by an evening newspaper and was still known as this right up to eventual electrification in 1960.

Passenger numbers at Liverpool Street peaked in the 1920s, allowing the GER's successor from 1923, the London and North Eastern Railway (LNER), to postpone the inevitable electrification until after nationalization in 1948. By this time the Liverpool Street suburban services to Epping had been transferred to an extension of the London Underground's Central line. The first electric trains into Liverpool Street itself were on the suburban service to Shenfield, inaugurated in 1949. During its twenty-five years of running Liverpool Street, the LNER did virtually nothing to improve or modernize the station.

British Railways (BR) announced the electrification of all suburban services into Liverpool Street under its Modernization Plan of 1955. The last steam suburban trains on the old GE lines ran in November 1960, and two years later all other steam workings were replaced by diesel and electric trains. This was the end of two unique features of the steam age at this terminus. One was the distinctive panting sound of the Westinghouse air-brake pumps on the tank engines, which had made the intensive Jazz Service possible with steam locomotives. The other was the sight of the two station pilots gleaming in the surroundings of the 'black cathedral', which despite the great height of the trainshed always seemed to have a smokey haze about it. One of the pilots was a tiny J69 tank engine, the other a slightly larger N7, both of them built at the Great Eastern's locomotive works at Stratford, just up the line in east London. It was a matter of pride for the staff at Stratford's huge engine sheds, one of the largest in the country, to keep the two station pilots immaculately clean and polished at all times. This local tradition died with the arrival of diesel and electric trains, which all pass regularly through automatic washers. The 2012 Olympic Park and Westfield shopping centre now occupy the entire Stratford depot and works site, which was once enormous, but nothing now remains there of its railway heritage.

The redevelopment

A plan to rebuild Liverpool Street completely was proposed by BR in 1975. This scheme involved closing and demolishing Broad

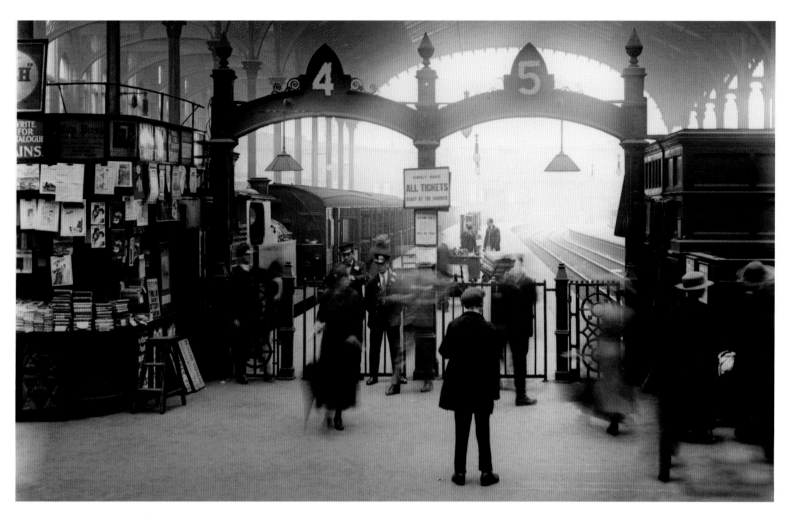

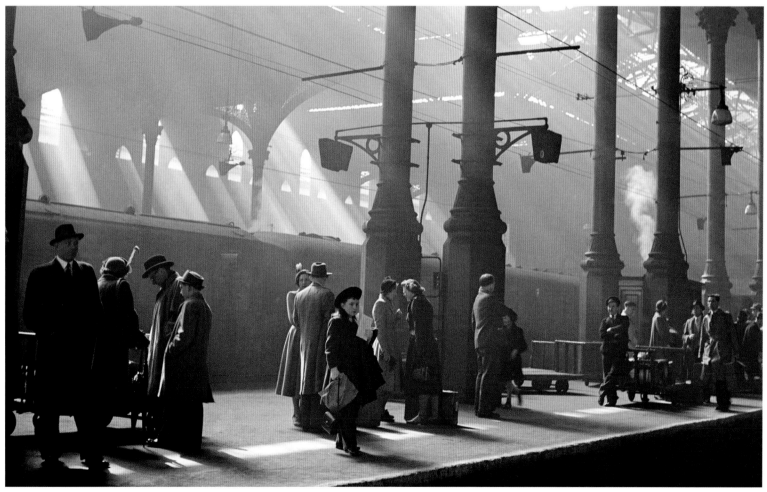

Memorials of conflict

In the First World War, Liverpool Street was hit during the first raid on London by German Gotha bombers on 13 June 1917, which was the deadliest air raid on Britain in the course of the war. Two bombs dropped through the station roof and hit trains ready to depart. Sixteen passengers and staff were killed and fifteen injured.

Over 1,100 GER employees who died during the war were commemorated on a large marble memorial at Liverpool Street, originally installed in the booking hall. It was unveiled on 22 June 1922 by Field Marshall Sir Henry Wilson and dedicated by the Bishop of Norwich. A few hours later, on his return home from the ceremony, Wilson was shot and killed on his own doorstep in Eaton Place, Belgravia, by members of the Irish Republican Army (IRA). A month later a plaque commemorating Wilson was added alongside the GER memorial. Both were moved to the upper level of the main concourse during the reconstruction of the station in 1989 and combined with a memorial to Captain Charles Algernon Fryatt, commander of the GER passenger steamer SS *Brussels*, who was another casualty of the Great War. Fryatt was executed by the occupying German army in Belgium in 1916 for attempting to ram a German U-Boat with his unarmed civilian vessel, an action widely considered heroic in Britain at the time, while his execution was condemned as murder. German propaganda maintained that justice had been served, but like the death of the British nurse Edith Cavell it was considered an illegal execution by the British Government and used by the newspapers to stoke anti-German feeling during the war.

Thousands of Jewish refugee children arrived at Liverpool Street in 1939 as part of the *Kindertransport* rescue mission to save them from imprisonment in the labour camps of Nazi Germany where many of their parents later died. An art installation commemorating the rescue was opened at the station in 2003 but had to be removed when the objects included in a showcase display began to deteriorate. A replacement memorial of life-size child figures in bronze by Fritz Meisler was installed outside the main station entrance on Liverpool Street in 2006. A bronze sculpture of a girl by Venezuelan artist Flor Kent, which had formed part of the original installation, was re-erected separately on the station concourse in 2011.

Top The elaborate GER war memorial, repositioned on the upper level of the concourse in the 1980s.

Above The *Kindertransport* commemoration at the main Liverpool Street station entrance.

Right *West Side Suburban in the First World War*, painting by Marjorie Sherlock (1897–1973).

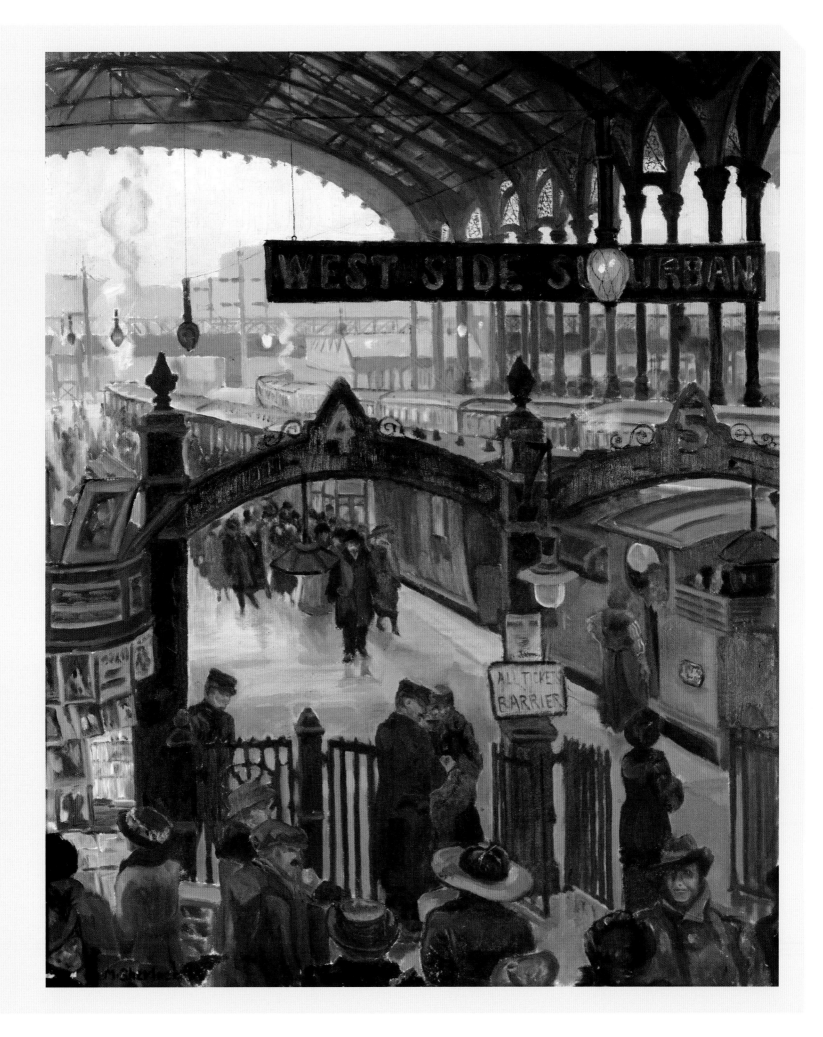

THE MOST POPULAR RENDEZVOUS IN THE CITY

GREAT EASTERN HOTEL

OWNED AND MANAGED BY THE LONDON & NORTH EA

FOR PARTICULARS OF TARIFFS APPLY RESIDENT N

VERPOOL ST STATION
ONDON, E.C.2.
ERN RAILWAY
AGER

HAYCOCK PRESS, LONDON.

Street next door and creating an enlarged twenty-two platform combined station across both sites, but buried under a huge commercial office development. There was strong opposition to this from heritage bodies, and a long public inquiry was held in 1976–7 that recommended retention of a substantial part of the old station and hotel in the new development. When planning permission was eventually given in the early 1980s it was for a considerably altered scheme that retained the 1874 West Side trainshed and the Great Eastern Hotel, as well as the Metropolitan Railway arcade opposite. Liverpool Street was not to disappear below ground like the rebuilt Birmingham New Street or Penn Station in New York.

Work on the final reconstruction scheme began in 1985 and took six years to complete. Instead of a straightforward demolition and functional rebuild, as had happened at Euston, Liverpool Street demanded a more thoughtful and subtle approach that could blend heritage features convincingly with high-tech modernity. The Broad Street site was completely redeveloped as the Broadgate Centre after the closure and demolition of the station in 1986. The 1894 eastern trainshed of Liverpool Street was also sacrificed for air-space development as part of a separate commercial office scheme on Bishopsgate.

A partnership for the co-ordinated rebuilding of Liverpool Street station, involving developers, architects and engineers was led by BR's Director of Architecture and Design, Nick Derbyshire. The result was an interesting new aesthetic, where the retained

143

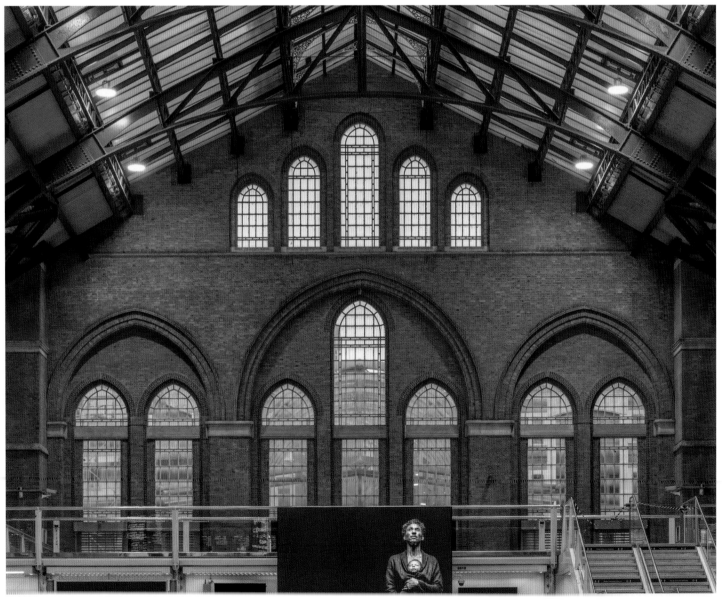

parts of the original station were adapted and partly extended with replica features. Four new brick towers in Victorian style, inspired by the design of the Great Eastern Hotel, were installed in pairs to mark the station entrances on Liverpool Street and Bishopsgate.

Inside, the listed western trainshed was renovated, with the acanthus leaf decoration restored to the 1874 columns. The whole roof was extended southwards to the new concourse and can now be distinguished from the original trainshed only by the colour scheme: off-white for the replica columns, cream for the originals to the north. A light, spacious and airy new concourse is surrounded by an elevated steel-and-glass walkway with shops and cafés. The two main station entrances are on this high level, with stairs and escalators down to the concourse, where a new booking office and a spacious Underground entrance were created. An unfortunate loss here was the Edwardian tearoom, which perched above the narrow stairs down to the Tube. On the high level to the west is a new bus station, and below it an arcade of shops leads out to Broad Street and the Broadgate Centre. When Crossrail was planned in the early 2000s to run deep below the City here, this site in front of the former Broad Street station was selected for the principal entrance to the new Elizabeth line, and a major archeological investigation took place before construction of the underground station could begin.

Everything has been transformed from the inconvenient and chaotic layout of the old station. Liverpool Street is almost unrecognizable, but all over the new station quirky architectural features and war memorials have been renovated, replicated and relocated. There was a deliberate attempt to recreate what architect Nick Derbyshire called the 'richness' of the old station, and these still make Liverpool Street an interesting environment to explore in a way that clinical Euston is not. The arrival of the Elizabeth line in 2022 will further add to this.

Liverpool Street's transformation was a vitally important moment in the history of London's great stations and a novel approach to modernization. For the first time careful thought was given to respectfully combining heritage with future needs in a dignified manner. As architectural writer Colin Amery remarks in his introduction to Derbyshire's book *A Station for the Twenty-first Century*, explaining how it was done 'the architectural excitement lies in the great space of the station itself – it is a triumphant rebuilding and a very happy marriage of old and new'.

Thirty years on, with the arrival of Crossrail just outside and below the main-line terminus, the adaptable 'future proofing' of Liverpool Street still looks secure in the 2020s.

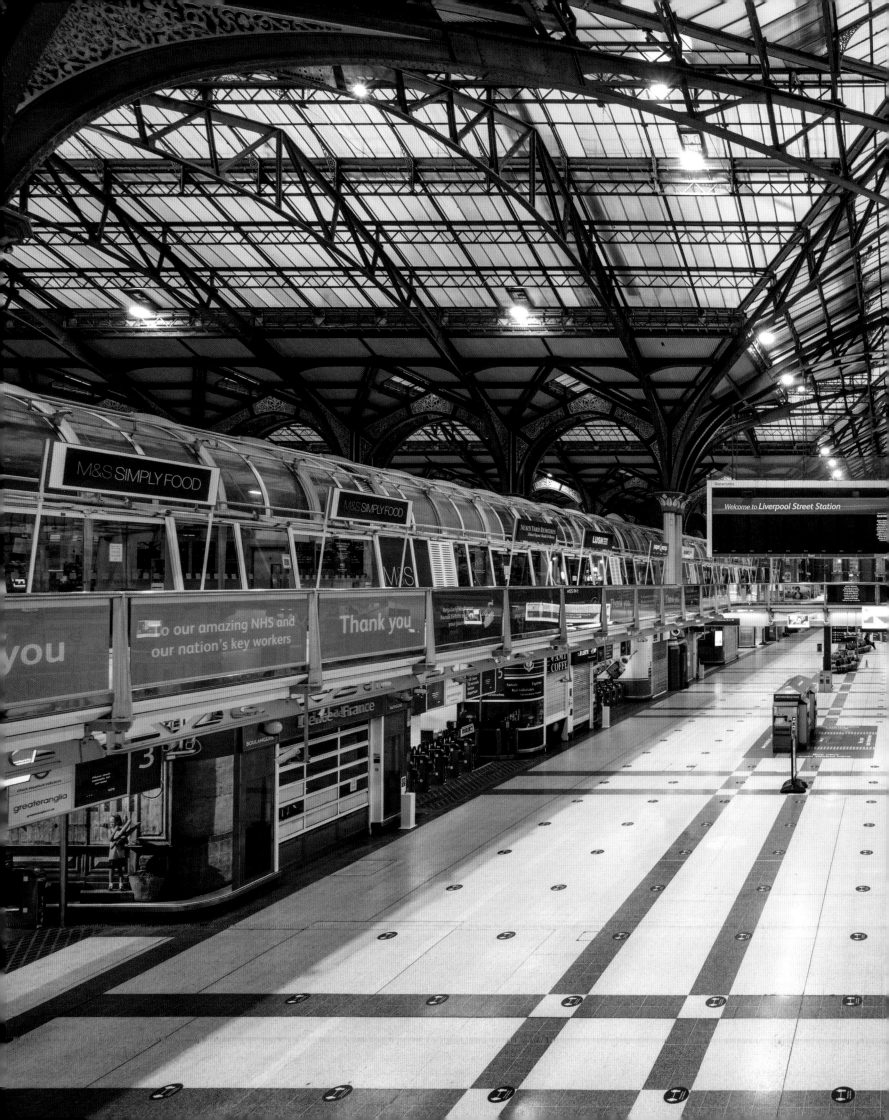

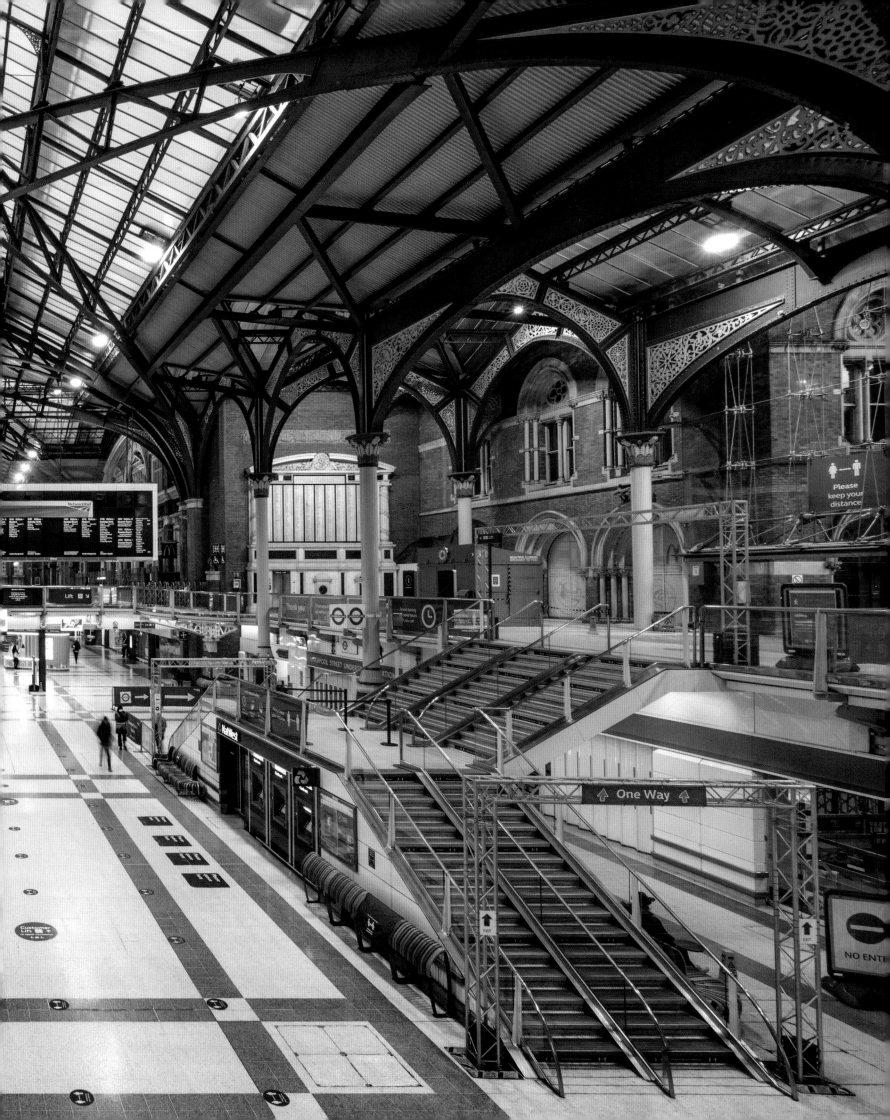

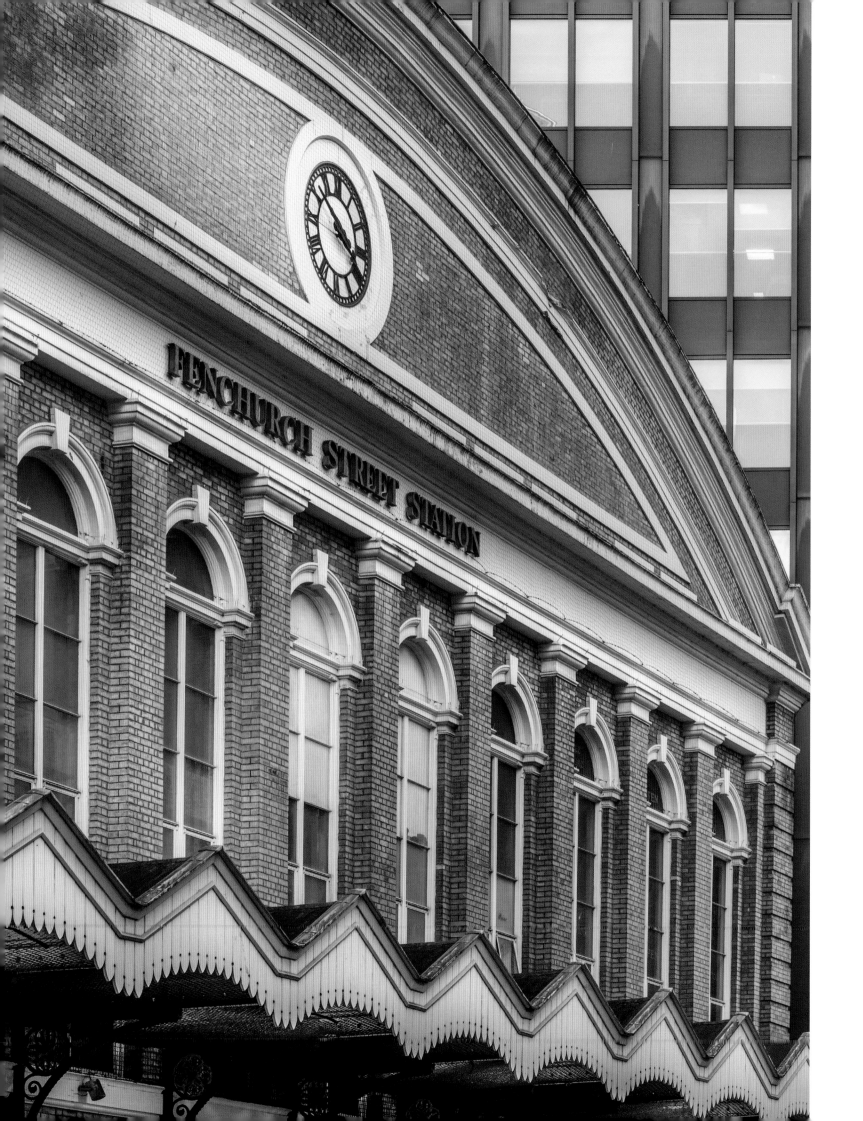

Fenchurch Street

Left The 1849 façade of Fenchurch Street has been cleaned and conserved, while the interior has been modernized and built over.

Right The high-level platform area of Fenchurch Street, with a Great Eastern suburban train for Ongar, c.1900.

Small but periodically busy Fenchurch Street was the first railway terminus within the boundaries of the City of London and coincidentally the first in the country to have a station bookstall. This was operated by William Marshall, whose newspaper distribution company later came to rival WH Smith. A station was opened on the present site by the London and Blackwall Railway (L&BR) in 1841, just beyond the original terminus of its short 5.6km (3½ mile) line. Built largely on a brick-arched viaduct, the L&BR connected the Minories, an area on the edge of the City, with the East and West India Docks. It had the dual object of providing a short cut to river passengers and connecting the principal London docks with the City. The line was cable hauled, powered by stationary steam engines at either end that drove a continuous cable, to which coaches were attached manually.

The L&BR opened on 6 July 1840, and a year later the service was extended to Fenchurch Street. There was no cable over the extension: incoming coaches from Blackwall were released from the rope at Minories station and continued up the short slope to Fenchurch Street under their own momentum. For the return, coaches were given a push by platform staff and attached to the cable at Minories. This was a far quicker way to get from the City to the London Docks than taking a paddle steamer on the Thames, but the cable system proved cumbersome and unreliable. In 1849, cable traction ended up being abandoned and the railway introduced conventional locomotive-hauled trains.

From 1850 a junction at Bow connected Fenchurch Street with a new line opened right across the inner north London suburbs through Islington and Camden Town. Originally known by the cumbersome title of the East and West India Docks and Birmingham Junction Railway, this company sensibly renamed itself to the North London Railway (NLR) in 1850. The extra traffic brought by the NLR, and the prospect of more business from another proposed line to Tilbury and Southend, led the L&BR to enlarge and rebuild its Fenchurch Street terminus.

The new station was designed by the L&BR's engineer, George Berkeley, as a joint terminus with the London, Tilbury and Southend Railway (LT&SR), which was part sponsored by the L&BR, and opened in 1854. There were five high-level platforms and a small passenger concourse covered by a single-arch all-over roof. The two-storey stock-brick station building at the City end has a plain but pleasant frontage on to Railway Place, topped with a curved pediment that matched the profile of the trainshed roof. Inside, on the ground floor, there were originally two separate booking offices for the L&BR and the LT&SR, with stairs up to the concourse and platforms.

Fenchurch Street station barely changed physically for more than a century, but had a complex history of operation by several different railway companies, who were at various times both partners and rivals. It was the City terminus for NLR services until the company opened a branch to its own new terminus at Broad Street in 1865.

Murder on the line

The first recorded railway murder took place on a North London Railway train on 9 July 1864, a few minutes after it had left Fenchurch Street station. Thomas Briggs, chief clerk of a City bank, was attacked, robbed of his gold watch and chain and thrown from a first-class compartment of the 9.50pm train between Bow and Hackney Wick. He was found fatally injured, lying on an embankment beside the track with 'his foot towards London and his head towards Hackney'. A young German, Franz Müller, was identified as the assailant by a jeweller who was offered the watch and a cabbie who knew Müller and recognized the unusual hat he had left behind in the train. Within five days of the murder Müller had boarded a sailing ship from Liverpool to New York, but was pursued by a Scotland Yard detective whose fast steamship overtook Müller's on the Atlantic crossing. Müller was arrested in Manhattan with Briggs' gold watch in his possession and brought back to London. He maintained his innocence throughout his three-day trial at the Old Bailey but was found guilty of murder and sentenced to death. Over 50,000 people gathered to watch the public execution, and loud cheering accompanied Müller on his walk to the gallows. The unruly execution scenes caused

Right Franz Müller, a young German tailor convicted and hanged for the first known railway murder in 1864.

great public debate over the morality of public hangings and Franz Müller became one of the last people to be hanged in public in Britain. The case also alarmed the travelling public and the railway companies. As a direct result, the communication cord safety device was introduced in most passenger trains and tiny circular windows, soon known as Müller lights, were fitted between some individual compartments, an unpopular safety feature because it reduced privacy. However, this notorious and well-publicized crime did not appear to dent the growing popularity of the North London Railway's services.

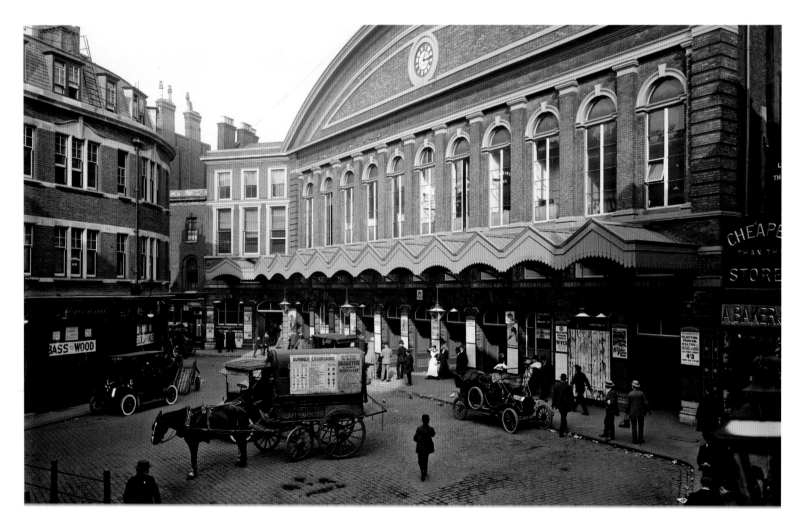

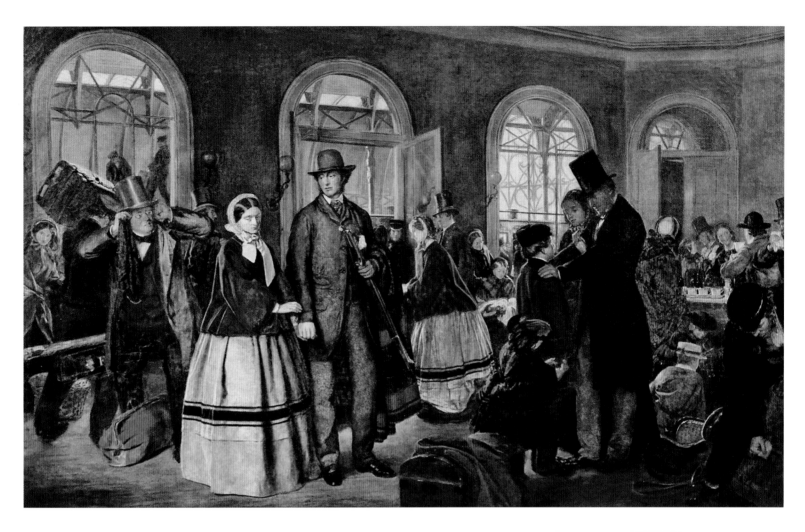

In 1866, the L&BR, which owned the station, was taken over by the Great Eastern Railway (GER). The GER already operated eleven daily LT&SR services between Tilbury and Fenchurch Street, as well as its own suburban services to the City from its new Loughton branch in Essex. The LT&SR became a fully independent company in 1862 but was eventually taken over by the Midland Railway in 1912. This led to a curious situation at the railway Grouping in 1923, when Fenchurch Street became the responsibility of the London and North Eastern Railway (LNER), as successors to the GER, but the main services from the station, run by the LT&SR until 1912, were now operated by the London, Midland & Scottish Railway (LMS), which had absorbed the Midland.

The LT&SR traffic at Fenchurch Street boomed in the early 1900s. Season ticket sales nearly doubled between 1902 and 1909 as City office workers took advantage of the cheap fares and fast trains to move out to the Thames Estuary coast and commute from Westcliff-on-Sea and Southend. By the 1920s, Fenchurch Street was handling 300 trains a day, with most of the 50,000 daily passengers packed into crowded commuter services in the rush hours. Plans to electrify the line and enlarge the station had been announced before the First World War, but neither of the private railway companies involved could afford to do this. Some limited improvements took place in the 1930s when the LMS introduced a fleet of new steam tank engines to improve performance. Passenger numbers rose to 70,000 a day, but full electrification of the Southend line had to wait until 1962.

Opposite Fenchurch Street station yard in 1912, with a horse-drawn delivery vehicle and early motor cars.

Above *Parting Words, Fenchurch Street Station* (1859) by Frederick Bacon Barwell. Train interiors and railway stations became popular as locations for 'modern life' paintings in the 1850s, with all the emotional implications of meetings, partings and journeys.

Below Fenchurch Street high-level concourse, c.1900.

Above *Thundersley*, one of the big Tilbury tanks used on the Southend trains, elaborately decorated to celebrate the coronation of King George V in 1911. It is now preserved in the national collection, the only LT&SR locomotive to survive.

Right Fenchurch Street station in springtime.

A plan by private developers to rebuild Fenchurch Street with an office block on top of the station was first proposed in 1959 but turned down by the City of London Corporation. In the 1980s a more sophisticated air-space development scheme was agreed, which gave British Rail (BR) sufficient income to modernize the station completely. George Berkeley's attractive 1854 façade, now listed, was preserved and renovated, but the interior was gutted and the trainshed removed to make way for the office building above. This is a stepped pyramid structure set back from the station frontage so that it does not overpower the Victorian façade visually. Escalators were installed from the old booking hall, now occupied by retail units, up to an enlarged concourse with a new ticket office and more shops. The design of the station interior is bland but functional, but does makes better use of the limited space available.

Fenchurch Street remains a curious anomaly among London's terminals. It is still the smallest of them all, with just four platforms, and the least known because of its back-street location and lack of direct Underground interchange. In fact it is only a few minutes' walk from Tower Hill on the District and Circle lines, and the Tower Gateway terminus of the DLR. The station is almost exclusively used by City commuters from south Essex on weekdays and is deserted at weekends, but passenger throughput is still over 15 million a year. Fifty years ago the future of Fenchurch Street looked uncertain but the oldest City terminus looks set to be as busy as ever in the 2020s, although with less pressure on weekday rush hours if post-COVID commuting patterns change.

London Bridge

London Bridge station stands on the site of the first passenger railway terminus in London, opened on 14 December 1836 by the Lord Mayor. The London and Greenwich Railway (L&GR), which built it, was a pioneer in bringing the first steam railway to the capital, but its ambitions were modest. The railway, as originally proposed in 1832, was to be just 5.6km (3½ miles) long, running between Greenwich and Tooley Street in Southwark, close to the southern end of London Bridge.

The promoters adopted a scheme designed by a retired Royal Engineer, Lieutenant Colonel G.T. Landmann, who suggested that the line should be on a brick-arched viaduct. Much of the route was then still open country, mainly used for market gardening, and at high level the line could easily bridge roads at the built-up London end, as well as the Surrey Canal. It was also intended that the railway arches would generate income by being rented out as stables, workshops or even, rather optimistically, as homes. The most successful tenancy was to a pub midway along the viaduct, which opened as The Half Way House.

By September 1835, the *Mechanics Magazine* was writing that 'The London and Greenwich Railway is now fast approaching completion and presents a very imposing appearance. It forms a highly interesting object from the summit of Nunhead Hill at the back of Peckham, from which the range of arches, seen in its entire length, appears like the "counterfeit presentment" of a Roman aquaduct.'

Even before any trains were running, Landman's 878-arched viaduct was being promoted as an entertainment to visit and stroll along the tree-lined 'boulevard' alongside. The entire length of the viaduct was illuminated by gas, making it a novel spectacle even after dark. As early as March 1835, *The Times* reported that 'The number of people who paid 1d [one penny] each to walk on the footpath of the London and Greenwich Railway on Sunday last amounted to upwards of 3000.' This brought in about £400 a year.

The centre section of the line was ready first and opened between Spa Road, Bermondsey and Deptford on 8 February 1836. Technically, therefore, Spa Road was the first London terminus, but the line was extended to Tooley Street only ten months later. At the other end, Greenwich was not reached until 1838. London Bridge beat Euston by seven months as the first rail gateway to the capital, but the station was, in Alan Jackson's words, 'a very Spartan affair'. Trains arrived and departed from two open platforms at the end of the brick viaduct, reached by a ramp and steps from the street below. The only station building was a plain three-storey block on the south side of the viaduct, which contained the booking office. Up on the viaduct itself there was no trainshed, roof or weather protection of any kind for waiting passengers. A design was prepared for a triumphal arch, but this was never built.

Nothing remains of the original terminus at London Bridge except for part of the viaduct structure, which can still be seen at the Tooley Street end of what was formerly Joiner Street and is now a pedestrian tunnel under the station. London Bridge started small but grew rapidly into a large, sprawling station complex

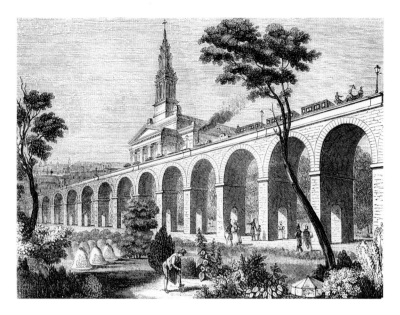

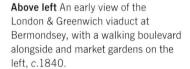

Above left An early view of the London & Greenwich viaduct at Bermondsey, with a walking boulevard alongside and market gardens on the left, c.1840.

Above right A ticket to the opening of the London & Greenwich Railway at London Bridge station, 14 December 1836.

Right above Balloon view of the London & Greenwich Railway and River Thames, c.1845. The London Bridge terminus, not yet enlarged, is top left, close to the river bridge as it is today.

Right below This station opened at London Bridge in 1844 for joint use by the three railway companies. They quickly fell out and created separate stations instead (see page 163).

divided between different railway companies. The little L&GR did not have aspirations itself to develop into a main-line company, but saw the revenue potential in giving other railways access rights over its viaduct to London Bridge, where it owned enough land to develop a much larger terminus.

Divisions force change

The first such company was the London and Croydon Railway (L&CR), which paid a toll to the L&GR to run into a separate terminus just north of the original station at London Bridge. The L&CR station opened in 1839 with a proper trainshed over the high-level platforms and a booking office down below in Joiner Street. Two more companies, the London and Brighton Railway (L&BR) and the South Eastern Railway (SER), also wanted access to London Bridge. This meant widening the viaduct to provide more access tracks and building a new joint station on the site of the original L&GR terminus, with an 'Italian palazzo'-style frontage designed by Henry Roberts. But even before the joint station was opened in 1844, the L&GR had fallen out with its clients over the level of tolls they were charging. In an effort to break the Greenwich company's stranglehold on entry to London from the south-east, the SER built a short spur off the L&CR's approach line to a separate terminus at Bricklayers Arms on the Old Kent Road, which was also opened in 1844.

Bricklayers Arms, because of its inconvenient location, was not a viable competitor to London Bridge as a passenger terminus. The

SER ran regular services there only until 1852, when it became a goods depot. By this time they had achieved their objective and forced the L&GR to reduce its tolls to London Bridge. Under a new lease the SER decided to build its own station on the north side of the London Bridge site in 1850. Meanwhile, the Croydon and Brighton companies had merged in 1846 to create the London, Brighton and South Coast Railway (LBSCR).

When the SER physically divided the London Bridge site with a boundary wall, the LBSCR was left to develop its own station on the south side. The machinations and fallouts between a number of competing Victorian railway companies were the cause of more than a century's chaos at London Bridge. Decisions taken in the 1850s and 1860s effectively blighted its layout for 150 years.

London Bridge developed as two stations side by side, and with an exceptionally fast rate of passenger growth. Between 1850 and 1854 the annual number of passengers using the London Bridge terminals doubled from 5.5 million to more than 10 million. Both railway companies were pushing for closer access to the City and the West End, which they achieved in the 1860s with extension lines over the river to Cannon Street, Charing Cross and Victoria. At London Bridge this required the transformation of the SER terminus into a through-station, with the Charing Cross extension taking a tortuous path at high level around Southwark Cathedral before bridging the river. The LBSCR side of London Bridge remained a terminus but was rearranged with more platforms and increasing lengths of platforms.

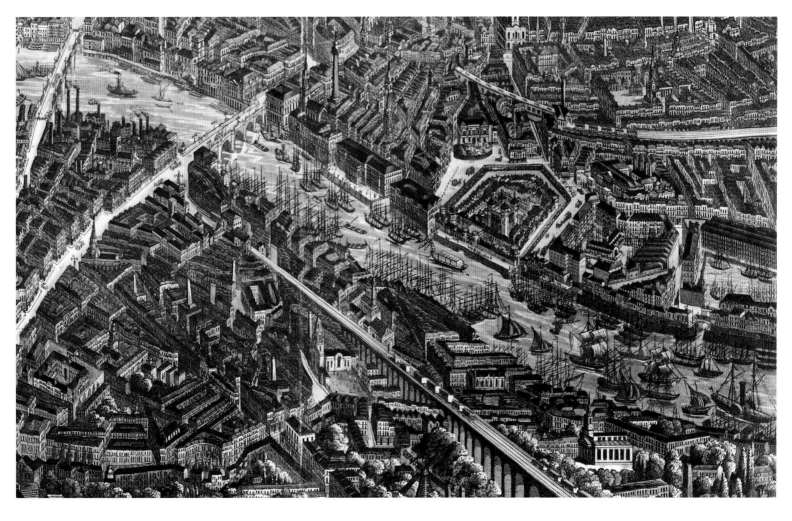

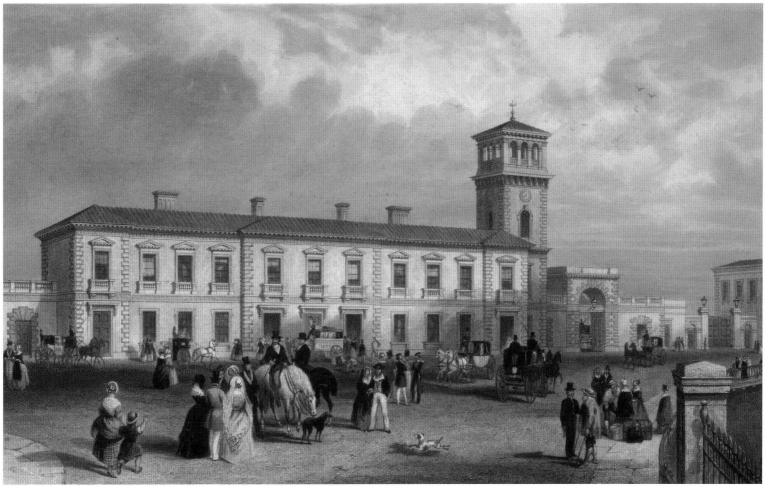

Left The brick vaults of London Bridge station, opened up as a passenger walkway in 2018.

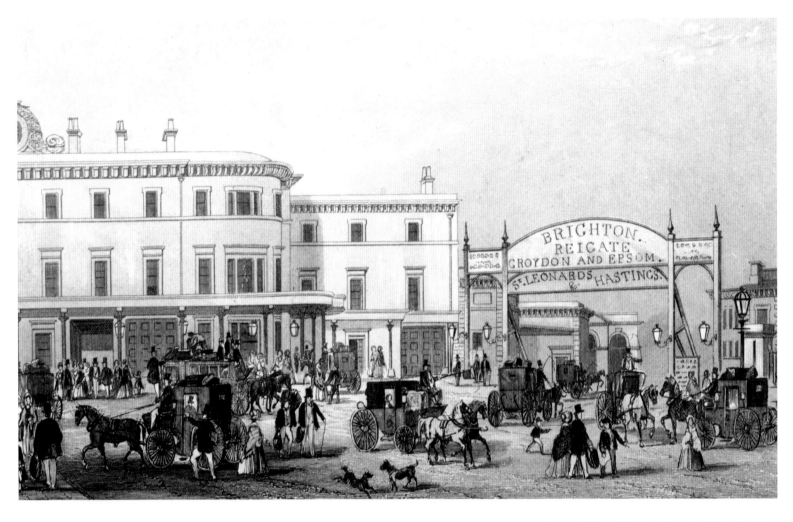

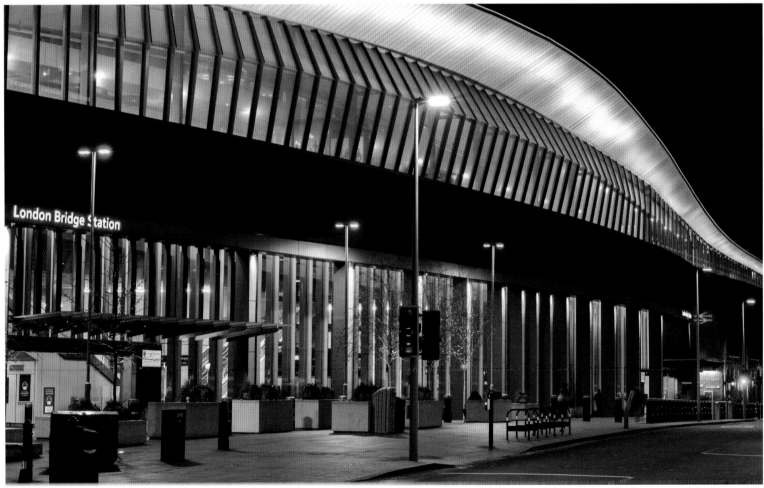

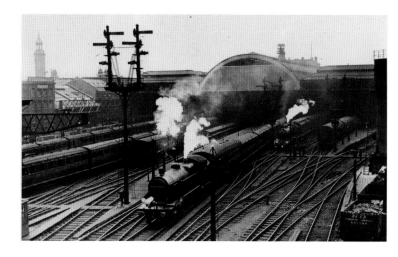

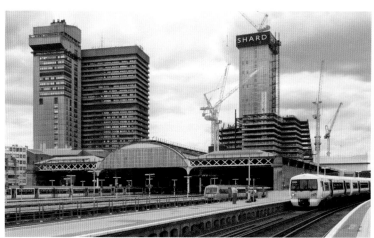

Until the recent rebuild, the most impressive thing about London Bridge was not the station but the approach. By the beginning of the twentieth century, the viaduct that had begun in the 1830s had been widened to accommodate eleven parallel tracks. All of these are still intensively used by commuter trains on a daily basis; the busiest rail approach to central London. Electric trains were first introduced at London Bridge by the LBSCR using an overhead power supply for their South London line around to Victoria via Denmark Hill. In the 1920s, the Southern Railway, which had taken over in 1923, began electrifying all the lines into London Bridge but using the third-rail power system.

The full electrification of the Brighton side and removal of the overhead wires in 1928 coincided with the first breach in the wall between the two London Bridge stations. A new footbridge across the divide made it easier for the growing number of commuters needing to change trains here, but it did not solve the complexity of mass passenger flow through the station at rush hour. By 1936, the combined stations were handling about 250,000 passengers a day, largely concentrated in the morning and evening peaks. There was a particular glut of commuter services to the Sussex coast all departing at or shortly after 5pm. A typical timetable included twelve-car services to Brighton, Eastbourne and Littlehampton, all leaving on adjacent tracks out of London Bridge between 5.00 and 5.05pm. 'The Fives', as they were known to railway staff, continued to run until the mid-1970s.

During the Second World War the station was badly damaged by bombing but only patched up afterwards. In the post-war period, passenger numbers recovered and grew even faster, but a complete reconstruction plan by British Railways (BR) in 1961, to be funded by commercial office development above the station, was turned down. Instead there was partial and inadequate redevelopment and improvement from the late 1960s onwards. The remains of the bomb-damaged station buildings were demolished, and the old LBSCR trainshed of 1866 was given a new roof. Two separate tower blocks and a covered bus station sprouted on the frontage and concourse area, which was remodelled, but none of this formed part of an integrated master plan for the whole site.

Final redevelopments

A final twentieth-century development came with the construction of the Jubilee Line Extension (JLE) in the 1990s. The Northern line (then the City and South London Railway) had been the first Tube to run under London Bridge in 1900, with an awkward link to the surface station. A century later the JLE arrived and was ingeniously threaded through the crowded sub-surface structures and services. The JLE project architects and engineers used the opportunity to open up and revitalize the cavernous brick catacombs supporting the main-line station, using them as an attractive access route to the Underground booking hall and escalators. Joiner Street, formerly a grim brick tunnel running

Opposite, left and below Three views of the completely refurbished and reconstructed London Bridge station, which was officially opened by Prince William, Duke of Cambridge, on 9 May 2018. The formerly divided station has been opened up and integrated, with an extensive and spacious interchange concourse beneath the platforms. Particular attention has been paid to wayfinding, with clear signage and pictograms throughout, transforming the most confusing station in London.

Overleaf All platforms at London Bridge can now be accessed by lift, stairs and escalator.

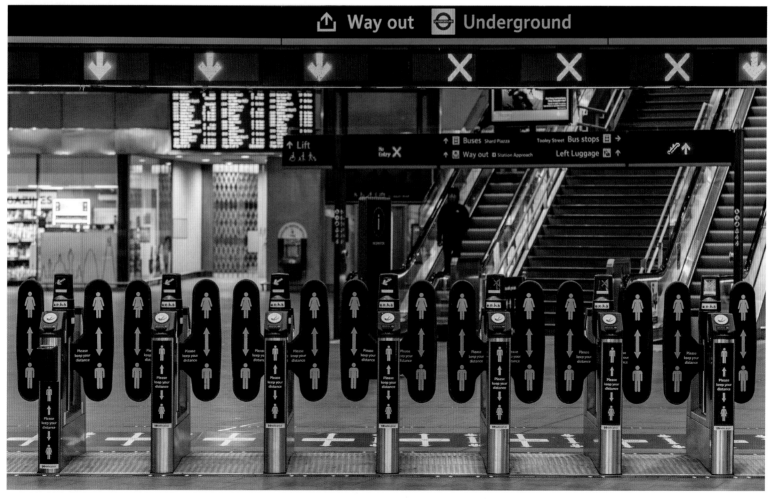

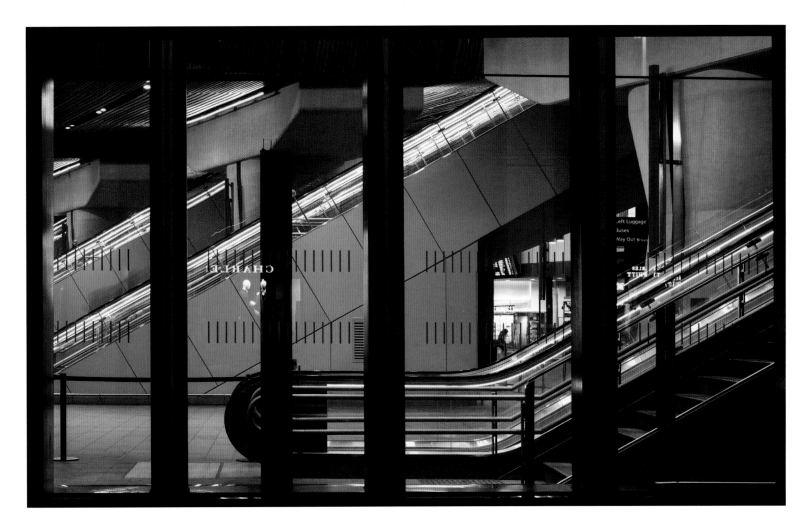

below the station, was closed to traffic, cleaned up and converted into an inviting subterranean environment, complete with shops and cafés in the arcade. This cleverly reworked complex, now far more than a quick commuter cut-through, was opened in 1999.

In 1991, a 'Thameslink 2000' project was proposed that would improve services on the newly created cross-London link over Blackfriars Bridge, including the reconstruction of the viaducts and junction over Borough Market on the through lines just beyond London Bridge station. It was originally hoped the work would be complete by 1997, but the scheme was delayed by the privatization of British Rail in 1996 and the knock-on effect of changes to the routing of HS1 into St Pancras.

Railtrack, the public sector company that took over responsibility for most of BR's track and infrastructure, announced a £500 million refurbishment programme for London Bridge station in 1999, but this too was postponed during the crisis period that followed BR's badly handled break-up and the replacement of the struggling Railtrack by Network Rail (NR) in 2002. NR is an 'arm's length' public body of the Department of Transport, with no shareholders, which reinvests its income in the railways.

London Bridge station was comprehensively redeveloped by Network Rail between 2009 and 2017 with the rebuilding of all fifteen platforms, the addition of two major new street-level entrances, and changes to passenger concourses and retail facilities. In a separate project the impressive but controversial Shard office tower, designed by Renzo Piano, and currently

the tallest structure in Europe, was completed immediately alongside the station in 2012. This included a new entrance and roof for the terminal level concourse, and a larger, open bus station was constructed beside the building. Architects for the station project were Grimshaw, previously responsible for the design of Waterloo International when it was constructed in the 1990s. The main contractors were Costain and Balfour Beatty.

In a five-year build, the Thameslink Programme, a partnership between the Department for Transport, Network Rail, Govia Thameslink Railway, Southeastern and Siemens, created the largest street-level station concourse in the UK. Work included a major track upgrade, a new rail underpass on the approach to the station and platform widenings and extensions, all of which meant that 30 per cent more trains could use the station than before.

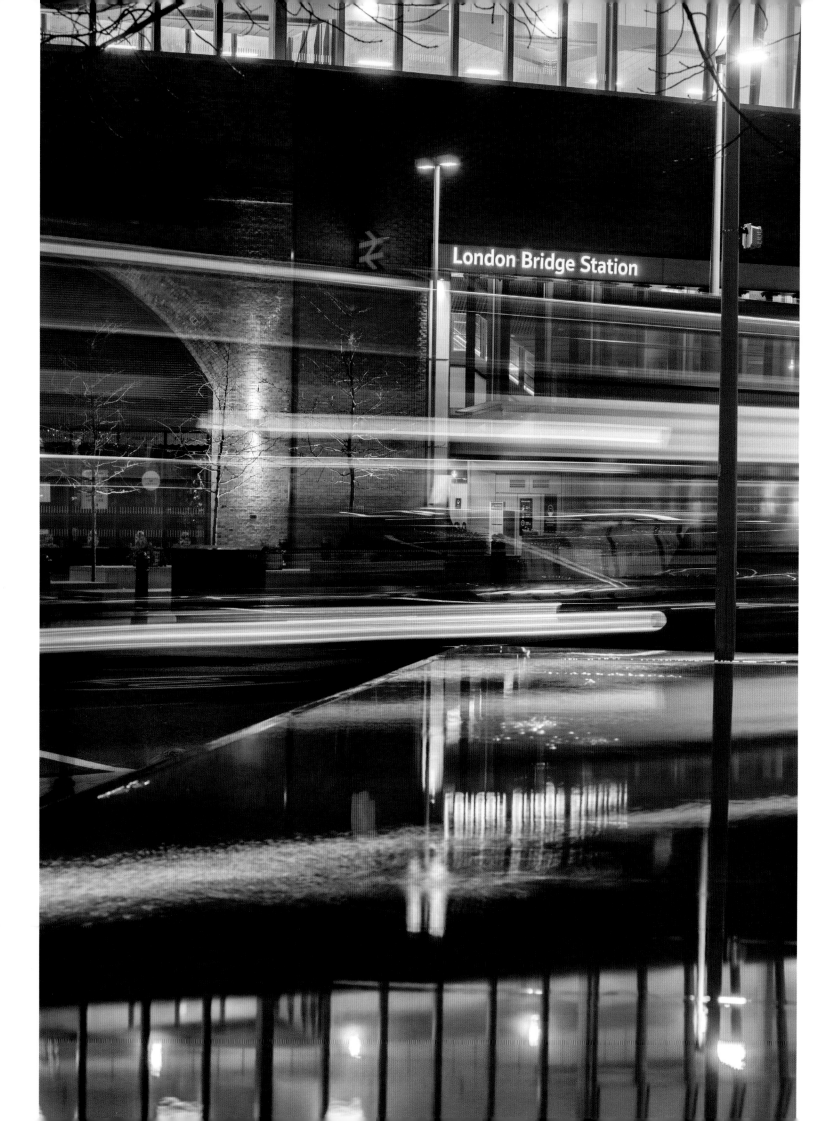

Opposite, left and below A wide range of materials and surfaces, from brick and wood to metal and glass, give all areas of the station, inside and out, the feel of variety and quality.

Overleaf Wood-panelled ceiling areas and subtle lighting make the interior seem more like a concert hall than railway station, a world away from the concrete and strip-lighting brutalism of the 1960s platform areas at Euston.

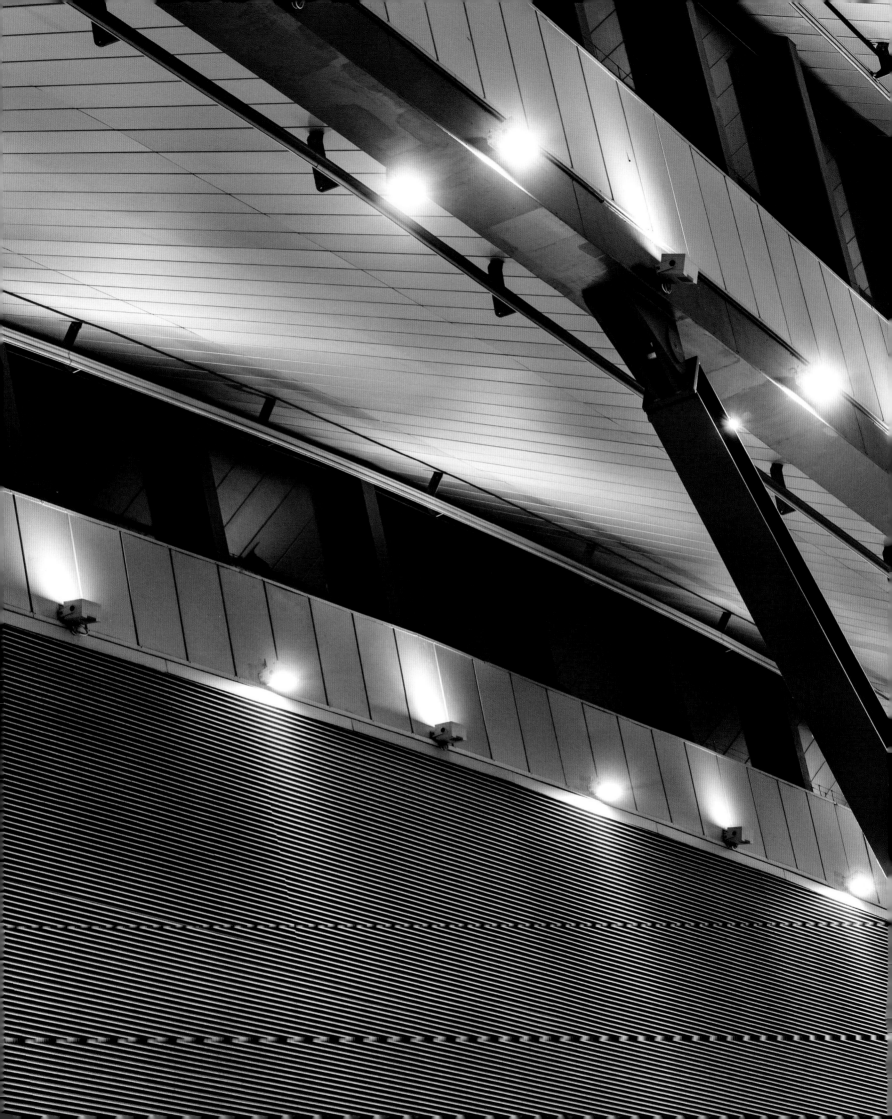

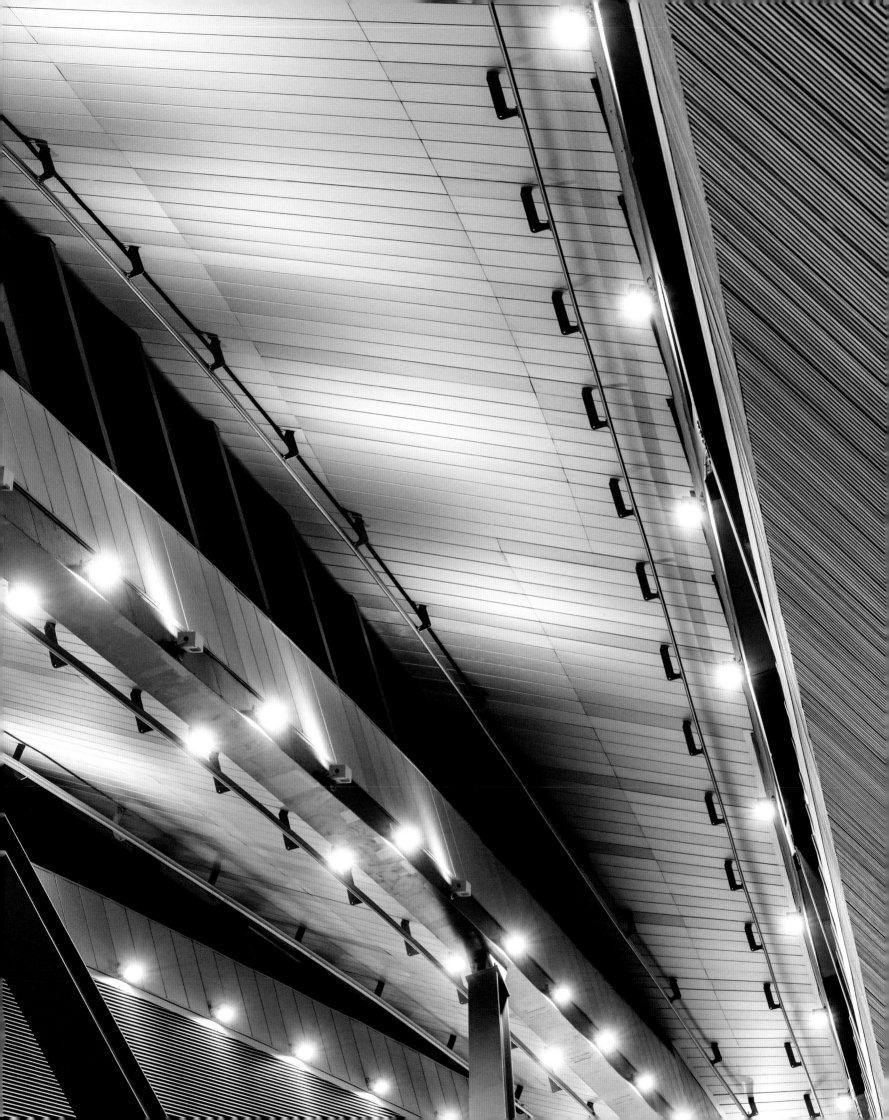

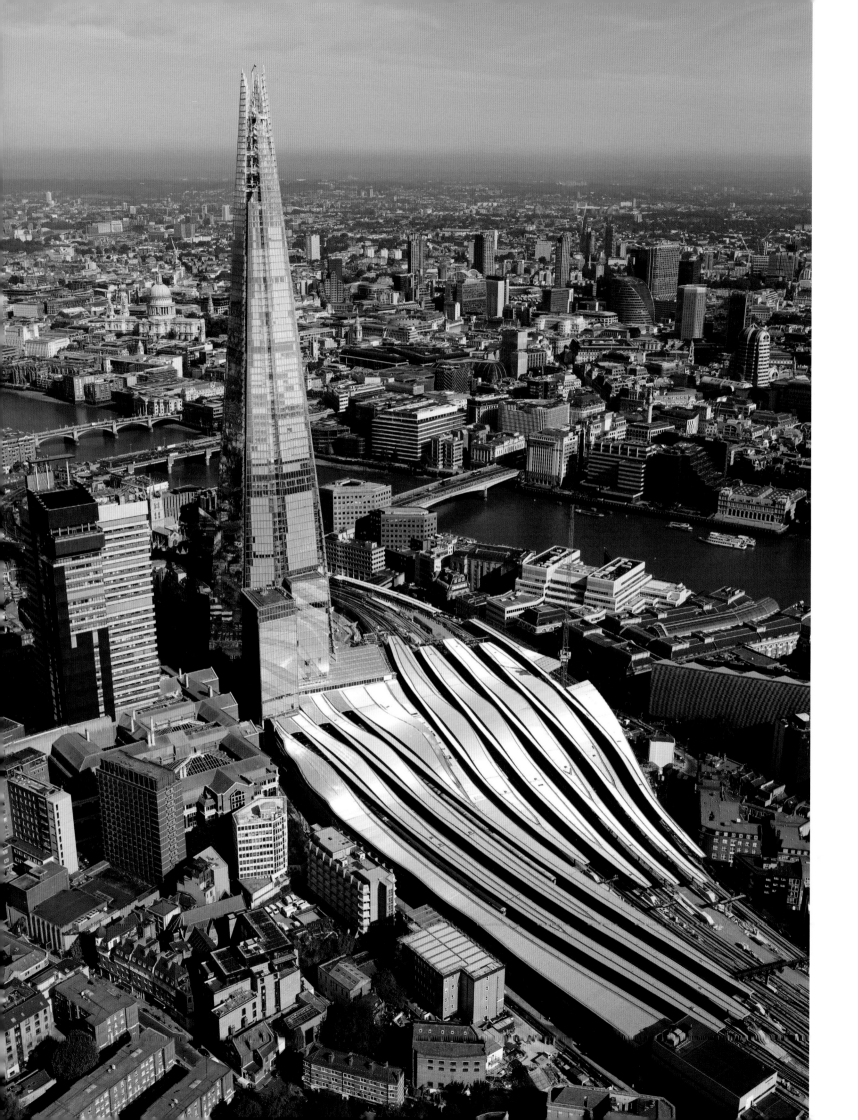

Opposite London Bridge from the air, with the reconstruction of the station complete and the Shard tower open for business.

Left The Shard glowing at night, high above the station platforms.

Overleaf A wider pedestrian route was created below the platforms through the Western Arcade to Joiner Street and the Underground station. This meant relocating existing shops into renovated barrel vaults set back from the arcade on either side.

The total estimated value of the project was around £1 billion. Throughout the rebuild, the station remained open to ensure rail services were maintained for the 50 million passengers who use it each year. London Bridge is currently the fourth busiest station in the UK.

As part of the rebuilding works, permission was given for the demolition of the Victorian trainshed over the terminal platforms. This is in the remaining Brighton side of the station built in the 1860s. As this was a listed structure, its removal was on condition that it had to be carefully dismantled for potential re-erection elsewhere. The ironwork has now been removed to storage in Aberystwyth, Wales, where it will eventually be resurrected as a heritage feature for the Vale of Rheidol narrow-gauge steam railway.

The less historic footbridge dating from the 1970s that linked the through and terminal platforms was also taken down, and replaced by an interchange concourse below the platforms accessed by lift, stairs and escalator. Opening up this area required the demolition of brick vaults at street level between Stainer and Weston Streets, which were pedestrianized and became part of the spacious new concourse. A wider route was created through the Western Arcade to Joiner Street and the Tube station by relocating existing shops into renovated barrel vaults. Two major new street-level entrances were opened to the south on St Thomas Street and to the north on Tooley Street.

This unfortunately required the demolition of the 1893 SER office building, but the overall effect has been to create an attractive and integrated station environment. London Bridge had always been confusing and difficult to use, with poor access on multiple levels, but it is now a model of clarity. The signage and wayfinding on the new station is particularly clear and London Bridge no longer feels like an intimidating warren. It has also been opened up on all sides rather than acting as a grim brick barrier dividing the local area.

The refurbished station was officially opened by Prince William, Duke of Cambridge, on 9 May 2018. In July 2019, it made the shortlist for the Stirling Prize for excellence in architecture. It had already won the RIBA London Building of the Year Award 2019, and the *Architects' Journal* Building of the Year 2019. The station earned high praise from the judges, whose comments included: 'hugely impressive – a giant of a project' and 'does grandeur with huge modesty'. London Bridge has come a long way since 1836, when the capital's first railway terminus was opened with just three tracks and two uncovered platforms on the stub end of a viaduct.

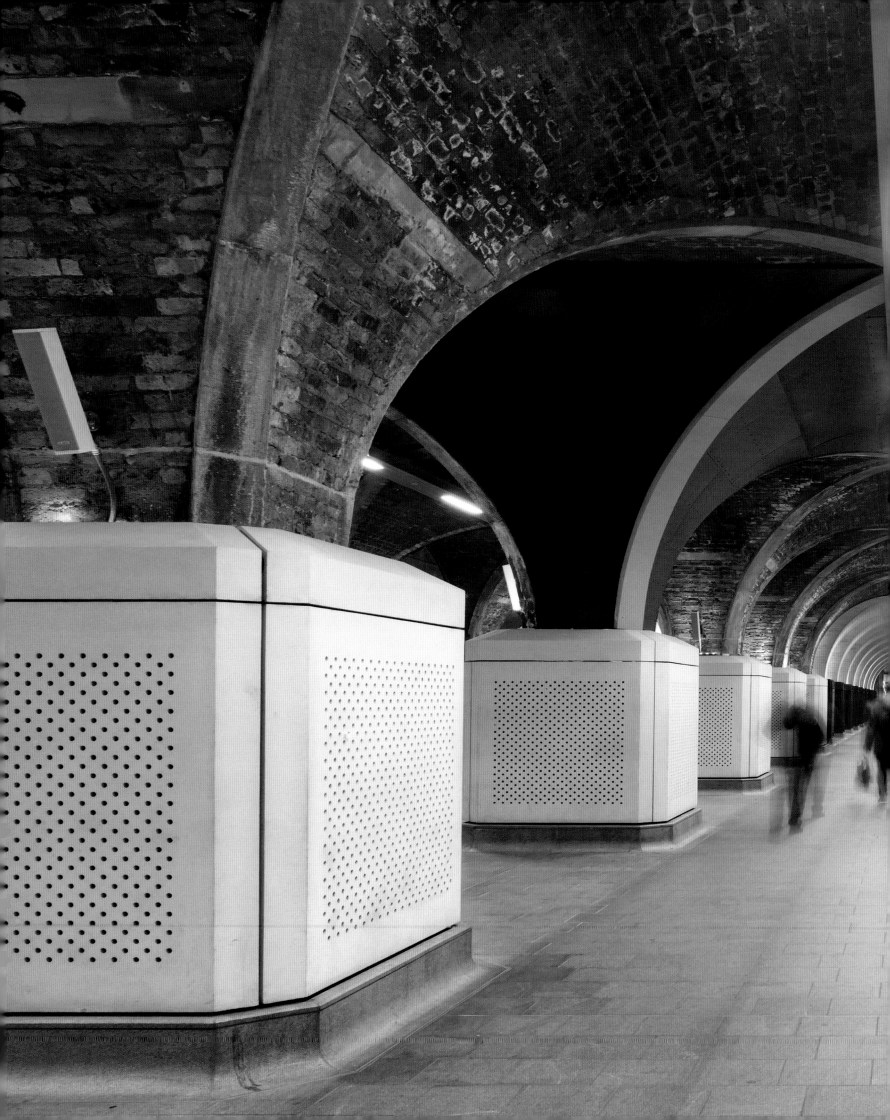

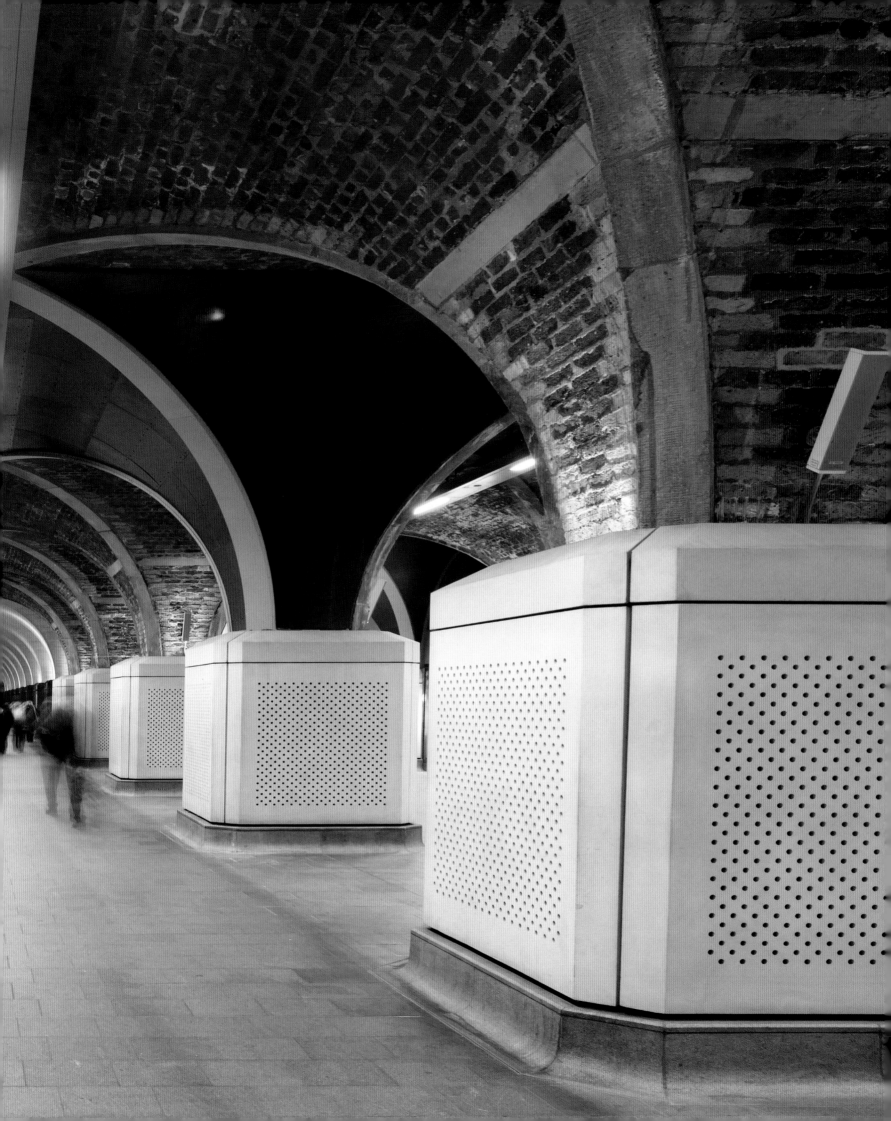

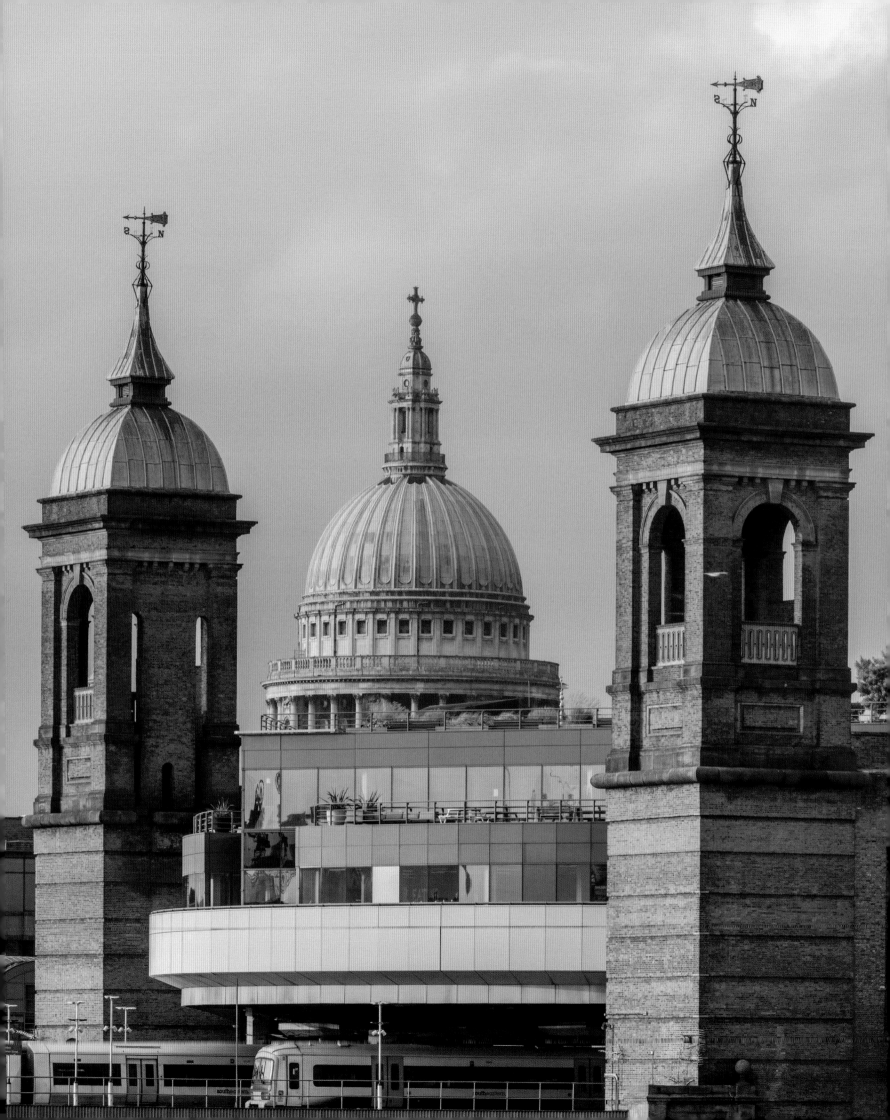

Cannon Street

Cannon Street is the product of Victorian railway rivalry. The South Eastern Railway (SER), which had brought its trains from the Kent coast as far as London Bridge in 1844, was soon in competition with the London, Chatham and Dover Railway (LCDR), which developed an alternative route to the capital across north Kent in the 1850s. When the LCDR planned to get direct access to the City by crossing the Thames at Blackfriars with a line to Ludgate Hill, the SER secured its own route over the river to Cannon Street on a branch from its Charing Cross extension. A triangular high-level junction on the new viaduct just west of London Bridge created the first rail link between the City and the West End via the south bank.

The station, river bridge and viaducts were all designed by John Hawkshaw, the SER's consulting engineer. Work began in July 1863 and Cannon Street station was opened just over three years later on 1 September 1866. There was a frequent shuttle service around to Charing Cross, which was the quickest way to get from the City to the West End before the District Railway opened along the Embankment. In 1867, 3.5 million passengers made this 7-minute local journey, nearly half the numbers using the new station in its first year of operation. Nearly all main-line trains in and out of Charing Cross, including the SER's Continental boat-train expresses to Dover and Folkestone, originally called at Cannon Street as well, requiring complex manoevring through Borough Junction and back over the river.

Hawkshaw's station was built on a great brick-arched base structure at the northern end of the railway bridge over the Thames. Massive arcaded walls down both sides originally supported a crescent-shaped iron and glass roof over the platforms, with tall twin towers at the river end. At the other end of the trainshed, the City Terminus Hotel was built by a separate company to a design by E.M. Barry. It opened for business eight months after the station, in May 1867, and was later acquired by the SER. The hotel's public rooms became popular for banquets and business gatherings, including the meeting in July 1920 at which the Communist Party of Great Britain was established.

Cannon Street was electrified by the Southern Railway in the late 1920s for suburban services, and rush-hour commuter traffic became the mainstay of the station. The boat-trains to Kent nearly all ran from Victoria by this time, but some steam-hauled express services still left Cannon Street until the early 1960s. The terminus and hotel were badly damaged by wartime bombs, possibly attracting more direct hits than larger stations because the bridge and twin towers made it such a prominent target for bombers flying up the Thames. The overall roof was patched up after the war, but was eventually taken down in 1958, and the hotel, which had become offices, was demolished in 1963.

The station then went through two long phases of rebuilding over the next thirty years. At the City end, bland 1960s office blocks designed by architect John Poulson were

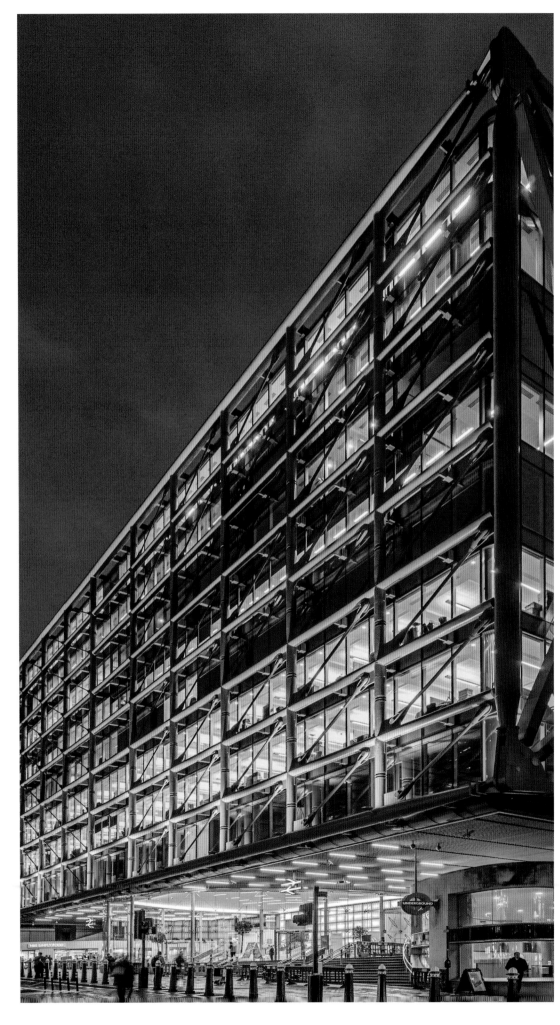

Left Cannon Place, the latest office development on the former hotel site at Cannon Street. The entrance to both the main-line and Underground stations is now below the offices.

Right Postcard view of Cannon Street from the platform ends over the river, *c.*1905, with the overall roof between the towers still intact.

Below *Cannon Street Station, Interior* (1913) by Frank Brangwyn. The platforms are crowded with working-class Londoners returning from their annual working holiday hop-picking in Kent, for which special trains were laid on.

Overleaf View upriver from London Bridge with Cannon Street on the right (north) bank.

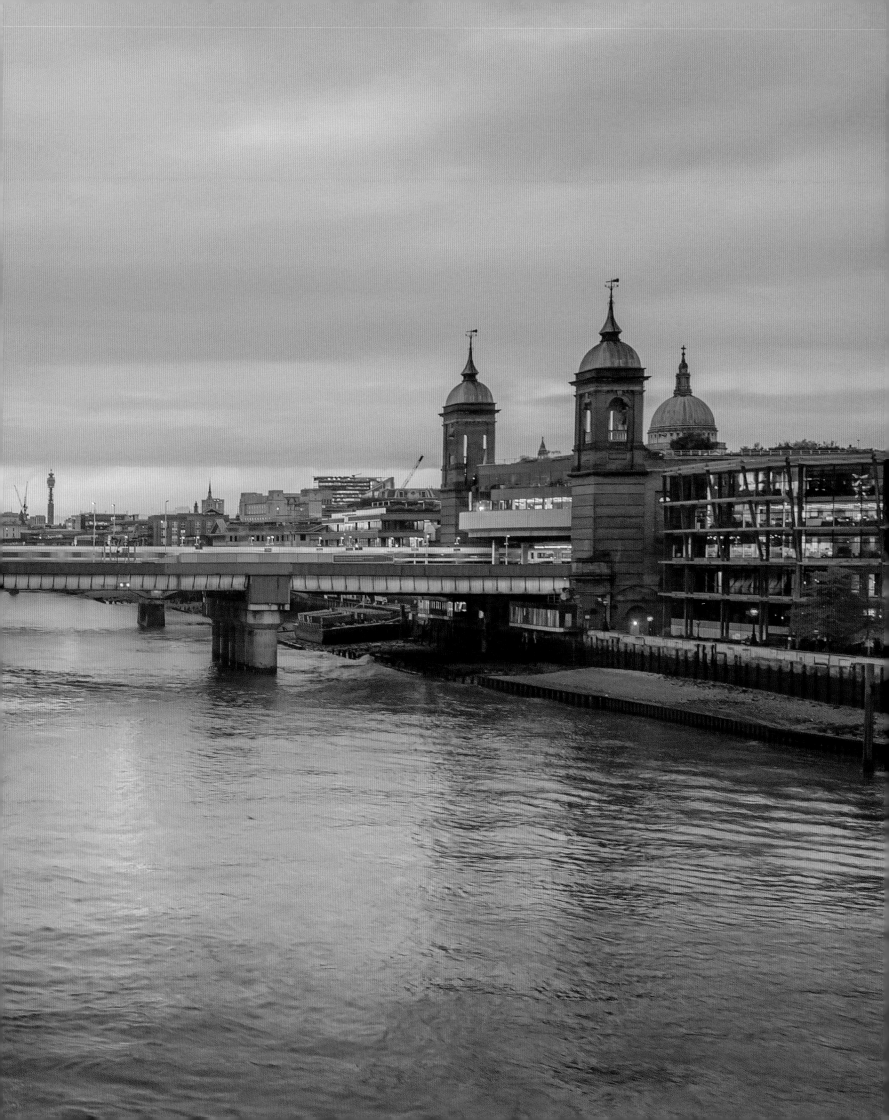

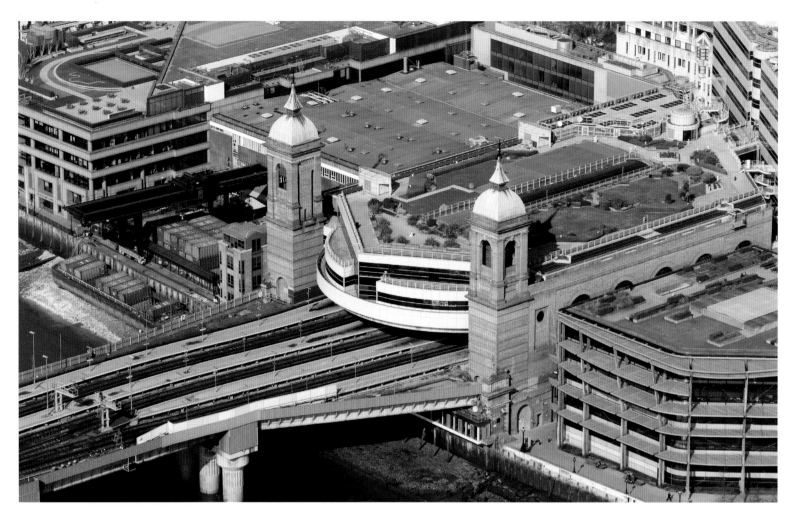

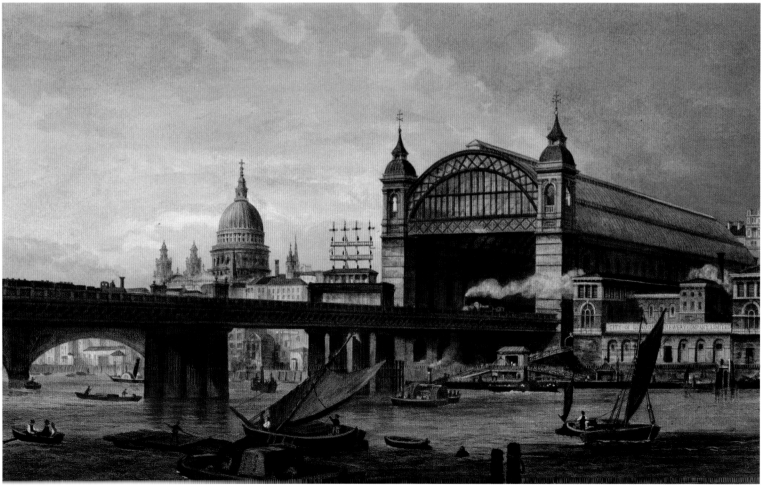

built in place of the hotel and over the station concourse, which was remodelled and linked to a modernized Underground station below. Poulson was later jailed for corruption and admitted at his trial in 1974 that shortly before receiving the Cannon Street contracts he had given his friend Graham Tunbridge, a senior British Rail surveyor involved in redevelopment projects at several BR stations, money and presents. The Poulson office block on the Cannon Street hotel site and over the Underground was in turn replaced by another commercial development in 2010. This large successor office block has a tubular external frame, which is undistinguished by day but acquires dramatic blue lighting after dark.

The main-line station platforms at Cannon Street were left open to the sky until the late 1980s, when an ingeniously designed office building on a steel deck was inserted between the remains of the great walls that had supported the original roof. The smoke-blackened Victorian brickwork and towers were cleaned and now bookend the black-and-white prow of the new commercial offices, as if enclosing a liner being launched into the Thames. The River Building has two storeys, providing 8,800m² (95,000ft²) of office space and a ½-hectare (1-acre) garden on the roof, which is invisible from the ground. Below the deck is a modern commuter station, but from the river, Cannon Street's impressive contribution to the City skyline has been artfully maintained.

Opposite above Cannon Street from the air, showing the deck between the station towers carrying The River Building offices and roof garden.

Opposite below Victorian print of Cannon Street station and St Paul's Cathedral, c.1870, with river traffic and a train about to depart under the large signal gantry over the tracks.

Above Three details of Cannon Place, the office development built in front of and partly over the station in 2010, which has external bracing.

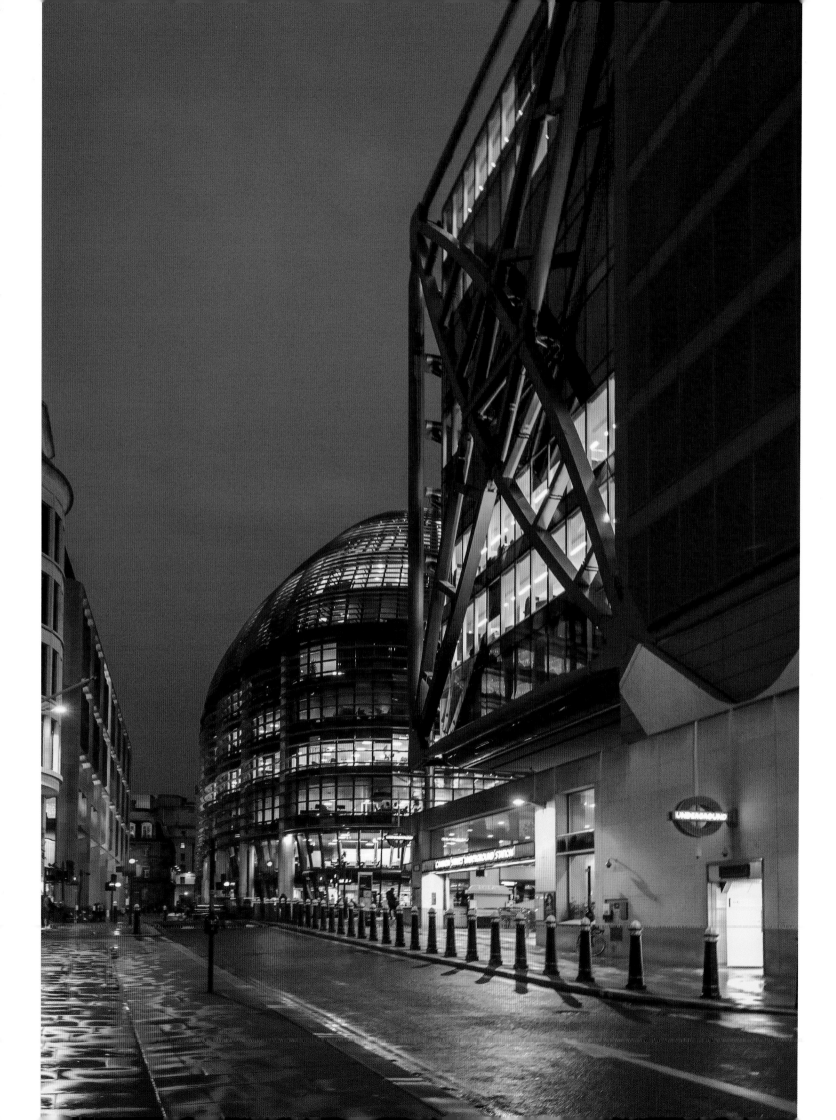

Left The northern entrance to the Underground station on Cannon Street below the new Cannon Place office development.

Right Twilight view along Cousin Lane to the west of the station. The River Building incorporates the lower storey of the original 1866 Cannon Street.

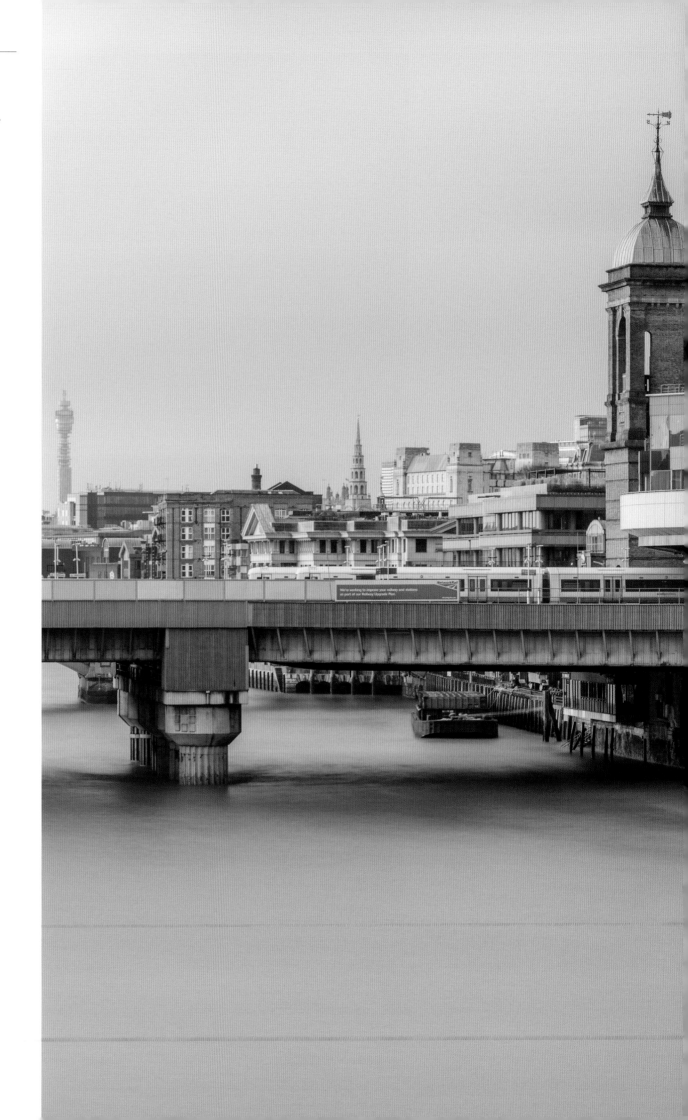

Right Cannon Street from London Bridge. St Paul's to the right, BT Tower on the far left.

Overleaf Cannon Street reflections.

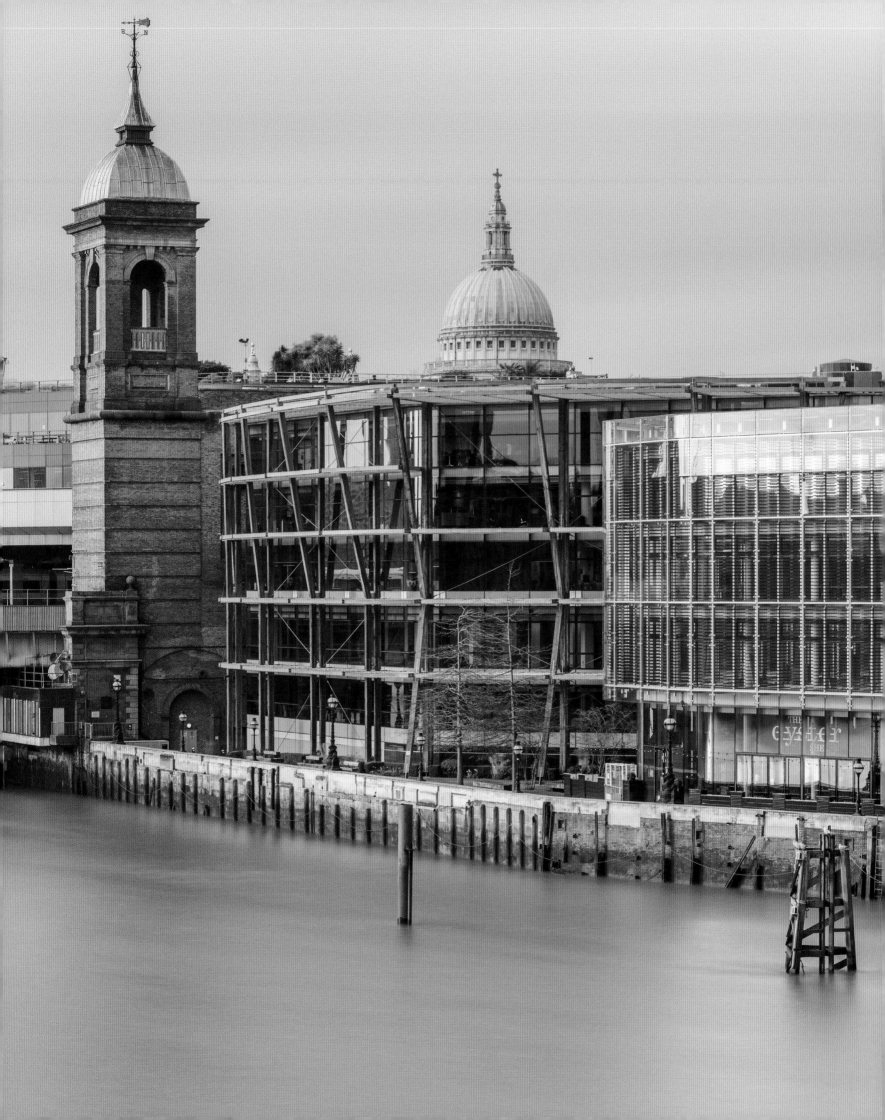

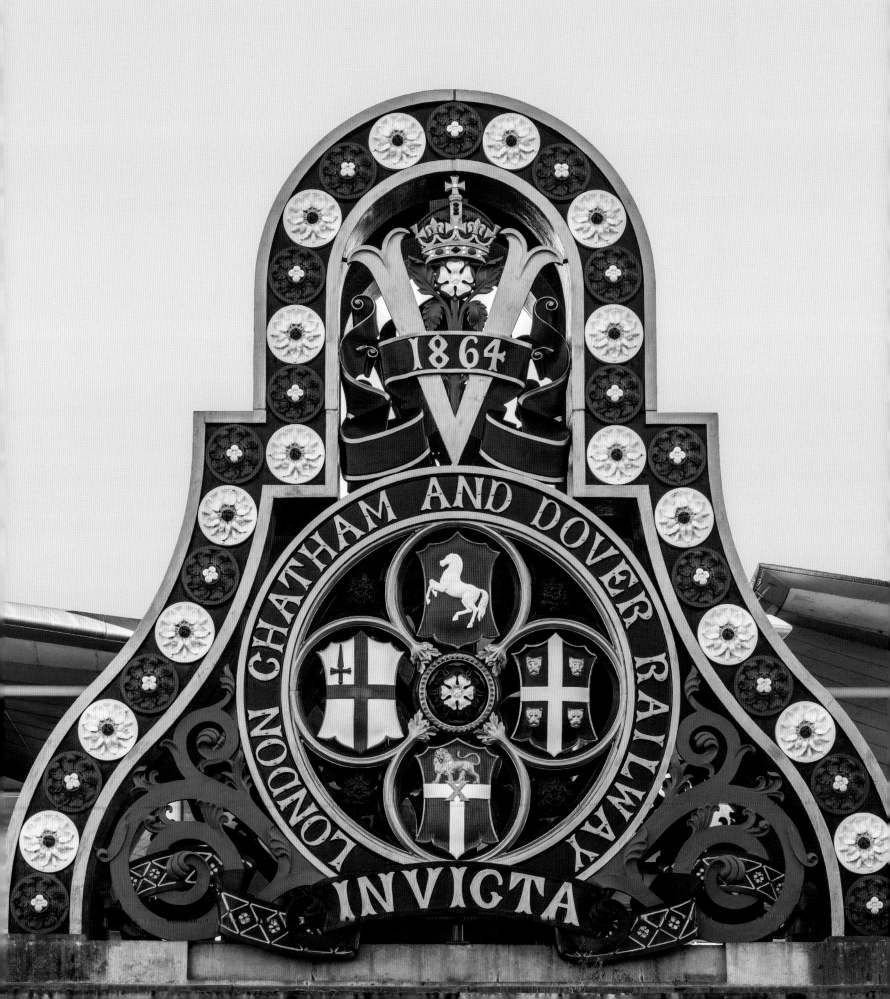

Blackfriars

Left The large cast-iron coat of arms that survives on the South Bank side of the first Blackfriars Railway Bridge, which opened in 1864.

Right Current National Rail and Underground logos on Blackfriars station.

The next rail crossing of the Thames after Cannon Street is at Blackfriars, just up river beyond Southwark Bridge. It was built by the South Eastern Railway's (SER's) rival, the London, Chatham and Dover Railway (LCDR), in 1864. The original bridge was dismantled in 1985, leaving only the iron support piers and granite plinths. On the south side is a striking pair of giant cast-iron pylons decorated with the railway company's coat of arms. These are now listed structures and have been restored and painted in full colour, best viewed from the southern end of the Blackfriars Road bridge.

The LCDR opened a station called Blackfriars Bridge here on the south bank in June 1864. This was a temporary terminus for their new line until they could run services over the bridge from 21 December, which would be the first trains into the City from south of the river. A station was opened at Ludgate Hill in 1865, and a few months later the line was opened to join up with the Metropolitan Widened Lines at Farringdon. This formed the only north–south rail route through central London, which was to be revived in 1990 as Thameslink after decades of use by goods trains only.

Soon after its completion in the 1860s, the line was being heavily used by local passenger trains run by several railway companies vying for access to the City from both north and south London. To relieve the pressure from these commuter trains on their small through-station at Ludgate Hill, the LCDR built a spur to a new terminus at Holborn Viaduct, opened in 1874. This was then used by their main-line trains to the Kent coast, but later became yet another commuter terminus as part of the Southern Electric network in the 1920s.

After sustaining major bomb damage in the Blitz, Holborn Viaduct was reconstructed in a similar style to Cannon Street in the 1960s. It was closed in 1990, replaced by a new through-station at nearby Ludgate Hill and named City Thameslink. The railway bridge across the bottom of Ludgate Hill, which had spoiled the view of St Paul's Cathedral from Fleet Street and Ludgate Circus since the 1860s, was demolished at the same time and the line level was dropped to run underground below the streets from City Thameslink to Farringdon.

In the 1880s, the LCDR built a second railway bridge over the river at Blackfriars to another small combined terminus and through-station on the north bank, opened in 1886. This was originally called St Paul's, but renamed Blackfriars in 1937. The original station building on Queen Victoria Street was a modest design, which was all the overstretched Chatham could afford, but showed the railway's aspirations in a list of fifty-four domestic and foreign destinations incised in the stonework of the façade. This included Bromley and Broadstairs, but also Baden Baden and Brindisi; the mundane and the romantic. John Betjeman once asked a booking clerk here for a return to St Petersburg but was referred to Victoria Continental.

A separate, and rather grand four-storey building over the District Railway's entrance and platforms at Blackfriars was opened in 1870. This was designed by the architect Frederick J. Ward and described by *The Builder* magazine at the time as 'somewhat bizarre … in the Oriental style'. Photographs show it to have had an elaborate Turkish frontage with Mooresque windows, gilded iron balconies and decorative Bath stone, brick and coloured mosaic detailing. It was

Right The Oriental/Ottoman style building by F.J. Ward over the District Railway station entrance seen in the view below, 1870.

Below The joint entrance for Blackfriars Underground and the Southern Electric station, soon after the SR name was changed from St Paul's in 1937. The main-line booking hall was further along Queen Victoria Street.

Opposite above The City skyline over the extended Blackfriars station platforms, now roofed with photovoltaic panels. The current bridge below them dates from 1886 when the station (then called St Paul's) opened on the north bank.

Opposite below View south with Blackfriars Bridge on the right and the extended station platforms of the second rail bridge on the left. The pillars of the first rail bridge still stand in the centre, and were used to brace the weight of the extended platforms.

Overleaf The glazed main entrance hall at Blackfriars, substantially remodelled between 2009 and 2012. A second entrance was opened on the South Bank in 2011.

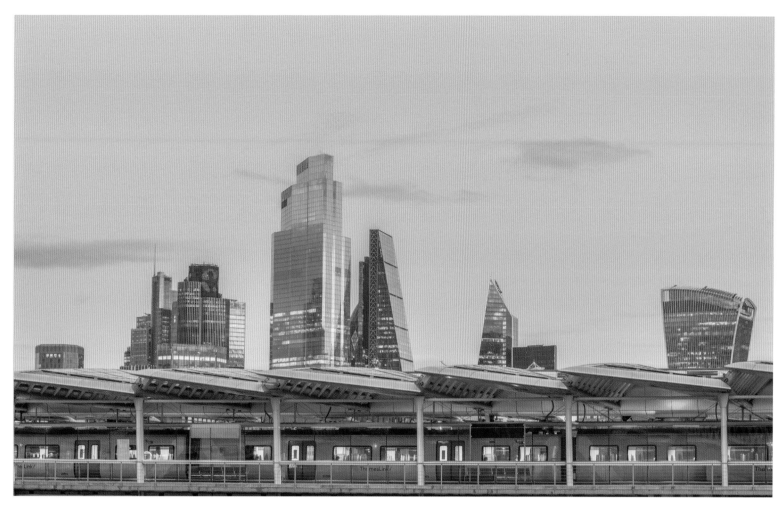

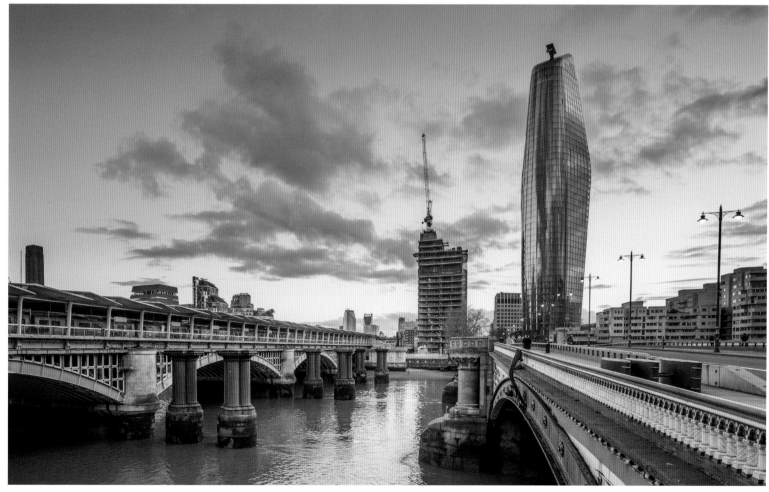

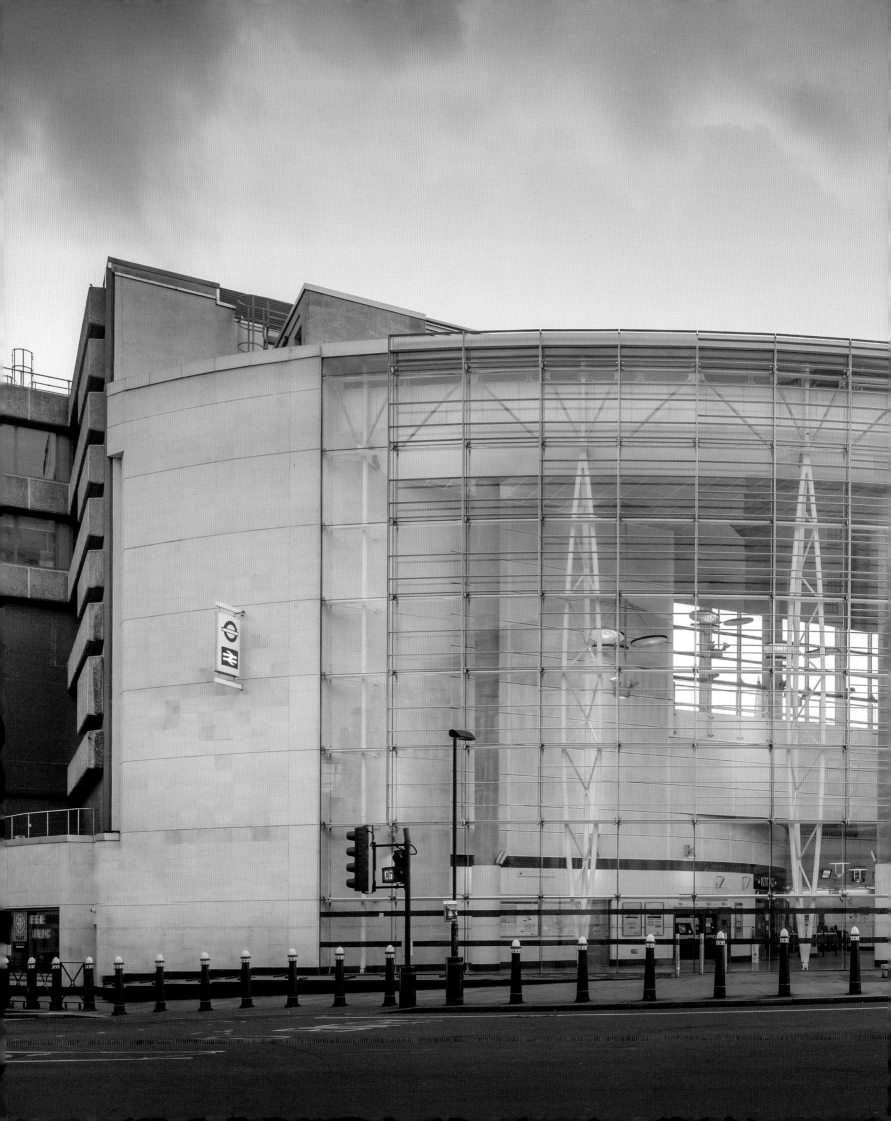

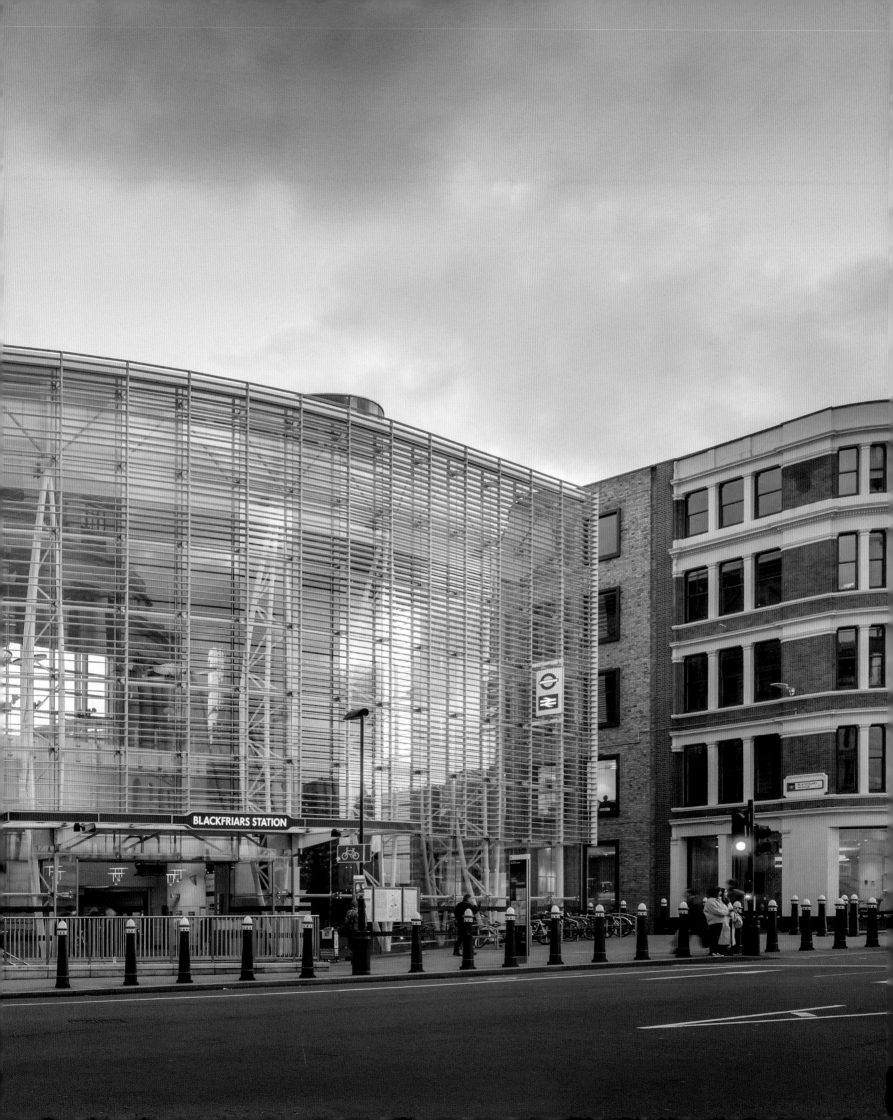

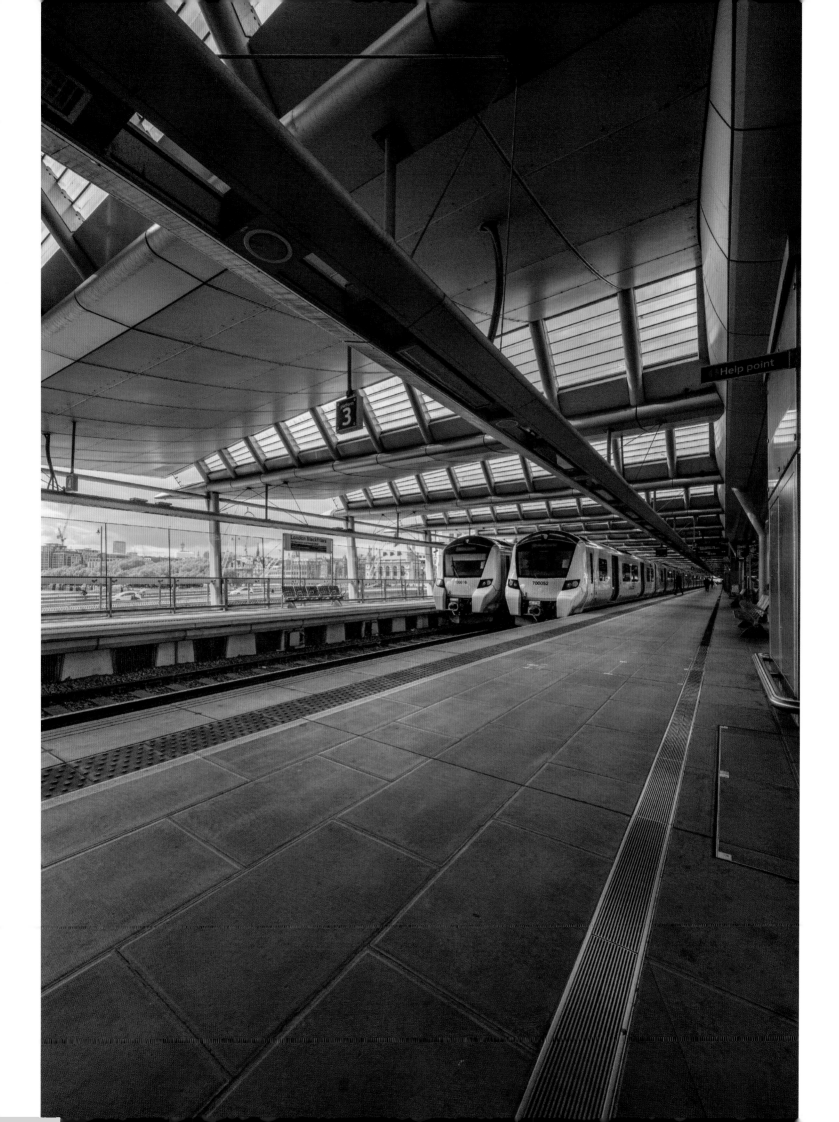

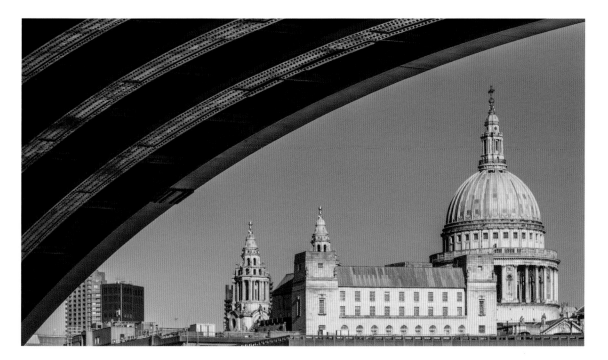

apparently hoped to let it as a hotel and restaurant but it seems to have become offices with no connection to the railway – an early example of 'air space' development over a station that did not thrive. The street entrance below it gave combined access to the Underground and main-line station, which continued even after Ward's superstructure was almost destroyed by a wartime bomb in 1940.

The LCDR was unable to survive as an independent company, and in 1899 was forced into an effective merger with its more powerful long-term competitor, the SER. The new joint operation was known as the South Eastern and Chatham Railway (SECR), becoming part of the Southern Railway in 1923. Blackfriars station survived the Blitz, although the entrance building and Underground station were badly damaged and not rebuilt and modernized until the 1970s.

At this stage, the street-level building was replaced by a new entrance hall shared with the Underground, and an expanded high-level concourse to the main-line platforms reached by escalators. Reconstruction was problematic as the original station building had sat on top of a cold store, which had frozen the ground below it. The District line tunnel had to be removed and replaced by a new structure that could support the weight of the redesigned station building above it. Fortunately, the destination stones from the façade of the 1886 building were rescued and built into the new concourse at platform level, which was opened by the Lord Mayor of London in 1977. Even more remodelling was to take place as the Thameslink programme got under way to revive and develop cross-London passenger services through Blackfriars, first introduced in 1990.

The station was even more extensively rebuilt between 2009 and 2012 in a £500-million redevelopment programme to increase capacity on Thameslink. This was an ingenious architect- and engineer-designed project that involved building new platforms extending right across the river bridge so that they could accommodate twelve-car instead of eight-car Thameslink trains. The through-tracks were also moved to the east side, with new bay platforms on the west side, avoiding the need for through-trains to cross the path of terminating ones. The works cleverly exploited the disused piers west of the existing railway bridge, strengthening the closest piers, tying them into the existing bridge and cladding them in stone. This enabled them to support the weight of the widened station bridge and lengthened platforms. A second station entrance was built at Bankside on the southern end of the platforms, giving direct access to Tate Modern, which had become one of London's biggest tourist attractions since opening in 2000.

The station now has a stylish glazed entrance hall at the City end of Blackfriars Bridge and the entire platform area across the railway bridge also has glazing right along both sides. In 2014, the Blackfriars Railway Bridge became the world's longest solar powered bridge, having been covered with 4,400 photovoltaic panels providing up to half the energy needed to power the station (but not the trains!). In 2017, Blackfriars won a Major Station of the Year award at the National Rail Awards, recognizing the completion of its pivotal role in the development of the Thameslink programme.

Opposite, left and below Blackfriars Bridge and station have some hidden access routes, including a lift and stairs from the Embankment, and (below) a secret entrance to the National Rail station on the east side.

Overleaf Blackfriars station platforms extending over the river, seen from the road bridge looking south-east, with the Switch House, Tate Modern's extension building, visible on the left.

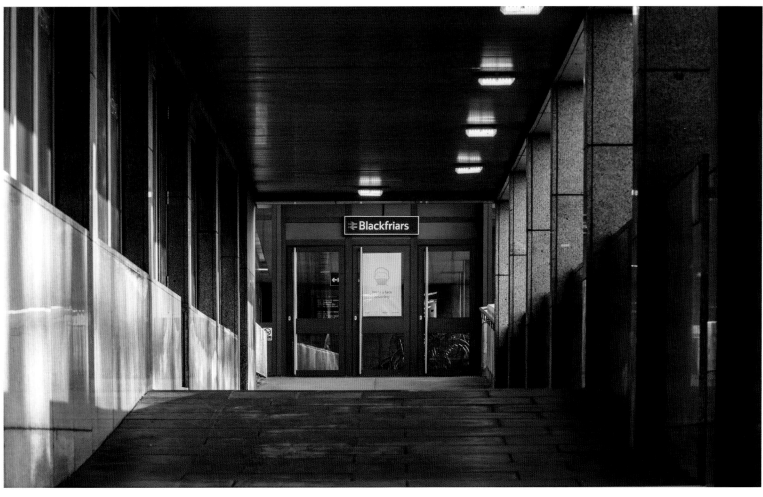

Charing Cross

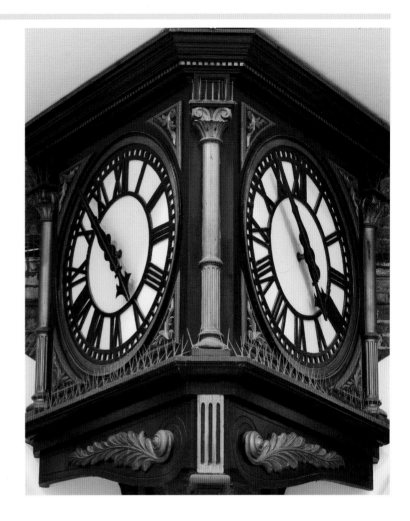

Charing Cross is the only main-line terminus conveniently serving the West End of London, being just a few minutes walk from Whitehall, Piccadilly and Covent Garden. It was a late arrival, opening in 1864 as a result of the South Eastern Railway's (SER) determination to compete with the rival London, Chatham and Dover Railway (LCDR), which ran to Victoria, in offering a well-placed new station for its Continental boat-trains to the Kent coast. The SER already knew that more than half of its passengers arriving at London Bridge were heading for the West End. An extension further west across Southwark, bridging the river to a new terminus on the north bank, was essential. A new City branch off the extension to Cannon Street and a link with the London and South Western Railway (LSWR) terminus at Waterloo were both part of the SER's ambitious growth plan.

For its terminal site, the SER acquired Hungerford Market at the western end of the Strand, and for its river crossing took over the Charing Cross Suspension Bridge built by I.K. Brunel in 1845. The chains and ironwork of the bridge were sold and later used for the Clifton Suspension Bridge in Bristol. To carry trains over the Thames to Charing Cross, the SER's engineer, Sir John Hawkshaw, designed the severely practical Hungerford Bridge, heavy latticed iron girders on fluted pairs of columns, which the late Victorians found extremely ugly. It incorporated a footbridge to replace Brunel's on its downstream side. One of the most successful of the Millennium projects in London was the addition of elegant matching independent suspension footbridges on both sides of the railway bridge, dramatically improving the riverscape at this point by effectively hiding Hawkshaw's structure. These were formally opened and named in 2003, the Queen's Golden Jubilee Year.

Hawkshaw was also responsible for the design of Charing Cross station, which originally had a long, tall arched trainshed over the platforms. At the river end, the approach over the bridge is elevated, with the Strand end of the station at ground level because of the steep rise from the river shore. The Embankment was built along the Thames in the late 1860s, incorporating both Bazalgette's main drainage scheme for London and the District Railway, which opened a separate station here in May 1870, just before the new road opened above it. This is now London Underground's Embankment station.

In the station forecourt stands an imaginative reconstruction, designed by Barry, of the memorial cross to Queen Eleanor that was erected in Whitehall soon after her death in 1290 by King Edward I, but destroyed by Puritans in 1647. The story of the building of the medieval Charing Cross is told pictorially in a remarkable mural designed by David Gentleman in the 1970s when the Tube station below was modernized and rebuilt. His striking design, with lifesize Medieval masons building the original cross, was enlarged from tiny woodblock prints, and runs the full length of both the Northern line platforms below. Barry's 1865 memorial above was cleaned and renovated in 2010, giving it a new visual prominence that had been lost over the years.

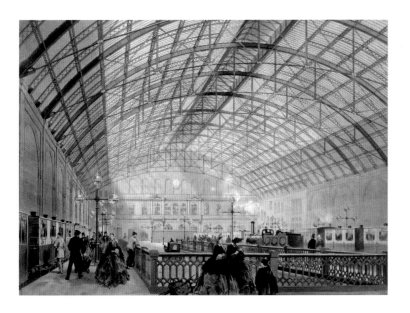

Opposite View towards the station from one of the Millennium footbridges, built on either side of the lumpen Hungerford Railway Bridge and hiding it quite effectively when they opened in 2003.

Left The interior of Charing Cross station with fashionably dressed passengers at its opening in 1864.

Below The oppressively low ceiling that followed the rafting over of the platforms for Farrell's office development in the 1980s. Only the station concourse still has natural light from above.

Overleaf Escalator access from Embankment level to the platforms.

The Station Hotel

Across the Strand frontage is the Charing Cross Station Hotel, designed by Edward Middleton Barry, son of the architect of the House of Commons, in an imposing French Renaissance-style. The 250-bedroom hotel opened in 1865 and is still in operation as the Ambi Charing Cross, with many of its sumptuous public rooms intact. John Betjeman, writing in 1972, described it as having the best-proportioned Victorian hotel dining room in London, though he regretted the loss of some of its other features: 'During the war this hotel still possessed what my friends and I used to call The Club. Down the main corridor on the station side of the hotel there were a bar and coffee room, whose French windows opened onto the balcony, where one could sit and watch the trains. The smoking room had been refurbished in, I should think, about 1905, with long comfortable leather chairs and benches. There was even a small library with a set of Shakespeare and a set of Scott, and a quiet white-uniformed waiter of pre-1914 type in charge of things. Alas! This room and a billiard room next door to it are no more, and I can only imagine they have been given over to conferences and committee meetings.' Although some of the interiors survive, the top floors of the hotel were unfortunately replaced after wartime bombing by a drab neo-Georgian addition that is completely out of keeping with Barry's elaborate façade.

Below Charing Cross Hotel from the Strand, *c.*1912. The hotel was designed by Edward Middleton Barry, son of the architect of the Houses of Parliament.

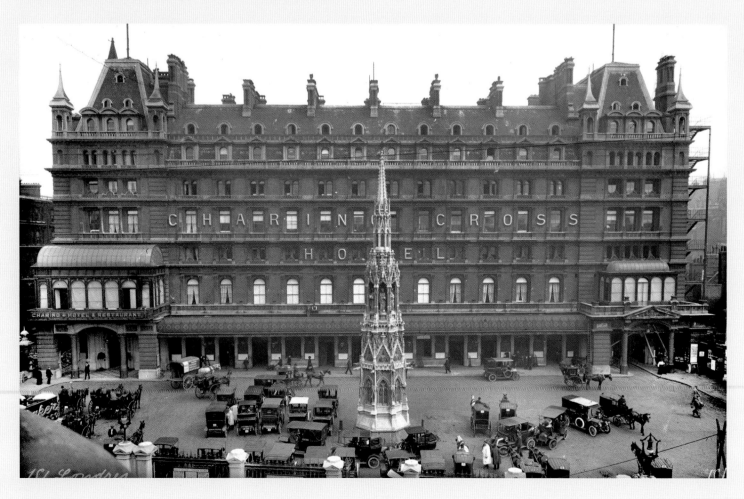

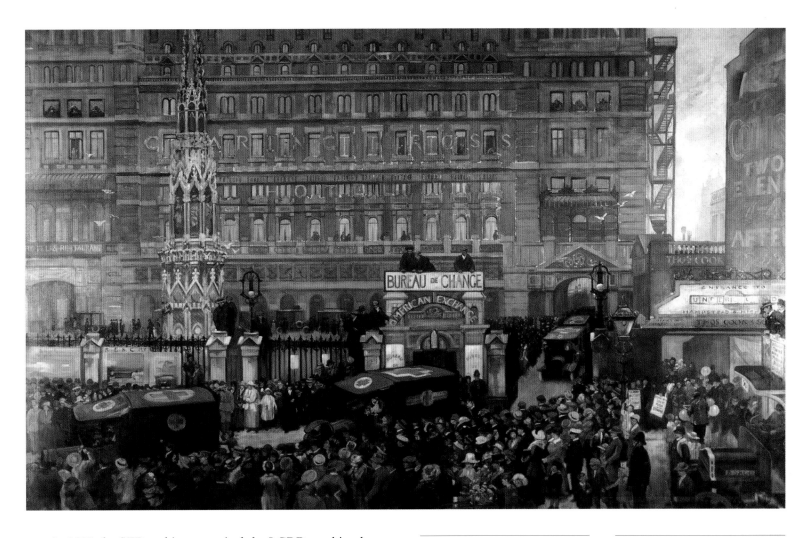

In 1899 the SER and its great rival the LCDR combined to form the South Eastern and Chatham Railway (SECR) and began operating Charing Cross as a joint concern. In December 1905 the main part of the station roof collapsed suddenly during maintenance work, killing six people. The cause was found to be a structural weakness in one of the wrought-iron tie-rods, which had fractured. Rather than attempting a repair, the SECR decided to replace Hawkshaw's roof with a completely new design. While this reconstruction took place and the station was closed, the Hampstead Tube was given permission to dig up the forecourt for the creation of a new Underground station below, which became the initial southern terminus of this new line when it opened in 1907.

During the First World War, the SECR played an important strategic role as the British railway running closest to the Western Front. Many troop trains left Charing Cross for Dover and Folkestone, soldiers often travelled through the station when on leave, and ambulance trains returned here with growing numbers of casualties. In December 1918, a month after the Armistice, King George V welcomed President Woodrow Wilson of the United States at Charing Cross on his first post-war visit to Europe. Two years later the SECR decided to run all its boat-trains from Victoria, and the Continental facilities at Charing Cross were removed. The customs shed was demolished, the kiosk on the Strand forecourt offering money exchange facilities was closed and all the foreign-language signs at Charing Cross were taken down.

Above Painting of Charing Cross during the First World War by John Hodgson Lobley, dated 1918, but showing an earlier scene. The Strand is lined with civilians watching Red Cross ambulances leaving the station carrying wounded soldiers brought back from the Western Front by train.

Overleaf Charing Cross Hotel from the Strand today. The hotel was badly damaged by wartime bombing and Barry's Mansard roof (see page 212) was replaced with weak neo-Georgian upper floors that ruined the look of the building.

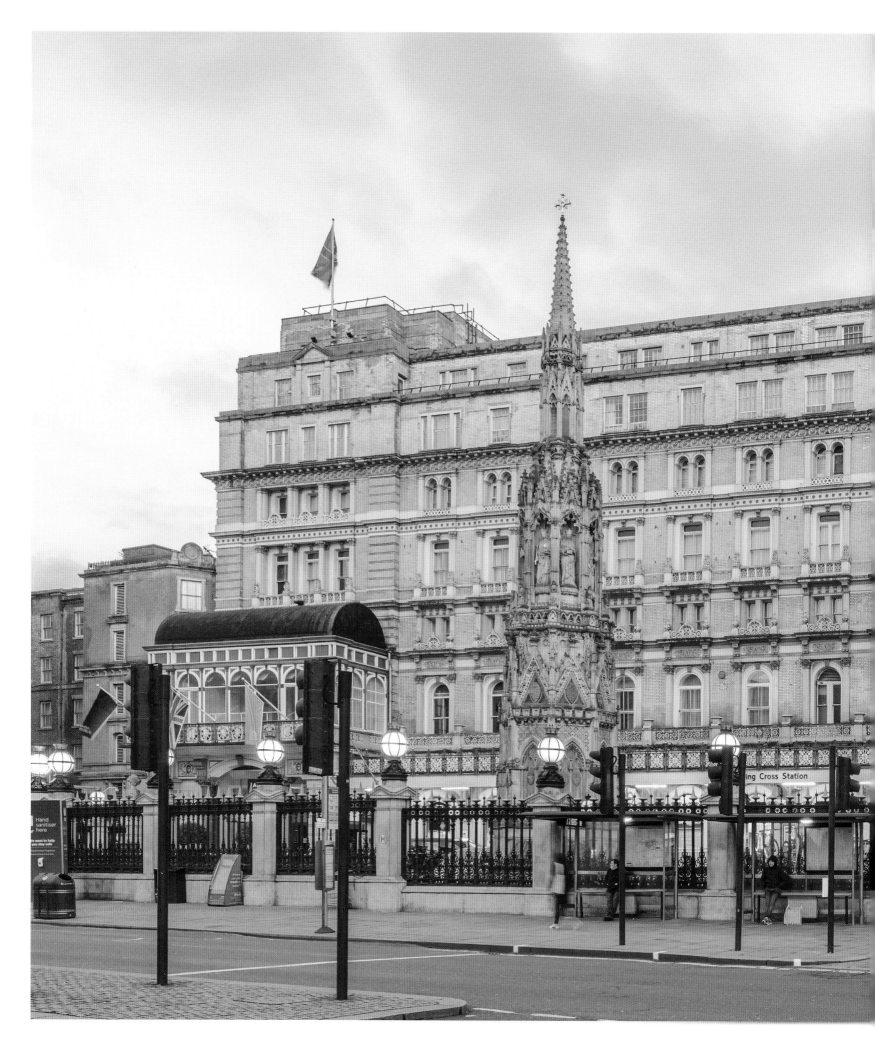

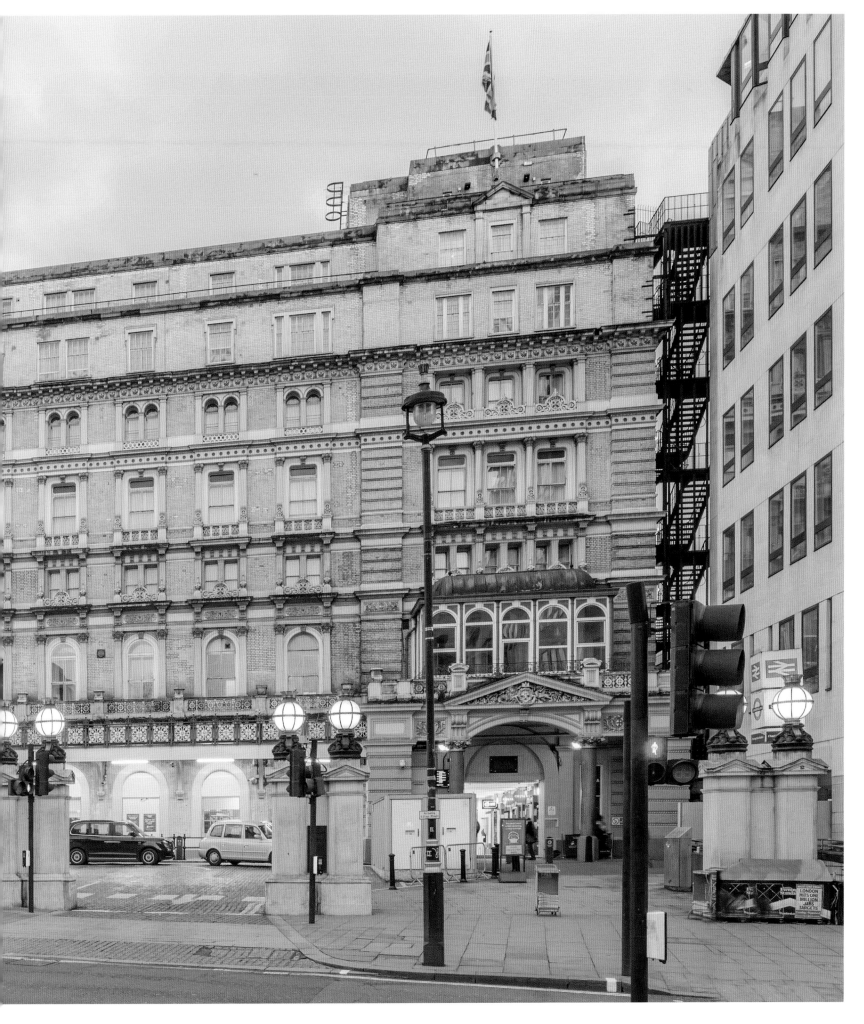

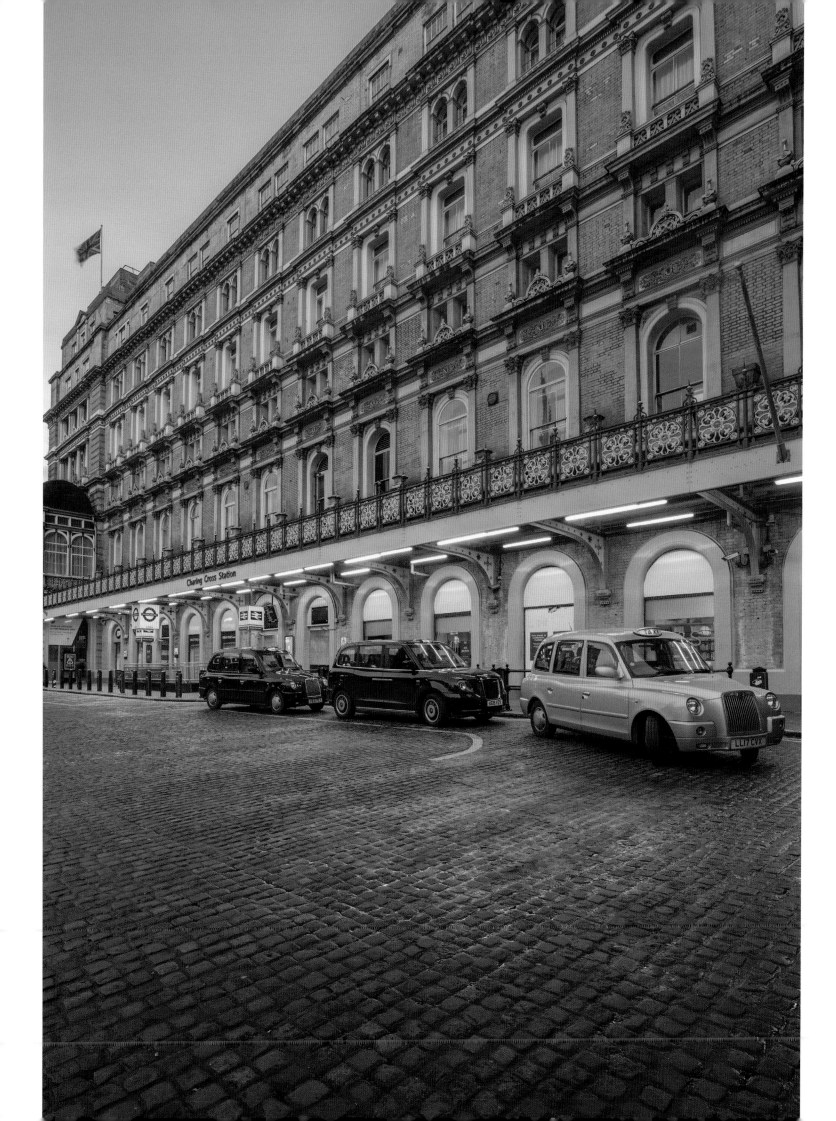

Opposite Cabs in the Strand forecourt.

Left Barry's imaginative reconstruction in the station forecourt of the memorial cross to Queen Eleanor that was erected in Whitehall soon after her death in 1290 but later destroyed by Puritans in 1647. The church of St Martin-in-the-Fields stands across the Strand to the left, on Trafalgar Square.

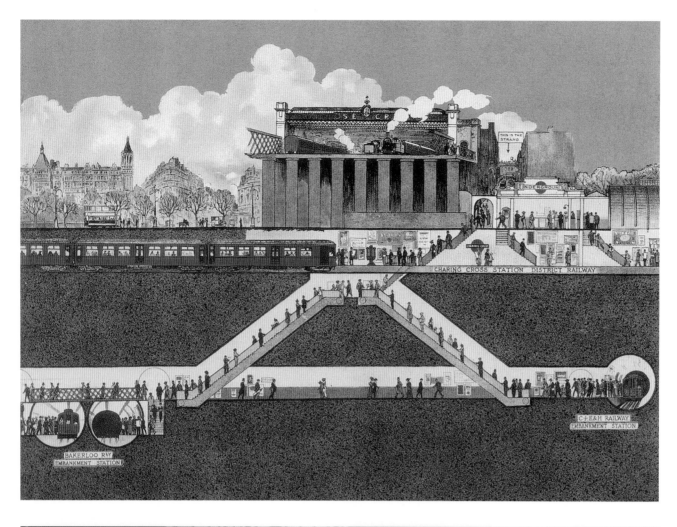

Charing Cross became more important as a commuter station between the wars, when the Southern Railway (SR) electrified the suburban network inherited from the SECR. Little was done to the station either by the SR or British Railways (BR), which took over in 1948, other than repairing bomb damage. Dramatic change came in the 1980s, when a huge air-space development project called Embankment Place was created both over and under the main-line station. The office development cannot be seen from the Strand elevation, where the station façade is still formed by the hotel, but from the South Bank or Embankment Gardens the bulky post-modern office structure, designed by Terry Farrell and Partners, is now the dominant building along this part of the river.

Inside the station, the passenger concourse is still naturally top-lit through a glazed roof and has been fully refurbished, with the retention of the double-faced Victorian station clock above the booking office. Beyond the barriers the platforms are now almost entirely rafted over, with an oppressively low ceiling cutting out all natural light. The only historical reference in this rebuilt part of the station is the SR badging on the river front of the Farrell building, which is visible only from the outer end of the platforms. Charing Cross now looks its best from a distance, particularly when viewed over the river from the South Bank at night, when both Embankment Place and the Golden Jubilee footbridges are dramatically lit.

Opposite above A cross-section of Charing Cross station in an Underground poster, showing the main-line terminus, the District Railway just below the Embankment and the deeper Tubes which opened in 1906/7.

Opposite below A trial run for a new 1.5-deck suburban electric train at Charing Cross in 1949. It was a cumbersome design, and particularly disliked by women, but the trains were not withdrawn until the 1970s.

Above The riverfront of the 1980s station is decorated with the old Southern Railway emblem.

Below The station as built, photographed in c.1880. This is the original roof which collapsed in 1905 (see page 207).

Overleaf The bulk of post-modern Charing Cross, seen looking west over Waterloo Bridge.

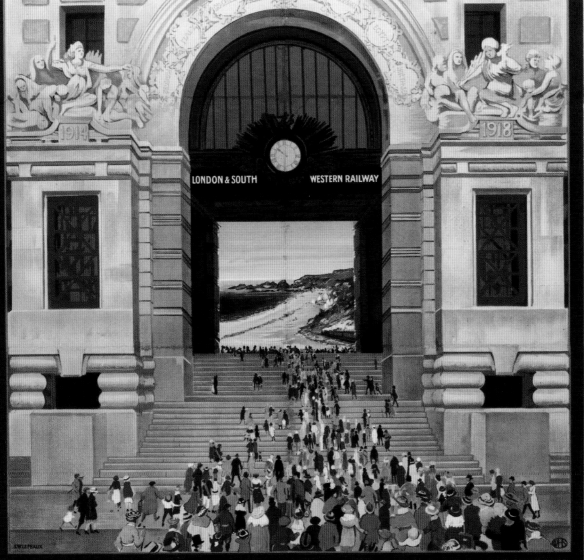

Waterloo

Left LSWR poster issued in 1922, using the newly completed Victory Arch at Waterloo as 'The Gateway to Health & Pleasure' for post-war leisure, as well as for remembrance.

Right The clock on the station concourse.

Waterloo had a reputation in the Victorian period as London's most confusing station. First opened in 1848, it grew in a piecemeal and unplanned way until, by the end of the nineteenth century, some 50,000 passengers were arriving at the sprawling station every working day. Today, Waterloo is the busiest railway station in Great Britain, used by over 80 million passengers a year.

In the Victorian period, the experience of using Waterloo had almost become a standard music hall joke. The station's appearance in Jerome K. Jerome's *Three Men in a Boat*, published in 1889, is a typical comic characterization. Heading for Kingston-upon-Thames for a leisurely river trip, the three heroes arrive at Waterloo by cab and 'asked where the eleven five started from. Of course nobody knew; nobody at Waterloo ever does know where a train is going to start from, or where a train when it does start is going to, or anything about it.' Eventually, they bribe an engine driver to make sure their train goes to Kingston. 'We learned afterwards that the train we had come by was really the Exeter mail, and that they had spent hours at Waterloo looking for it, and nobody knew what had become of it.'

This was an exaggeration of course, but the operation of Waterloo had become sufficiently chaotic for the London and South Western Railway (LSWR) to decide that complete reconstruction of their station was the only way forward. This took more than twenty years to achieve, but it created Britain's first and best-laid-out twentieth-century terminus, the only one that could take both holiday traffic and a huge daily tide of commuters in its stride.

The origins of Waterloo

Waterloo was not the original terminus of the first main line from the south-west. The LSWR, promoted in 1831, opened its route as far as Woking in 1838, reaching Southampton in 1840. The London terminus was at Nine Elms, just south of Vauxhall Bridge and close to a river pier that was convenient for goods transfer on to barges. It also gave passengers onward access to the City by steamboat, and there were horse bus connections with other parts of central London, too. But the railway company, renamed the LSWR in 1839, soon recognized the benefits of extending closer to central London, particularly when a new branch line from Richmond to Clapham Junction opened in 1844 and boosted passenger numbers. This line was later extended westwards to Windsor and Reading.

The extension of just under 3.2km (2 miles) to the south end of Waterloo Bridge was built mainly on brick viaduct to minimize property demolition along the route, but even so, some 700 houses had to be knocked down, and the line had to snake around Lambeth Palace and Vauxhall Gardens. Waterloo station was built well above street level at the end of the viaduct, with provision for further extension towards the City. No proper station buildings were erected in the early years, but the terminus grew, with extra platforms added in an almost haphazard fashion. On the west side, what became known as the 'Windsor station', dealing with the Windsor and Reading lines and other local traffic, first opened in 1860. More platforms were added to the central station in 1878. A new roof was built over the Windsor station in 1885 and the approach tracks were

Waterloo in wartime

Waterloo was bombed several times during the Second World War, its extensive glazed roof making it an easy target for enemy bombers flying up the Thames. On 7 September 1940, in the first mass Blitz raid on London by the Luftwaffe, the John Street viaduct immediately outside the station was destroyed by a bomb, which prevented any services running in or out of the station for twelve days. Full services did not resume until 1 October, which particularly affected mail traffic, with over 5,000 unsorted bags piling up on the platforms. The station was closed again for a week in December–January 1940–41 and just as it reopened the station offices on York Road were destroyed in a direct hit. The station took heavy damage again in what turned out to be the last heavy raids of the Blitz on 10–11 May 1941, with fires burning for four days.

London Terminus, a short wartime documentary film made three years later at Waterloo, underlines the calm and committed way in which railway staff 'carried on' in difficult circumstances, running as normal a passenger service as possible. Most of the platform workers seen waving off trains and collecting tickets in the film are women, recruited by the Southern Railway (SR) to roles they would not have had before the war. Their work and the wider 'passing show' of wartime Waterloo was also captured by book and magazine illustrator Helen McKie, whose well known pair of posters showing the station in war and peace was produced to mark Waterloo's centenary in 1948.

One of Waterloo's more unusual operations was brought to a premature end by wartime bombing. This was the London Necropolis Company's funeral service, which since 1854 had run a daily train from its private platform at Waterloo to its cemetery at Brookwood, near Woking. In the late nineteenth century, Brookwood had become the largest cemetery in the world, but the one-way rail traffic from Waterloo was not proving the solution to Victorian London's burial problems that its promoters had hoped. The Necropolis station had been moved in 1902, with a new entrance building at 121 Waterloo Bridge Road and a rail platform above. This still survives as offices, but the station and funeral service were closed down after taking a direct hit in an air raid on 16 April 1941.

Right above Female ticket collectors at Waterloo, c.1916.

Right below Women in uniform at Waterloo: a military officer and an SR porter, drawn by Helen McKie in 1942.

Opposite above The LSWR Roll of Honour on the Victory Arch.

Opposite below The entrance to the News Theatre at Waterloo, another of Helen McKie's wartime sketches at the station.

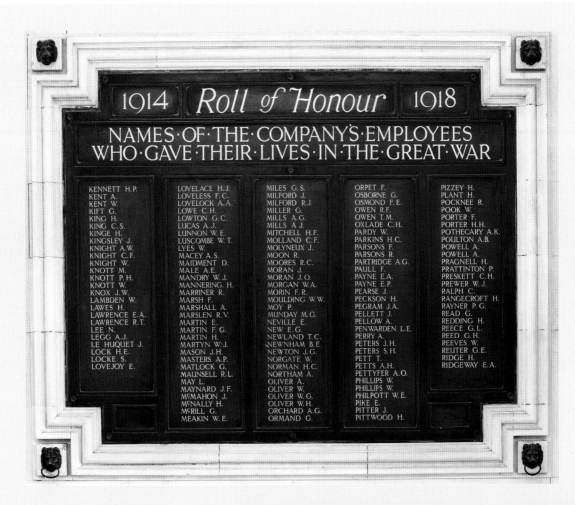

1914 *Roll of Honour* 1918

NAMES·OF·THE·COMPANY'S·EMPLOYEES
WHO·GAVE·THEIR·LIVES·IN·THE·GREAT·WAR

KENNETT H.P.	LOVELACE H.J.	MILES G.S.	ORPET F.	PIZZEY H.
KENT A.	LOVELESS F.C.	MILFORD J.	OSBORNE G.	PLANT H.
KENT W.	LOVELOCK A.A.	MILFORD R.J.	OSMOND F.E.	POCKNEE R.
KIFT G.	LOWE C.H.	MILLER G.	OWEN R.F.	POOK W.
KING H.	LOWTON G.C.	MILLS A.G.	OWEN T.M.	PORTER F.
KING C.S.	LUCAS A.J.	MILLS A.J.	OXLADE C.H.	PORTER H.H.
KINGE H.	LUNNON W.E.	MITCHELL H.F.	PARDY W.	POTHECARY A.K.
KINGSLEY J.	LUSCOMBE W.T.	MOLLAND C.F.	PARKINS H.C.	POULTON A.B.
KNIGHT A.W.	LYES W.	MOLYNEUX J.	PARSONS F.	POWELL A.
KNIGHT C.F.	MACEY A.S.	MOON R.	PARSONS R.	POWELL A.
KNIGHT W.	MAIDMENT D.	MOORES R.C.	PARTRIDGE A.G.	PRAGNELL H.
KNOTT M.	MALE A.E.	MORAN J.	PAULL F.	PRATTINTON P.
KNOTT P.H.	MANDRY W.J.	MORAN J.O.	PAYNE E.A.	PRESKETT C.H.
KNOTT W.	MANNERING. H.	MORGAN W.A.	PAYNE E.P.	PREWER W.J.
KNOX J.W.	MARRINER R.	MORIN F.R.	PEARSE J.	RALPH C.
LAMBDEN W.	MARSH F.	MOULDING W.W.	PECKSON H.	RANGECROFT H.
LAWES H.	MARSHALL A.	MOY P.	PEGRAM J.A.	RAYNER P.G.
LAWRENCE E.A.	MARSLEN R.V.	MUNDAY M.G.	PELLETT J.	READ G.
LAWRENCE R.T.	MARTIN E.	NEVILLE E.	PELLOW A.	REDDING H.
LEE N.	MARTIN F.G.	NEW E.G.	PENWARDEN L.E.	REECE G.L.
LEGG A.J.	MARTIN H.	NEWLAND T.C.	PERRY A.	REED G.H.
LE HUQUET J.	MARTYN W.J.	NEWNHAM B.E.	PETERS J.H.	REEVES W.
LOCK H.E.	MASON J.H.	NEWTON J.G.	PETERS S.H.	REUTER G.E.
LOCKE S.	MASTERS A.P.	NORGATE W.	PETT T.	RIDGE H.
LOVEJOY E.	MATLOCK G.	NORMAN H.C.	PETTS A.H.	RIDGEWAY E.A.
	MAUNSELL R.L.	NORTHAM A.	PETTYFER A.O.	
	MAY L.	OLIVER A.	PHILLIPS W.	
	MAYNARD J.F.	OLIVER W.	PHILLIPS W.	
	McMAHON J.	OLIVER W.G.	PHILPOTT W.E.	
	McNALLY H.	OLIVER W.H.	PIKE E.	
	McRILL G.	ORCHARD A.G.	PITTER J.	
	MEAKIN W.E.	ORMAND G.	PITTWOOD H.	

NEWS THEATRE WATERLOO (RE-OPENED AFTER BEING BLITZED) NOV. 1942.

HELEN McKIE

SCOTT HOUSE

widened in 1892. When the SER's London Bridge to Charing Cross extension opened in 1864, a rail link into Waterloo was opened, and five years later the SER opened their own Waterloo East station. But for many years the LSWR and SER could not agree on through-booking arrangements, and passenger transfer from Waterloo to the SER's City terminus at Cannon Street remained difficult. Eventually the LSWR got its own access to the City when it sponsored a short Tube line direct to the Bank, which opened in 1898. The Waterloo and City line, popularly known as 'the Drain', is physically separate from the rest of the Tube system and was run by the main-line railway until 1994, when it was transferred to London Underground control. A separately promoted underground railway, the Bakerloo Tube, running south to Elephant and Castle and north under the West End to Baker Street, opened a station at Waterloo in 1906.

The radical reconstruction of the main-line terminus was planned by the LSWR's new Chief Engineer, J.W. Jacomb-Hood, who was appointed in 1901. He designed the new station after a study visit to look at the latest railway terminals in the United States. Jacomb-Hood proposed a large station with twenty-three platforms and a wide passenger concourse, all on a new superstructure, with a steel-framed frontage block housing the main facilities such as the booking hall, cloakrooms and refreshment rooms. The *Railway Magazine* was particularly taken with the large underground men's toilet hall, described in its December 1910 issue as 'perhaps the finest in England', featuring a marble floor, tiled walls, bathrooms and a hairdressing salon

There were some economies, such as retaining the old Windsor station roof. This meant losing two of the proposed platforms, but the rest of the station was built to Jacomb-Hood's design, with a new nine-span steel-and-glass roof at right angles to the tracks over Platforms 1–15. Jacomb-Hood died in 1914 before the station was completed, and his successor, A.W. Szlumper, finished the job.

Electrification of the LSWR's suburban lines on the third-rail system started during the First World War, with the first electric trains running from Waterloo to Wimbledon via East Putney in 1915.

The decorative architectural features of the main frontage block at Waterloo, which contrasted with the plain practical engineering of the new trainshed, were designed by J.R. Scott, who was to become chief architect of the Southern Railway (SR) in 1923. By the 1930s, his department's style had evolved and simplified into Streamline Moderne, best represented in the rebuilt SR suburban stations at Richmond, Wimbledon and, above all, Surbiton. Scott's very different early work at Waterloo culminated in the monumental Victory Arch, a baroque gateway at the London end of the concourse, which incorporated the LSWR's war memorial to its 585 staff killed in the First World War. Its unveiling by Queen Mary in 1922 marked the completion of Waterloo's lengthy reconstruction programme.

Waterloo heyday
Waterloo became the flagship station of the SR when it took over from the LSWR in 1923, expanding the programme of suburban electrification that was soon branded 'Southern Electric'

and astutely promoted by the company's first public relations
manager, John Elliott. His posters and publicity encouraged
middle-class Londoners to become commuters: 'Live in Surrey
Free from Worry' or 'Live in Kent and Be Content', as the
straplines exhorted. The SR had much less reliance on freight
traffic than the other three main-line companies, and developing
better commuter services to London was the obvious way to go.

By the late 1930s all suburban services into Waterloo and
the main line from Portsmouth had been electrified, but steam
remained on long-distance services to the south coast and the
West Country. A public address system was introduced at the
station in 1932, which provided train announcements interspersed
with jaunty military band music across the concourse. This was
presumably intended to keep passengers on the move rather than
standing around on the concourse. Those with time to spare
could still get refreshment service in the Windsor Tea Bar or
visit the News Theatre cinema, which opened on the concourse
next to platform one in 1934. This was designed like a miniature
streamlined Odeon, built against the inside wall of the station
in Southern Moderne, Art Deco style. It screened a continuous
programme of newsreels and cartoons, projected through an
ingenious mirror system to make optimum use of the limited
auditorium space. Both the cinema and the Windsor Bar closed
in the early 1970s. The cinema was later demolished, but the two
attractively decorated domed pay boxes of the Edwardian tea rooms
have survived to become display features in Hatchard's book shop.

Above Decorated window over the
former cab entrance at Waterloo, now
visible close up for the first time from
the balcony around the concourse that
opened in 2012.

Overleaf Terence Cuneo's giant
painting of Waterloo, commissioned
by the Science Museum in 1967,
shows the station just before the end
of steam. Details include the prime
minister, Harold Wilson, filling his
pipe outside WH Smith's on the left.
Behind him is a bulldog, Winston
Churchill, who made his last journey
through Waterloo after his state
funeral procession in January 1965.
The picture is now on display at
the National Railway Museum. The
funeral train carrying his coffin left
Waterloo behind the *Battle of Britain-*
class Light Pacific named after him
in a ceremony at the station in 1947,
an event which Churchill declined to
attend. The loco is now preserved in
the national collection.

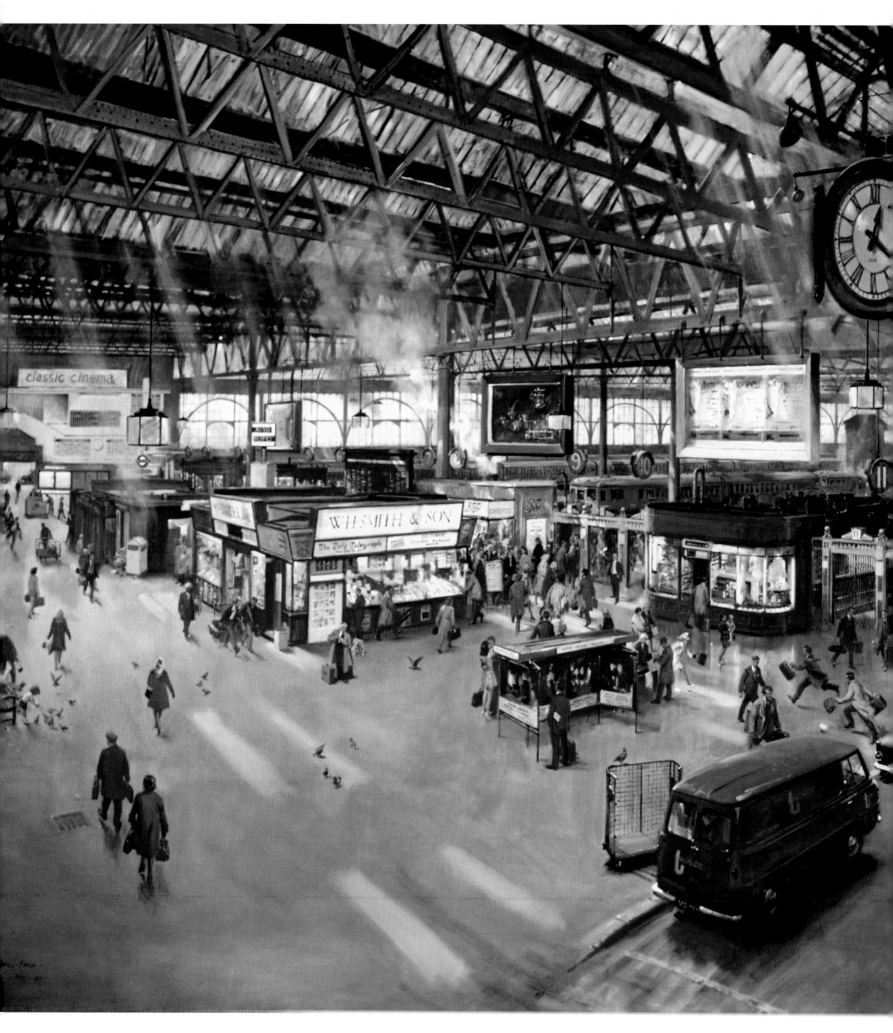

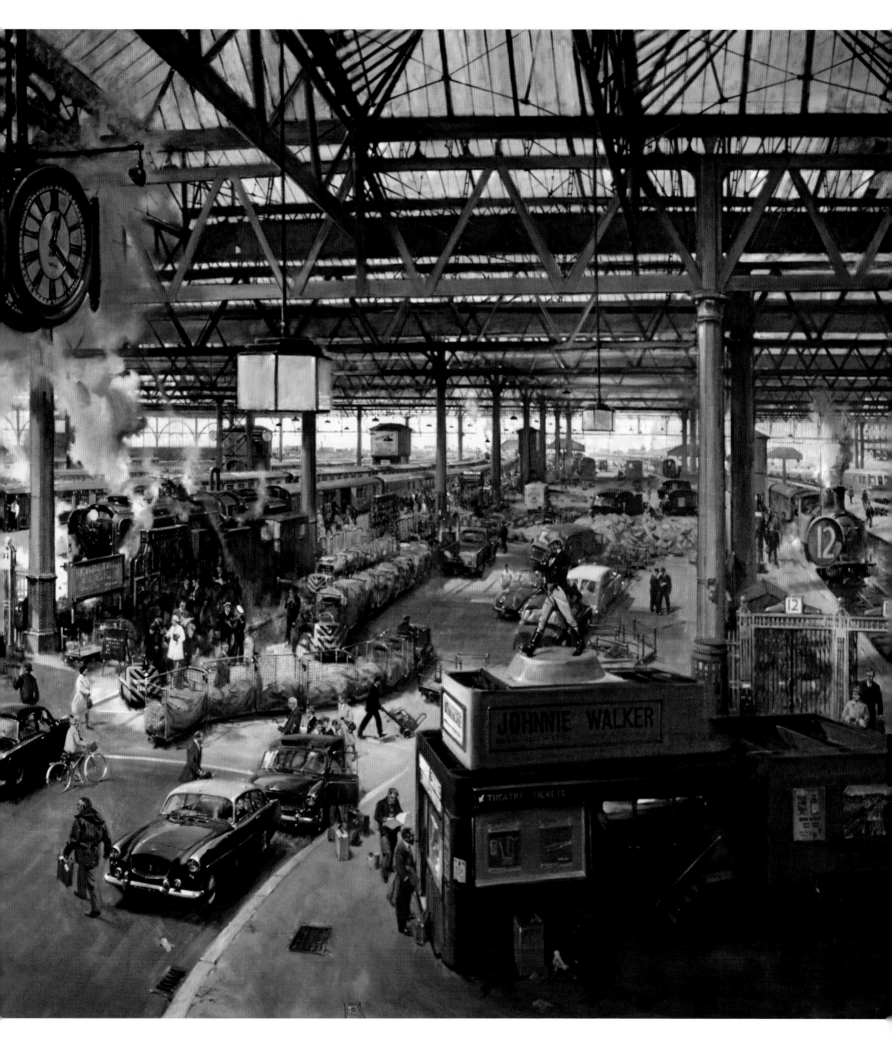

A day in the life of Waterloo was beautifully observed by director John Schlesinger in his classic 1961 documentary *Terminus*, with a jazz score and sound but no spoken commentary, made for British Transport films. *Terminus* captured everyday scenes that would disappear by the end of the 1960s: an army of porters meeting the boat-trains from Southampton, the all-Pullman *Bournemouth Belle* and the arrival of Afro-Caribbean migrants in London. With apt timing, the final steam-hauled passenger trains in the capital departed in July 1967, just as the Kinks' London lament 'Waterloo Sunset', written by Ray Davies, reached the top of the charts.

A new day

There were major changes to the infrastructure of Waterloo in the last decade of the twentieth century. The two most important developments were the construction of the Jubilee Line Extension (JLE) underneath the main-line station, and the creation of the first international terminal for Eurostar services from the Continent. Both projects made extensive and ingenious use of the undercroft areas at street level to provide new passenger access routes down to the Tube and up to the new Eurostar platforms. The JLE booking hall was inserted at the Waterloo Road entrance formerly used as a bus station, avoiding a major intervention in the main-line station. New escalators run straight down from here to the Jubilee line platforms below, with a flat travelator connection in a deep tube tunnel to the Bakerloo and Northern line platforms, which run below the York Road side of the station. The JLE opened in 1999.

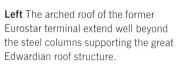
By this time Waterloo International had been operating for five years as the first London terminal for Eurostar services through the Channel Tunnel. The new station replaced the 1885 Windsor line platforms on the north-west side, the only part of Victorian Waterloo that had not been comprehensively rebuilt in the early twentieth century. Nicholas Grimshaw and Partners produced a spectacular design for the Eurostar station. It is a modern interpretation in steel and glass of the traditional Victorian trainshed, running down the side of the main Edwardian roof and then extending in a gentle curve to cover the sleek, double-length Eurostar trains. Below the platforms, but linked by angled travelators, were check-in and customs facilities, a departure lounge and a separate arrivals hall.

This brilliant piece of architectural engineering was delivered on schedule in 1993 but not opened until 1994, when the delayed Channel Tunnel project was finally completed. Sadly, Waterloo International then had a working life of just thirteen years. Eurostar services to Waterloo approached London on existing tracks used by other trains and could not travel at top speed. Britain's first high-speed main line (HS1) was eventually built across Kent from 1998, and a route under the Thames and below east and north London to St Pancras was chosen. When high-speed Eurostar services to St Pancras began in November 2007, Waterloo International immediately became redundant. It lay almost unused for twelve years until full re-opening of Platforms 20–24 for domestic services in 2018–19 increased overall capacity at Waterloo by 30 per cent.

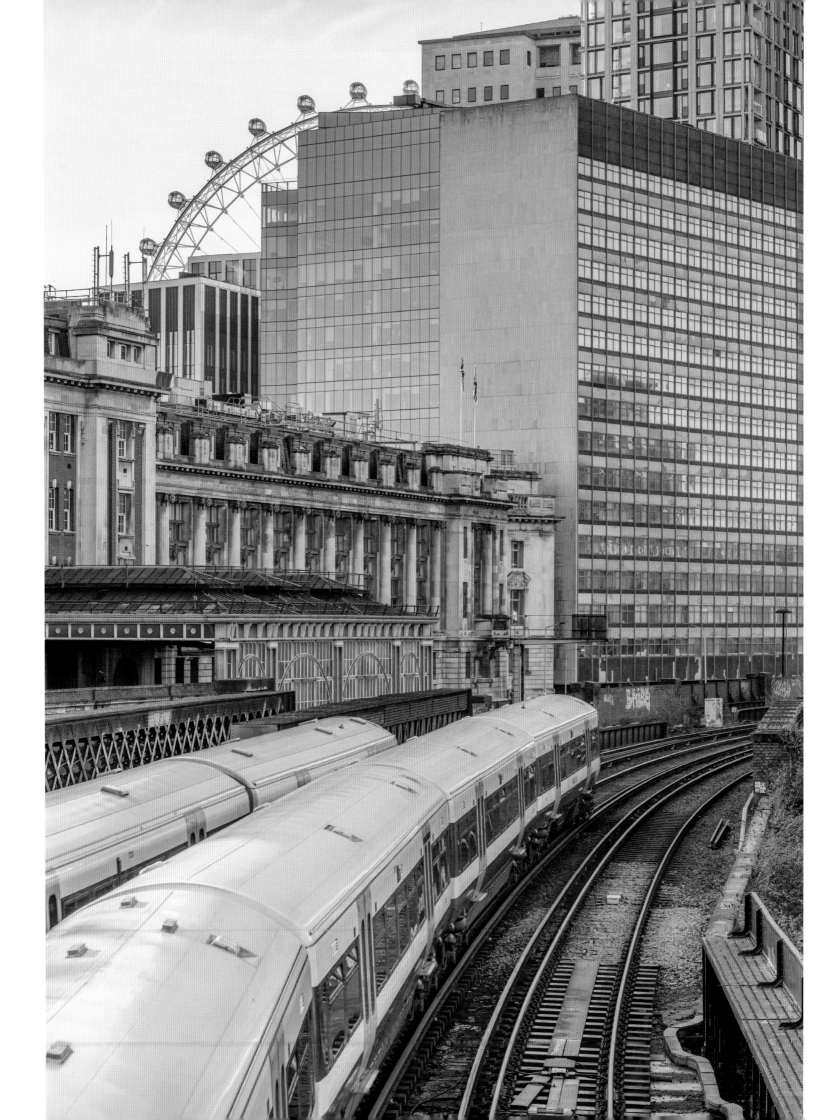

Left The view from the footbridge to the Waterloo East platforms, with trains to and from Charing Cross, the Victory Arch entrance, 1960s office buildings (including the top of the Shell Centre) and a glimpse of the London Eye.

Right Waterloo's light and airy trainshed, still the largest in London, with one of the remaining Edwardian goods lift towers in the centre.

Below The view from the buffer stops. These impressive hydraulic safety devices were manufactured by Ransome & Rapier of Ipswich and installed at Waterloo more than a century ago. They are no longer operational but are preserved *in situ* as part of the station's heritage.

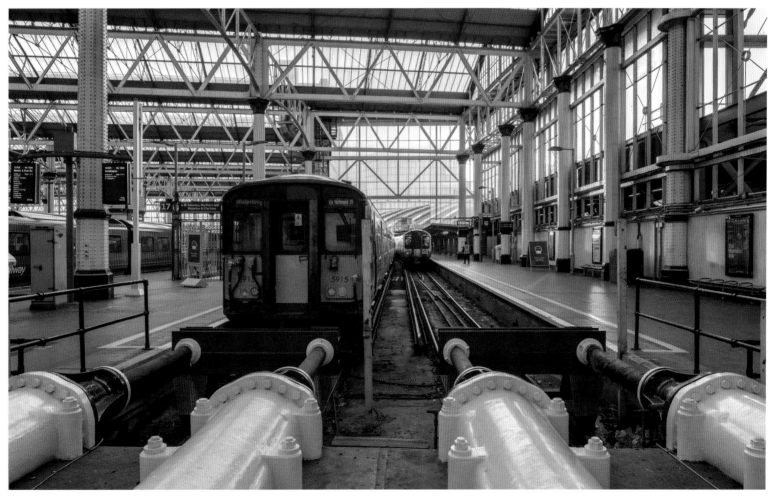

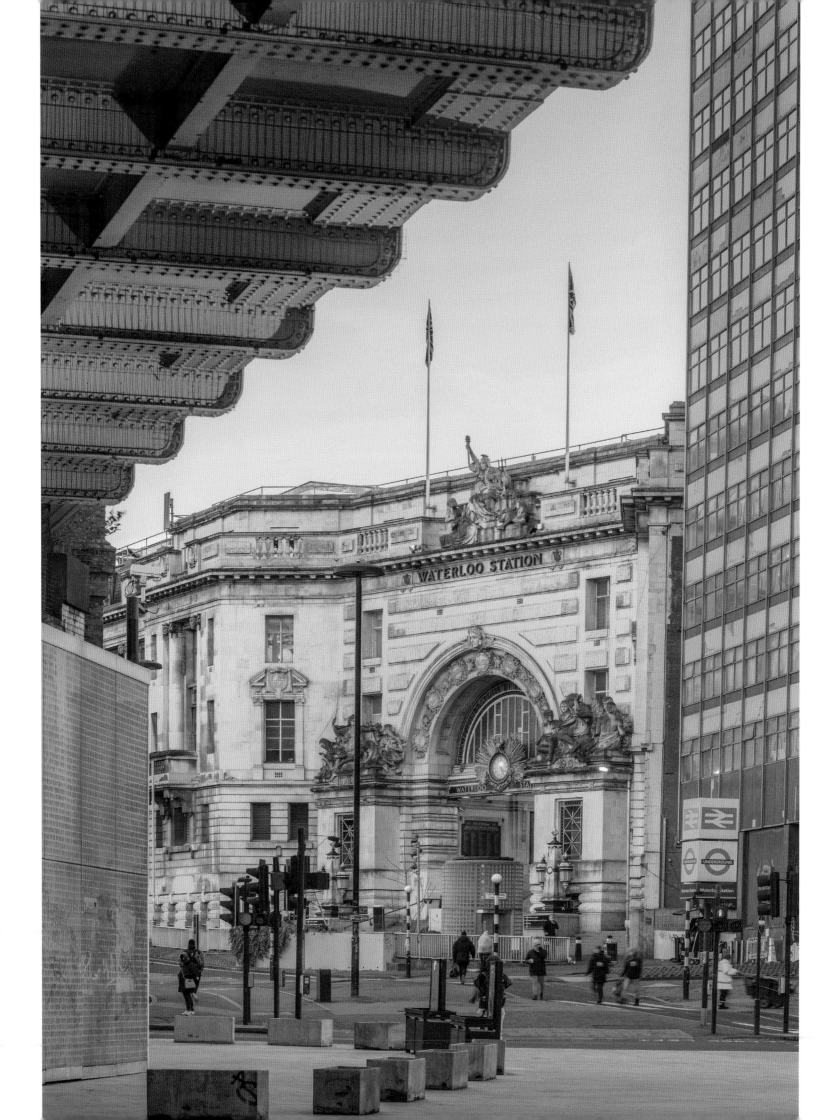

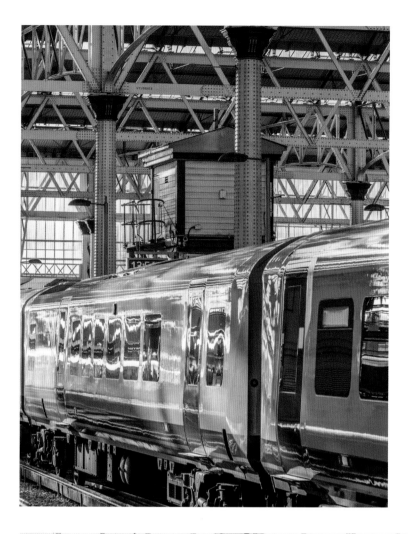

Oppoiste The main entrance to Waterloo. The bland 1960s office tower on the right replaced buildings destroyed by bombing in the war. It is now empty and due for more sympathetic redevelopment.

Left Platform view at Waterloo.

Below The curious clock over the bicycle racks outside the main exit at Waterloo. Did anyone ever check their time to reach the office from here?

Overleaf The former Waterloo International terminal, opened in 1994 but closed in 2007 when HS1 opened to St Pancras International. It then lay unused for twelve years until the platforms could be converted back for domestic services, opening again in 2019. This brilliant design was a shocking waste of public money through poor planning.

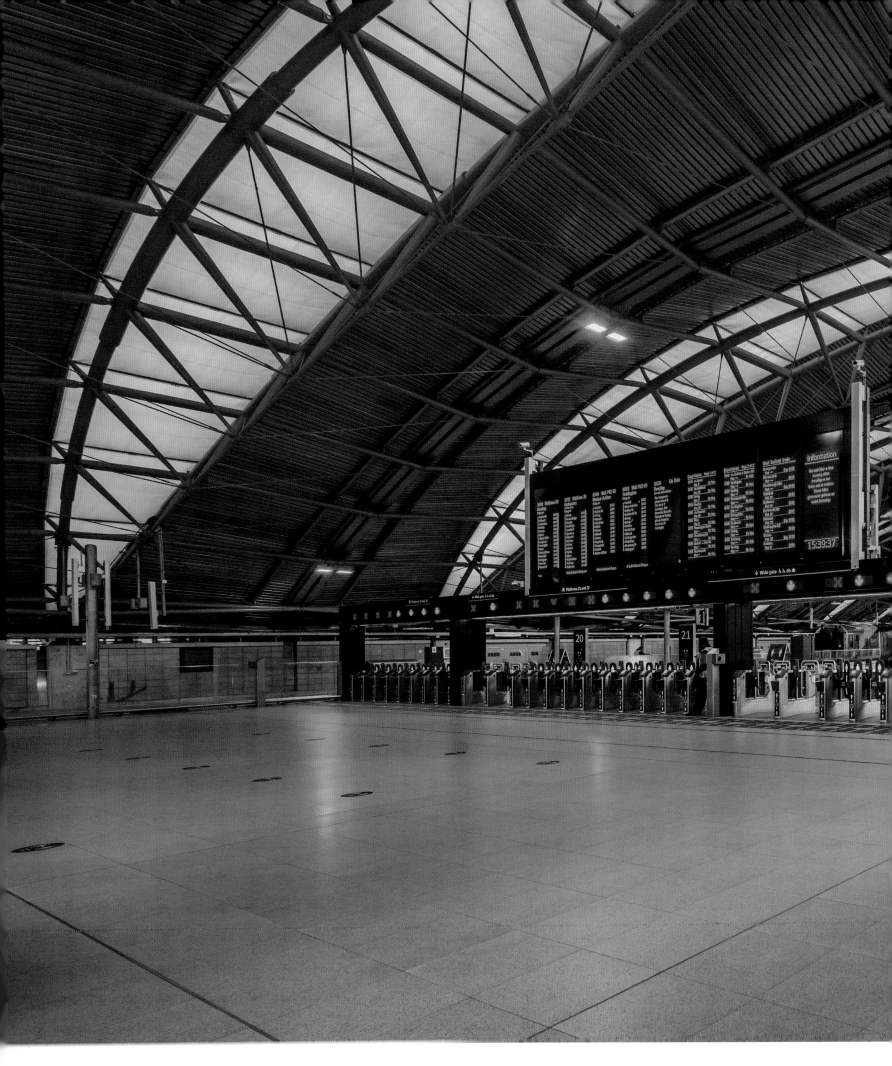

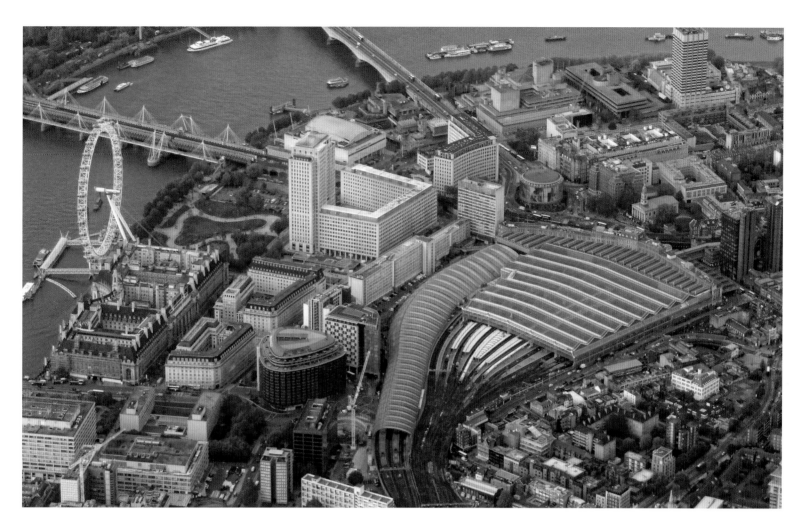

The ground floor former Eurostar reception area below the platforms has, inevitably, been turned over to retail, which may struggle if there is a post-COVID drop in commuting.

Waterloo was already Britain's busiest railway station by patronage, with just under 100 million National Rail (NR) passenger entries and exits in 2015–16. If NR interchanges, the Underground station and Waterloo East are added to this, the complex handled a total of 211 million arrivals and departures in 2015–16, making it the busiest transport hub in Europe. Waterloo also now has more platforms and a greater floor area than any other station in the UK. To reduce congestion on the concourse, and improve access to Waterloo East, Network Rail constructed a balcony along almost the entire width of the main station, which was opened in 2012. This provided eighteen new retail spaces and catering outlets, allowing more circulation space on the main concourse.

The supposedly traditional meeting place 'under the clock at Waterloo' is now a safer rendezvous than at any time since the four-faced hanging timepiece, designed by Gents of Leicester, was installed more than a century ago. The central roadway has gone and anyone loitering below the clock no longer risks being hit by a parcels van or a string of BRUTE (British Rail Utility Trolley Equipment) platform trolleys. A terrazzo floor has replaced the grim acres of black tarmac. Since 2010 the refurbished clock has even been fitted with new technology that automatically adjusts it twice a year to and from British Summer Time.

Opposite Britannia presiding over the Victory Arch.

Above Aerial view of Waterloo, showing the double-length trainshed of the former International station snaking round the western side. The large building above it is the former Shell Centre.

Overleaf The main entrance to Waterloo is the Victory Arch, designed by Scott as a memorial to the 585 LSWR staff killed in the First World War and opened by Queen Mary on 21 March 1922. This marked the final stage in the twenty-year programme to rebuild Waterloo.

Victoria

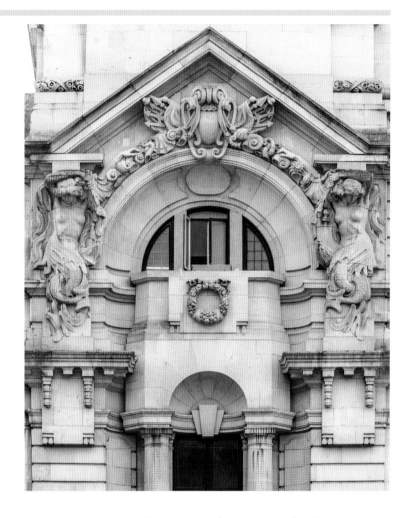

Victoria was built originally as two separate stations alongside each other, later combined uncomfortably into one. Today Victoria is the second busiest London terminal after Waterloo, but still split down the middle and showing signs of the divided original layout. John Betjeman memorably called it 'London's most conspicuous monument to commercial rivalry'.

None of the early terminals for main lines from the south was conveniently located for the City or Westminster. London Bridge, Bricklayers Arms and Waterloo were all south of the Thames, and the rival companies jostling for closer access to central London looked for an alternative way in to the west. A proposal by a new company to build a short connecting line over the river at Battersea to a new terminal site in Pimlico was approved in 1858. The Victoria Station and Pimlico Railway (VS&PR) was backed by the London, Brighton and South Coast Railway (LBSCR) and agreement was reached with the London, Chatham and Dover Railway (LCDR) over use of the approach tracks and a long lease on the eastern side of the station site. The engineer for the VS&PR was John Fowler, who was already working on London's first underground railway, the Metropolitan. Fowler designed the Grosvenor Bridge, the first to take trains over the Thames in central London when the line to Victoria was opened in 1860.

Twin terminals were built on the station site in Pimlico. The LBSCR station, designed by its resident engineer, Robert Jacomb-Hood, with a long overall roof, was completed first, opening on 1 October 1860. The slightly smaller LCDR terminus alongside, with an iron trainshed by John Fowler, was completed two years later. These two stations were run entirely separately and there was no physical connection between them, to the confusion of many travellers. Victoria's split personality is acknowledged in the well-known 'handbag' episode in Oscar Wilde's *The Importance of Being Earnest*, first performed in 1895. Jack tries to bolster his account of being found as a baby in the cloakroom at Victoria station with the added detail of its specific location on the Brighton side. This elicits Lady Bracknell's dismissive response: 'The *line* is immaterial, Mr Worthing.'

A third Victoria station was opened by the District Railway in 1868. The entrance to this separate underground station was on the other side of the large bus and cab yard to the north of the two overground terminals, but linked to them by a subway. A new sub-surface booking hall for the Underground was constructed below the station forecourt when the Victoria line Tube was built a century later. Even then this was a rather cramped and inadequate route to the Underground on different levels that became very crowded in the morning rush hour from the main-line station. The Underground was finally opened up with wider additional entrances in 2018, offering both lift and escalator access from the street to the various lower levels of the station and much improved passenger flow.

Neither the Brighton nor the Chatham company bothered to add any architectural embellishment to the joint frontage at the end of their original trainsheds at Victoria. Wooden buildings and boarding gave both station entrances a shabby, temporary

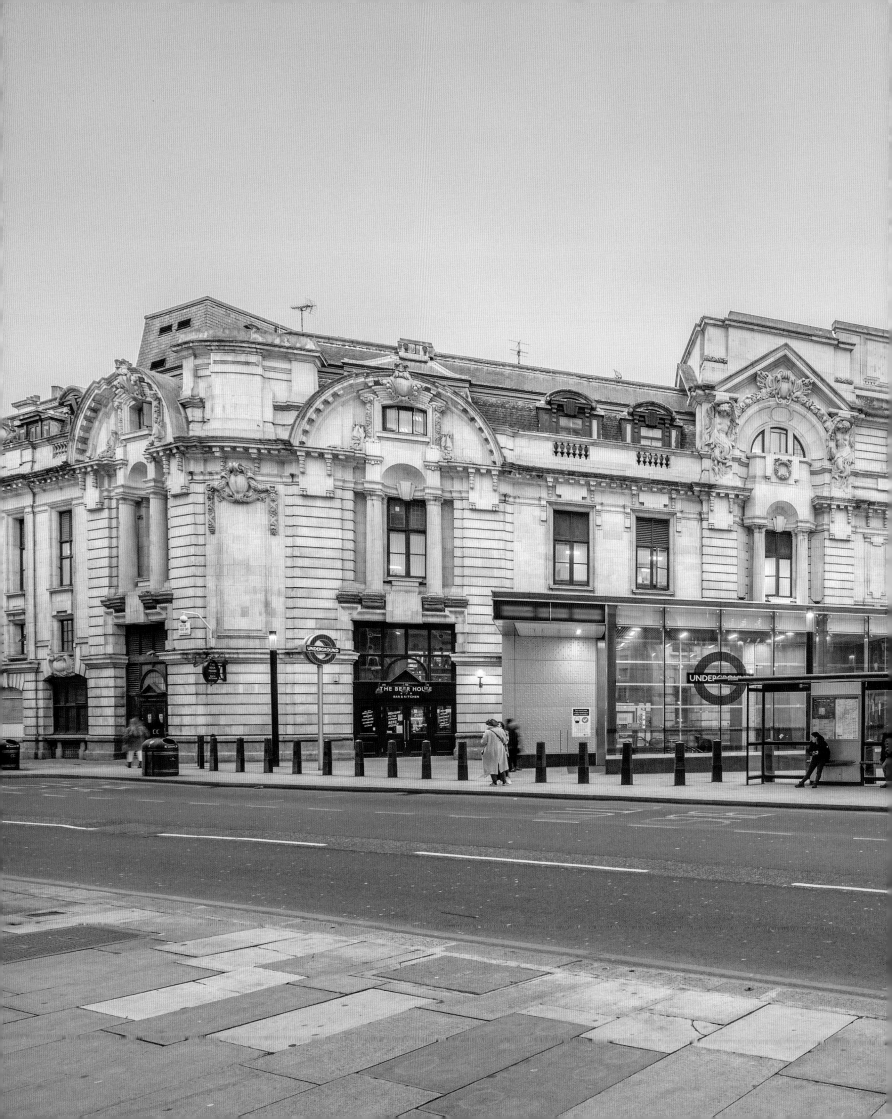

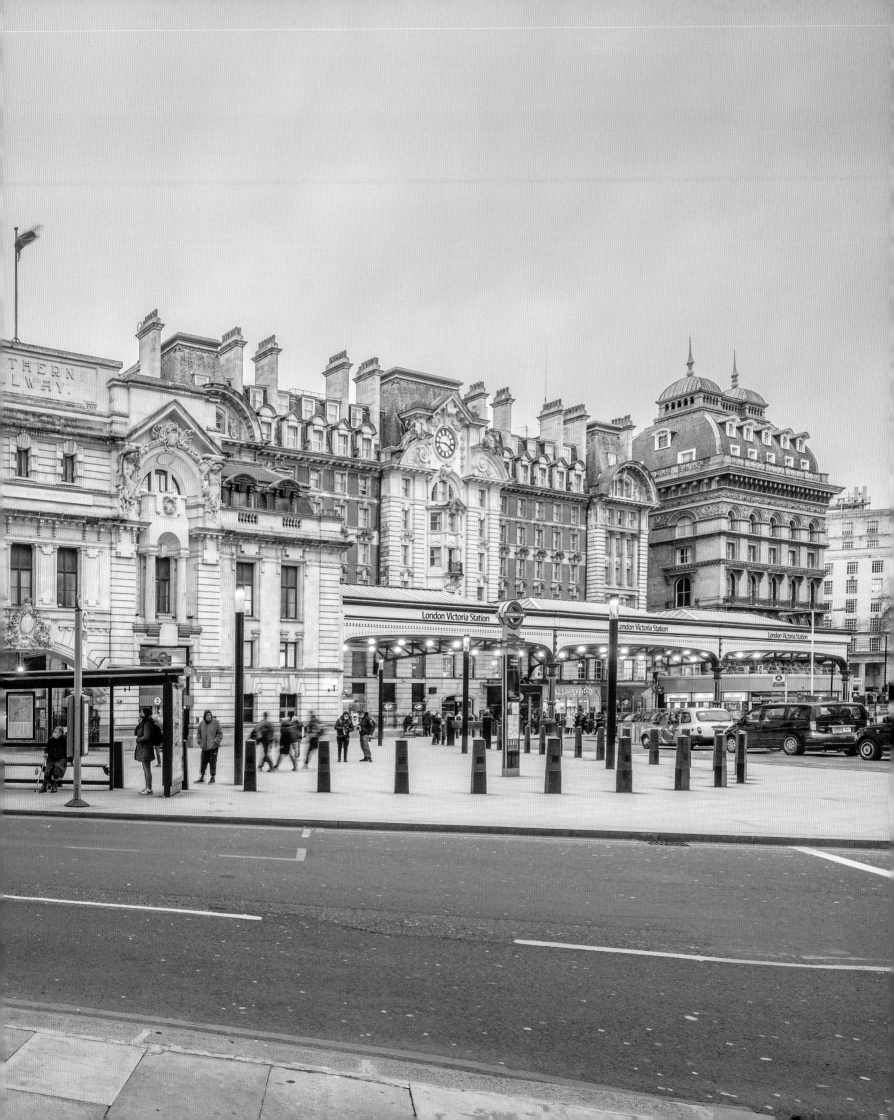

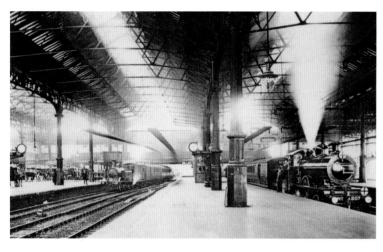

appearance that was virtually unchanged for the first forty years. The LCDR's modest permanent buildings were along the side of the trainshed, around the corner from the cab yard in Hudson's Place, unseen then and now by most passengers arriving at or leaving the station. The LBSCR's entrance was no better, but at the northern end of its station, alongside Buckingham Palace Road, an imposing grand hotel was opened in 1861.

The massive 300-room Grosvenor Hotel, designed in French Renaissance style by J.T. Knowles, was originally independent of the railway company but gave Victoria its only real architectural presence in the nineteenth century. The impressive entrance hall, grand staircase and restaurant inside the former Grosvenor, now the Ambi Hotel Victoria, have been sensitively renovated to maintain its traditional interior layout and external appearance. As Simon Jenkins has described it, 'the façade drips with friezes, fronds and relief busts in carved roundels ... [while] the cornice suffers from sculptural indigestion'. None of the many individual busts is named and Jenkins admits that he has been unable to identify any more than Pevsner, who could only recognize Victoria, Albert and Lord Palmerston, the prime minister when the hotel was built.

The LBSCR eventually modernized its frontage in the early 1900s, buying the Grosvenor Hotel in 1899 and extending the hotel at right angles with a nine-storey building across the station entrance. The enlarged hotel, opened in 1907, was leased to Gordon Hotels for operation. Its rather pompous new Edwardian baroque wing, which included much-improved passenger facilities

on the concourse inside the station, was designed by the LBSCR's engineer, Charles Morgan. Many of the decorative details, which were later neglected and covered up in the course of the twentieth century, have been renovated. Perhaps the station's best feature is a lovely pair of tiled maps showing the LBSCR's main line and suburban networks in about 1908, now revealed in one of the entrances from the forecourt. Both maps were obscured for many years behind a row of wooden public telephone booths, no longer needed in the age of the mobile phone.

At the other end, the Brighton station was extended towards the river and widened alongside Buckingham Palace Road. This allowed double-length platforms to be installed, which could each take two trains, effectively doubling the capacity of the LBSCR station. The extension was complete by 1907 and was followed by improved train services two years later when the first stage of suburban electrification was introduced using the overhead wire system. The first 'Elevated Electrics' ran across south London from Victoria to the LBSCR's other terminus at London Bridge. The service was designed to compete with the London County Council's newly introduced electric trams, which by then were offering cheap and very popular local services all over south London.

Not to be outdone, the Chatham (which had by then become the South Eastern and Chatham Railway, SECR) had built an even more ostentatious Edwardian frontage to its station next door. The building, designed by architect Arthur Blomfield, was lower than the Brighton's Grosvenor Hotel extension, but set forward

Right Some of the unidentified heads decorating the Grosvenor Hotel.

Above The *Southern Belle* departing Victoria for Brighton under the wires for the LBSCR's Elevated Electric suburban lines, c.1909.

Below A clumsy demonstration of the new name for the electric Pullman at Victoria, 1934.

Right SR poster by Shep, promoting the *Brighton Belle*, 1935.

Below New Britannia-class Pacific *William Shakespeare* on the *Golden Arrow* at Victoria, 1951. In the year of the Festival of Britain, the luxury train promoted traditional British products with a new set of British-built Pullman cars, as well as friendship with France by flying the Tricolour alongside the Union Flag.

Right BR poster for the *Golden Arrow*, 1959, still fashionable but soon struggling to compete with new airline services to Paris from Gatwick.

from its neighbour and faced entirely in white Portland stone. Appropriately, as the entrance to the SECR's main Continental boat-train terminus, the wide central archway was set in a French Second Empire-style surround with maritime decoration including four statuesque mermaid caryatids supporting the roof pediments. The new passenger concourse inside the station was more restrained, but featured large separate restaurant and tearooms run by J. Lyons and Company. The old Chatham trainshed over the platforms was left untouched.

The SECR station was very heavily used during the First World War when it became the main London station for troops heading for France or coming home on leave. By 1918, thousands of men in uniform were passing through Victoria every day. Alan Jackson has described what became a regular scene at the cab arch, where 'almost every day, pathetic little groups of soldiers, families and girlfriends could be seen making their farewells. Relatives and friends were not allowed on the platforms for fear this might delay departures. Many, too many, of these men were never to see London again.'

The Southern Railway (SR) took over both Victoria terminals in 1923 and started what was to be a long process of integration by knocking holes through the dividing wall between the stations. The LBSCR's 'Elevated Electric' system was quickly abandoned and both stations were electrified on the London and South Western Railway's (LSWR) third-rail system, soon branded by the SR as 'Southern Electric'. The rapid extension of the suburban electric network nearly doubled commuter traffic into Victoria, with

wealthier season-ticket holders making a daily journey into London from Surrey, Kent or Sussex. The flagship of the service was the *Brighton Belle,* the first all-Pullman electric train, which succeeded the steam-hauled *Southern Belle.* The new name was announced in 1934, some months after the electric Pullman sets had been introduced. The train was scheduled to make the 97km (60 mile) journey from Victoria to Brighton non-stop in one hour – or a mile a minute – a speed that has not been improved upon since.

The SR found a growing market for its boat-train services from Victoria, not yet electrified but given the glamour and luxury of special Pullman coaches and Wagons-Lits sleeping-cars. The all-Pullman *Golden Arrow* service to Dover was introduced in 1929, linking with a Channel crossing to Calais and its French equivalent, the *Flèche d'Or,* taking passengers on to Paris. In 1936, the *Night Ferry* was inaugurated, a luxury train of sleeping-cars that ran from Victoria to Dover, was loaded on to a special train-ferry to Dunkerque, and then ran through northern France to Paris Gare du Nord.

Imperial Airways opened its London headquarters and terminal building alongside Victoria station on Buckingham Palace Road in 1939. On 6 June the first SR Flying Boat train left Victoria for the new Empire Air Base at Southampton Docks. Air passengers could check in at the front of the building and board a train for Southampton at a special platform at the back. This was the first rail-air service in Britain. Imperial Airways were hoping to launch a Transatlantic air service to New York that summer, but the

Opposite 'Little Ben', the miniature clock tower just outside the station yard at the top of Victoria Street, was first put up in 1892.

Left The concourse at Victoria, still physically split into the Chatham (east) and Brighton (west) sides, like separate stations.

Below Waiting with granny at Victoria station, c.1960.

Overleaf The listed roof of the Chatham station at Victoria, designed by John Fowler, engineer of the Metropolitan Railway.

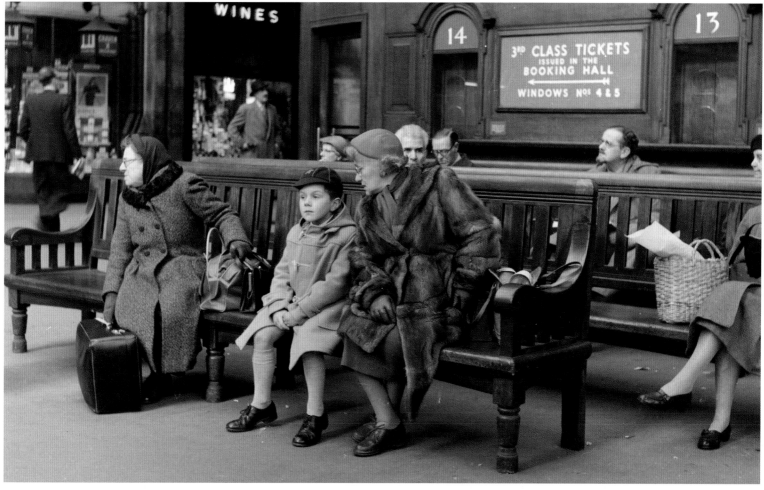

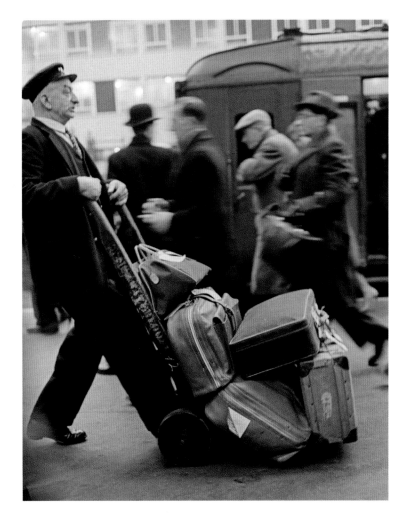

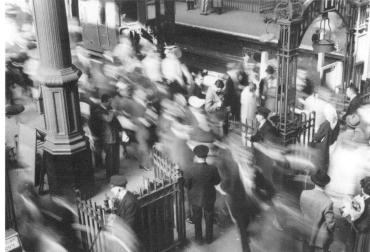

deteriorating international situation in Europe quickly ended these plans. When war with Germany was declared in September all civil aviation in the UK was suspended and Imperial's staff, who had only just moved into their swish new art-deco building in July, were evacuated to Bristol. In April 1940, Imperial was nationalized as the British Overseas Aircraft Corporation (BOAC) but civil aviation was not possible under war conditions. The former Imperial Airways building at Victoria still stands, but has no connection with rail or air services. It is now occupied by the National Audit Office.

After the Second World War a new rail-air service at Victoria was eventually created with the opening of a new station at Gatwick Airport in 1958 and a rail-air terminal at Victoria itself in 1962. A regular rail service to Gatwick for air passengers every 15 minutes was eventually transformed into the non-stop Gatwick Express in 1984. The rise of this rail-air service was matched by the declining patronage of Victoria's Continental boat-trains. The last *Golden Arrow* left for Dover in 1972 and the *Night Ferry* service was withdrawn in 1980. Victoria's inviting international departure board, still topped with a sunburst clock and a pre-war header announcing 'THE GATEWAY TO THE CONTINENT', suddenly became irrelevant and redundant.

The ageing *Brighton Belle* electric Pullman sets were also taken out of service in 1972, much to the disgust of regular passengers like Sir Laurence Olivier, who had led a customer revolt only a few months earlier when kippers were taken off the *Belle*'s breakfast menu. It made no difference to British Rail, who

withdrew all three *Belle* sets from service and saw no reason to replace them with special modern luxury trains on a standard commuter service. Shortly before this, the main station clock, which hung over the Brighton concourse and had been the traditional meeting point at Victoria for decades, was removed and shipped to the United States to decorate a restaurant.

Ironically, Victoria had never possessed a well regarded station restaurant of its own even in the heyday of its Continental services. It could never have matched the renowned *Train Bleu* restaurant in the Gare de Lyon, Paris with its over-the-top *Belle Epoque* décor, enticing painted views of the Cote d'Azur and traditional French menu. The *Train Bleu* has been enduringly popular with both Parisians and travellers heading for the south of France since the opening of that city's second busiest station in 1901. But perhaps this says more about the long standing British disdain for railway catering than any particular deficiencies at Victoria. The success of the Renaissance Hotel restaurant and other catering outlets at St Pancras International suggests that it is not impossible to attract people to a meal or drinks in an historic railway station even if they are not taking the train.

While some of Victoria's long-standing features disappeared and its international atmosphere faded, the station became ever busier with commuters. It needed comprehensive reorganization to a single, logical plan but commercial pressures and opportunities led British Rail to base the selective redevelopment of Victoria in the 1980s largely around exploitation of the air space over half the station

Opposite South Eastern service on the Chatham side of the station.

Left Westminster Cathedral tower, just beyond the latest glass offices on Victoria Street and a new Underground entrance.

Below The boxy 1980s office development above the Brighton side looks cheap and nasty when viewed against Fowler's lattice arch roof spans on the Chatham side, put up more than a century earlier and now protected by listing.

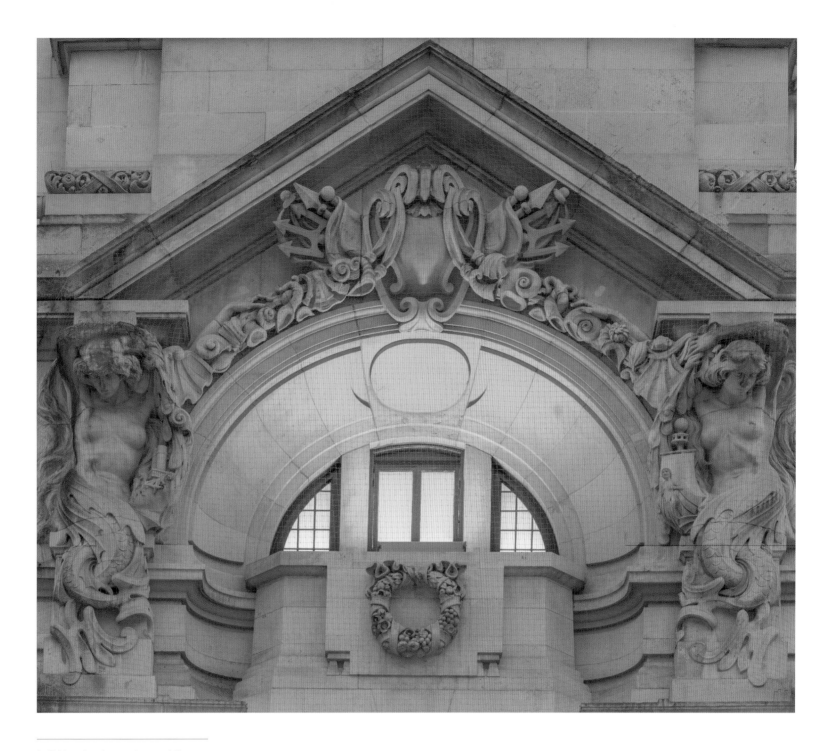

Left New development around the station is still pressing in on Victoria, which struggles to maintain its heritage.

Above Keeping the glow round the Chatham side's Edwardian maidens.

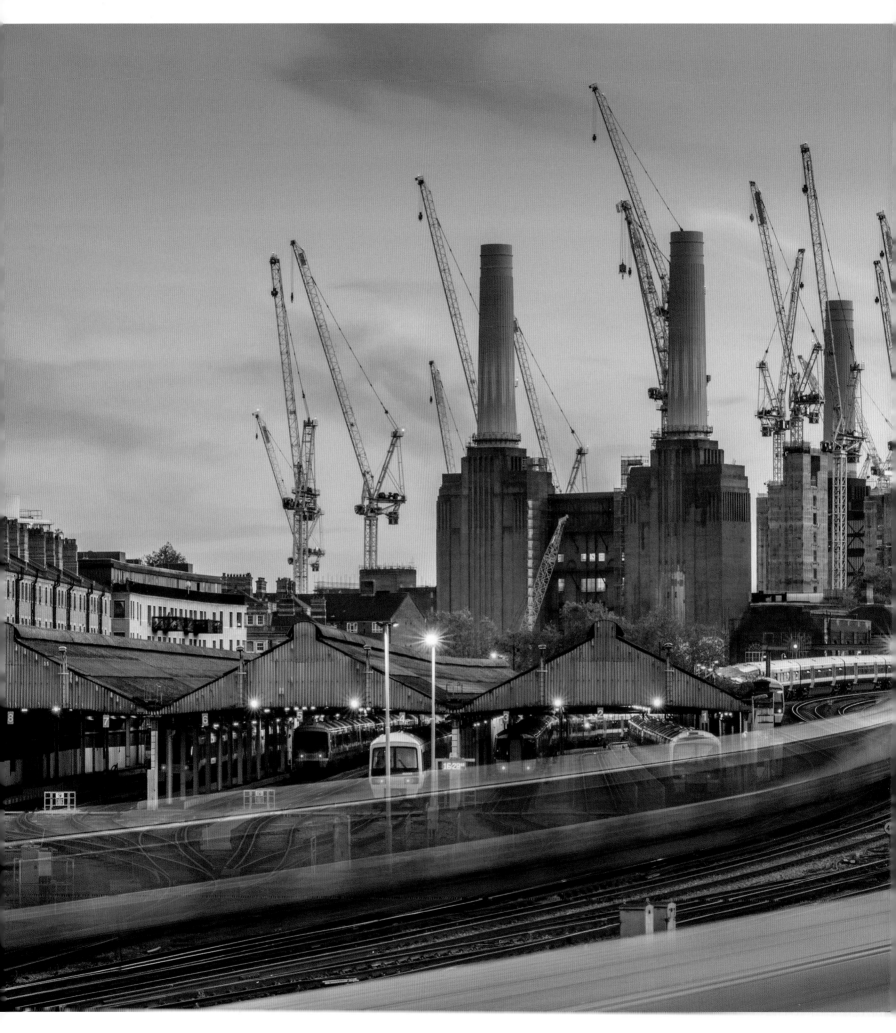

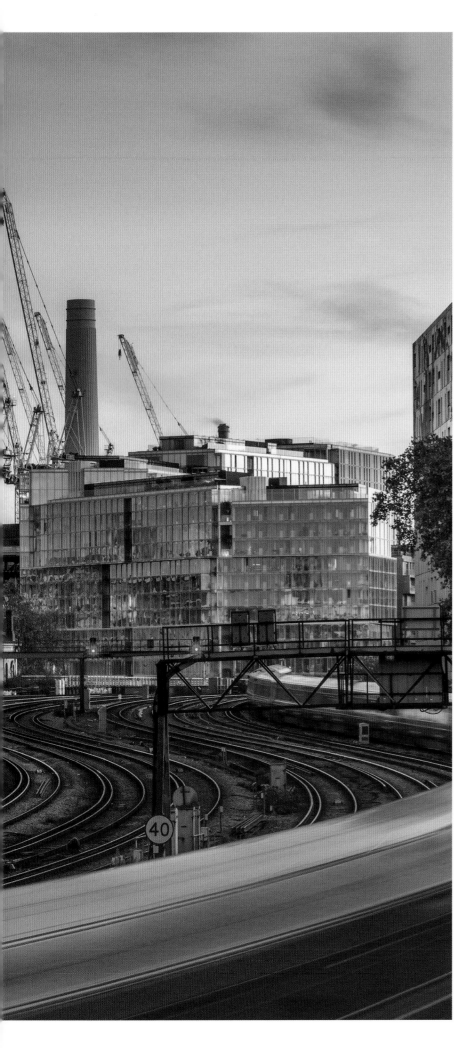

Left The railway exit from Victoria, up the bank to Grosvenor Bridge, over the Thames then past the shell of Battersea Power Station, now being restored to offices and apartments.

Most of the Brighton side was covered with a steel raft on which first an office block, Victoria Plaza, and then a retail mall, Victoria Place, were built. The raft also accommodated a new rail-air terminal for Gatwick Express, but this side of the station now feels functional and soulless; its glitzy 1980s design already looking tacky and dated. The station at Gatwick Airport is at last being rebuilt and hopefully both the rail service and the passenger welcome at the London end might now be given the quality improvement they deserve to match the rail experience of the Heathrow Express from Paddington.

Meanwhile, the main concourse and eastern side of the station, where the listed LCDR roof remains in place, has been partly opened up and the dividing wall replaced by a central retail block called Victoria Island. By the start of the twenty-first century Victoria was challenging Waterloo in numbers, with more than 200,000 passengers passing through every weekday. Further redevelopment of the station to make it fit for purpose seems inevitable, but after the partial rebuilding of the 1980s a comprehensive new scheme for Victoria seems unlikely. More attention has been given in the 2010s to the remodelling of the bus station in the forecourt and the provision of better access to the Underground, both more or less complete by 2020. As London's second busiest main-line station, Victoria is now looking tired and neglected, definitely in need of something more than a quick design makeover, which could give this great terminal a sense of style and welcome to its customers. At the moment Victoria is not a station that encourages anyone to linger or spend any more time in than is absolutely necessary.

Index

Further reading

Barker, T.C. and Robbins, Michael, *A History of London Transport, Vol. 1: The Nineteenth Century* and *Vol. 2: The Twentieth Century to 1970* (George, Allen & Unwin, 1963, 1974).

Bayley, Stephen, *Work: The Building of the Channel Tunnel Rail Link* (Merrell, 2007).

Betjeman, John, *London Railway Stations in Flower of Cities: A Book of London* (Max Parrish, 1949).

Betjeman, John, *London's Historic Railway Stations* (Capital Transport, new ed. 2002).

Biddle, Gordon, *Britain's Historic Railway Buildings* (Oxford University Press, 2003).

Binney, Marcus and Pearce, David, *Railway Architecture* (Orbis Publishing, 1979).

Bradley, Simon, *St Pancras Station* (Profile Books, 2007).

Bradley, Simon, *The Railways: Nation, Network & People* (Profile Books, 2015).

Brindle, Steven, *Paddington Station: Its History and Architecture* (English Heritage, 2nd ed. 2013).

Brooksbank, B.W.L., *London Main Line War Damage* (Capital Transport, 2007).

Bryan, Tim, *Paddington: Great Western Gateway* (Silver Link Publishing, 1997).

Bryan, Tim, *Railway Stations* (Amberley Publishing, 2017).

Christopher, John, *London's Historic Railway Stations Through Time* (Amberley Books, 2016).

Cordner, Ken, *Tunnel Vision* (Ian Allan Publishing, 2008).

Course, Edwin, *London Railways* (Batsford, 1962).

Darley, Peter, *The King's Cross Story: 200 Years of History in the Railway Lands* (The History Press, 2018).

Davies, R. and Grant, M.D., *London and Its Railways* (David & Charles/ Book Club Associates, 1983).

Dendy Marshall, C.F.A, *History of the Southern Railway* (Southern Railway, 1936).

Derbyshire, Nick, *Liverpool Street: A Station for the Twenty-first Century* (Granta Editions, 1991).

Faulkner, J.N., *Railways of Waterloo* (Ian Allan, 1994).

Fawcett, Bill *Railway Stations* (Shire, 2015).

Green, Oliver and Graham, Benjamin, *London's Underground: The Story of the Tube* (White Lion Publishing, 2019).

Holder, Julian and Parissien, Steven (eds), *The Architecture of British Transport in the Twentieth Century* (Yale, 2004).

Hunter, Michael and Thorne, Robert (eds), *Change at King's Cross* (Historical Publications, 1990).

Jackson, Alan A., *London's Termini* (David & Charles, 1969).

Jenkins, Simon, *Britain's 100 Best Railway Stations* (Viking, 2017).

Jenkinson, David, *The London & Birmingham: A Railway of Consequence* (Capital Transport, 1988).

Kellett, John R., *The Impact of Railways on Victorian Cities* (Routledge & Kegan Paul, 1969).

Lambert, Anthony J., *Marylebone Station Centenary* (Metro Publications, 1999).

Lansley, Alastair, *The Transformation of St Pancras Station* (Laurence King, 2008).

Leleux, Robin, *Restoration Rewarded: A Celebration of Railway Architecture, 40 Years of the National Railway Heritage Awards* (Unique Books, 2019).

Meeks, Carroll L.V., *The Railroad Station* (Yale University Press, 1956).

Minnis, John, *Britain's Lost Railways: The Twentieth Century Destruction of our Finest Railway Heritage* (Aurum Press, 2014).

Parissien, Steven, *Station to Station* (Phaidon Press, 1997).

Powell, Kenneth, *St Pancras, London* (Manhattan Loft Corporation Ltd, 2011).

Richards, Jeffrey and MacKenzie, John, *The Railway Station: A Social History* (Oxford University Press, 1986).

Richards, Peter and Simpson, Bill, *A History of the London & Birmingham Railway, Vol 1: Euston to Bletchley* (Lamplight Publications, 2004).

Schabas, Michael, *The Railway Metropolis: How Planners, Politicians and Developers Shaped Modern London* (ICE Publishing, 2017).

Scholey, K.A., *London's Railways*, Tempus, 1999.

Simmons, Jack, *St Pancras Station* (Historical Publications, revised ed., 2003).

Simmons, Jack, *The Victorian Railway* (Thames & Hudson, 1991).

Simmons, Jack and Biddle, Gordon (eds), *The Oxford Companion to British Railway History* (Oxford University Press, 1997).

Thorne, Robert, *Liverpool Street Station* (Academy Editions, 1978).

Tutton, Michael, *Paddington Station 1833–1854* (Railway & Canal Historical Society, 1999).

White, H.P., *A Regional History of the Railways of Great Britain, Vol. 3: Greater London* (David & Charles, new ed. 1971).

Wolmar, Christian, *Cathedrals of Steam: How London's Great Stations Were Built – And How They Transformed the City* (Atlantic Books, 2020).

Picture credits

The publishers would like to thank the following for permission to reproduce the images in this book. Every effort has been made to provide correct attributions. Any inadvertent errors or omissions will be corrected in subsequent editions.

28–9 Mary Evans Picture Library/Mapseeker Publishing; **32** SSPL/Getty Images; **33 above** Private collection; **33 below** Wikimedia Commons; **35** Network Rail Archive; **38** Royal Collection; **39** SSPL/Getty Images; **42** Private collection; **43** SSPL/Getty Images; **46** SSPL/Getty Images; **47 below** SSPL/Getty Images; **51** Historic England; **53 left** London Transport Museum; **57** SSPL/Getty Images; **58 left** SSPL/Getty Images; **58 right** Popperfoto/Getty Images; **61 left** London Transport Museum; **61 right** Heritage Images/Getty Images; **62** Private collection; **63 above** Private collection; **69** Chronicle/Alamy Stock Photo; **70 above** Heritage Images/Getty Images; **70 below** SSPL/Getty Images; **71** SSPL/Getty Images; **72** SSPL/Getty Images; **73 left** Culture Club/Getty Images; **73 right** Private collection; **74 above** SSPL/Getty Images; **74 below** Construction Photography/Avalon/Getty Images; **75 left** Construction Photography/Avalon/Getty Images; **75 right** Philip Pound/Alamy Stock Photo; **84** Joseph Robson; **85** Crossrail; **86–7** Crossrail; **90** © National Railway Museum/Science & Society Picture Library; **92 right** © National Railway Museum/Science & Society Picture Library; **93 below** SSPL/Getty Images; **104–5** © Museum of London; **111** Private collection; **114** © National Railway Museum/Science & Society Picture Library; **115 above** © National Railway Museum/Science & Society Picture Library; **115 below** © National Railway Museum/Science & Society Picture Library; **118 above** LMPC/Getty Images; **118 below** © National Railway Museum/Science & Society Picture Library; **119 above** Topical Press Agency/Getty Images; **119 below** © National Railway Museum/Science & Society Picture Library; **121 above** © National Railway Museum/Science & Society Picture Library; **131** SSPL/Getty Images; **133** Tim Brown; **137 above right** © National Railway Museum/Science & Society Picture Library; **137 below left** Crossrail; **137 below right** SSPL/Getty Images; **138 above** Private collection; **138 below** Chronicle/Alamy Stock Photo; **139 above** © National Railway Museum/Science & Society Picture Library; **139 below** Historic England Archive/Getty Images; **141** SSPL/Getty Images; **142–3** SSPL/Getty Images; **149** Private collection; **150 above** Hulton Archive/Getty Images; **150 below** Heritage Images/Getty Images; **151 above** Artefact/Alamy Stock Photo; **151 below** Mary Evans Picture Library; **154** SSPL/Getty Images; **157** Private collection; **159 left** De Luan/Alamy Stock Photo; **159 right** SSPL/Getty Images; **159 above** London Transport Museum; **159 below** © National Railway Museum/Science & Society Picture Library; **162 above** SSPL/Getty Images; **163 above** © National Railway Museum/Science & Society Picture Library; **163 below** Oliver Green; **174** A.P.S. (UK)/Alamy Stock Photo; **179** © Museum of London; **181 above** Chronicle/Alamy Stock Photo; **181 below** William Morris Gallery, London Borough of Waltham Forest; **184 below** SSPL/Getty Images; **195 above** © National Railway Museum/Science & Society Picture Library; **195 below** © Museum of London; **209 above** SSPL/Getty Images; **206** ND/Roger Viollet/Getty Images; **207** Chronicle/Alamy Stock Photo; **218 above** Shawshots/Alamy Stock Photo; **218 below** SSPL/Getty Images; **219** London Transport Museum; **222** SSPL/Getty Images; **224 above** © National Railway Museum/Science & Society Picture Library; **224 below** SSPL/Getty Images; **225 below** SSPL/Getty Images; **228–9** SSPL/Getty Images; **231 above** © Howard Grey; **231 below** Heritage Images/Getty Images; **250 above left** Chronicle/Alamy Stock Photo; **250 below left** Chronicle/Alamy Stock Photo; **254 above** Popperfoto/Getty Images; **254 below left** E. Dean/Topical Press Agency/Getty Images; **254 below right** SSPL/Getty Images; **255 left** J.A. Hampton/Topical Press Agency/Hulton Archive/Getty Images; **255 right** © National Railway Museum/Science & Society Picture Library; **257 below** © Henry Grant Collection/Museum of London; **260** © Estate of Bob Collins/Museum of London; **261** © Estate of Bob Collins/Museum of London.

Acknowledgements

Author Oliver Green and photographer Benjamin Graham would like to thank all the many attentive and accommodating railway staff who facilitated the photography for this publication. We'd like to give special shout-outs to Sir Peter Hendy, Chairman of Network Rail, to his PA Shauna Devlin, and to media facilitator Rajinder Pryor, without whose efforts much of the contemporary photography for this book would not have been possible. Benjamin Graham would like to thank the ever-generous Rob MacNeice of Nikon UK who magnanimously loaned some of Nikon's new state-of-the-art digital imaging equipment that produced many of the photographs in the final editorial gallery. Lastly – but not leastly – thank you to our designer, Glenn Howard, and to our editors, Michael Brunström and Philip Cooper at Frances Lincoln Publishing. We are honoured to have been involved in the creation of a further addition to their library of London titles. Our heartfelt thanks to everyone who helped to make this project become a reality.

First Published in 2021 by Frances Lincoln, an imprint of The Quarto Group.

The Old Brewery, 6 Blundell Street, London N7 9BH, United Kingdom. T (0)20 7700 6700 F (0)20 7700 8066 www.QuartoKnows.com

Text © Oliver Green 2021
Introduction © Sir Peter Hendy 2021
Principal photography © Benjamin Graham 2021

A catalogue record for this book is available from the British Library.

ISBN 978-0-7112-6661-2

9 8 7 6 6 5 4 3 2 1

Typeset in Bulmer MT and News Gothic BT
Design by Glenn Howard
www.untitledstudio.com

Printed and bound in China

Brimming with creative inspiration, how-to projects and useful information to enrich your everyday life, Quarto Knows is a favourite destination for those pursuing their interests and passions. Visit our site and dig deeper with our books into your area of interest:Quarto Creates, Quarto Cooks, Quarto Homes, Quarto Lives, Quarto Drives, Quarto Explores, Quarto Gifts, or Quarto Kids.